RUSSELL LEE

RUSSELL LEE

A Photographer's Life and Legacy

MARY JANE APPEL

LIVERIGHT PUBLISHING CORPORATION
A Division of W. W. Norton & Company
Independent Publishers Since 1923

For information about permission to reproduce selections from this book, write
to Permissions, Liveright Publishing Corporation, a division of W. W. Norton &
Company, Inc., 500 Fifth Avenue, New York, NY 10110

For information about special discounts for bulk purchases, please contact
W. W. Norton Special Sales at specialsales@wwnorton.com or 800-233-4830

Manufacturing by Versa Press
Book design by Ellen Cipriano
Production manager: Lauren Abbate

Library of Congress Cataloging-in-Publication Data

Names: Appel, Mary Jane, author. | Hayden, Carla Diane, 1952– writer of
foreword. | Library of Congress, issuing body.
Title: Russell Lee : a photographer's life and legacy / Mary Jane Appel.
Other titles: Russell Lee (Liveright Publishing Corporation)
Description: First edition. | New York, NY : Liveright Publishing Corporation, a division of
W.W. Norton & Company ; [Washington, D.C.] : Library of Congress, [2021] |
Introduction by Carla D. Hayden, Librarian of Congress. |
Includes bibliographical references and index.
Identifiers: LCCN 2020027626 | ISBN 9781631496165 (hardcover) |
ISBN 9781631496172 (epub)
Subjects: LCSH: Lee, Russell, 1903–1986. | Photographers—United States—
Biography. | United States. Farm Security Administration—History.
Classification: LCC TR140.L438 A77 2021 | DDC 770.92 [B]—dc23
LC record available at https://lccn.loc.gov/2020027626

Published by Liveright Publishing Corporation, a wholly owned subsidiary of
W. W. Norton & Company, in association with the Library of Congress

Liveright Publishing Corporation, 500 Fifth Avenue, New York, N.Y. 10110
www.wwnorton.com

W. W. Norton & Company Ltd., 15 Carlisle Street, London W1D 3BS

1 2 3 4 5 6 7 8 9 0

FOR STEVE

CONTENTS

FOREWORD ix

A NOTE TO THE READER xi

INTRODUCTION: October 19, 1936 1

CHAPTER 1 1903–1926 8

CHAPTER 2 1927–1936 28

CHAPTER 3 Stryker and the File 46

CHAPTER 4 November 1936–January 1937:
 Farm Tenancy in the Midwest 71

CHAPTER 5 1937: The Land in Ruins 104

CHAPTER 6 1938: Creative Limitations 132

CHAPTER 7 1939: Texas 171

CHAPTER 8 1939–1940: Migrants 196

CHAPTER 9 1941: The Water Problem 227

CHAPTER 10 1942: "Defense Plants and Shipyards
 and God Bless America" 253

CHAPTER 11 1943–1986: Reexamination 277

ACKNOWLEDGMENTS 303

A NOTE ABOUT SOURCES 307

FREQUENTLY CITED SOURCES AND ABBREVIATIONS 309

NOTES 315

IMAGE CREDITS 345

INDEX 349

1. *Sign painter, Sioux City, Iowa, December 1936.*

FOREWORD

IN 1963, almost two decades after compiling the largest visual record in American history, under the auspices of the Farm Security Administration (FSA), Roy Stryker recalled, "I was pretty unsophisticated when I took that job as far as how to pick a photographer. . . . I began to realize it was curiosity, it was a desire to know, it was the eye to see the significance around them." Stryker had an inherent knack for recognizing talent and hired individuals who would become some of the twentieth century's most famous photographers, including Dorothea Lange, Walker Evans, and Gordon Parks. But it was a less well-known photographer—Russell Lee—who would most closely share Stryker's vision for creating a thorough pictorial record of America through these photographs.

Out of almost 15 million photographs in the Library's collections, those in the Farm Security Administration–Office of War Information Collection stand out as some of the most powerful and enduring. Originally conceived as a public relations effort for New Deal government programs aimed at helping agricultural workers, the archive morphed into a massive study of America and Americans, eventually numbering about 175,000 black and white negatives. More than a document of hard times, they also captured the human emotion held in a sin-

gle moment: the pleasure in a starkly modest Christmas meal, the pride felt for a newly built kitchen, and the dignity inherent in a carefully curated display of family photographs. That these images can move us even nearly a century later speaks to the unique ability of the photographic medium to connect us to the lived experience of the past.

More than a quarter of the printed photographs in the FSA-OWI Collection were taken by Russell Lee, the most prolific, widely traveled, and long-tenured of all of the FSA photographers. Visiting twenty-nine states over six years, Lee captured epochal moments of American history—farm tenancy and rural poverty, technological advances in agriculture, ecological disasters, western migration, racial discrimination, and the country's preparations for World War II—with a keen eye and impressive technical skill.

In addition to highlighting Lee's photographs, the publication of *Russell Lee* gives readers a sense of his personality and motivations for the first time. Author Mary Jane Appel spent two decades meticulously researching Lee, his family, and his influences. Her unveiling of the details of Lee's childhood show the origins of his curiosity and techniques, and her astute observations about his photographs offer insight into their significance then and now. Appel's fresh engagement with this material proves that close study of even a well-known collection can reveal new angles.

I invite you to further explore the power of photography by visiting the Library of Congress, either in person or online at www.loc.gov.

—*Carla D. Hayden,*
Librarian of Congress

A NOTE TO THE READER

THE FIRST TIME I remember seeing Russell Lee's work was in 1988, when I was a college student, majoring in photography. That summer, I interned at a gallery in Pittsburgh, Pennsylvania, called Blatent Image/Silver Eye (today Silver Eye Center for Photography). Though it usually featured contemporary local artists, this time it exhibited sixty-four color photographs taken in the late 1930s and early 1940s by the Farm Security Administration (FSA).

The color FSA work had caused a bit of a stir in 1979 when *Modern Photography* magazine published an article titled "The Forgotten Document." Before that, most people only knew of the black and white FSA photographs; the color transparencies (housed along with the black and whites at the Library of Congress) had gone largely unexamined. Capitalizing on this newfound attention, a New York commercial gallery made color prints and put together a traveling exhibition in the 1980s. When I saw the color work, I was stunned by how incredibly modern it seemed. One particular image caught my eye: Russell Lee's *Saying grace before the barbeque dinner at the Pie Town, New Mexico, Fair, October 1940* (fig. 72).

The traveling color FSA show generated significant discussion, and though I didn't realize it at the time, it altered the direction of my life. One afternoon I chatted with a founding member of the gallery, *Pittsburgh Post-Gazette* photographer Bill Wade. After divining my interest, he told me about a field of study devoted to the history of photography. Inspired, I went on to graduate school at the University of New Mexico.

After graduation I moved to Washington, D.C., to start a museum and archives career, and was fortunate to find project-based work in several institutions. Eventually I set my sights on the Prints and Photographs Division at the Library of Congress, made some phone calls, and learned the Division was looking for project staff to digitize one of their high-profile photography collections and prepare it for online access. As it turned out, that collection was the Farm Security Administration–Office of War Information (FSA-OWI) Collection. Of course, I knew the FSA—from both my Pittsburgh gallery days and my graduate studies—and was eager to take part.

My work on that project gave me a unique introduction to the FSA-OWI. At that time, we could only see a portion of it: prints made in the 1930s and 1940s, organized via a complex subject classification system in banks of file cabinets in the Prints and Photographs Division Reading Room. Today, thanks to the Library's efforts, we can see (and search) the entire collection online.

One of my first tasks for the digitization project was to search for all the prints made from 35mm negatives and photocopy them in negative number order. This proved challenging not only because the prints were filed by subject (rather than negative number), but also because my only clues were captions, which may or may not have included enough information to find a print. I spent months in the Reading Room, searching through the file cabinets and pulling prints in the approximate chronological order they were made.

I quickly started to recognize each photographer's individual style, how they approached their assignments, and how their images worked together to create a record of America at that time. For me, though, Lee's pictures stood out—the bold aesthetic of his interior shots and the sensitivity of his portraiture. And I was fascinated by his habit of consistently documenting family photographs on display inside people's homes.

From what I could tell, Lee shot the most film and had the highest percentage printed. I later calculated that during his FSA tenure—from the fall of 1936 until mid-1942—he shot 19,000 negatives that were captioned and printed, more than twice that of any other FSA photographer. His photographs accounted for nearly

30 percent of the printed FSA portion of the Collection. And he shot another 3,400 images for the FSA that weren't printed, but remained in the files. His OWI work—made later in 1942—added another 1,000, for a grand total of more than 23,000 photographs.

I looked for books about Lee, but found only two. One acknowledged that Lee had left a lot unsaid in interviews; the other concentrated on a single Lee assignment. In my search for articles, most of what I turned up related to Lee's Pie Town, New Mexico, series, generated by the publicity surrounding the color FSA photographs, the very work that had caught my eye a decade before at the gallery in Pittsburgh. Yet after seeing so many Lee photographs in those file cabinet drawers, I realized Pie Town represented only a tiny sliver. From my perspective—seeing the broad sweep of Lee's work—the books and articles I found seemed to barely scratch the surface.

Biographical sketches in books and articles about the FSA did the same. Most repeated the same general information, but something was missing. Here was an independently wealthy man who lived out of his car for six years, traveling the country and photographing rural America. I knew there had to be more to that story.

Another discovery piqued my interest: millions of people were seeing Lee's photographs in popular culture, but his images appeared anonymously, uncredited. For example, Microsoft featured *Tenant purchase clients at home* (fig. 62) as a screensaver in its brand-new operating system, Windows 98, and the television series *Cheers* (by then syndicated worldwide) included *Saturday night in a saloon* (fig. 40) in its opening credits. So, Lee's *work* was widely known, but he wasn't. How did that happen?

After finishing my project at the Library, I took along a firm desire to continue researching Lee and his FSA work. A few months later, as I was settling into a new project at another museum, one of the Prints and Photographs Division curators, Carol Johnson, got in touch. Carol had supported my interest in Lee while I was at the Library and told me Southwest Texas University (today Texas State University) in San Marcos was looking for an archivist to organize their Russell Lee collection. She urged me to apply.

When I got the job in the summer of 1999, I moved to Texas for three months and immersed myself in Lee's life. I catalogued his papers, vintage photographs, and personal items such as his FSA notebooks, the going-away card his FSA-OWI colleagues made for him, and his 35mm Contax camera. I remember holding that camera and thinking of the places it had gone with Lee during his photographic odyssey with the FSA.

During my summer in Texas, I sought out the house in Austin where Lee lived for more than thirty-five years and researched two other Lee collections at the University of Texas. I also met some of his friends, who were incredibly generous, giving their time and enthusiastically sharing memories. One group took me and a colleague on a tour of the local barbecue places Lee once haunted with them on Friday afternoons.

Over the ensuing years, wedged in between my collections-related projects at other museums, libraries, and archives, I continued studying Lee and visiting places and people connected to him: I traveled to his hometown of Ottawa, Illinois, and to his alma maters in Culver, Indiana, and Bethlehem, Pennsylvania. I spent time in locations he documented (including Pie Town, New Mexico) and met residents he photographed. One of my most exciting research experiences was riding on a thirty-six-row planter across an Illinois cornfield.

Lee had no surviving family (his wife, Jean, died in 1996), but I visited many of his colleagues, including some who knew him in the 1930s and 1940s. I also dug into the papers of those close to him, including his first wife, the painter Doris Lee, and Roy Stryker, the director of the FSA documentary project. The more I discovered about Lee, the more captivated I became.

As I mined the archives, I uncovered remarkable material formerly unknown or overlooked. In the Jack Delano Papers at the Library of Congress, for example, I found a never-before-published letter Lee wrote to Stryker about the injustices of the Japanese American internment during World War II. At the records offices of LaSalle County, Illinois, I discovered the source of Lee's wealth and later unlocked how it shaped his creative process. And in the Roy Stryker Papers, at the University of Louisville in Kentucky, I explored the fascinating symbiotic working relationship between Lee and Stryker. Even Lee's Pie Town work, hands-down his

most studied series, held surprises that speak to the complexity of his approach, the era's accepted conventions for documentary photography, and how opinions about those conventions changed over the decades.

While studying Lee's photographs, I came to appreciate their depth and continuing relevance. Many of the social problems he documented are still with us: homelessness; chronic poverty; the struggle for a living wage; abusive labor practices; hostility toward migrants; and environmental damage inflicted in the name of economic progress. Lee, who was White, also concerned himself with discrimination against multiple racial and ethnic groups, as well as the country's conflicting views of immigrants and American identity. And today, as we face a global pandemic, I see parallel circumstances: precipitous unemployment and economic devastation; massive government relief measures; the politicization of crisis; and selfless action by countless individuals. In addition, just as we see all too often today, in Lee's time various news outlets and other organizations manipulated facts and suppressed information to support their editorial biases and political agendas. But Lee's photographs are powerful evidence of his era's social concerns, and they stand as a testament to his documentary integrity, reminding us how far we've come as we continue to grapple with many of these same problems.

Formally trained as a chemical engineer, Lee taught himself photography and applied a scientifically based methodology to systematically examine, classify, and document his subjects. In an often-repeated quote, Stryker once compared Lee's photographic method to the field of taxonomy, the science of classification. Stryker described Lee as an engineer who worked to dissect his subject, then laid it out on the table and said, "There you have it in all its parts."

Russell Lee's work is engaging and complex and his story is a compelling one, and though I never met him, he is a man I've come to know. With Stryker's words always in the back of my mind, I plowed on, researching the many aspects of Lee and examining him and his work from all possible angles. It wasn't until a few years ago that I came to realize I used Lee's own systematic methodology to write this book.

Mary Jane Appel
June 2020

RUSSELL LEE

October 19, 1936

*R*OY STRYKER HAD A LOT of ideas, so many that his pockets bulged with *them. He dipped his hand into the breast pocket of his suit coat and pulled out slips of paper. Most made it to his desk, a few fluttered to the floor. He pushed his small, wire-rimmed spectacles up, retrieved the fallen papers, and continued to empty the pockets of his jacket and pants until he had amassed a small pile of scraps. He then sorted through each piece, taking note of the scribbles on either side as he organized them into categories.*

Contrary to the seemingly random jottings he carried around in his pockets, organization was one of Stryker's great strengths. His relentless flow of ideas, a talent for motivating staff to realize them photographically, and an ability to arrange the images into a complex reference

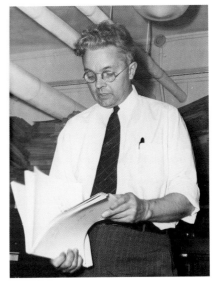

2. Roy Stryker looking through photographs in the FSA office, likely 1937–42, photographer unknown.

system made him an effective leader of the Historical Section of the Resettlement Administration (RA).

In the RA, later reorganized into the Farm Security Administration (FSA), Stryker managed a vast project to document America's lower third—those suffering most from a rural poverty almost inconceivable today—and the New Deal programs designed to assist them. But his ambitions far exceeded his federal mandate. Envisioning a much broader pictorial sourcebook of America, he assembled what became known within his inner circle as the File: a lasting visual record of the Great Depression and America's mobilization for World War II, and the benchmark for documentary photography since. In the end, his team would create 175,000 negatives: a landmark visual archive that has shaped our national collective memory of the era.

During Stryker's eight-year FSA tenure, a cadre of now-famous photographers contributed to the File including Arthur Rothstein, Walker Evans, Ben Shahn, Dorothea Lange, John Vachon, Marion Post Wolcott, Jack Delano, Gordon Parks, John Collier Jr., Edwin and Louise Rosskam, and Carl Mydans.

On one particular October day in 1936, it was Mydans—who had just resigned to join the nascent Life *magazine—and Mydans's potential replacement who most occupied Stryker's thoughts as he rummaged through his pockets and scattered a confetti of notes across his desk.*

A few weeks before, a young photographer had stopped by looking to join Stryker's staff. Nearly six feet and with the natural ease of an athlete, he had settled into effortless conversation with Stryker, as if they were old friends. Self-assured and poised but not patronizing, this plain-talking Midwesterner presented himself as another one of the guys, though closer consideration of his demeanor suggested something different. Stryker was impressed, very much impressed with him and the series of bootleg coal mining photographs he'd brought along. At the time of the visit, Stryker had no positions vacant and couldn't hire him, but with Mydans leaving, this man might be just the ticket—if only he could find the right bit of paper, the one where he had written his name and the way to hunt him up.

Stryker meticulously turned fragment after fragment over in his hands, smoothing each one until he found what he'd been looking for, a name and address jot-

ted down among the creases and folds. His new photographer was Russell Lee (fig. 3).

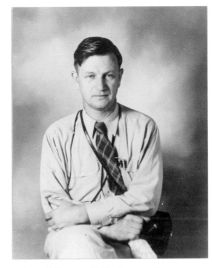

3. Russell Lee, ca. 1942, photographer unknown.

OVER THE COURSE OF Russell Lee's FSA career, he became Roy Stryker's most prolific photographer, and Stryker shepherded Lee through the most productive and creative period of his professional life. By the time Lee left the project in 1942, he'd become the most widely traveled and longest-serving member of Stryker's team, having covered twenty-nine states over six years. Though his discerning eye and technical proficiency quietly revolutionized the documentary mode, earning him a place among the outstanding American photographers of the twentieth century, Lee doesn't enjoy the same name recognition as two of his colleagues, Dorothea Lange and Walker Evans.

For more than seventy years Lee and his contributions to the FSA have remained largely unexplored. Paradoxically, this is due in part to the sheer volume of his work: his status as the largest contributor to the File worked against him, for the range and breadth of his FSA images has deterred in-depth examination.

Mostly, however, the anonymity surrounding Lee and his work was his own doing. Averse to self-promotion, he was always quick to downplay his accomplishments. He preferred the role of team player and thrived as a part of Stryker's group, sharing in the collective spirit and common goals of the Historical Section.

Lee also had a complicated self-identity as an artist. Despite being trained as a painter, he ultimately rejected the label and instead fostered an image of himself as a journeyman government photographer providing yeoman service. Unlike some of his colleagues, he never aggressively marketed his FSA photographs within the art world. He regarded them as instruments for social change rather than precious

objects to be reserved for art galleries or museums. Yet many of his photographs have made that journey, their role as social documents having been eclipsed by their intellectual and aesthetic value. Premier institutions such as the Museum of Modern Art and the Metropolitan Museum of Art now collect them.

In the decades following his Farm Security tenure, Lee rarely discussed his photographs outside the context of the overall project and didn't articulate influences or experiences that shaped his work. Though charming and genial with interviewers, he sidestepped any attempt to delve into his background or go beyond superficial commentary. And curiously, though a documentarian, Lee didn't document his own life; unsentimental about his past, he retained few personal records.

Born in Illinois in 1903, Lee lived a childhood marked by tragedy and emotional loss and an adolescence shaped by both culture and strict regimentation. He grew up in an opulent Victorian home, attended a military academy, and studied to be a chemical engineer.

Heir to a family fortune, his affluence afforded him endless choices. When he married an American Scene painter in 1927, he completely transformed: he left his job to study painting, adopted a bohemian life at a progressive artist colony, and became interested in radical politics. With no prior experience, Lee bought a camera at age thirty-two and in just over a year joined the vanguard of the social documentary movement.

Part of what makes Lee's choice to join Stryker's team so fascinating is the source of his money, which if revealed at that time could have ruined his FSA career. But Lee used his position—which some may have viewed as a conflict of interest—to define his pioneering documentary approach. Ultimately, this strategy, coupled with his groundbreaking advances in flash photography and his painterly sensibilities, distinguished his work and brought an entirely new aesthetic to the File. In his six years with the FSA, Lee created a multi-layered portrait, a legacy far more valuable than his monetary wealth.

As an epic portrait of the United States, Lee's photographs address a sweep of social issues emblematic of early twentieth-century concerns. Examining his work

in the context of its creation is key to understanding his remarkable vision of an American epoch, an era that saw a confluence of financial, social, and political programs as the country labored to restore prosperity, prevent further depression, and reduce inequality. He documented ecological catastrophes such as dust storms and floods, the transformation of agriculture by technology, the population shift from rural to urban areas, the evolution of the small town, the birth of environmentalism, the last gasp of homesteading, the closing of the Western frontier, migration to and within the country, discrimination against—and segregation of—multiple racial and ethnic groups, and the home front during World War II.

In addition to offering a portrait of the country, his work also serves as a unique portrait of Stryker's project and the FSA at large. Lee was the only photographer to document the full arc of Farm Security initiatives—and interactions with other government agencies—and his body of images is therefore the only one representative of all phases of the documentary project, as the agency moved with the country from depression to war. In this respect, and owing to their quality, scope, and continuity, Lee's photographs can be seen as the backbone of the File and open a path for appreciating the FSA photographic project and all the complexities that surrounded it, both as a significant documentary record and as a serious art form. Furthermore, examining Stryker's project via Lee's photographs—and his lifetime—offers an exceptional perspective on the File, from its development in the thirties and disintegration in the forties, to its subsequent "rediscovery" in the sixties and reexamination in the seventies and eighties.

Lee's FSA oeuvre also illuminates the 1930s documentary style, a simultaneous cross-discipline exploration via photography, painting, film, and literature, as well as broadcast, radio, oral history, and other recordings. In addition, his fresh and innovative color work stretched the era's boundaries of documentary expression while at the same time illustrating its complexities.

And finally, Lee's work is a portrait of Lee himself. We can consider his photographs simultaneously as windows into other worlds and as reflections of his self and his own lived experience. His photographs give us a sense of him recording his place in history, and his feeling of the disappearing moment. He excelled at

documenting rural America and the small town—the setting of his youth—and within this environment he enjoyed capturing the material traces of a quickly vanishing era. At the same time, Lee's FSA work also reveals his spirit of adventure and discovery. Less than eight weeks after being hired, he received a letter from Stryker suggesting he photograph the last remaining caribou in the United States living in a "north woods" game refuge sponsored by the RA. Stryker wrote: "You would have to go the last several miles by dog trail."[1] Lee replied with characteristic alacrity: "The pictures of the caribou game refuge should be very interesting to take. The dog sled sounds swell and I'd like to add it to my experiences."[2]

Lee regarded his Farm Security years as one of the most important periods of his life.[3] He wholeheartedly embraced his FSA assignments and endured hardship and hazard to accomplish them. During his tenure Lee rode a packet boat down the Mississippi River, a wheat combine through the fields of Washington State, and a continuous track tractor along the muddy and remote logging roads of Minnesota. He visited locales accessible only by horseback, scaled the construction site of Shasta Dam, descended into a New Mexico gold mine, and balanced over the precipice of one of the largest waterfalls in the world. He photographed victims of numerous contagious diseases and contracted a few nasty illnesses in the process. He went weeks without running water and photographed in temperatures ranging from 15 below zero to 108 degrees. He was threatened by a farmer wielding a shotgun in Oklahoma, became embroiled in a public controversy in Iowa, and was pursued by the FBI in New Mexico when they mistook him for a German spy.

After America entered World War II, Stryker's project changed dramatically when it was absorbed by the Office of War Information (OWI) and focused on creating strictly positive home front imagery. Less interested in this type of work and wanting to contribute to the war effort through active military service, Lee resigned from the project in October 1942 to join the Air Transport Command (ATC) as head of the Still Pictures Unit.

On the eve of his induction into the ATC, Lee's FSA-OWI colleagues gave him a heartfelt send-off. They bought him a weekend officer's bag and made a farewell card,

which features a caricature of Lee and his typical modus operandi (fig. 4). With his head under a dark cloth, Lee's face appears through the lens of his large format camera. He smiles broadly as his outsized hand squeezes the shutter release. His wing-emblazoned combat boots and tripod represent not only his imminent airborne ATC future, but also allude to his recent past with the FSA-OWI and the extensive ground he covered. The card is addressed: "Happy Landings to the Great Guy Who Did America's Portrait" from "The Gang" and is signed by the entire FSA-OWI staff.

The occasion would have been a reflective time. Many of Lee's fellow photographers had already left the project, and most of those who remained

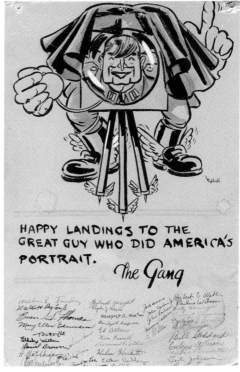

4. Caricature of Russell Lee, ca. 1942, attributed to Herbert V. Webb.

were in the field on war-related assignments. The farewell card undoubtedly revived memories of his own days in the field, as well as his photographic accomplishments. By the time Lee departed for the ATC, his images had been widely published and materially contributed to New Deal legislation.

Lee valued his place as one of Stryker's photographers striving for social improvement, or failing that, for heightened social awareness. He also treasured his farewell card—a gesture that quietly praised his FSA years, given to him by those who knew and appreciated his work. He kept this memento hanging in his darkroom like a family portrait until the day he died.

1903–1926

RUSSELL LEE CAME ACROSS as the quintessential common man, a member of the rank and file, with a pronounced Midwestern accent and preference for work boots, khakis, and denim shirts. Mild-mannered but self-assured, he had a charisma and magnetism friends struggled to put into words. He liked to be called Russ and though he didn't talk much, he had a marvelous ability to draw people out and put them at ease. Strangers opened their homes and lives to him and to his camera; many whom he photographed recalled decades later how much they "took a liking to him."[1] He had an open smile, a twinkle in his eye, and a well-practiced skill of keeping people at arm's length. His second wife confessed that after forty years of living with him she still didn't know who he was.[2]

A fervent New Dealer, Lee committed himself to social change and described his favorite subject matter as "work in the public interest."[3] He understood the country's agricultural problems from an informed but complicated perspective. Some of his best-known pictures, taken to support congressional reform, show the many abuses and shortcomings of the farm tenancy system. But at the same time, as the scion of a wealthy pioneer family, he owned vast tracts of Midwestern farmland, which he rented out to his own tenants.

Like his persona, the images he created appear straightforward and uncomplicated, but underpinning them was careful forethought, empirical exactitude, and technical excellence. His photographic approach, which Stryker once referred to as taxonomic, was a systematic visual dissection, a sophisticated and artful methodology rooted in science and engineering.[4] Lee's documentary career spanned forty years, but his greatest legacy remains the 23,000 photographs he created between 1936 and 1942 for the Farm Security Administration and Office of War Information, an exceptional body of work shaped by his personality and biography.

OTTAWA

His roots can be tracked to the quintessential turn-of-the-century small town of Ottawa, Illinois, where he was born Russell Werner Lee in 1903. Picturesquely situated at the confluence of the Illinois and Fox Rivers 83 miles southwest of Chicago, Ottawa boasted a range of industries, all derived from the town's position as county seat and its cornucopia of natural resources: fertile agricultural lands, navigable waterways, and abundant deposits of high-quality silica and clay. As a crossroads for several rail lines and a key stop along the busy Illinois and Michigan Canal, the town occupied a central position east of the Rockies. Made famous as the site of the first Lincoln-Douglas debate, Lee's birthplace typified the Main Street landscape of America.

For much of his youth he lived with his maternal grandparents in a magnificent Victorian home on Ottawa Avenue, a tree-lined, tony boulevard in the western part of town referred to by locals as Silk Stocking Street.[5] His grandmother, Eva Werner, née Pope, built the resplendent home for $12,000 in 1881, a time when the average value for real and personal property in Illinois was $835.[6] Described in a LaSalle County directory as "elegant in all its appointments,"[7] the two-and-a-half-story house was graciously positioned on a double lot and exemplified the Queen Anne style: asymmetrical façade, projecting bays, imposing turret, expansive veranda, painted balustrade, elaborate scrollwork, and surfaces full of ginger-

bread ornamentation. A local society guide featured the house as one of Ottawa's most stately and prestigious residences.[8]

Indulgent of her own material desires, Lee's grandmother was never so generous with her husband, Charles Werner. A piano tuner with a sparse income, Charles depended on Eva and her substantial family resources; throughout their marriage, he often borrowed sums of money from her, which she carefully documented for repayment.[9]

Lee's parents, Burt and Adele Lee, also lived with him for a time in the Ottawa Avenue house, but their union was unsurprisingly short-lived. They had been thrown together in an arranged marriage to cover a scandal and had no other children.

Adele, born in late 1881, was known for her wealth, beauty, and musical talent. She attended Ferry Hall, a progressive finishing school in Lake Forest, Illinois, where the Midwestern social elite sent their daughters. The school distinguished itself by supporting missionary work and instilling in its students a sense of social awareness. It welcomed a broad range of reform-oriented guest lecturers, from proponents of Jane Addams and the Settlement House Movement to Jacob Riis, a pioneering social reformer. Somewhat cloistered, Ferry Hall expected its students to abide by a strict code of conduct, forbidding interaction with "strangers" (implying men) except under controlled circumstances.[10]

Lee's mother completed college prep classes and substantial coursework in both instrumental music and the German language, suggesting she may have been preparing for one of the esteemed music programs in Germany, her father's ancestral homeland. However, her studies ceased in the midst of her fourth semester, when, despite Ferry Hall's seclusion and close supervision, she became pregnant in the late spring of 1900. The father of her child is unknown.

To conceal Adele's transgression from Ottawa society and protect the family from the stigma of a child born out of wedlock, a quick marriage and a long trip to Europe followed. The groom chosen, local resident Burton Cook Lee, was ten years Adele's senior and by all accounts a stranger to her at the time of their betrothal. Evidence suggests Eva offered a substantial dowry because concurrent

with the marriage Burt Lee's career prospects improved dramatically. He had previously been employed as a carpenter and more recently had sold "hats and gent's furnishings." By the time Burt married Adele in September 1900, he was an insurance salesman for the Mutual Benefit Life Insurance Company of Newark and featured as a prominent resident in the local society guide.[11] After the wedding, the couple embarked on an eight-month Grand Tour with Adele's mother, Eva, in tow, on hand to attend to Adele during the pregnancy and ensure the baby's discreet placement with a family in Europe.

In December, Eva, Burt, and the seven-months-pregnant Adele arrived in Italy and settled into a private residence in Rome to await the birth of the child. During the final weeks of Adele's pregnancy, Eva's friend and confidante, Ottawa physician Ella Fitch Milligan, arrived in Rome to deliver the baby. Around February seventh, Adele gave birth to a baby girl.[12]

The fate of Adele's daughter remains one of the great mysteries of the Werner-Lee family. Many presumed the child had been left in Italy, but investigators later employed to locate her found no trace there. Available evidence suggests Adele's daughter may have been left somewhere in Germany. Shortly after the birth, Charles Werner traveled to Europe and met the party in Italy; together they traveled directly to Germany, where they spent more than a month, including some days in Spangenberg with Charles's extended family. Their longest stay, though, was in Berlin, where they met several times with a man identified by Adele in her travel journal as "Mr. Peters," who may have been the go-between for the adoption.[13]

Throughout Germany, the Werners' wealth and ancestry afforded them access to some of the country's more exclusive circles. They socialized with Luitpold, the Prince Regent of Bavaria; Kaiser Wilhelm II, whom Adele noted "bowed most graciously to us"; and the Kaiser's son, the Crown Prince of Germany, whom she described as "a fine-looking gentleman." In Baden-Baden, Adele and her party "took dinner with the Duke and Duchess of Saxony."[14]

Back in Ottawa, Burt moved into Eva's house with Adele and the couple resumed their lives. Burt returned to the insurance business and Adele picked

up her music. A few years later she gave birth to their only child, Russell Werner Lee; the attending physician, Dr. Ella Fitch Milligan, recorded the birth as Adele's first.[15] The illusion was complete.

Set against the backdrop of his grandmother's house, Russell Lee's childhood was filled with art, culture, and opulent Victorian style: rooms filled with Oriental rugs, leather chairs, davenports, mahogany furniture, jardinières, wall tapestries, and lace curtains. Eva Werner complemented this décor with marble statuary from Italy and other objets d'art she'd picked up on the Grand Tour. She also had several notable paintings including *Hollander and Child* by the seventeenth-century Dutch genre painter Pieter de Hooch and *Lady* by the Austrian Classicist Eugen von Blaas.[16]

In addition, the house overflowed with Adele's music as she performed for friends and family at the Steinway grand in the parlor. She studied at the Conservatory in Chicago, worked with the prominent professors Lewis and Volcker, and sang before large audiences. Adele's talent was widely acknowledged and stories circulated of her ardent and sometimes famous admirers. For instance, while in Italy on her wedding trip, the great pianist and composer Ignacy Paderewski, enthralled by one of her performances, presented her with three of his compositions.[17]

While the arts flourished in Lee's childhood home, his parents' marriage deteriorated. Burt drifted out of the insurance business and by 1907 had no occupation. Sometime around 1910 he left his wife and son and moved permanently to Chicago; evidence indicates Lee had no direct contact with his father over the next decade.

Life in the Werner home went on after Burt's departure. Lee attended elementary school in Ottawa, became interested in science, and enjoyed extended travels abroad with his mother and grandmother. When he was eight, they took him on a trip to Panama and Cuba; the trio's return in March 1912 appeared on the front page of the local paper.[18]

Adele continued her musical pursuits and Lee later recalled with fondness the small keyboard she had installed in the backseat of their automobile: "It was like

a little calliope . . . The family chauffeur would drive us around town in the evenings and she would play popular tunes that people enjoyed hearing."[19]

In addition to occupying herself with music, she often took the train to Chicago to shop, dine, and attend the theater. One evening in mid-September 1913, she returned from just such an excursion and before going home stopped off for dinner with friends at the posh Clifton Hotel on Columbus Avenue. Around seven o'clock, the family chauffeur drove Lee and his grandfather downtown to pick up Adele, parking across the street to wait for her. When Lee's mother emerged from the Clifton, she spotted the family automobile and stepped off the curb to cross the thoroughfare. As she made her way around the rear of a streetcar, it began to move forward, obstructing her view up the avenue.

Moments after she came from behind the moving streetcar, a touring car heading south struck her in the middle of Columbus Avenue. From inside the Werner vehicle, ten-year-old Lee watched as his mother clung to the touring car's front right fender and radiator in an attempt to avoid being knocked onto the pavement. But when the radiator burned her hands, she loosened her grip and fell; the car dragged her beneath the front wheel and crushed her chest. The driver stopped and two bystanders ran to the scene, pulled her from beneath the touring car, and placed her inside. The driver rushed her to the local hospital, while the Werner car followed immediately behind. Lee and his grandfather met Adele at the hospital entrance; she recognized her son and father but was bewildered as to what had just taken place. Three doctors, including Dr. Milligan, attended her, but it was immediately clear she would not survive her massive internal injuries. Adele died the next day, on her thirteenth wedding anniversary. Eva and Charles held her funeral at the house and buried her a few blocks away at Ottawa Avenue Cemetery in the Werner family plot.[20]

The community eulogized her. Every front page relayed detailed accounts of the accident and effusive stories of her life. For instance, the *Daily Republican Times* wrote there was "no woman in the city [with] as many friends among the working classes . . . no one too lowly for her to be interested in, and in time of affliction or trouble . . . a veritable ministering angel." With flecks of hyperbole,

newspapers also carried exhaustive reportage of the funeral. The *Times* informed its readers: "Probably never in the history of Ottawa have as great a number of sorrowing friends gathered around a grave as there were yesterday at Mrs. Lee's. The Werner home was not large enough to hold the great number of sympathizing friends who came to the service at the house, and at the cemetery the crowd was so great that it was impossible to get within half a block of the grave."[21]

Yet among the scores of detailed obituaries—listing each pallbearer, musical performer, and out-of-town attendee—the deceased's husband was barely noted. If Lee's father attended the funeral, no one mentioned it. Literally written out of the family, Burt remained in Chicago, earning his living as a salesman.

Lee was thus left under his grandmother's guardianship. And though his half-sister wasn't there, her presence loomed in the house, occupying Eva's thoughts. Eva had acted with autonomy and purpose when she swiftly married off her daughter and left her first grandchild in Europe, yet it appears she reconsidered her decision after Adele's death and hired investigators to find the child.

Existing documents don't detail whom she employed or how she did it, but it's unlikely she would have engaged anyone in writing—in the United States or abroad—as corresponding about the child would have been unusual and potentially risky. According to a contemporary article in the *Journal of Criminal Law and Criminality*: "Owing to the prevailing Puritan and hypocritical spirit, and partly also to the policy of the United States postal authorities it is almost impossible to discuss [children conceived out of wedlock] in public."[22] A more prudent option would have been for her to make an in-person request to someone who could travel to Europe as an emissary or to travel abroad herself and engage someone in country.

Some of Lee's most vivid memories of this period were from a European trip he took with his grandparents the year after his mother died, in the summer of 1914, and evidence suggests a goal of this trip may have been to find Adele's daughter. Lee later recounted they traveled to Germany to seek medical advice for his grandmother's ongoing health problems, and documents show that for at least a portion of the trip Dr. Milligan accompanied them. Besides being Eva's physician,

Milligan was a trusted friend and may have acted as a liaison. The party spent some time in Berlin, the same city where Adele had noted a prolonged stay in 1901.

Lee recalled they were in Berlin when World War I began; he remembered seeing troops marching down the boulevard Unter den Linden. The party left Europe almost immediately.[23]

It's unclear when Lee learned about his half-sister or whether he knew of her while in Berlin. In any case, during his youth the child was an open secret within Lee's family and among Ottawa residents.[24] Despite Eva's multiple attempts to locate her, the child was never found and the courts later declared her dead.

Though iron-fisted and authoritarian, Eva proved a conscientious and generous guardian to Lee. Valuing education and a strict code of conduct, and consistent with her choice to enroll her daughter in Ferry Hall, she chose an equally rigorous school for her grandson. In February 1917 she and Charles applied for Lee's admission to Culver Military Academy in Culver, Indiana. Their application letter, which stated the boy wished to study science, revealed great affection for him: "Our grandson will start in September 1917. He is all we have, we all hope that he will have good luck at your academy. He is anxious to go to Culver School. We surely will miss him."[25]

Yet Eva didn't see her grandson enroll at Culver that September. Almost as abruptly as Adele, she passed away in May in her grand Victorian home at age fifty-nine. Dr. Milligan certified her death as chronic nephritis, a disease of the kidneys, though the local papers speculated she had never really recovered from her daughter's death.[26] Eva was buried next to Adele in the Werner family plot.

As a key figure in Lee's youth, Eva furnished him with a sense of stability, a place in Ottawa society, and a respect for education. By choosing Culver she ensured he would learn orderliness, restraint, self-discipline, and a code of conduct. And with great foresight, she encouraged his study of science. She had witnessed the dawn of the century of progress across Europe: in Paris she marveled at the Eiffel Tower (the world's highest structure at the time) and rode the Grande Roue de Paris (the world's tallest Ferris wheel); in Rome, she admired St. Peter's Basilica being illuminated for the first time with electric lights.[27] She herself was

transitioning to the modern age: at the time of her death in 1917, she owned two horses and a Packard limousine. Instilling in Lee her appreciation for technological advancement and innovation, she guided him on a progressive path.

Eva also positioned him for financial independence. She bequeathed cash, investments, and property that included her substantial trust funds, her magnificent house, her extensive collection of fine jewels, and a life estate in a 120-acre farm in nearby Manlius Township, first settled by her parents in 1843. To administer her estate and serve as Lee's legal guardian, Eva designated her older brother, Milton Pope, a wealthy landowner, successful financier, and philanthropic capitalist.

BMOC

Ottawa residents knew Milton Pope to be one of the largest landholders in the region. His innovative farming practices—coupled with adroit financial management—brought great success to the family farmland he oversaw. By 1891 he had acquired an additional 500 acres in LaSalle County and 320 in Kansas. When he moved into the real estate and loan business, he was able to acquire even more land throughout Illinois, Kansas, South Dakota, and Missouri. He managed his business affairs so capably that by 1898 the prestigious First National Bank of Ottawa appointed him director.

In 1902, Pope and his wife, Cora, built an extravagant eighteen-room mansion in South Ottawa. Situated on a bluff almost 600 feet above the Illinois River, the three-story house offered expansive views of Ottawa and much of the valley in both directions. They outfitted the home with luxuries of the day: inlaid paneling, a music room, four fireplaces, indoor bathrooms with imported marble, and an open staircase that flowed into the main halls of the first and second floors.

Pope's personal aspirations, however, went beyond amassing wealth and achieving success in business. Like many Republicans of the Progressive Era, he advocated economic and social reform and belonged to a variety of fraternal organizations, including the Ancient Free and Accepted Masons and the Royal Arch

Masons, whose central goals were (and remain) charitable work within the local community.

Following his sister's death in May 1917, Pope began settling her estate, which included formalizing Lee's guardianship. He contacted Burt in Chicago, who by 1917 had become somewhat transient, having moved at least four times in as many years. Burt surrendered all parental rights and appointed joint legal guardianship to Pope and the First Trust Company of Ottawa. Lee continued living in the West Ottawa house with his grandfather until September, when, at age fourteen, he began his four-year education at Culver Military Academy.

Lee didn't favor Culver's military discipline, later quipping his primary interests were "staying astride an ancient artillery horse" and playing on the scrub football team.[28] Still, Lee distinguished himself there and earned exceptional academic and discipline records. His instructors described him as a "bright, eager boy of fine character and pleasing personality with whom it is a decided pleasure to work."[29]

Lee's move to Culver evidently saddened his grandfather, who peppered his letters to the staff there with a combination of anxiety, worry, and tenderness for his grandson. For example, in response to word that Lee had taken ill, Charles wrote Culver's physician: "I hope this is not serious. I hope and pray he will be alright again, soon. I wrote him not long ago to be careful, not catch cold, he is not so strong as he looks to be. He is all I've got. I know you will take good care of him."[30]

Charles was as timorous as his letter appears. When Eva entrusted her brother with legal guardianship, she ensured her husband would be powerless to make any significant decisions regarding Lee's future. She allocated to Charles a small income, on a schedule she dictated in her will. (Charles ended up borrowing money from Pope, which he didn't repay.)[31]

While Charles remained devoted to his grandson, Lee didn't get along with him, later recalling he found his "vagueness" irritating.[32] Instead, Lee looked to his great-uncle for affection and counsel, and Pope readily gave him both. In addition to managing Lee's finances, Pope guided him toward adulthood, with evident warmth and dedication, offering advice on what career to pursue and university

to attend. By the summer of 1920 Lee decided to study chemical engineering, a decision Pope heartily endorsed.[33]

Regrettably, a few months later, at the beginning of Lee's last year at Culver, Pope died at his home in Ottawa after a brief illness. Though his guardianship was short-lived, his impact was tremendous. Pope safeguarded Lee's inheritance with secure investments and a diversified portfolio, which he substantially increased by bequeathing his own cash, securities, and real estate—an act of generosity that tripled Lee's net worth. Among the properties he left Lee were a life estate in a 240-acre Miller Township farm that had been in the family since the 1850s, a 212-acre farm in nearby Dayton Township, and a 240-acre farm in Sedgwick, Kansas.[34] Lee was freed from ever having to depend on a job—or anyone else—for a living.

Pope's imprint on Lee extended beyond enriching and securing his financial future. He advocated philanthropic responsibility, public service, social change, and leadership by example, all of which he demonstrated through charitable gifts and visionary contributions to the schools and hospitals of his community.[35] Pope was remembered as "the friend of all he met. He never showed his position or his worldly possessions to make him feel better than the man in the ordinary walk of life."[36]

When Pope died in September 1920, Lee was relatively alone. His grandfather had remarried the previous June and moved to California. And though Lee owned the Ottawa Avenue house, Charles exercised his life estate right and rented it out to supplement his small income from Eva's estate.

Rather than withdraw, Lee involved himself in a variety of school activities and demonstrated an outgoing personality, veiling any sense of isolation he may have felt. He shined in Culver's goal-oriented, team environment and became the prep school's Big Man on Campus, excelling in school athletics and extracurricular clubs. In addition to scrub football, he played on Culver's basketball and baseball teams and was editor of the school yearbook, *Roll Call*. In that publication, his classmates described him:

There is somewhere hidden within this handsome young lover heaps of friendliness, of loyalty, and of ability. We chose him Editor of the *Roll Call* because we loved him; Vice President of the Cadet Club because we admired him, and secretary of the Hop Club because we wished to honor him. Throughout it all he has worked for us and for what he has gained; remaining in his successes the same lovable chap with the same modest characteristic of earlier days. Although one of the busiest he has proven himself a friend and counselor to high and low alike, and today stands out as one of the finest men on our campus.[37]

Despite the positive way his peers viewed him, Culver judged his personality as detrimental to his military leadership potential, criticizing his "apparent desire to be a good fellow to all . . . [as] perhaps his most serious fault in a military way."[38] Indeed, Lee absorbed Culver's lessons in self-discipline, motivation, and resolve, but rebelled against the academy's hierarchical, command-and-control methods, and demonstrated a blithe disregard for its leadership philosophy. For example, while acting head of the mess hall, Lee didn't report a fellow cadet for throwing food and compounded the problem by joining in the horseplay and throwing food himself. Culver temporarily reduced his rank and assigned fifty demerits for his infraction.[39]

Lee's nature eluded many who knew him, including his fourth guardian, Horace Hull (a third guardian appointed after Pope's death stepped down after just a few weeks). A LaSalle County Circuit Court reporter, Hull was, in his own words, "practically a stranger to Russell" when asked to be his guardian. Hull had known Lee's parents but had admittedly lost track of Lee during his Culver years and hesitated considerably before accepting the guardianship in mid-November 1920.[40]

Shortly after his appointment, Hull wrote the Culver administration to introduce himself and ask the staff to provide any information they could, which, he told them, "will be very gladly received and I can assure you, used to Russell's best advantage."[41] Hull also laid out his concern that Lee be prepared to handle his own

finances when he came of age, writing that when he turned twenty-one "there will be dumped into his lap a very, very liberal annual income from a considerable fortune held in trust, and my aim, as guardian, is, to the best of my ability, prepare him for that day."[42]

In order to reacquaint himself with Lee, Hull invited him to spend the Christmas break with him and his wife at their Ottawa home. As a test, Hull gave him ample pocket money and free rein to spend it, while keeping close watch. At the end of the Christmas break, Hull concluded his ward was "a bright 'kid' of good moral habits, excellent character, a lovable, likable youngster" but with a "considerable lack of appreciation for the value of money and the way to handle it."[43] Hull feared that Lee's good nature would make him prey to unscrupulous people set to rob him of his fortune.

As guardian, Hull was justified in his concern, but mistook Lee's outward benevolence for weakness and naïveté. Records in Lee's guardian file show he was prudent and kept a careful account of his finances, a habit he practiced throughout his life. Hull remained Lee's guardian for just over a year and in that time saw him through his graduation from Culver in the spring of 1921 and his university enrollment the following fall.

Lee had options for college; he considered the University of Michigan and was offered an appointment to the United States Military Academy at West Point. Ultimately, he chose Lehigh University in Bethlehem, Pennsylvania. Combining progressive teaching methods, humanitarian convictions, and advances in scientific observation, Lehigh taught him a new kind of leadership, the importance of public service, and skills to look at the world in new ways.

"THE FLANNEL SHIRT VARIETY"

Founded by railroad magnate Asa Packer in 1865, Lehigh University was established as an applied science school focused on occupational education. It distinguished itself from other universities by teaching professional rather than cultural

studies and took pride in its brand of "usefulness" training, a course of study that combined practical skills with theory, judgment, and reasoning.[44] Historian Catherine Drinker Bowen described Lehigh students as being of "the flannel shirt variety" because "engineers come to college to work."[45] They regarded themselves as the antithesis of Yale's "Cigarette Brand," who, according to Lehigh, went to college seeking amusement while learning the classics.[46]

Lee attended from 1921 to 1925, a pivotal period when faculty and administrators were updating courses of study. Like many U.S. schools, Lehigh championed the new, progressive approach to education, with principal theories including the importance of direct experience and the primacy of method over memorization. Bowen later remarked that the university emphasized "not facts but facility."[47]

Lehigh also shifted from a narrow occupational education (upon which the school had been founded) to a broad-based vocational training. For instance, rather than preparing engineering students for a particular job as it had in the past, Lehigh taught all facets of an industry so that one could apply engineering methods to other fields, which Lee later did with photography.

This vocational approach developed immediately after World War I when engineers emerged from their wartime experiences convinced of the country's need for organization and leadership and of their own potential for providing it. For that reason, Lehigh added a leadership program for engineering students, basing its ideology on Herbert Hoover. The wealthy mining engineer emerged from World War I as a paragon, a magnanimous figure who labored for the good of his country. In 1914 he helped organize the return of more than 100,000 Americans stranded in Europe and then led a relief effort during the global food crisis.[48] Lehigh alumnus (and Bethlehem Steel president) Eugene G. Grace described Hoover as a great engineer, a benefactor of mankind who knew how to build and what should be built.[49]

When Lee arrived on campus in the fall of 1921, he entered a public-spirited atmosphere and a student body subscribed to this Hoover-based ideology. In 1922, Charles Russ Richards, a progressive dean of engineering from the University of Illinois, became the university's sixth president and in his inaugural

address defined engineering as "the art of organizing and directing men . . . for the benefit of the human race."[50] Lee absorbed the school's leadership principles and socially conscious convictions. He joined the exclusive social fraternity Sigma Phi, which required volunteer community work and advocated individual responsibility. In addition, he participated in extracurricular activities around campus, taking on leadership roles in many of them. With a brawny build and the nicknames "Truck" and "Horse," he played football and as a sophomore was elected captain. He served as editor-in-chief of the school yearbook, *Epitome*, and managing editor of the school's student humor magazine, *The Lehigh Burr*. He also joined fraternal groups, including the journalism honor society Pi Delta Epsilon, and the senior organizations Cyanide Club and Sword and Crescent. Lee's fellow students inscribed in Lehigh's yearbook: "Russ has been defined as one of the leaders of the class. He has been a friend to everyone on Campus."[51]

Along with its distinctive leadership and humanitarian philosophies, Lehigh offered Lee unconventional training in chemical engineering. When the university established this program between 1900 and 1902, faculty members believed the curriculum should be weighted more heavily toward chemistry—a reverse of programs at other universities, including MIT—and that its chemical engineers should be "primarily chemists with a good knowledge of Mechanical Engineering."[52] Lee therefore spent most of his time in Lehigh's state-of-the-art chemistry building where he took two to eight chemistry courses per semester.

As a student of both chemistry and engineering, Lee mastered multiple techniques, all of which later shaped his photographic approach. Most significantly, he learned methods of observation, a key scientific practice and the first step of the scientific method.

Lehigh's empirical training was crafted around direct experience and observation outside the classroom. Though common today, in the 1920s the idea that direct experience was the best teacher was akin to the new social science approach. Lee made site visits to commercial operations, touring factories and plants in Bethlehem, Philadelphia, and New York to see practical applications of the concepts and techniques he was studying.

Into its progressive empirical methods Lehigh integrated a more traditional one: the habit of keeping a notebook, which was a prominent part of the school's grading and examination system. Across disciplines, keeping a notebook channels the attention and trains the senses; it calibrates the eye, shapes visual perception, and transforms the author from a passive observer into an active one.[53] And like a microscope or observation tube, the notebook became for Lee another tool of his trade.

The early shaping of Lee's photographic eye didn't come from his study of photographs, but rather his study of drawings. Around the time of his Lehigh enrollment, scientific practitioners began to doubt the value of photographs in their work, believing mechanically produced images were "too cluttered with incidental detail." Scientists therefore returned to engravings, technical drawings, and sketches, which they considered superior to photographs for depicting spatial depth, registering detail, and presenting all possible angles.[54] Perfected, excerpted, and smoothed illustrations could emphasize certain qualities of an object, from carefully chosen points of view. Blending an object of inquiry with knowledge about it, this approach followed the emerging belief that we see not only with the eye, but also with understanding.[55]

These drawings were visual exercises aimed at teaching Lee to analyze a particular object of inquiry from different points of view. For his metallurgy coursework, for instance, he studied a copper blast furnace from an aggregate of perspective, profile, longitudinal, and transverse views, a diagram of reactions, and a selection of interior component parts.[56]

Lee thus became able to form at a glance an understanding of the ensemble of parts that captures the essence of an object and to perceive patterns where the novice might see confusion. By viewing groups of related images, he developed a practiced eye, which science historians Lorraine Daston and Peter Galison have termed the "disciplinary eye," analogous to what art historian Michael Baxandall described as the "period eye."[57]

Historian Brooke Hindle, a scholar of nineteenth-century American artists who embraced science and technology, considered "visual or spatial thinking" the "factor that connects" art, science, and technology. Hindle argued that the depen-

dence of the three fields on visual and spatial thinking helps to explain how some-one from one field—who would seem entirely unprepared—might be able to move into another.[58]

The multitude of related methods of visualization Lee learned in the 1920s figured prominently in his way of looking at the world. Indeed, the documentary strategy he employed for the FSA has close analogies with the scientific method. Furthermore, scholars have shown that the scientific ethics of observation and empirical study developed in the earlier part of the century charted the strategy for 1930s-defined social documentary style.[59]

THE GOLDEN AGE OF AGRICULTURE

Upon graduation from Lehigh in the spring of 1925, Lee accepted a position as a chemist with CertainTeed Products Company in Marseilles, just outside Ottawa. Horace Hull had inexplicably petitioned the court to be replaced after just a year, so Lee now lived in the home of his fifth and final legal guardian, Burton Jordan, just a few blocks from his grandmother's house. Jordan had been a Werner family intimate and a pallbearer at Adele Lee's funeral; Lee later recalled him and his wife with fondness: "They had a very nice home and they were really great to me. . . . They, in essence, became my mother and father. I'd come back and stay with them in the summertime, and they were very important to me at that time."[60] Jordan oversaw the entirety of Lee's financial affairs for two-and-a-half years, until Lee came of age in July 1924.

Among Lee's attendant responsibilities was management of the LaSalle County farms he inherited from Eva Werner and Milton Pope, requiring his knowledge of the region's soil and agricultural practices. His grandmother and great-uncle had bequeathed this acreage as life estates; that is, Lee couldn't sell these farms, but could enjoy benefits of ownership, including income derived from rent or other uses of the property. As his grandmother and great-uncle had done, Lee rented out his land to area farmers on a crop-share basis, an arrangement common in the

Midwest at that time. Lee's farm tenants furnished the labor, equipment, and work animals and received use of the land in exchange for a predetermined proportion of the cash crop, which in Ottawa was customarily 50 percent.[61] In turn, Lee paid the property taxes, provided a house, and maintained all permanent (immobile) structures. He also sometimes paid additional expenses incidental to production (such as fertilizer and seed) or an amount proportionate to the share of crop he received in rent.

At harvest time, Lee's farm tenants delivered the entire cash crop to the local grain elevator, where the sale price was distributed according to the prearranged shares. Lee didn't have to be present at the elevator when the crop was divided and sold, but a clause in Pope's will stipulated that Lee travel to Ottawa to receive—in person—proceeds of the sale, along with income from other investments Pope had made for him. Pope had chosen his own bank, the First National Bank of Ottawa, to administer Lee's trust funds, and his requirement kept Lee tied to the community and encouraged his active participation in managing the farms.

Available evidence indicates Lee was an involved and attentive landlord and had a positive working relationship with his tenants.[62] He shared the risk with them, for his rent income and the ultimate value of his land depended directly on the outcome of the crop and the fertility of the soil. Lee understood the consequences of mismanagement and, in fact, witnessed the potentially fragile nature of land ownership in the summer of 1925, when, at age twenty-two, he was a plaintiff in a farm foreclosure.

The 120-acre farm, nearly a quarter section, had been in the Anderson family since just after the Civil War. In 1896, Malina Anderson began renting the land to area farmers. Over the next two decades—a period known as the Golden Age of Agriculture—average farm incomes more than doubled and land values more than tripled. So Anderson, like many farm owners during the Golden Age, leveraged her property and took out three loans against it, for a total of nearly $17,000. However, when the war boom ended and foreign demand for American farm products dissolved, commodity prices collapsed, farm prices plummeted, and Anderson wasn't able to pay her debt.

Milton Pope had been Anderson's mortgage lender and when he died in 1920, Lee inherited 50 percent of the three Anderson notes. By 1922, Anderson defaulted on her mortgages and though foreclosures were uncommon in LaSalle County—a tight-knit community of first- and second-generation Norwegian farmers—Pope's executors initiated proceedings. After three years in the courts, they obtained a judge's decree to foreclose. Lee, by this time of age, became an active participant during the protracted proceedings and appeared in court to petition for authority to sell the farm at public auction to recoup at least part of the outstanding loans.

On sale day, August 29, 1925, townspeople and prospective buyers gathered at the north door of the LaSalle County courthouse in downtown Ottawa. Among them was George Erickson, a local farmer who placed a winning bid of $13,230.[63]

The Anderson foreclosure wasn't the first from which Lee benefited: fully one third of the cash Eva Werner bequeathed to him came from a series of foreclosures initiated by her mother, Louisa Reddington Pope Brundage.[64] Louisa arrived in LaSalle County in 1843, an era of surging settlements, nascent railroads, and brisk land sales. Together with her first and second husbands, she built a sizable personal fortune, a portion of which resulted from profitable real estate sales of their substantial land holdings and their extension of mortgages. Thus, she made gains on property sales and also on the interest earned on each mortgage. Shortly after her second husband's death in 1891, Louisa began settling his extensive estate and, in the process, called in all of his notes. Many area farmers lost their farms to "Mother Brundage," and more than a hundred years later her name still incites anger among their descendants.[65]

It's reasonable to surmise that Lee knew the origins of this part of his inheritance and of the anguish his great-grandmother caused to acquire it. How much of an impact this knowledge—as well as the direct experience of the Anderson foreclosure—had on his life decisions can never be known, but both certainly contributed to his understanding of the era's growing agricultural crisis and previewed for him the serious national economic collapse that was to come. And even more valuable than the $6,400 he netted from the Anderson foreclosure was his bird's-eye view of a forced sale and its effect in his community, especially from his posi-

tion as noteholder. For it was this complicated perspective, along with his mantle of land ownership and role as landlord, that informed his deep understanding of the agricultural problems of the country and later contributed to his nuanced and complex documentary approach as an FSA photographer.

Lee had the connections and capital to follow the family tradition of property and asset accumulation; indeed, the local newspaper at this time referred to him as "scion of a pioneer Ottawa family."[66] Yet Lee ultimately chose a different path, determined to use his wealth in a different way.

1927–1936

DORIS, NEW YORK, THE SOVIET UNION, AND JOHN SLOAN

In 1927, at the age of twenty-four, Lee married Ottawa resident Doris Emrick, a vivacious artist one year his junior. The daughter of a prosperous banker and merchant, she grew up in Aledo, Illinois, a small town in the northwestern part of the state, where from a young age she demonstrated an inclination toward nonconformity—riding ponies bareback, jumping streams, and skipping piano lessons to study painting on a neighbor's back porch.[1]

Like Lee's mother, Doris attended the prestigious Ferry Hall, enrolling in the fall of 1920. Though the country was changing quickly—with the dawning of the Jazz Age—Ferry Hall was not: for example, after bobbing her hair in the new flapper style, Doris was expelled for a week with the reprimand that "nice girls have long hair." She later deemed those school years as "the least adventuresome and imaginative" of her life.[2]

Doris went on to attend art school at Rockford College in Illinois and in 1926—her junior year—achieved mild fame when the *Chicago Evening Post Magazine* published one of her paintings. That same year her parents moved from Aledo

to Ottawa, where her father opened a popular ladies ready-to-wear and dry goods store in the town's bustling commercial district.

We don't know how Doris Emrick and Russell Lee met or how long they knew each other before they married. Their stylish wedding at the picturesque St. John the Evangelist Episcopal Church in nearby Lockport appeared as the lead story in Ottawa's social news. Afterward, the couple embarked on an extended European honeymoon, traveling to London, Amsterdam, Florence, Venice, Cologne, and Munich, with an extended stay in Paris.

An alluring destination for artistic Americans during the interwar years, Paris offered expatriates and visitors alike an opportunity to break free of traditions and inhibitions and, paradoxically, gave Americans a fresh perspective on their homeland.[3] They both later recalled this trip as a milestone, spending weeks on end "taking in" Parisian life and European art in the city's galleries and museums and wandering along the banks of the Seine buying "cheap reproductions of great art which were for sale everywhere."[4] Novelist Louis Bromfield opined that the American abroad was "unmistakably a man just born,"[5] and indeed, the Lees felt this kind of reawakening as they absorbed inspiration from their stay in Paris.

Upon returning to Ottawa, Doris continued painting and Lee resumed his chemical engineering career and management of his farms. A short time later, CertainTeed offered Lee a transfer to Kansas City and promotion to plant manager. Doris took the opportunity to study at the Kansas City Art Institute with Ernest Lawson, American realist and member of The Eight, a group of artists who, earlier in the century, set out to create a uniquely American painting style reflecting everyday life.

Inspired by his wife's work, Lee painted on weekends. Within a year he resigned from CertainTeed to pursue painting full-time, a change made possible by his personal wealth. The couple traveled to Europe again and after another extended stay in Paris, on their return moved to San Francisco to study painting at the California School of Fine Arts (today the San Francisco Art Institute).

During their second year of study, the Lees met the figure who would be key in connecting them to a broader arts community: Arnold Blanch, a respected painter

who had studied with two other members of The Eight, Robert Henri and John Sloan. Blanch and his wife, fellow student Lucille Lundquist, both had attended New York's Art Students League's summer school in the arts colony of Woodstock, New York. They moved to San Francisco when the School of Fine Arts offered Arnold Blanch a one-year teaching position.

Blanch took an immediate interest in Doris, who later recalled she had come to San Francisco painting modern abstractions "on the half-baked side." Blanch advised her to paint in a more representational style.[6] She took his advice, mining from both her childhood memories as well as the scenes in front of her and, like many artists in the 1930s, began to depict typically "American" subjects.

The Lees spent considerable time socializing with the Blanches and other artists in the Bay Area, including Hans Hofmann, who was teaching at the University of California, Berkeley, and Diego Rivera, who had come to paint murals at the Stock Exchange and the School of Fine Arts. At the end of Blanch's teaching year, he and Lucille returned to Woodstock and, at their invitation, the Lees joined them in mid-1931.

Unlike many colonies where artists worked in one prevailing style, Woodstock was noted for its diversity of expression, as well as its alternative lifestyles and relaxed social mores. The Lees took up summer residence in a rough-and-ready cabin on a farmstead converted for artist use, within an enclave known as Lark's Nest.[7]

During the winter months they lived in New York City, in a large studio at 30 East Fourteenth Street. Like Woodstock, Greenwich Village no doubt appealed to them with its bohemian atmosphere. In addition, the Village occasioned their sustained interaction with other artists who worked in a variety of media. A number of painters had studios in their building, including Kenneth Hayes Miller, Alec Brook, Emil Ganso, Stuart Davis, and Yasuo Kuniyoshi. Also included in their circle at this time were Paul Burlin, Stuart Edie, Arshile Gorky, Joe Jones, and Bradley Tomlin, as well as Marguerite and William Zorach, storied luminaries celebrated for the intimate salons they hosted in their Greenwich Village house.[8] As Doris Lee later recalled, "New York in the middle thirties was a very much smaller place

5a–b. Doris and Russell Lee, likely 1935–36, photographer unknown.

as far as artists were concerned and one usually knew almost everyone who was professionally painting."[9] That the Lees found their robust community visually and intellectually stimulating is evident in their experimental portraits from the early 1930s (figs. 5a–b).

Along with its dynamic arts community, the Union Square and Fourteenth Street district was a hub for radical movements, political activism, and progressive cultural organizations. The Artists Union, the principal social and cultural meeting place for artists in New York, was a block from the Lees' studio. Historian Gerald M. Monroe later noted, "If there was a community of artists in New York City, then the Union was its place of congregation."[10]

The area was also home to the radical labor movement in America. The Socialist Party headquarters and the American Civil Liberties Union were both nearby, and at one point the New York Workers School and Communist Party headquarters were next door to the Lees' building. Union Square regularly hosted large crowds of protesters who assembled to demonstrate for government relief

programs, better working conditions, and social justice.[11] According to Monroe, "Participation in the actions of organized labor was an exhilarating experience for the artists who saw themselves as 'cultural workers' playing an active part in the great social change that seemed to be taking place in the nation."[12]

Lee's interest in politically minded art—initially roused when he met the outspoken communist Diego Rivera in San Francisco—grew in this charged Union Square atmosphere. Soon he began to actively engage with other left-leaning painters in his circle who employed the visual arts to respond directly to the Depression and promote social change. Many embraced what photo historian Laura Katzman has described as "a Soviet model for their own critique of American capitalism and attempts to come to terms with the U.S. stock market disaster."[13] As the decade progressed, Lee's curiosity about—if not sympathy with—the communist cause deepened.

In the fall of 1933, during an extended European trip with the Blanches, Lee broke away for a month-long tour of the USSR. Later, in the 1970s, Lee framed this trip as merely a remedy for boredom while Doris studied painting in Paris, an understandable explanation given the targeting of liberal and leftist artists in the Cold War era.[14] Yet, for artists on the left, traveling to the Soviet Union in the early 1930s was not a casual, last minute trip.[15]

Making his journey across the Soviet Union by train, boat, and car, and under the close watch of Intourist (the official state travel agency staffed by NKVD officials), Lee visited a number of principal cities including Moscow, Leningrad, Stalingrad, Gorky, Rostov, and Kharkov. He toured industrial sites, including agricultural machinery factories, metallurgical works, and a mammoth automobile plant. In tourist areas he shopped the Torgsin stores, "especially designed for trade with foreigners" and which accepted only foreign currency, gold, or silver.[16]

In the months following his return to New York, Lee penned a series of articles about his trip for his hometown newspaper. His essays express an open-mindedness about the Soviet system, which is no surprise given the idealization of Russian proletarian culture among the American intellectual left in the 1930s, before disillusionment set in later in the decade.[17] Thus, rather than an exposé of social ills or the brutal repression of the Stalinist regime (not widely

known in 1933), Lee's coverage was more of an inquisitive exploration, with hints of optimism. He described programs he considered beneficial, such as health care with free hospitals and medical attention, free childcare for factory workers, and "old age and unemployment insurance."[18]

Yet, at the same time, Lee resisted the urge to simplify the Soviet structure to an idealistic alternative to capitalism. In counterpoint to his praise, he also systematically examined many of the socioeconomic problems he witnessed plaguing the USSR: crowded housing conditions, depreciated currency, commodity shortages, waste in industry, a labyrinth of bureaucracy, and the inefficient distribution of goods, manifested in notoriously long lines.

Lee also discussed communist ideology and methods of indoctrination, with particular attention to the country's youth: "From the day he is placed in his mother's arms, the life of the Russian is controlled by the state and his efforts are directed toward improving the state."[19] He enumerated the government-sponsored youth groups, classified by age—Oktober children, Pioneers, and Komsomols—and at least once had the opportunity to hear a young Soviet's viewpoint.

With documentary rigor, Lee provided other firsthand impressions that gave human dimension to social concerns and partisan convictions and, in many ways, his articles prefigured his pictorial approach. Notably, he isolated a concrete visual example to symbolize an economic problem and illuminate a political philosophy in a relatable way:

> Clothing is threadbare and scarce for the textiles industries are not sufficiently well developed and the country needs cotton badly. It is a rare thing to see coat, vest and trousers matching, but clothing is not regarded as a necessity by the Russians, who think more of the work they have to do. It is a far greater honor to be the son of a working man than the son of a bourgeois.[20]

In three sentences Lee vividly captured his direct experience, depicted commodity shortages in an accessible way, informed his reader of a prevailing (or at

least a party line) attitude, and grounded his reportage in observed reality. Conveying the feeling of lived experience while addressing social problems, Lee's writing embodies a style known as informant narrative—a mainstay of newspapers and magazines of the decade.[21]

Ultimately Lee evolved into a moderate liberal and a passionate New Dealer, but his journey to the USSR and his subsequent journalistic examination of the Soviet system were key factors in that evolution.

Another experience shaping Lee's political perspective—and pictorial approach—at this time was his study at the Art Students League where he worked with John Sloan, the politically engaged American painter, etcher, and illustrator with whom Arnold Blanch had studied two decades before.

An artist with a deep-rooted social conscience (he had been a Socialist at one point and had executed drawings for *The Masses* in the teens), Sloan depicted scenes of daily life in New York's working-class and poor neighborhoods and was considered a leader of the Ashcan School (though Sloan hated the phrase, believing it was too closely associated with muckraking).[22] Best known for his gritty urban views and unidealized portraits of ordinary Americans, he created a body of work praised for its narrative power. By the early 1930s many regarded him as the dean of American painters.[23]

Through lectures and studio courses Sloan taught his League students perspective, composition, lighting, design, and color, all illustrated with the works of Western art masters. These included da Vinci, Rubens, and Rembrandt, as well as Courbet, Van Gogh, Cézanne, Matisse, and one of Sloan's favorites, the French painter, printmaker, and sculptor Honoré Daumier.

A pioneer in approach, technique, and content, Daumier created penetrating political and social satires, which, though particular to Second Empire France, remain timeless in their depiction of the human condition. Sloan, who had made a career of portraying New York and its struggling, overlooked classes, admired Daumier's humanistic approach—particularly the way he ennobled working-class citizens in Paris and depicted downtrodden men and women with decency and respect. Sloan frequently invoked Daumier in his lectures, advising his League students:

Don't be afraid to be human. Draw with human kindness, with appreciation for the marvel of existence. Humanism can be applied to drawing chairs and cobblestones. Look at the work of Daumier.[24]

Like many politically motivated, documentary artists of the thirties, Lee looked to Daumier as a role model.[25] Two artists with whom Lee later worked at the RA/FSA also held Daumier in high regard: photographer Walker Evans and his friend, the painter, muralist, graphic artist, and photographer Ben Shahn. Evans later reminisced: "we, in the amplitude of our youth, believed we were working in the great tradition of Daumier and the *Third Class Carriage*."[26]

Lee also shared a kinship of sorts with his mentor, John Sloan, who considered himself a "spectator of life"[27] and excelled at depicting scenes of the ordinary and everyday: the backroom of McSorley's tavern, a hairdresser's window, scrubwomen in the Astor Library, a young couple eating at a Chinese restaurant, working men and women during rush hour on the Third Avenue "El." Believing the most prosaic moment merited depiction, Sloan urged his students to "get out of the art school and studio. Go out into the streets and look at life. Fill your notebooks with drawings of people in subways and at lunch counters."[28]

To sketch these reflective scenes, Sloan strove to remain unseen. Indeed, one critic remarked that his "glimpses of city life contrive to be both anonymous and intimate," and in lectures to his League students Sloan stressed the importance of remaining out of sight, likening his vantage point to that of an elevated train passenger depicting the interiors of second- and third-floor apartments.[29]

Sloan also addressed technical skills in his classes. He advocated assiduousness, both in planning and process, a diligence that Lee—with his Lehigh training—understood. In fact, Sloan called design and composition "an engineering problem" and taught his students, "The well-articulated design has the same unity, design, proportion, and dynamic structural excitement as a fine bridge."[30]

While Russell Lee studied with Sloan, Doris Lee remained under Arnold Blanch's tutelage. Heeding his earlier advice to move away from abstraction, she began painting the scenes she saw in her immediate view, from both memory and using photographs.[31] By mid-decade she firmly situated herself as an American Scene painter depicting what were considered quintessentially American subjects.

The American Scene had emerged in the aftermath of World War I and reached its height with the onset of the Depression, when Americans engaged in a rush of national rediscovery, a phenomenon identified by critic Van Wyck Brooks as a search for a "usable past," in other words, a shared American culture that could be used to help shape the present. By the mid-1930s, manifestations of this renewed interest in the country's history, folklore, and customs abounded in the era's painting, music, historical novels and films, scholarly biographies, WPA guides, Historic American Buildings Survey, Index of American Design, and the deep embrace of documentary photography.[32]

American Scene painters responded to the country's renewed passion for Americana by fostering national pride and portraying subject matter accessible to the masses. Some, like Ben Shahn, depicted urban scenes celebrating the common man and respect for working people. Seeking to make a political statement, many lent their art to revolutionary and radical causes.

Others, like Doris Lee, worked in more of a Regional style that ignored postwar bleakness and disillusion pervading the country. With quaint and reassuring scenes of America's past, Regionalists portrayed a sentimental return to the mythic simplicity of days gone by, a visual "escape" from the complexities of the modern age. Regionalists celebrated the country's agrarian roots and democratic ideals, using America's historical iconography to depict small towns and rural landscapes.

As Doris Lee's style matured, she graduated from local exhibitions in Woodstock to prestigious invitational and national shows. Her stature in the art world rose considerably in 1935 when the Corcoran Gallery of Art chose her painting *Thanksgiving* for the museum's fourteenth biennial, one of the country's most

important exhibitions at that time. Painted in the flattened, faux naïve style that became her hallmark, and described by critics as a "comic valentine of U.S. farm life,"[33] *Thanksgiving* depicts the preparation of the traditional holiday meal, evoking a powerful sense of nostalgia for a simple and unchanging past, with imagery that even in 1935 was old-fashioned. Later that year, jurors at the Art Institute of Chicago chose *Thanksgiving* for its forty-sixth Annual Exhibition of American Paintings and Sculpture and bestowed upon Doris and her canvas the Institute's most important award, the revered Logan Prize.

The exhibition received heavy rebuke from some of Chicago's leading art critics. For example, C. J. Bulliet of the *Chicago Daily News* began his review: "A sullen, soggy, dull, dumb, almost animal brutishness pervades the American show at the Art Institute."[34] A sponsor of the exhibit, Mrs. Frank G. Logan, concurred with Bulliet and went a step further by singling out Doris's painting, denouncing it as atrocious and unworthy of the award she and her husband funded: "Fancy giving a $500 prize for an awful thing like that."[35] Newspapers ran a photograph of Mrs. Logan, a wealthy dowager in fur hat and coat, pointing her finger at *Thanksgiving*. Yet the effect of her condemnation was likely the opposite of what she intended, catapulting Doris and *Thanksgiving* into newspaper headlines and magazines across the country.

Within days of winning the Logan Prize and amid the hailstorm of that publicity, the Treasury Department awarded Doris a coveted mural commission in the new Federal Post Office in Washington, D.C. The following month, the Carnegie International exhibition of contemporary art accepted her painting *The Noon*, and she had a one-person show at the Studio House in Washington, D.C. In early 1936, the Maynard Walker Galleries gave Doris her first comprehensive New York City exhibit and began representing her. The Art Institute of Chicago purchased *Thanksgiving* and the Metropolitan Museum of Art purchased another painting entitled *Catastrophe*.

As Doris Lee's painting career skyrocketed, Russell Lee's stagnated. During this period he emulated his wife, painting as she did in the American Scene style: a photograph of one of his pastoral canvases (now lost) bears a striking resemblance to her painting *Farm in the Spring* from the early 1930s. Both share an analogous

style, subject, and composition.[36] Yet, he struggled with the mechanics of painting, despite five years of study with Sloan. He found portraiture especially difficult, later remarking his subjects always "ended up with sort of a deadpan expression."[37] Only a handful of his portraits are known to survive; they confirm his self-criticisms and display technical immaturity and unintentional naiveté.

Lee speculated a camera might help, so following in a long tradition of artists who used photography to aid in their painting, he bought a Contax in mid-1935. Invented the previous decade, 35mm cameras were all the rage in the 1930s. Relatively easy to use, they were embraced by amateurs, and their small size allowed users to move unobtrusively to get their shot.

Lee initially pursued photography with fellow Woodstock artists Emil Ganso, a painter, and Konrad Cramer, a radical modernist and 35mm devotee. Fifteen years Lee's senior, Cramer started experimenting with photography in the teens, becoming proficient by the time he settled permanently in the Woodstock art colony around 1920.[38] A Leica enthusiast, Cramer wrote articles for *Leica Photography* magazine, participated in Leica exhibitions, and his work appeared in the first *Leica Annual*. He joined the pioneering Circle of Confusion group, founded in 1931 by those drawn to the new 35mm technology, and in the mid-1930s established the Woodstock School of Miniature Photography.[39]

With Cramer and Ganso, Lee explored photography's technical aspects and within months handled his new medium with knowledge and sophistication. Driven by curiosity and a determination for perfection, he tested lenses, filters, films, and developers. He experimented with flash and added medium format film to his repertoire. Lee later recalled his time working with Ganso and Cramer: "The three of us pursued photography so to speak for a year. I got interested in this, and there were technical problems of gray, and properly exposed negatives, and all of this to be overcome immediately."[40]

Painter and printmaker Yasuo Kuniyoshi was also experimenting with photography at this time. The Lees knew him from Woodstock and New York City; all three were active members of the artist colony and their studios were in the same building in Union Square. Kuniyoshi's portrait of Russell Lee, with its intimate, off-

6. Russell Lee, ca. 1936,
photograph by Yasuo
Kuniyoshi.

the-cuff quality, reflects their close friendship (fig. 6). Likewise, Lee made portraits of his fellow artists, in their studios and other familiar surroundings.[41]

Before long, Lee heeded Sloan's advice to "Get out of the . . . studio. Go out into the streets and look at life." He began photographing in and around Woodstock and New York City, pivoting from using photography as a painting aid to regarding it as a documentary tool, a method of capturing his observations.

In sharp contrast to his wife, who painted scenes from America's idealized past, Lee pictured harsh realities of the country's present. And even in his earliest photographs, it's clear that photography had become his preferred medium of expression, a powerful means of recording and interpreting the world before him.

MASTERING THE DOCUMENTARY MODE

By design, the 1930s documentary approach was subjective. According to scholar William Stott, it was intended to encourage social improvement and work "through the emotions of . . . its audience to shape their attitude toward certain

public facts." At the same time, it conveyed an aura of objectivity and authenticity, which Stott has referred to as "the texture of reality . . . the particularity of the common man's life."[42] Cultural historian Warren Susman characterized the documentary approach as "ma[king] it possible to see, know, and feel the details of life . . . to feel oneself part of some other's experience."[43]

By the time Lee switched from painting to photography in 1935, he was already comfortable in the documentary mode, as evidenced by the informant narrative articles he'd written a year or so prior about his trip to the Soviet Union. As a writer he had tested out many of the same strategies he would soon perfect as a documentary photographer: weaving together thorough research, firsthand inquiry, and informal interviews to create a socioeconomic analysis. Furthermore, by isolating visual details, such as the threadbare and mismatched clothing he'd seen in Russia, Lee learned how to effectively link imagery and text to illuminate an abstract socioeconomic idea in a relatable way. It was only a matter of months after finishing these articles that Lee bought his Contax and embarked on a self-assigned social documentary course in America, integrating the techniques he had learned as a writer and applying them to his camerawork.

Lee ventured beyond his small communities in Woodstock and Union Square, and in his first year as a photographer—from mid-1935 to mid-1936—he traveled throughout the Northeast and made hundreds of compelling photographs chronicling the social and economic crisis engulfing the country. In Pennsylvania's anthracite coal region, he covered the volatile bootleg mining industry, in which unemployed miners pilfered coal from properties owned by large coal companies and sold it through a rudimentary distribution organization. On the sidewalks of New York City, he photographed demonstrations, protest marches, and picket lines related to the International Seamen's Union of America strike under labor leader Joseph Curran.

Staying focused on proletarian subject matter, he made other labor-related images. For example, in the winter of 1935–36, on a busy Manhattan street corner, Lee portrayed one of the Depression's most visible effects on the urban population: massive unemployment (fig. 7). National jobless rates had been hovering around

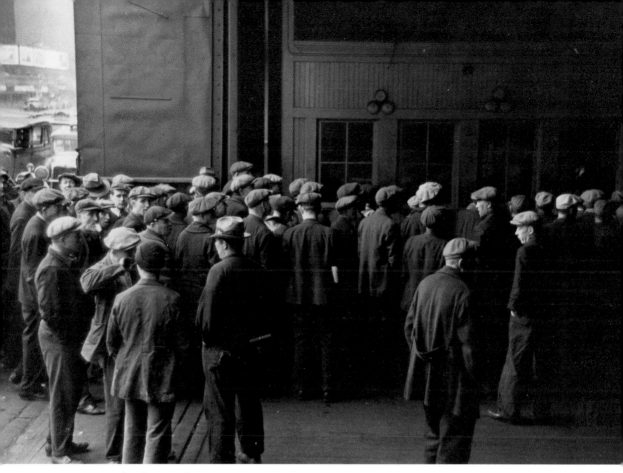

7. *Unemployed, New York City*, winter 1935–36.

25 percent and in New York City it was slightly higher.[44] Typifying this financial anguish, Lee's photograph depicts roughly fifty men of varying ages milling about outside a nondescript building. He captured the dispirited nature of these would-be workers as they shuffled with hunched shoulders, hands digging in their pockets; some looking at the ground, others mingling in conversation.

The scene's complex spatial geometry and dramatic lighting demonstrate Lee's exceptional ability to picture depth, both in form and content. Through skillful use of light and space he blended the image's powerful narrative with its formal composition to direct the viewer's reading. The figures move from left to right, from daylight into darkness, where they form a solid jobless mass, a gathering of Forgot-

8. *Auction, Woodstock*, 1936.

ten Men. Though photographing a group sharing a common plight, Lee conveyed a sense of isolation rather than solidarity, creating a collective portrait of despair.

Lee pictured other moments emblematic of the Depression, images that, like the unemployment line, focused on the human dimension of economic hardship. Appealing to the emotions of the viewer "to shape their attitude toward certain public facts," Lee made poignant portraits of individuals, carefully framed eloquent visual statements that speak to the transient nature of financial security.

At a country auction in Woodstock, he witnessed the sale of household goods by desperate people with little else to sell. Near the front porch of the house, he

created a multilayered image, a visual puzzle of the day's activities and responses to it (fig. 8). Bringing his camera in close to the mirror of a drop-front desk being carted away, he captured the reflections of three women attending the auction: two wipe their eyes while the third stares off into the distance, her pensive gaze extending beyond the frame of the picture plane. All around the desk the auction continues: another item is taken from the house, two men inspect various goods, a third looks on with curiosity. A somber picture of loss, Lee's photograph speaks to the cycles of commerce and even life itself.

9. *Couple on New York City sidewalk (Floods Kill Hundreds)*, winter 1935–36.

Lee found similarly elegiac scenes in the city. On a winter night in Manhattan he spotted an elderly man and woman down on their luck and his image seizes upon multiple misfortunes (fig. 9). The couple stands beneath a lighted theater marquee announcing newsreels of the country's latest calamity: "Floods Kill Hundreds in East—Complete Films Now Showing." The woman leans forward on her crutches while the man plays a violin, making music for their plight on the street or the natural disaster on the screen inside. A cup nearby waits for spare change, but passersby pay no notice as they cluster in conversation or look in lighted shop windows.

These rural and urban vignettes exemplify Lee's vantage point as the person on the street. They also show his acute and engaged observation and point to salient elements of his future FSA work, including a fondness for complex picture planes, a powerful use of light and shadow, and a penchant for signs that anchor a scene in time and place. With a painter's vision, he presented the Depression's direct effect on individuals, giving weight to the larger topics he would repeatedly tackle such as massive unemployment, forced auctions, ecological disasters, and the fragile position of the elderly. To Lee's eye, the documentary mode was a form of visual expression that could forcefully influence public opinion and effect social change.

Seeking a broad audience for his photographs, Lee acquired an agent, who placed spreads of his pictures in *Collier's* and the *American Magazine*.[45]

In early 1936 he attended the first American Artists' Congress (AAC), a consortium created to unite visual artists against war and fascism abroad and founded as part of the Popular Front of the Communist Party USA. Among the 341 well-known artists who signed the call were many in Lee's circle: Doris Lee, Arnold and Lucille Blanch, Paul Burlin, Stuart Edie, Joe Jones, Yasuo Kuniyoshi, Marguerite and William Zorach, and Ben Shahn, whom Lee later recalled meeting for the first time at the Congress.[46]

In addition to protesting international war and fascism, the AAC also concerned itself with the rise of reactionary trends within the United States, including censorship. To that end, two speakers—Arnold Blanch and Joe Jones—cited the cause célèbre of Doris Lee's painting *Thanksgiving*, the exhibition at the Art Institute of Chicago, and the protest by Mrs. Logan the previous fall. Blanch con-

demned the "inane reactions of snobbish patrons and 'lovers of art' in their search for a new popular realism."[47] Jones, stronger in his attack on "art benefactors," termed the events surrounding the show a "reactionary" move "toward censorship and repression" affecting "liberty of artistic expression."[48]

Significantly, it was Jones who steered Lee toward the Resettlement Administration (RA). Jones, an outspoken Regionalist and champion of worker's rights, was already connected with the RA, having taken to the highway under the auspices of the agency the previous year to tour small town America and paint the lives of ordinary people.[49] While visiting Woodstock in the summer of 1936, Jones told Lee of an exhibition of photographs in New York City sponsored by the New Deal organization.[50] The photographs were the work of the RA's Historical Section, established to create a photographic record of rural America's plight and to lobby for national support for the many New Deal programs designed to address it. Historical Section photographers depicted problems such as dust storms and drought in the Great Plains and the mass migration of farm workers to California; they also recorded initiatives such as land use programs, migrant camps, and cooperative communities.

Captivated by the photographs, Lee was determined to get involved. After driving to Washington in late summer 1936, he got in touch with his new friend Ben Shahn, who was part of the RA's Special Skills Division as a graphic artist and affiliated with the Historical Section as a photographer. Through Shahn, Lee found his way to a cramped third-floor office of the Barr Building in downtown Washington, and, with his bootleg miner portfolio in hand, went to see the head of the Section, Roy Stryker.

Stryker and the File

I have never known anyone whose temperament was less fitted to work for a government agency.

Carl Mydans on Roy Stryker, 1962[1]

EARLY LIFE

Born in 1893 in Great Bend, Kansas, Roy Emerson Stryker was the youngest child of George Stryker, a Civil War veteran.[2] After losing one homestead in Oklahoma and another in Kansas, George moved his family to Colorado, settling near the town of Montrose, a frontier community on the western slope of the Rocky Mountains. He and his wife, Ellen, became tenant farmers on a piece of land in the semi-arid Uncompahgre Valley and by 1905 managed to purchase 160 acres of their own.

The following year, however, George was diagnosed with cancer and soon became unable to work the land. As their debts mounted, the Strykers mortgaged their property; when George died in 1907, the mortgage was nearly twice the value of the farm's assessed worth. Insolvent, Ellen sold the farm in early 1908, just one year before the Bureau of Reclamation opened the Gunnison Tunnel, an irrigation project that turned the Uncompahgre Valley into a productive agricultural area and tripled land values.[3] She applied for a veteran's widow pension for herself and

fourteen-year-old Roy, and they moved in with one of her older sons and his family, to a house in town.

Despite being penniless, Roy Stryker described his early home life fondly, as an "environment of curiosity," and became an avid reader in a house filled with books ranging from Department of Agriculture bulletins to volumes on Greek mythology. He recalled his wonderment with visual stimuli, from Montgomery Ward and Sears Roebuck catalogs to cabinet cards and stereographs. He particularly enjoyed vicarious travels with his family's stereoscope and sets of European views.[4]

In high school, Stryker showed an aptitude for chemistry, earning near perfect scores, and in 1912 enrolled in the Colorado School of Mines (CSM) in Golden but withdrew after the first year because of financial problems and trouble with his eyesight.[5] To earn a living he spent summers ranching on homestead land in the highlands above town with one of his brothers and did manual labor in the winter until he enlisted during World War I. After a noncombat year in France, he returned to Montrose and resumed ranching with his brother, but later recalled that the postwar economic slump had "pretty well cleaned out the cattle business."[6] So, in the fall of 1920, at age twenty-seven, he re-enrolled as a chemistry student at CSM.

There, Stryker befriended an unconventional minister named George Collins who taught an economics course. Over the summer, Collins created an innovative seminar in Denver, one that integrated Christian doctrine and empiricism into what Stryker later called a "kind of crazy workshop."[7] Collins focused on the industries of Denver and employed a distinct investigative method later termed "participant-observation" by social scientists, an approach which today we might call an immersive or embedded experience. By day Stryker and the other participants worked in industry to observe and experience economic and labor conditions, then met as a group in the evening for collective discussions with labor experts.[8]

For Stryker this "crazy workshop" was truly a pivotal experience, compelling him to pursue an economics degree at Columbia University. After divesting him-

self of his share of the cattle business, he married his sweetheart, Alice Frasier, and moved with her to New York. To ease their financial strain, Collins arranged for the couple to live and work at the Union Settlement House on East 105th Street.[9]

"REX THE RED"

During his first year at Columbia, Stryker formed a lifelong friendship with another professor and mentor, the visionary economist Rexford Guy Tugwell, whose radical ideas and avant-garde teaching methods provided Stryker with a framework to study economics and view the world in new ways.

In line with modern social science—and the observation methods Russell Lee was learning concurrently in the hard sciences at Lehigh—Tugwell's Contemporary Civilization course taught students to seek concrete visual representations of the commodities, institutions, and principles they were studying. Characterizing Tugwell as a "descriptive economist," Stryker explained,

> So often he said in his classes, "How can you talk about the economic system if you don't know what a bank looks like?" . . . not how it works, but principally you have to know what it looks like. You ought to know what the horse looks like before you dissect it later on, because it doesn't look like a caterpillar.[10]

Stryker also engaged in social issues under Tugwell's mentorship, later recalling how he absorbed "social awareness through the pores."[11] Like many in the Progressive Era, Tugwell believed poverty was the result of unregulated capitalism and stressed the possibilities of improving conditions through "social management" or a government-managed economy.[12] Stryker read *The Survey*, a journal focused on sociological and political issues, and *Survey Graphic*, an illustrated companion journal; both were published by reformer Paul Kellogg, director of the groundbreaking Pittsburgh Survey. And Stryker studied the emotionally charged

photographs of social reformers Jacob Riis and Lewis Hine; photographs by the latter appeared regularly in Kellogg's publications.

After graduating in 1924, Stryker became a teaching assistant in the Contemporary Civilization class while he pursed a doctoral degree. He developed an experiential component for the class, taking students to various socioeconomic institutions around New York.[13] On non-field trip days, he brought in illustrations to augment the syllabus.

With a developing sense of documentary pictorial materials, he clipped the rotogravures of the *New York Times* and searched other periodicals for drawings and photographs to use in his classes.[14] He later reflected, "Everywhere I went I kept a pocket full of notes about my ideas for pictures. I wanted there to be a file on the things we were seeing but of course there wasn't."[15]

A "milestone" in Stryker's relationship to the photograph came when Tugwell began work on a textbook to be titled *American Economic Life.* Tasked with researching, selecting, and organizing the illustrations, Stryker "hunted pictures" in various image files, an experience which would be invaluable for later setting up his own.[16]

During his illustration quest Stryker met Lewis Hine, who, like Tugwell, believed that wealth disparity was not the fault of the poor; his social reform stance clearly informed Stryker's approach to the image selection for *American Economic Life.* For Hine, the collaboration offered the aging photographer exposure and renewed interest in his work.[17]

First published in 1925 by Harcourt Brace and Company, *American Economic Life and the Means of Its Improvement* took a decidedly progressive stance and introduced substantive changes in social welfare thinking.[18] It was also one of the first uses of social documentary photography as a teaching tool; scholar William Stott termed it "the first book about American society with pictures on virtually every page."[19] A 1930 edition reflected Stryker's broadening knowledge and growing confidence with images, as well as the influence of several works published in the interim, notably *Middletown* by Robert and Helen Lynd, *North America* by J. Russell Smith, and *Yale Pageant of America.*

SHORTLY AFTER THEIR COLLABORATION, Tugwell's career diverged from traditional academia. Consequently, so did Stryker's.

Throughout the twenties, Tugwell had been a regular contributor to *The Nation* and *The New Republic*, writing articles on business regulations, labor issues, and the problems of agriculture. When the stock market crashed in October 1929, Tugwell contended that the Depression hadn't resulted solely from the crash but had actually started years before on the nation's farms. He publicly blamed longstanding USDA policies and decisions made by Hoover, a man he deemed ill-equipped to deal with the complexities of the nation's economy.

In March 1932, Tugwell was recruited into the inner circle of advisors to presidential candidate Franklin Delano Roosevelt. He quickly became a member of Roosevelt's Brain Trust and took charge of the group's agricultural division, planning economic recovery programs and writing speeches. When Roosevelt won the election, Tugwell resigned from Columbia, moved to Washington, D.C., and became Assistant Secretary, later Undersecretary, of Agriculture, under Henry Wallace.

Within days of his inauguration in 1933, Roosevelt began to implement the New Deal he had pledged to the American people, a magnitude of social programs, regulatory measures, and public works projects created to promote recovery and restore the nation's economy. Among the first was the controversial and unpopular Agricultural Adjustment Administration (AAA), of which Tugwell was a principal architect.

In an effort to boost the agency's image, Tugwell recruited Stryker to work on exhibits promoting the AAA. The position was short-term, but Stryker accepted and spent the summer of 1934 in Washington.

Digging through government picture files, Stryker decided to collect images for a pictorial history of agriculture, believing such a resource could benefit his students at Columbia, who "didn't know a disc harrow from the steeple of a church."[20] Conferring with Tugwell and Columbia professor Harry Carman, he began building a *Pictorial Sourcebook of American Agricultural History*.

Soon, the prospect of creating such an encyclopedic image file consumed him. He wrote outlines on small slips of paper, which he "always" kept with him, so that his "pockets were bulging with the notes" he made.[21] With a singular focus—verging on obsession—he collected visual materials from both government and private sources, accumulating, as he later recalled, somewhere between three and fifteen thousand pictures.[22]

Stryker's sourcebook work was interrupted in the summer of 1935 when Tugwell again invited him to Washington for a job with another controversial agency. Established in April 1935 and placed under Tugwell's direction, the Resettlement Administration (RA) was designed to help the country's poorest farmers: sharecroppers, migrants, and tenants. Already a disadvantaged group, these farmers had been further impoverished by the AAA, which benefited relatively prosperous landowners. The RA focused on rural rehabilitation and programs to relocate farm families displaced by the AAA as well as by farm mechanization, drought, dust storms, and overworked land. The agency established rural cooperative enterprises and communal farms; constructed model suburban communities; sponsored camps for migrant farm laborers; and offered grants and loans to tenants and small farmers. With a note of satisfaction, Tugwell later boasted that "rehabilitation of poor people and poor land together in one federal agency" was his own novel idea.[23]

To head this agricultural agency, Tugwell chose two men who weren't agriculturalists: Will W. Alexander and Calvin Benhan Baldwin. Alexander, known fondly as "Dr. Will," was president of Dillard University and a veteran crusader for civil rights. Baldwin, nicknamed "Beanie," was an administrator on Secretary Wallace's staff and had "militantly liberal ideas" that meshed with Tugwell's.[24]

From the RA's inception, anti-Roosevelt and anti–New Deal groups criticized its policies of government intervention on behalf of the small farmer, which were contrary to longstanding Department of Agriculture policies. That it was an independent agency created by executive order (rather than legislation) was never overlooked in denunciations. Agribusiness, large landowners, and even organized labor remained suspicious of Tugwell, already labeled "Rex the Red" by detractors, and what they viewed as his radical and collectivist policies.

Building on lessons learned from the promotional AAA exhibits, Tugwell counterattacked, but this time on a much larger scale, creating an entire public relations department charged with persuading Americans that the Resettlement program offered effective solutions to the country's ecological and agricultural problems. He called this organizational arm the Information Division and within it created five units, including one named the Historical Section, which was charged to create a record of Resettlement activities.[25] Tugwell asked Stryker to administer this section. After some deliberation, Stryker left Columbia in July 1935 to become chief of the Resettlement Administration's Historical Section.

ESTABLISHING THE FILE

Operating out of a makeshift office in the Agriculture Building, just off the National Mall, the Historical Section had inauspicious beginnings. Tugwell initially saw the Section's main function as a clearinghouse of materials, including photographs—an archive to record the agency's history. As Ben Shahn later explained it, Stryker was supposed to collect "even the typewritten memoranda that came through."[26]

Tugwell offered little guidance on how to establish or administer the Historical Section, so Stryker visited other RA divisions to see what they were doing and what kinds of records they were producing. He noticed "two or three . . . were already setting up their own photographic operations" to document the progress of their housing and resettlement projects. Engineers wanted Leicas for pictures "of the buildings before and after" and "clients in their old clothes and after they were rehabilitated."[27]

Doubtful that a scattered image-making approach would work, Stryker convinced Tugwell that all photography should be overseen by one office. A few days later, Tugwell unilaterally reorganized the RA's photography operations; he told the

10. [Edwin Rosskam making] *picture selection from FSA files for war bonds mural in Grand Central Terminal in New York City, December 1941*, photograph by John Collier Jr.

Information Division director John Franklin Carter to transfer all agency photography under Stryker's authority and worded Stryker's job description ambiguously, allowing it to be developed on the fly. Stryker recalled little supervision: "J. Franklin left us alone because he was busy with other things. So I had a good deal of freewheeling."[28] When the photographs from other sections transferred to Stryker's office in mid-1935, the File was born (fig. 10).[29]

Aware of the Historical Section's great potential, Stryker and Tugwell discussed a general mission for the office and the photographs it would create, shaping both around New Deal ideology. Stryker later recalled that Tugwell said the agency's challenge was "to try to tell the rest of the world that there is a lower third, that they are human beings like the rest of us. Their [shoes] are a bit shabbier and their clothes are a little bit more holey and worn, but they are human beings."[30]

So, the Historical Section pivoted. Suspecting that pictures of the progress being made in housing construction would build little support for RA programs, Stryker curtailed photography of rural and suburban communities. He recognized this "project work" as a necessary evil and did, on occasion, capitulate to

regional office requests, but he primarily focused on producing effective images that would both form an archival record of problems the agency was trying to address and generate public support for the programs it administered. To accomplish this, Stryker needed photographers who understood the problems of rural America and could shoot them with sensitivity and skill. He hired, or accepted on transfer from other departments, Arthur Rothstein, Dorothea Lange, Carl Mydans, Walker Evans, and for a brief time, Paul Carter and Theodore Jung.

Though Ben Shahn worked as an unofficial, part-time member of the photographic team, Stryker credited him with steering the intellectual and aesthetic direction of the File in its early days. Shahn advised him: "Look Roy, you're not going to move anybody with this eroded soil. But the effect that eroded soil has on a kid, who looks starved, this is going to move people."[31] Eliciting emotion, a key component of the 1930s documentary approach, was central to Shahn's own work, such as his 1931–32 series on the trial of anarchists Nicola Sacco and Bartolomeo Vanzetti.[32]

Dorothea Lange's work also affected Stryker's vision. Before Stryker hired Lange, her husband, economist Paul Taylor, brought some of her photographs to Washington to lobby the RA for migrant camps. Shahn distinctly remembered the day her work came through the office, later describing it as "a revelation" and saying that after seeing Lange's work, Stryker's "whole direction changed."[33]

Stryker also credited Walker Evans with influencing his ways of seeing, despite their well-documented contentious relationship: "Walker had a great effect on me, he showed me pictures he had, and we walked and talked." Alluding to their disagreements, Stryker added for emphasis, "Walker won't believe that I would say this about him but, by God, he gave me a piece of education that had terrific impact."[34]

Stryker proved to be a dedicated leader, fostering camaraderie and hosting dinners resembling design charettes, where photographers could discuss situations in the field and collaborate on the development of the File. Years later, Shahn described the project as in "strange harmony with the time" and saluted the "esprit de corps" that grew among them as "beautiful."[35]

Stryker expected photographers to know about the subjects they documented. He famously distributed extensive reading lists and had long discussions with his staff, stressing critical thinking to avoid a simplified representation. To illustrate this point, Mydans described an amusing interaction, just as he was about to leave for an assignment to document cotton in the South. On his way out the door, he bid farewell to Stryker, who stopped him and asked, "By the way, what do you know about cotton?" Mydans told him, "Not very much." Stryker asked a few more questions and finally said, "Sit down. What you indicate is that you know nothing about cotton." Mydans recalled, "This, of course, was so. [Stryker] called in his secretary and said, 'Cancel Carl's transportation. He's going to stay here with me for a while.' He sat down and we talked almost all day about cotton." They went to lunch, dinner, and discussed well into the night the commodity of cotton, its history and impact on U.S. politics, and how it affected areas outside the country. Mydans said, "By the end of that evening I was ready to go off and photograph cotton."[36]

Mydans appreciated Stryker's insistence on an informed approach, adding that he "made us realize that one doesn't just make pictures; one learns about the subject first, if he has any chance at all he absorbs himself in it." Mydans asserted that all the photographers "had this point of view. Perhaps all had some of it before Stryker. But I think it is fair to say that all of us reached a fine point of perception because of Roy, and that once he inspired us, none of us have ever gotten over it."[37]

As a part of reaching this "fine point of perception," Stryker worked with his photographers—and scores of other colleagues—to develop what he referred to as "shooting scripts." He considered them collaborative efforts, "outlines of ideas" and "a way of thinking or planning . . . a device for discussion." Rather than autocratic assignments or image checklists, shooting scripts were a departure point, distributed with the caveat that if photographers found something more worthwhile, they should shoot that instead.[38]

Within its first fifteen months, the Section's four principal photographers—Mydans, Rothstein, Evans, and Lange—shot around 5,700 images for the File, covering a range of topics: cotton in the South, dust storms and drought in the

Great Plains, the abuses of the sharecropping system in Alabama, and mass migration of farm workers to California.[39] Among the pictures taken were some of the project's most famous: Lange's *Migrant Mother* (February 1936); Rothstein's *Farmer and sons walking in the face of a dust storm, Cimarron County, Oklahoma* (April 1936), and Evans's Hale County series (Summer 1936), later published with James Agee's text as *Let Us Now Praise Famous Men*. Their photographs also depicted RA programs including agency-sponsored migrant camps, the relocation of farmers onto more productive land, and the construction of cooperative communities.

To handle the stream of photographs coming in from the field, Stryker established an extensive support staff in Washington, a well-coordinated office of twenty-one administrative and lab employees under his supervision: eleven darkroom technicians, a photographic editor, two stewards of the photographic files, three layout artists, and four people who handled clerical and fiscal duties.[40] His Washington staff kept photographers stocked with supplies in the field, logged in and tracked exposed negatives, edited and typed photographers' captions, created captioned prints, and distributed them to the many outlets that used them. These outlets included various RA divisions and other federal agencies that produced brochures, slide-films, posters, and exhibitions.

Seeking broader publication, Stryker tirelessly cultivated media contacts and established an efficient method for print circulation in newspapers and magazines. In a four-month span—August through November 1935—his office sent out 940 photographs, an average of 235 a month, or 12 each business day. Stryker later remarked that he made a regular circuit in New York because he "always had something to sell."[41]

According to FSA historian F. Jack Hurley, one of the first appearances of Section photographs in a nongovernment publication was in a January 1936 *Survey Graphic* article "Relief and the Sharecropper," illustrated by two Rothstein images.[42]

Later that year, the publication of another Rothstein photograph caused a problem for the Section, as it triggered a hostile debate on the authenticity of Sec-

tion pictures, and ultimately launched a recurring discourse on the concept of truth in documentary photography. While covering drought conditions in the South Dakota Badlands, Rothstein photographed a bleached steer skull baking in the sun. To optimize the lighting and get variant background textures, he moved it a few times, picturing it on both parched earth and grass-covered ground. The anti-Roosevelt *Fargo Forum* newspaper ran one of the photographs and labeled it "fake," accusing Rothstein of using the skull as a prop, and noted the animal could not have died from recent drought conditions because the skull had obviously been bleaching for years. The paper warned readers not to be taken in by "unreliable stories" of drought in their state.

Washington reporters for two other anti-Roosevelt newspapers—the *New York Herald Tribune* and the *Chicago Tribune*—found Rothstein's other photographs of the skull in the File and ran another story questioning the overall truthfulness of RA photographs, as well as the integrity of the agency. Political cartoonists had a field day; one cartoon, titled "Skullduggery," depicted Rothstein carrying his skull around to different locations. For the Roosevelt administration, in the midst of an election year, the controversy became a campaign issue.[43]

Stryker's office rushed into damage control and issued a statement "denying the spuriousness" of Section photographs. For good measure, his assistant chief, Ed Locke, wrote to Rothstein, "if you still have that goddamn skull, hide it for Christ's sake. Stick close to my story."[44]

WHILE CARRYING OUT HIS official mandate to photograph RA activities, Stryker also saw his project as an opportunity to record contemporary American life, a goal he later articulated as "immortalizing the ever-dying, ever reborn present."[45] His broad documentary vision fit within the country's search for a usable past and rush toward rediscovery, a 1930s phenomenon that writer Alfred Kazin characterized at that time as a "drive toward national inventory."[46]

Stryker's shooting scripts therefore evolved to include both historical and contemporary iconography. Along with disappearing artifacts—items such as

wooden sidewalks, horse-drawn spring wagons, and country stores with shelves full of patent medicines—he also sought common everyday items including rodeo advertisements, billboards, barber poles, and views of small-town life. He believed all these images held value for future generations, an attitude Jack Delano later summarized as, "everything is useful and you've got to have it, and if you don't need it now, you'll need it later, or somebody else is going to need it."[47]

To better achieve his goal, Stryker looked to other image files and documentary endeavors. These included the Picture Collection at the New York Public Library, headed by the visionary librarian Romana Javitz, who committed herself to creating a comprehensive visual record of America by systematically acquiring photographs and documents such as postcards, pamphlets, magazines, and theatrical bills.[48]

Stryker also drew meaningful inspiration from French photographers Charles Marville and Eugène Atget and their efforts to record the Paris of their time.[49] Atget in particular permeated the documentary scene of the 1930s after photographer Berenice Abbott introduced his work to America in the book *Atget Photographe de Paris* (1930).

With aspirations firmly grounded in documentary tradition and contemporary archival collecting practices—and confident of Tugwell's support—Stryker expanded the scope of the File and asked his photographers to record anything that would build a visual inventory of the United States. Rothstein, for example, recalled a trip to the South in the fall of 1935: "I took a lot of pictures . . . which had nothing to do with the usual project type pictures that the Department of Agriculture wanted."[50] Stryker termed these unofficial photographs "American Background."

Though he kept his personal goal under the radar, Stryker included a vague description of it in the RA's *First Annual Report*, which explained the Historical Section charge as "not only in keeping a record of the administration's projects, but also in perpetuating photographically certain aspects of the American scene which may prove incalculably valuable in time to come."[51] Administrator Beanie Baldwin recalled, "I guess we had legal authority to do this, but if Congress had known at the time what we were doing we would have been blown right out of the place."[52]

HIRING LEE

When Russell Lee came in, I was curious about him. I liked him . . .
[his] forthrightness . . . [He] literally walked into my office one day. . . .
Frank, healthy, open, whatever you'd want. We coordinated, just like
that . . . there was no second thought that I didn't want Russell.

Roy Stryker, 1972[53]

When Lee went looking for a job with Stryker in late summer 1936, the Historical
Section had moved to a second location, a Gothic Revival building overlooking
Farragut Square. Typist Charlotte Aiken later described the office as "very small
quarters . . . a very busy place and not too well organized. . . . There were pictures
all over on top of the files."[54]

Lee introduced himself to Stryker and Locke and showed them his work
from New York and the Catskills and his bootleg coalminer series from Penn-
sylvania. Though he had no openings at the time, Stryker remembered, "I was
impressed—very much impressed—with the man's ability and the series of pic-
tures he showed me."[55]

When Mydans resigned in October for a position at *Life* magazine, Stryker
immediately thought of Lee: "As soon as Carl had decided to leave, I hunted
Russell up."[56] Writing him at Woodstock, he offered Lee a temporary job and
suggested he drive back to Washington to first spend a few days looking over
the File, which Lee did.[57] Stryker recalled he "took [Lee] home and talked with
him for a couple of evenings," then just smiled and said to himself, "There's
my man."[58]

The assignment Stryker had in mind for him, the Jersey Homesteads project
near Hightstown, New Jersey, was a problematic one that would gauge Lee's skills
and disposition. And Lee was the first photographer who, according to Stryker,
"had to match himself up against a going concern, a block of material that was
already in, and from that time on every new photographer had to face that prob-
lem . . . pictures in the file they had to match, equal or better."[59]

[a] Louis Gushen, chief cutter.

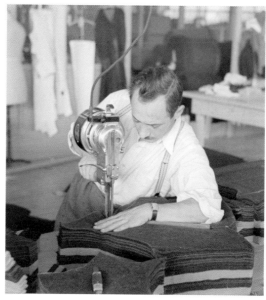

[b] Philip Goldstein, assistant cutter.

[c] Isadore Snyder, cloak operator.

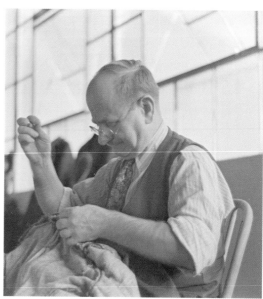

[d] Sam Imber, tailor.

11a–d. Cooperative garment factory, Jersey Homesteads, Hightstown, New Jersey, November 1936.

ORIGINATED IN 1933 under Subsistence Homesteads (an unsuccessful and broadly criticized New Deal program), Jersey Homesteads epitomized the back-to-the-land movement of the Depression. The project intended to move two hundred skilled Jewish garment workers and their families from New York City to a newly established agricultural-industrial community, the agency's first triple cooperative: a factory, farm, and store. Jewish immigrant Benjamin Brown conceived of the idea, estimating the total project would cost $600,000, with each participant contributing $500 and a Subsistence Homesteads loan covering the remaining $500,000.[60]

From the beginning, financial, administrative, and public relations problems plagued Brown's project. New building codes raised housing costs even before construction began; the cows Brown acquired from drought areas in the Midwest hadn't been protected against tuberculosis and couldn't enter New Jersey; WPA workers left the construction site just as a shipment of lumber arrived because they had already finished their allotted hours for that month. Controversies arose about the project's validity and worth, attracting public charges of foolish government spending.

In May 1935 the RA inherited the Subsistence Homesteads program and Jersey Homesteads along with it. Tugwell disagreed with the program's philosophy that industry would move to the workers, but later recalled Roosevelt told him that if he wanted a new agency to deal with rural problems, he had to take the whole package.

The project continued to stumble in the public eye under Tugwell's direction. When he decided to use it as a testing ground for prefabrication methods, the RA spent $200,000 building temporary factories, but after a series of disastrous setbacks tore them down and—to avoid any more bad publicity—excluded all visitors from the construction area. Opponents branded Jersey Homesteads "Tugwell Town" and cast it as an experiment in socialism, a "Communistic village in the mud."[61] The *New York Times* ran stories casting the project as a wasteful, financial failure and a "mirage of New Deal regimentation."[62]

By October 1936, Jersey Homesteads was a hotbed of animosity toward the

12a–c. *Hair tonic salesman advertising his wares, 7th Avenue at 38th Street, New York City, November 1936.* (Two photographs originally uncaptioned.)

RA. Garment workers—who had already personally invested $500 each—blamed their dismal factory season on the RA for not building enough housing. Construction crews were angry because Resettlement inspectors were on site looking for graft; several bosses were fired.[63]

Though Lee represented the organization that residents and contractors had come to resent, he managed to achieve a rapport with them. With his Contax camera, which he relied on for its quick and inconspicuous operation, Lee pictured administrators around the community, construction crews building houses, residents shopping at the newly opened co-op store, children learning Hebrew, and garment workers plying their trade in the 22,000-square-foot factory (declared the most modern building for needlework on the Atlantic Seaboard). Lee also traveled to New York City to document the living conditions that project participants had left behind and a Garment District showroom where women modeled coats made at the New Jersey factory.

Lee's photographs show his engagement with his subjects: some situated themselves for group portraits (including a women's group inside a member's home), and garment workers proudly showed him a blanket one of them made from cloth scraps. Some offered a relaxed smile.

Two series he made for this assignment are particularly worthy of note and recall his empirical training. The first, a linear series of more than two dozen pictures, depicts the construction of a garment in the factory, from pattern drafting and cutting to sewing, pressing, fitting, measuring, and tailoring (figs. 11a–d). Rather than making singular images of garment workers, he dismantled their complex workflow into a series of sequential steps. Demonstrating close attention to process, this image group shows his fascination with how people work and speaks to his respect for expertise and skilled labor.

A second, but different, type of series features a trio of images depicting a hair tonic salesman pitching his wares in the center of the Garment District, at Seventh Avenue and Thirty-eighth Street (figs. 12a–c). The salesman displays two compelling advertisements for his product: a sign that promises "Keep Your Hair Forever" and an unruly beard and mane. Sunlight skips across the

tops of the hats of men gathered on the street, landing on the salesman's face, illuminating his craggy features. Lee lingered at the scene, circling the salesman to capture him from front, back, and side. When viewed together the photographs provide a multi-perspective view of the salesman and the changing crowd around him.

Both series build up a complex picture of Lee's chosen subject and evoke the illustration groups he studied in textbooks and science atlases at Lehigh. They also figured prominently in his permanent hiring by Stryker.

STRYKER LATER ADMITTED to being unsophisticated and inexperienced when it came to first hiring photographers for the Section, but after a year on the job he believed he was better able to recognize what he wanted: "I think by and large I was looking for people . . . [with] curiosity . . . a desire to know . . . the eye to see the significance around them. Very much what a journalist or a good artist is, is what I looked for." Stryker asked himself, "Could the man read? What interested him? What did he see about him? . . . How sharp was his mental vision as well as what he saw with his eyes?"[64]

Stryker was also looking for someone compatible with his staff and who would contribute to the collective efforts of his office to document and promote New Deal reform. He already had two photographers—Lange and Evans—resistant to camaraderie; they regarded themselves as independent artists and perpetually sought control over what they perceived as their own work.[65] Lange biographer Linda Gordon summarized both Evans and Lange in a succinct comparison: Evans interacted with Stryker in "a passive aggressive manner" whereas "Lange's interactive mode, by contrast, was direct. She argued and pestered. But she never refused an assignment."[66]

Stryker saw the many advantages to having these established artists on staff, but believed their difficult temperaments disrupted the Section's collective spirit. He didn't want any more high-profile or high-handed photographers: he was already dodging efforts by Lewis Hine to join his staff.[67] So, Stryker trusted his

instincts after his first meeting with Lee: "It was as simple as that. I liked him. And I was damned sure I was right. And I was right."[68]

Lee quickly proved to be a team player. In contrast to Lange, who battled to do her own printing, Lee surrendered control of his. He trusted and respected the lab staff and believed they didn't get enough credit for their role in the project.[69] Not surprisingly, he got along swimmingly with them. A master technician both in camera and in the darkroom, he shared with lab supervisor Royden Dixon a passionate interest in chemistry; the two corresponded about cameras, lenses, fine grain developers, and photographic papers. Years later, Stryker admitted that he sometimes pulled Lee from the field for no other purpose than to "whip up the morale of the laboratory."[70]

But it was more than just a pleasing disposition and ability to get along. Lee had charisma and élan, and the Jersey Homesteads assignment demonstrated his remarkable ability to walk into an adverse situation and put people at ease. Stryker and his staff believed this was a necessary skill, as is evident in a special memo later crafted on the "special requirements needed" to be a Section photographer: "A man or woman who moves easily in any kind of society and can rapidly gain the confidence and cooperation of the people with whom he deals."[71]

Stryker knew that when a situation called for delicate intercession, he himself lacked finesse. Possessing a salty tongue and abrasive manner that frequently got him into trouble, he came to rely on Lee to smooth the many ruffled feathers he left in his wake. At one point he called Lee a "master at taking care of our public relations."[72] Colleague Bernarda Bryson Shahn, an artist in the Special Skills Division and Ben Shahn's second wife, recollected Lee was "good-naturedly tolerant of what were known as 'Roy's shortcomings.'"[73]

Lee also intuited Stryker's larger goals. Drawing on his training with John Sloan and his experiences as a Regionalist painter alongside his wife, he recognized the American Scene iconography his new boss sought, evidenced by his hair tonic salesman series. Over his tenure Lee laced his official assignments with hundreds of scenes of the ordinary and everyday, such as a sign painter in Sioux City, Iowa (fig. 1); milk cans in front of a window in Cook, Minnesota (fig. 36);

[a] Belle Fourche, South Dakota.

[b] Belle Fourche, South Dakota.

[c] Big Falls, Minnesota.

[d] Plentywood, Montana.

[e] Kenner, Louisiana.

[f] Muskogee, Oklahoma.

[g] Plentywood, Montana.

[h] Williston, North Dakota.

[i] Williston, North Dakota.

13a–i. Barber poles, 1937–39.

a circus in Klamath Falls, Oregon (fig. 56); an itinerant photographer in Steele, Missouri (fig. 57); a secondhand tire shop in San Marcos, Texas (fig. 61); a country store in Buttermilk Junction, Indiana (fig. 99); and barber poles everywhere (figs. 13a–i).

Lee's garment worker series appealed to Stryker's collector mentality and charted a new approach for the File. By 1940, in an interview with *Survey Graphic*, Stryker said he was coming to think more and more in terms of series, rather than single pictures.[74] Lee's first sequence anticipated several others, including the construction of a prefabricated house in Missouri in 1938 (figs. 46a–l), crafting a pair of cowboy boots in Texas in 1939, and making a parachute in California in 1942.

However, as much as Stryker chose Lee, Lee chose Stryker.

By 1936 Lee had already connected his deeply rooted social conscience to photography and embarked on a self-directed documentary course. The Resettlement exhibit in New York offered the opportunity to embark on a larger, more methodical one. But Lee wasn't simply looking to picture the nation's economic problems. After his first meeting with Stryker he could have explored the many photographic projects with social reform components at other New Deal agencies, such as the Department of Agriculture, Civilian Conservation Corps, National Youth Administration, and the Housing Authority.[75] Stryker actually referred Lee to the Forest Service during their first meeting, an option Lee rejected because he was more interested in aesthetic merit.[76]

Herein lies one of Lee's core contradictions. From the moment he dropped painting, he ceased calling himself an artist, yet incorporated his artistic training into his photographs and actively sought a documentary project with artistic cachet. Although just over a year old, Stryker's project had that cachet, bolstered, ironically, by the participation of Lange and Evans, and by the appearance of RA photographs in artistic venues. By the fall of 1936, Stryker was actively connecting the File to the art world, finding successful exposure in publications such as the 1936 *U.S. Camera* and exhibits sponsored by art museums and art associations, thus beginning what FSA scholar John Raeburn has called the "never resolved

dilemma of how to figure its work. Were its photographs, [as Tugwell wrote in the College Art Association exhibit catalog in 1936] 'purely documentary and utilitarian' or 'art expression' and if the former, could they also be the latter?"[77]

Perhaps Lee's rejection of the label "artist" was a false humility or a way of avoiding competition or comparison after failing as a painter. Or he may have believed documentary photography's functional purposes disqualified it as art, a belief popular at the time, and demonstrated in Tugwell's exhibit catalog text. Six years of detailed correspondence between Lee and Stryker reveal that Lee didn't concern himself with his artistic legacy but thought deeply—and often—about how best to use his photographs to bring attention to the era's economic and social problems.

The prospect of being away from his wife, Doris, doesn't appear to have factored into his decision to join Stryker's staff and he never expressed a moment's hesitation leaving her in New York. Lee later said being on the road for the Historical Section cost him his marriage,[78] but by the fall of 1936 the Lees were already drifting apart. Doris had been spending a lot of time with Arnold Blanch and—embracing Woodstock's bohemian attitude—began a romantic relationship with him, perhaps as early as 1935.[79] But open marriages were de rigueur in Woodstock, and Lee took their relationship in stride, holding no rancor toward either of them. Lee dedicated himself to his job and later remarked his life at that time "really was only work."[80]

Steeped in humanitarianism from a young age, Lee wanted to create photographs to serve what he felt was a greater good, rather than his own artistic or professional agenda. His decision to join Stryker's documentary project reflected his unshakable faith in the New Deal. Bernarda Bryson Shahn later wrote that the earnestness, energy, and zest with which Stryker's photographers pursued their work stemmed from "a conviction not only that something *could* be accomplished toward bettering the life of people, but that it *was* being accomplished, and that they were, in some part, doing it."[81] An epitome of Lehigh's "flannel shirt variety," he spent most of his time on the road and out in the field.

Though they were of opposing personalities, differing backgrounds, and

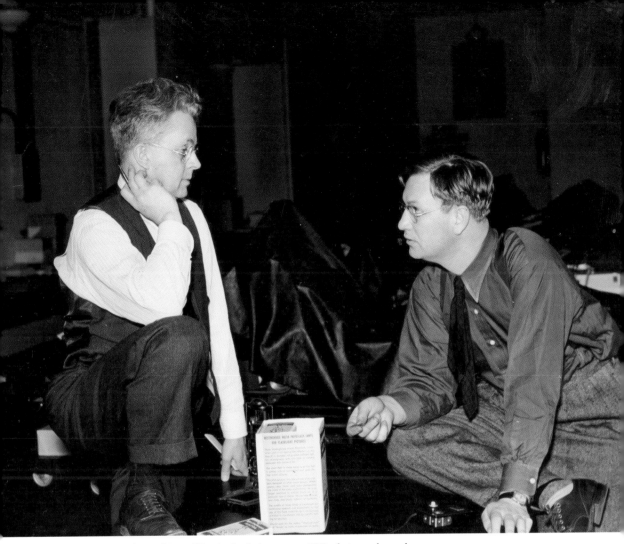

14. Roy Stryker and Russell Lee in the darkroom, ca. 1940, photographer unknown.

contrasting working methods, Lee and Stryker formed a unique bond (fig. 14). Somehow, Stryker's scrappy nature and frenetic manner blended with Lee's steady bearing and casual confidence. Louise Rosskam recalled their relationship: "As far as Russ and Roy were concerned, they belonged together. They really did. More than any other photographer ... They really fit together ... He didn't have the same relationship to anybody else."[82]

When Lee joined Stryker's permanent staff in November 1936, the central paradox of his career was about to unfold. Of all possible subjects to photograph, Lee's first job was to document farm tenancy in the Midwest for the upcoming Bankhead-Jones legislation. This assignment was critical for the Roosevelt Administration, consequential for Stryker and the RA, and momentous for Lee.

November 1936–January 1937

Farm Tenancy in the Midwest

"A GRAVE PROBLEM OF GREAT MAGNITUDE AND COMPLEXITY"

Farm tenancy in the Midwest differed from the sharecropping system in the South, which was an inherently exploitative practice that didn't convey any rights to the land. Yet 1930s media blurred the distinction between sharecropper and tenant farmer by using the terms interchangeably, so most Americans perceived the two systems to be one and the same.

A sharecropper functioned as little more than a farm laborer with no claim to the crop until everything previously received from the landlord (called "furnish") had been paid off. Frequently the sharecropper ended the season in debt, owing the landlord more for what had been advanced than what the crop yielded. In some Southern states, sharecroppers were legally classified as laborers, with no legal possession of the land or rights of ownership.[1]

Tenancy, on the other hand, could be a mutually beneficial arrangement. If properly administered, it could provide the owner a means of maintaining the

land's productivity and fertility while enabling the farmer to earn a living and avoid mortgage and tax burdens. The farmer used labor to accumulate experience and capital, which could then be invested in livestock and equipment, and ultimately in land. In the mid-1920s, one agricultural scholar termed the practice a necessary institution with a "legitimate place in our economic order."[2]

When improperly administered, however, the tenancy system created a perpetual state of insecurity for renters and devastated the land they worked. Signs of trouble began to manifest in the late nineteenth century, but real problems materialized during the agricultural boom in the early twentieth century and resulted from both land and crop speculation. Throughout the boom, scores of investors bought acreage intending to flip it in a few years. In the interim, they rented it out but took no interest in soil-building techniques, as their ownership was short-term. This attitude suited tenants, whose interest in the land's fertility was also short-term. Without investment from either party, soil quality deteriorated.

Crop speculation compounded the problem. Tempted by inflated commodity prices during the boom, farmers ignored sound practices such as crop rotation and instead planted cash crops exclusively. When prices collapsed, they planted more—often going into debt—to make up the income shortfall, yet only succeeded in further weakening the soil and creating a surplus that devalued the existing inventory. Owners and tenants alike sank deeper into debt. Foreclosures increased.

Rental agreements were often verbal, leaving the tenant vulnerable to eviction at any time and with no legal recourse. When landlords neglected houses and outbuildings, tenants lived and worked in structures that were falling down around them or in shacks cobbled together from scraps. If the cash crop exhausted the soil, the tenant moved on to another farm; soon the line between tenant and migrant blurred. These tenants became transient subsistence farmers caught in a cycle of system abuse: they contributed to the soil depletion of the 1920s and 1930s, while in turn soil depletion swelled their ranks and drove them deeper into poverty.

Tenancy mushroomed: tenant farms soon outpaced owner-operated ones—increasing at a rate of nearly four to one—which some economists viewed with

concern.[3] In 1920 tenant farmers operated more than a third of the country's farmland, and by the early thirties that percentage grew to nearly half. Many changed farms every two or three years and more than 30 percent moved every year.[4] Sociologists, agriculturalists, and economists began referring to farm tenancy as a national crisis, equating it with erosion, soil depletion, rural poverty, ill health, illiteracy, and instability of community life.

The Agricultural Adjustment Administration (AAA), created in May 1933, only exacerbated the problem. An audacious experiment, conceived in part by Tugwell, the AAA sought to right the farm economy through a complex series of measures, including curtailing production to raise commodity prices and paying landowners a subsidy to let a portion of their fields lay fallow. This primarily benefited prosperous owners, who often evicted their tenants then used them as cheap labor, or spent the benefit payments on tractors, obviating the need for that labor at all. The AAA gave rise to protests and the formation of organizations such as the Southern Tenant Farmers Union.

These conditions precipitated the creation of the Resettlement Administration and the drive for tenancy legislation. Several bills were introduced between 1934 and 1935, but only the one spearheaded by Senator John H. Bankhead II of Alabama and Representative Marvin Jones of Texas received serious consideration.

Along with Bankhead-Jones came a wave of national publicity reporting the growth of tenant farming and its associated problems. "The Evils of Farm Tenancy" became a favorite topic among journalists, political cartoonists, and reform leaders. Newspapers and magazines depicted tenants living in rural slums, and headlines termed farm tenancy a problem, a menace, and a bog.[5]

The volume of media attention aroused so much public interest that during the 1936 election campaign both major political parties pledged support for legislation to alleviate what was seen as an agricultural epidemic, what Roosevelt referred to as "a grave problem of great magnitude and complexity."[6]

Two weeks after winning reelection in November, he appointed a Special Committee to report "on the most promising ways of alleviating the shortcomings of the farm tenancy system" in advance of the next session of Congress, when

the well-publicized Bankhead-Jones Farm Tenant Bill would be considered.[7] Roosevelt appointed Wallace and Tugwell (among others) to lead the investigation.[8]

Tugwell believed the solution wasn't to eliminate the tenancy system, but rather to repair it—and address its repercussions on the rural population. In a *New York Times Magazine* article, he wrote that "the problem is poverty from whatever cause" and advocated dealing with those causes to enable "security in possession" for farmers. He believed "there is no more wrong with tenancy than there is with ownership in this country. . . . Setting out to abolish one in favor of the other merely avoids the deeper issue."[9]

With Tugwell so closely involved with the President's Committee on Farm Tenancy, and aware that Resettlement's fate—and thus his documentary project—hinged on the bill's success, Stryker dove into supporting it. As Bankhead-Jones moved through Congress, one of his primary objectives was supplying pictures for the popular media and the committee report.

The File already had tenancy images from the Cotton Belt, but few from the Corn Belt, where the *New York Times* reported tenancy was the leading farm problem.[10] Stryker tasked Lee with filling that gap, likely presuming the Illinois native knew something about it.

The job presented complexities and challenges for both men. From personal experience—and opposite perspectives—each knew tenancy to be a viable financial arrangement. Stryker's parents had been tenant farmers in Colorado around 1900 and used the system to accumulate capital. Lee also used the system successfully on his four farms in the Midwest, which together totaled more than 800 acres.

Yet Stryker wanted photographs illustrating the need for reform, persuasive images of tenancy's disadvantageous and abusive aspects, to influence public opinion in favor of Bankhead-Jones. Not knowing of Lee's farms—or his landlord status—Stryker deployed him to indict a system in which Lee was in the power position. Lee accepted the assignment, and there's no evidence he experienced any trepidation or felt conflicted.

Before heading out into the field, Lee spent some days preparing. With Stryker in Washington, he mapped out a plan to cover the states comprising the bulk of the

Corn Belt: Iowa, Indiana, and his home state of Illinois. And reminiscent of Mydans's marathon cotton tutorial, Stryker gave Lee a similarly exhaustive primer on corn and tenancy in the Midwest. Lee later recalled Stryker also gave him about five books, including J. Russell Smith's *North America*, which Lee referred to as a "working Bible."[11]

Lee then spent five days at Iowa State College in Ames with agricultural scholar Rainer Schickele, who gave him more background and statistics on the region. Schickele termed 70 percent of Iowa's tenancy "exploitative" in that landlords and tenants had only a temporary financial relationship, working on a straight one-year lease, with no incentive to take a longer-term interest in the soil. He outlined for Lee the types and percentages of farm tenancy, leases, and landlords; the effect of the drought; and the competition among tenants to rent farms. He also detailed some types of advantageous leases, which tended to maintain soil fertility.[12]

Lee knew it would be "very difficult to photograph just tenancy" and recognized it was an abstract economic arrangement to most Americans.[13] Stryker wanted images to support Bankhead-Jones, yet Lee knew tenancy was a more complex system than such a prescriptive strategy would suggest. And showing only pictures of ruined land, run-down houses, and dispirited farmers might lead citizens and lawmakers to believe that nothing could be done. By early December Lee wrote Stryker his approach was "beginning to crystallize."[14]

LAYING IT ON THE TABLE

> Never forget that Russ was an engineer and an analyzer, a thorough,
> fast operator and he turned in quantity and he turned in detail, and
> when he hit a thing he went through it from all phases and analyzed it
> and took it apart for you and laid it on the table.
>
> *Roy Stryker, 1952*[15]

The photographs Lee produced on his tenancy assignment are a tour de force of observation and depiction, rooted in scientific investigation and cataloging. Eschew-

ing the solely negative view that appeared in the popular press, Lee sought to capture a cross section of tenancy embodying the system's variations and complexities.

On Schickele's advice, Lee followed a course starting in northwest Iowa, proceeding along the drought belt at the western edge, then on to the southcentral region, a route where living and working conditions grew progressively worse. In these representative areas, over a four-week period, he systematically documented more than 60 farms. Lee visited properties rented from banks, loan companies, estates, families, and private parties. He met tenants on farms of various sizes rented under the four main arrangements (crop-share, stock-share, crop-share-cash, and straight cash). Some had leases, some didn't. He found owner-operators successfully working their land, and others with heavy mortgages; a few had fallen victim to foreclosure.

Lee documented diverse house styles: Victorians, saltboxes, shotguns, log cabins, transportable houses, converted rail cars, partial earth dugouts, and one- and two-room shacks. He photographed—and described in his captions—structural problems like cracking foundations and health hazards such as overcrowding and poor ventilation. If a house had undergone recent improvement he noted it, as well as stopgap measures taken by the tenant, such as "banking" the base of the exterior with straw or manure for added insulation.

In addition to houses, Lee drilled down to the particulars of outbuildings—the lifeblood of farming operations—noting their condition and whether it was the landlord or tenant who maintained them. Most were in various stages of neglect: sheds had missing roofs, corn cribs were falling off their foundations, silos had blown over for lack of a windbreak, barns were built of straw and wire.

As Lee traveled, he found the region's poverty and poor soil "incomprehensible" because he "had been raised in Illinois and . . . knew that Iowa had fine land . . ." but was shocked by the destitution and the "very severe problems among farmers who had not had crops for many years." He recalled some families in the region "were receiving outright Resettlement grants in order to live on, to provide clothes, and this kind of thing."[16] Lee made moving portraits of these farmers,

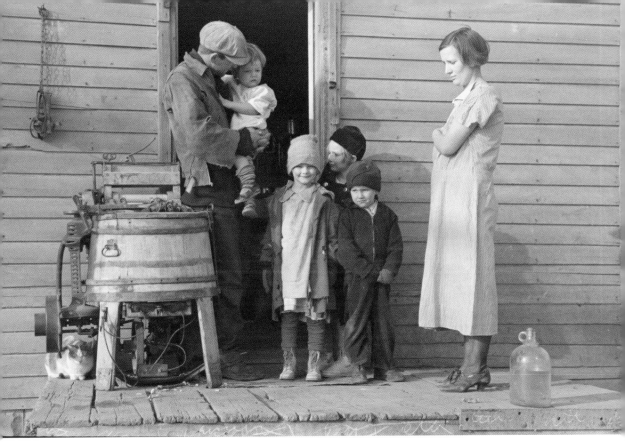

15. *Family of Glen Cook, who rents his farm from a loan company. . . . Woodbury County, Iowa, December 1936.*

such as the Glen Cook family in Woodbury County (fig. 15). With no money to feed animals or repair equipment, they were forced to sell off most of their livestock, leaving them with little besides a rented house, a blind horse, and a broken windmill.

Demonstrating mastery of portraiture in context, Lee photographed the Cooks on the stoop of their weatherworn house and employed detail to inform the viewer about their financial situation. Between the parents are their four children, dressed in hand-me-downs as worn as the floorboards on which the family stands. A makeshift chalkboard occupies the edge of the porch, while an animal trap hangs on the side of the house, indicating either a method for providing food or controlling vermin. Beneath the motor of the decades-old Maytag

washing machine a cat catches the sunlight. Yet the image's narrative is more complex than its depiction of poverty. The father tenderly embraces the youngest child, conveying a sense of family devotion and hopefulness, a recurrent theme throughout Lee's work. The portrait's central figure smiles broadly at the camera, suggesting that she, in contrast to her mother, is unaware of the family's desperate state.

Sometimes Lee isolated certain visual elements of a scene for impact, to illustrate the "particularity of the common man's life."[17] For example, at the home of Alfred Atkinson near Shannon City, he pictured part of the family—two adults and five children—standing on the porch. Then, he aimed his camera toward the floor, focusing on the feet of the three children in front (fig. 16). Literally positioning a core issue of the tenancy problem, he tightly framed their worn-out shoes

16. *Children's shoes and clothes, Alfred Atkinson family near Shannon City, Ringgold County, Iowa, December 1936.*

and threadbare clothes, inadequate for a winter day. Just as he did with his Soviet Union reportage—when he described mismatched clothing to illustrate cotton shortages—Lee again singled out apparel to show an economic problem in a relatable way.

Early in his assignment Lee recognized that showing "the effects" of tenancy would be the only way to illustrate the system's problems.[18] *Children's shoes and clothes* embodies that approach, and aligns with Shahn's advice to Stryker—that photographs of eroded soil wouldn't move people, but the effect that eroded soil had on a child would—and it shows Lee's understanding of the need for emotional impact in his work.

In another example, in Woodbury County Lee met the Ostermeyers, an elderly couple who were original homesteaders but had mortgaged their land and lost it to a loan company. Eighty-one-year-old Andrew Ostermeyer and his 76-year-old wife now lived on their son's farm and still worked. Lee made six photographs of the couple, including a close-up of Mrs. Ostermeyer's work-worn hands (fig. 17).

Firmly grounded in New Deal culture and worker imagery, Lee's Ostermeyer series also epitomized senior citizens of the era, a group with no social programs to protect them. Most elderly laborers in the 1930s worked until they were fired (or died), then depended on their family or went to one of the country's nearly

17. *The hands of Mrs. Andrew Ostermeyer, wife of a homesteader, Woodbury County, Iowa, December 1936.*

1,300 city- and county-supported "old-age homes." By mid-decade, nearly half of Americans over sixty-five were on some form of relief.[19] Roosevelt unveiled his Social Security program in January 1935, but it would be five years before the first recipient received a check. In any case, Social Security would offer no relief for the Ostermeyers because agricultural workers were excluded.

AFTER VISITING ABOUT TEN Iowa farmsteads and photographing families in their yards and on their porches, Lee contemplated the minutiae of their everyday lives: "How did they eat? How did they sleep? How did they cook? . . . What was around there in the house? . . . on the walls . . . the mantelpiece . . . the table?"[20] Driven by his curiosity, he moved indoors, creating interior domestic vignettes of ordinary, everyday objects.

18. *Piano with photograph and mementos in the farmhouse of J. E. Herbrandson near Estherville, Iowa, December 1936.*

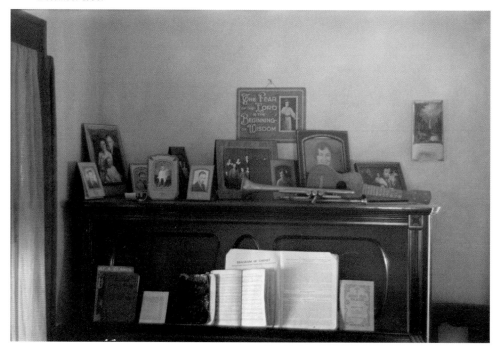

For example, in the home of J. E. Herbrandson near Estherville, a medita-tive tableau captured Lee's attention (fig. 18). In the image, nearly a dozen family photographs, a trumpet, and a ukulele rest atop an upright piano, while a placard hanging on the wall proclaims: "The Fear of the Lord is the Beginning of Wis-dom." These mementoes express a level of material wealth and emphasize what was important to the home's occupants: music, family, and religion.

At another farmhouse, Lee found winter clothing hanging next to a telephone (fig. 19). The jackets appear clean, not tattered, and perfectly adequate for cold weather; one has a fur collar. He composed his image to include the push but-ton light switch on the left, a noteworthy detail since only about a third of Iowa tenant homes had electricity.[21] And by showing the directory for the 1936 Ruth-ven Telephone Exchange Co. just above the jackets, Lee situated his image in time and place.

19. Garments hanging near telephone in Rustan brothers' farm near Dickens, Iowa, December 1936.
(Originally uncaptioned.)

20. *Washstand in house occupied by married hired hand and his wife. Harry Madsen farm near Dickens, Iowa. . . . December 1936.*

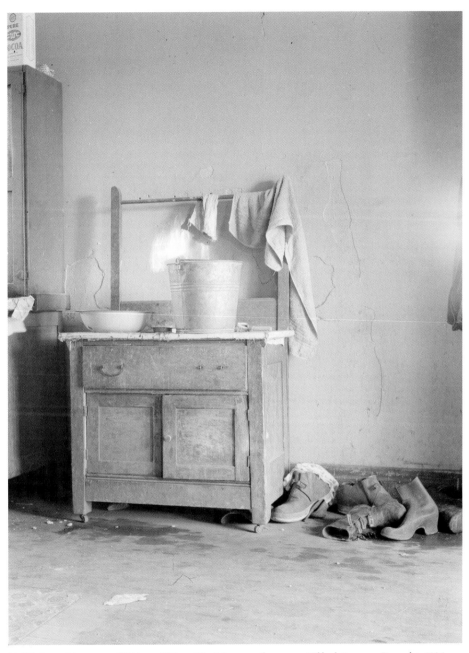

21. *Washstand in corner of kitchen of Edgar Allen's home on farm near Milford, Iowa. . . . December 1936.*

While photographing these domestic interiors, Lee's keen interest in detail induced him to step up his methodology. Calling on his Lehigh training in observation, he added a specific visual practice: he chose an object with a fixed purpose and documented it in multiple homes, a typological approach recalling his scientific atlases, the "systematic compilations of working objects."[22]

As his working object in Iowa, Lee selected the washstand. Washstands were common in rural homes in the late 1930s; in Iowa, for example, only about 15 percent of tenant houses had running water.[23] Lee selected his medium format camera to render detailed socioeconomic information on each washstand owner. In the Harry Madsen image (fig. 20) floral wallpaper, fresh white paint, a matched enameled basin set, delicate sheer curtains, and a Moderne design on the cupboard and floor all suggest a clean, well-ordered home. A scalloped mirror and metal comb holder await the owner's primping needs. Natural light streaming through the window evokes the work of Vermeer.

Lee photographed a grittier, more austere scene at the home of Edgar Allen using analogous composition and lighting (fig. 21). According to the caption he urged the viewer to "Contrast this with washstand picture of Harry Madsen farm, tenant house."

The same basic imagery exists in both images: washstand, basin, rags, towels, and freestanding cabinet for foodstuffs, but details suggest a dramatically decreased quality of life. Instead of an enameled bucket, here a galvanized one rests beside the basin, along with a well-used brush for dish cleaning, food scrubbing, or personal grooming (or all three). The washstand itself is smeared with grime and missing a drawer handle; a worn oilcloth covers the top and a soiled towel and rag hang haphazardly on the rear rack. Reflections shimmer on the pockmarked wall. Mismatched shoes lay in a jumbled pile on the floor. A corner of aging linoleum barely enters the left side of the frame.

Depicting a common denominator of tenant life, these two images are both windows into dissimilar worlds and reflections of Lee's scientific eye. But with these repeated motif photographs Lee's documentary motives are clear: to reveal

through comparison—and in concise visual language—the financial situation of each washstand owner and in turn different levels of tenancy. He employed this topicalizing practice throughout his Historical Section tenure, repeatedly photographing the same scene in multiple locales for eventual comparison, creating indices of interiors.

Photographing interiors presented Lee with a considerable challenge: inconsistent and sometimes unavailable light. For example, while spending time with the Allen family, he pictured members in various spots around their home. Some spaces, like the kitchen, had large windows that washed the area in sunlight, but other rooms were too dark to be photographed with natural light and the Allen home had no electricity. The Rural Electrification Administration, formed in May 1935, was only just beginning to bring power to remote rural areas. So, Lee turned to flash.

LEE'S FLASH

> He had one flash gun on the camera and he fired that flash gun, and got things in the greatest detail, and enjoyed the detail. And the detail is valuable. And Russ Lee did it, and did it for months on end, indefatigable, too. . . . You know, it's the fact of *revealing* the facts, not putting them down. It's opening them up and saying, "Here, look at me."
>
> *Dorothea Lange, 1964*[24]

Since photography's inception in 1839, capturing the details of dark interiors proved challenging, and efforts to develop portable artificial illumination began shortly after the medium's invention.[25] Early French photographer Nadar used Bunsen batteries and reflectors to photograph the sewers and catacombs of Paris, but the batteries were weak, requiring exposures of up to 18 minutes. Later in the century both Jacob Riis and Lewis Hine used magnesium powder, which was

hazardous because the flash came from an explosion (thus its common name of exploding flash powder). In addition, the harsh white light created severe tonal contrasts, exaggerating every blemish in the scene. Flash bulbs, invented in Germany in 1925, allowed photographers to work more safely inside, though these burgeoning technologies were cumbersome and could blur the image or illuminate only the foreground.

A revolutionary development appeared in 1930, which made much of Lee's signature flash work possible. Synchronized flash, also known then as synchroflash, allowed the photographer to automatically open the shutter and fire the flash bulb at the same instant. In addition, synchroflash offered a greater depth of focus, allowing for finely detailed negatives. Higher shutter speeds could be obtained to capture movement, and the photographer didn't have to manually synchronize the camera and flash.

From his days exploring photography with fellow Woodstock artists Konrad Cramer and Emil Ganso, Lee investigated variables and used different combinations of camera settings, films, filters, and flash outfits with both his 35mm and medium format cameras. Always concerned about the level of detail and what he called "textural rendering" in his photographs, he tested the efficacy of his "exposure data" such as film speed, lamp size, type and speed of shutter, aperture, type of reflector, and distance from lamp to subject, as well as the darkness of objects in the scene, such as clothing or walls.[26]

He worked with flash both on the camera (making the whole outfit a portable flexible unit) and off the camera (called extension flash). With the latter he held his camera in one hand and the flash unit in the other, directing the light in various positions and angles: above, in front, to the side, and below. To modulate or soften the light he might remove the reflector or cover the flash bulb with a handkerchief. On occasion he worked with multiple flash by stringing a relay of bulbs synchronized to illuminate predetermined locations, though he employed this technique sparingly, believing it sometimes made the scene resemble a "stage set."[27]

He experimented with various chemical formulas to develop his film, based on the combinations of flash type, film speed, filter, and camera settings he used. To obtain sharp detail and favorable density in his negatives, he tested many fine grain developers as well as settings in the darkroom equipment he used for printing. By the time Lee joined Stryker's staff, his extensive flash experimentation enabled him to synthesize all the variables into an exemplary method for each photographic situation he encountered.

For example, at the home of Edgar Allen—in one of his first uses of flash for the Historical Section—Lee photographed one of Allen's young daughters in a windowless attic space being used as a bedroom (fig. 22). This gripping photograph reveals an even illumination, a high level of detail, and excellent grada-

22. One of Edgar Allen's children sitting on the bed in the house on his farm. . . . Near Milford, Iowa. . . . December 1936.

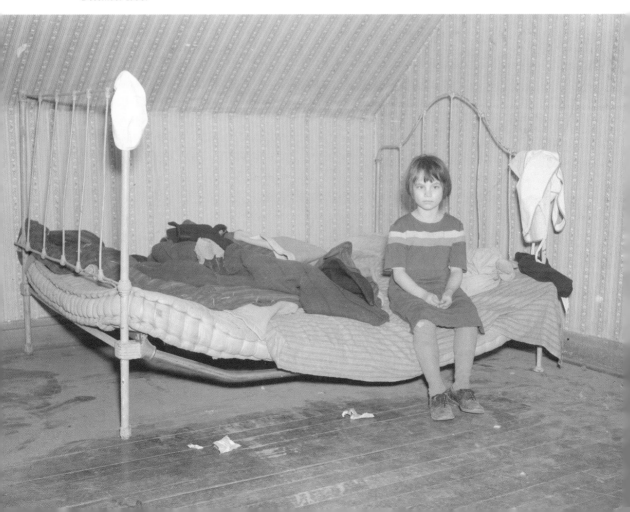

tion of tone, all of which infuse his work with richness, depth, and luminosity. Recalling Sloan's description of Daumier and the way he "used light and shade to design," Lee's photograph demonstrates how he employed flash to articulate depth and render not only the foreground but also the surrounding envelope of space, highlighting dust on the floor, rags and old blankets on the bed, and rippled wallpaper on the gabled ceiling.

While his flash laid bare the economic distress of the Allen household, he presented one of its youngest members with dignity and composure. The girl has positioned herself confidently among the castoff bedding, on a cleared area of the sagging mattress; the frayed hem of her simple dress and the hole in the knee of her stocking match the state of clothing strewn on the bed. Looking fixedly at the camera, her expression intensifies our direct engagement with her. Stryker referred to this image as a "knock-out of a picture" and Lee wrote that it was his favorite of those he had taken up to that point.[28]

Another notable example of Lee's early flash work can be seen at the home of Iowa tenant farmer Earl Pauley, near Smithland (fig. 23). Pauley rented his 185-acre farm from a loan company. When fire claimed the farmhouse, the landlord didn't replace it, so Pauley built a makeshift dwelling, cobbled together from scrap wood and cardboard and built into the side of a hill.

Lee visited the Pauley family on Christmas Eve 1936 and photographed four of the children eating their holiday meal. In the image, the children gather around a warped wooden table, intensely focused on their meager spread of potatoes, cabbage, and pie. Cardboard covers the cracks between the salvaged boards and blocks the winter draft. Rags wrap the ankles of one of the Pauley daughters, her feet illuminated and visible under the table. For lack of chairs, the children stand; a wooden crate boosts the youngest. A chipped porcelain bowl holds the holiday meal, a coffee pot rests atop a wood stove, a cat on the floor focuses on a distraction out of frame. Lee's flash highlighted even the tiniest pieces of information, including the cat's whiskers. Reflections bounce off the bowl of the cream separator, the handle of the broom, the silverware on the table, and the snaps on the lunch box hanging at the front door. Titled *Christmas dinner in home of Earl Pauley*, this

23. *Christmas dinner in home of Earl Pauley. Near Smithland, Iowa. . . . December 1936.*

image masterfully depicts tenancy's adverse effects on life's three basic necessities: food, clothing, and shelter.

Musing on his use of flash, friend and colleague Louise Rosskam said of Lee: "he stuck a flash bulb on the camera and went vroom, you know. And all of a sudden a little shack opened up with every little piece of grime on the wall . . . and everybody could see it."[29] Rosskam's husband, Edwin, a photo editor in the Historical Section, recollected that with flash Lee eliminated "all possible atmosphere, so that the picture becomes a bare, brutal kind of inventory of poverty."[30]

Christmas dinner's use of flashwork demonstrates another aspect of Lee's method: the trust he built with his subjects, accomplished in part by his personal approach. During his visit he took at least ten pictures of the Pauleys and initially used his 35mm Contax, a small, unobtrusive camera that allowed him to gradually connect with family members and acclimate them to his equipment. Within a short time, the Pauleys invited him into their dugout home for a holiday meal, the best they could provide. Once inside, still using his Contax, Lee photographed a baby in a crib using natural light from one of the home's two small windows. After the family started their meal Lee switched to his larger camera and flash outfit.

For *Christmas dinner* Lee relied on his single flash (which he estimated using in about 70 percent of his flash work) in a unit mounted on his camera. He preferred this unit because it was "with [him] at all times and [could] be swung into action at a moment's notice." It was also less intrusive—"portability and quickness of action" were crucial for keeping people at ease so that "one can move around quickly and unobtrusively and get a close-up or a group of people." On his working method and flash technique, Lee wrote:

> Often, when talking to a farmer in his home, I have noticed a particularly natural and true pose into which the farmer or one of his children has gotten. It is a relatively simple matter to focus and take the picture while the subject is not too concerned with the camera. If floodlights or even extension flash had been used in the majority of these cases, the subject would have been too much aware of the camera as an instrument and would have become very much self-conscious.[31]

Christmas dinner attests to the success of his method: the children appear oblivious to his presence. He nearly fades from the scene, no small achievement given the tiny proportions of the room and his large stature—nearly six feet tall.

With this image Lee gives us an event in progress, creating immediacy and lending the photograph a snapshot aesthetic. Yet as with much of his work, he

24. *Soda jerker flipping ice cream into malted milk shakes. Corpus Christi, Texas, February 1939.*

didn't simply record an event: he injected the element of actually experiencing it, a key component of the thirties' documentary approach. Lee's photograph engages the viewer with a carefully chosen perspective—the empty place at the head of the table—allowing us, in the words of cultural historian Warren Susman, "to see, know, and feel the details of life . . . to feel oneself part of some other's experience."[32]

Knowing his photographs would be used to lobby for New Deal reform and humanistic ideals, Lee sought to provide the most persuasive evidence to fight

for those ideals. At Earl Pauley's home, he pictured the children with compassion as he implicated the absentee landlord and the abuses of the tenancy system—and he manipulated the symbolic power of the Christmas meal to do it.

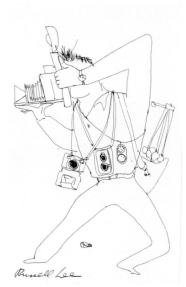

25. Caricature of Russell Lee, likely 1940–45, by Jack Delano.

WITH HIS MASTERY OF FLASH Lee established a new aesthetic for the File. Prior to the fall of 1936, some Historical Section photographers used flash sparingly while others outright shunned it.[33] Yet Lee saw its potential, and with continual experimentation and refinement perfected a visually arresting technique, making a stylistically bold departure from the work of his colleagues.

Flash was new and audacious, not ubiquitous as it is today, and Lee reveled in its newness. At one point in his tenure, in a community in Oklahoma, he noted he was the first person there to ever use it.[34]

Flash also widened Lee's documentary options: in addition to illuminating dark interiors, he employed it to fill in available natural light and on occasion to capture action.[35] For example, he photographed the great showmanship of a soda jerk flipping a scoop of ice cream into his cup; his flash froze the ice cream in midair (fig. 24).

During Lee's Historical Section tenure, he became a recognized authority on this new technology. He wrote articles and gave interviews on his various techniques and special developing methods for normal contrast negatives.[36] He equipped at least three of his cameras with flash outfits, some of which he designed and had custom built at his own expense.[37] Flash became one of his photographic signatures.

In friend and colleague Jack Delano's caricature of Lee, flash is a central element (fig. 25). Lee holds his view camera in his right hand, while his left grips his flashgun. Spare bulbs and a tripod protrude from Lee's shoulder bag while his light meter and two other cameras (Rolleiflex and Contax) hang around his neck. A spent bulb lies on the ground behind him.

INTERSECTION

At the end of December 1936 Lee left Iowa to continue his tenancy assignment in Illinois, where his personal and professional lives directly intersected. There he was able to visit his own tenants at the Manlius township farm, which he had inherited from Eva Werner in 1917.

In contrast to the transient, impoverished tenants depicted in the popular press—and that Lee met along the western edge of Iowa— Martin and Sina Myre thrived as longtime residents of the area. Immigrants from Norway, they settled in LaSalle County in 1911, where a Norwegian community was already flourishing. They began renting the Manlius township farm from Eva Werner in the teens; when she died, Milton Pope kept up the property and built them a one-and-a-half-story clapboard house. Lee took over management of the farm in 1924 and became an active and attentive landlord.[38]

During Lee's January 1937 visit, a windmill on the farm caught his eye (fig. 26). These were a prominent feature of the Midwestern landscape, and he had already photographed two in Iowa, one working, the other broken. It was the "old-style wooden" construction of this windmill that interested him.

Windmills weren't rare in the United States in the 1930s—an estimated 600,000 were in use—but the wooden tower (or derrick) was disappearing, especially in the Midwest.[39] At the turn of the twentieth century, manufacturers had introduced galvanized steel towers, which could last longer with less maintenance. Wooden towers still had advantages, such as the ability to be reinforced in high-wind areas, but were more vulnerable to the elements and eventually rotted away.

26. *Old-style wooden windmill in farmyard of Martin Myre's farm near Seneca, Illinois,* January 1937.

Lee recognized the wooden tower as a vanishing artifact, one that fit with Stryker's documentary vision for a comprehensive pictorial record of America. Channeling his attention to that characteristic iconography, Lee documented the windmill, as a majestic and powerful symbol of rural life. In this instance, he also captured a piece of his own life history, because the windmill, as an immovable structure on his farm, almost certainly belonged to him.

Lee reached into his own past again when he visited 120 acres owned by George Erickson, purchased from Lee eleven years earlier in the Anderson foreclosure.[40] Erickson worked the land but lived on his other farm close by. Lee photographed three scenes around the property, and in his field notebook wrote that the unoccupied house was in "bad shape" and that some people had lived there briefly the previous year.[41]

Lee's field notebook—a studied scientific practice from his days in the Lehigh chemistry lab—was a critical and multipurpose tool in his photographic practice. First, Lee used it to map out his potential subjects. On its pages he listed their names and directions to each farm—typically a string of descriptors of unmarked

and unpaved routes and lanes, such as "road from big filling station—2nd cinder to right, 1st house N. side of road."[42]

His notebook also served him as an aide-mémoire for later writing his captions. After interviewing the people he met and photographed, he then added more specific details to their entries in his notebook. For his tenancy assignment, for example, he included acreage rented, the type of owner, length of tenancy, condition of buildings, quantities of livestock, acreages in pasture and crops, types of crops, and the landlord's percentage.[43] Usually he incorporated this information into his captions.

For us, though, Lee's notebooks serve another function, beyond informing our understanding of his working methods. Like the photographs he made on the Myre and Erickson farms, Lee's field notebooks offer another glimpse into the intertwining of his personal and professional lives. In the same pages where he recorded dismal statistics about his subjects and their hardships as tenants, he also recorded how much money he was earning from the tenancy system on his Midwestern farmland. His notebook indicates that in the fall of 1936, his income from the Manlius Township farm included an Agricultural Adjustment Administration payment (for not farming part of the acreage), and the percentages of crops he received as landlord, which he scribbled on the back page of his notebook. There, Lee wrote that he and his grandfather Charles Werner received a $438 "Gov't check," as well as two hundred bushels oats and eight hundred bushels corn, a common regional crop rotation in the 1930s.[44]

Lee received his income for these crops directly from the local grain elevator —nearby along the I&M Canal—where at harvest time (November) the sale price was distributed between him and his tenants according to their prearranged shares.[45] Though Lee does not appear to have photographed the elevator he and his tenants used in La Salle County, he understood from a personal standpoint the grain elevator's importance in agrarian life, for it was central to many of his own—and his tenants'—financial transactions.

27. *Signs in a cooperative elevator at Ruthven, Iowa, December 1936.*

He did photograph at least two grain elevators during his tenancy assignment, though, including one in Ruthven, Iowa, which he described as very successful and run on a stock share basis (fig. 27).[46] With close attention to documentary detail, Lee crafted a painterly composition, a symbol of financial enterprise, a still life of agricultural society. He transformed a mélange of prosaic detail into a cohesive image of shapes and textures that pull the eye in: the geometric wall treatment, the fanning scroll work on the radio, the visual puzzle of reflections, and the alarm clock hanging from the window frame. The photograph also presents a trio of signs, which Lee valued for their aesthetic qualities and their merits as cultural indicators. With formalist deliberation and socioeconomic alertness, he framed

the handwritten price list on the chalkboard, the Occident Flour advertisement, and, the most significant one here, the sign assuring customers that "There is no substitute for a farmer's elevator."

USE IS WHAT COUNTS

So long as [photographs] are made without trickery, their effectiveness rests with men who know how to use them, to put them together so as to bring out strong and complete statements, and to supplement them with significant words and figures. Use is what counts.

Roy Stryker, 1947[47]

From the start of Lee's assignment, Stryker pressed him for photographs that he could shop around to the various media outlets he'd so strenuously cultivated. Writing of the "great demand" for pictures, Stryker implored, "We will be able to use everything we can get. . . . *The New York Times, Des Moines Register*, and various other papers are hollering now for anything we can get hold of on farm tenancy."[48]

With an eye toward supporting Bankhead-Jones, Stryker sent Lee a shooting script specifying "some tenancy pictures which we need very badly." When the images started to come in, Stryker complimented Lee's "very excellent material" and was confident he would get media interest.[49]

Indeed, the *Des Moines Register* ran nine of Lee's photographs in a May 1937 Sunday edition, accompanying an article on Iowa tenancy. Among the images published were *Family of Glen Cook* (fig. 15), *Hands of Mrs. Ostermeyer* (fig. 17), *Christmas dinner* (fig. 23), and *Daughters of John Scott* (fig. 28).

Such prominent placement marked an achievement for Stryker in his ongoing efforts to broadly circulate Historical Section images. The *Register* was part of the Cowles publishing empire and the Sunday edition had a readership of over 300,000.[50] Unfortunately, the spread ultimately worked *against* the Historical Section.

In an article titled "U.S. Studies Problems of Soil 'Slaves,'" the conservative *Register* questioned the existence of a tenancy problem in Iowa. Although the author, Richard Wilson, admitted that Lee's nine pictures were evidence of some poverty in the state, he accused the RA of sending a photographer to find only the worst examples—an ironic charge, given Lee's concerted efforts at providing a cross-section of tenant society. The article's only admission was couched in a comment that Iowa's tenancy problem (if it did, in fact, have one) was not as bad as the problems in the South.[51] The repudiating stance of Wilson and the *Register* typified many periodicals of the era in ignoring or belittling evidence of an economic depression.

A reverberating problem arose with the caption the *Des Moines Register* ran alongside Lee's photograph *Daughters of John Scott*. The image depicts a teenage girl sitting on a makeshift daybed in her family's shack home while cradling her toddler brother. Mistaking the little boy for a girl, Lee wrote his official caption as *Daughters of John Scott, hired man near Ringgold County, Iowa*, but that's not what appeared in the *Register*.

It wasn't uncommon for Information Division staff (or others) to edit photographer captions. Sometimes these edits simply added plaintive language to amplify a sentiment, while others changed the meaning, sometimes in an untruthful or damaging way.[52] Lee's image of the Scott children is a case in point of the latter: by the time the press print left the Information Division, its caption read, "*Tenant Madonna. The sad expression on this young mother's face tells the whole tragic story of tenantry—low income, lack of decent housing, lack of proper food, lack of clothing and furniture.*" The biblical reference is clear: the Virgin

28. *Daughters of John Scott, hired man near Ringgold County, Iowa, January 1937.*

Mary holds the baby Jesus who suffered for our sins, which the caption writer extended to include the sins of tenancy; the Information Division writer also likely intended to connect the photograph with the File's more famous mother image, from Lange's series on destitute pea pickers in California, a picture widely known as *Migrant Mother*.

When the girl in the photo, Marie Scott, saw the caption erroneously identifying her as a young mother, she was deeply embarrassed. Ringgold County residents contacted the *Register*, and the editors were only too happy to run a follow-up, front-page story accusing Lee of trickery. The *Register* claimed that Lee posed Marie—fifteen years old and just out of the eighth grade—with her two-year-old brother on her lap, and waited until the young girl "got a faraway look in her eye then snapped the camera's shutter." The article continued:

> When Marie saw the picture she blushed. She saw herself labeled in the picture as "tenant Madonna." Her embarrassment growing, Marie read on. She realized why the photographer had asked her to hold her little brother on her lap. He wanted a dramatic picture of a supposedly young mother. She and her little brother were handy. So he had pictured her and brother Max to the world as mother and child.[53]

Various versions of the story spread across the Midwest, appearing in other newspapers, including the *Chicago Daily News* and the *Daily Oklahoman*.[54] The incident created a controversy that rivaled the scandal caused a year earlier by Rothstein's mobile steer skull, putting public attention on the false caption instead of on the very real problem of tenancy.

No one owned up to rewriting Lee's caption. When Assistant Director of Information Arch Mercey wrote Lee in the field apologizing for the mistake, he blamed an anonymous caption writer working for the Information Division.[55] Stryker placed the blame solely on Mercey, whom he referred to as "a little operator, not as astute as he should have been, [who] got me in several dif-

ficulties."[56] The Tenant Madonna contretemps really got under Stryker's skin: he continued to bring it up with friends and colleagues in the years that followed and even alluded to the incident in an interview for an article on documentary photography.[57]

Lee apologized to Marie Scott for bringing shame to her family who had so kindly opened their home to him.[58] Mercey wrote to the *Register* and explained "where and how the mistake was made, and absolving [Lee] of carelessness and of any intention of 'trickery.'"[59] But the newspaper had their story and they stuck to it: a thorough search recovered no retraction or correction by the *Register* exonerating Lee of the deception the paper alleged.

AS AN UPPER-MIDDLE-CLASS MAN picturing the rural poor, Lee created a complex relationship with his subjects. Some scholars have criticized documentary pursuits for this reason, arguing that through the photographic act the subject is doubly victimized, first by economic circumstances and then by the photographer.[60] By this logic, all social documentary photography is inherently exploitative, since the photographer is necessarily part of a more privileged culture. But to categorically denounce or dismiss documentary photography because of its inequality implies that no one can depict a person less fortunate with a goal of social improvement or awareness.[61]

Lee's situation was further complicated by his financial interest in the very system he set out to document, which naturally raises impossible questions of objectivity and social ethics. For Lee, tenancy was both a viable mechanism to maintain land he couldn't sell and a system that provided a source of income, yet his photographic coverage shows he also viewed it as a source of system abuse in need of regulation and improvement. Therefore, like most of Stryker's staff, he used his position as a government photographer to try to effect social change.

Given the *Register*'s repeated accusations and eagerness to discredit Lee, there

is no doubt the paper would have worked even harder to question his integrity had his connection to tenancy been known. Little wonder then why Lee seemed to have concealed this fact.

CAREFUL EXAMINATION OF the Stryker-Lee correspondence reveals Stryker knew nothing of Lee's farms and tenants when he sent Lee to cover tenant farming in the fall of 1936. With tenancy such a topical issue portrayed so negatively in the press, along with the volume of RA critics on Capitol Hill and in the media, plus Stryker's constant fears of budget cuts and the sting of Rothstein's skull incident so fresh, it's debatable whether Stryker would have even hired Lee if he had known.

Stryker did eventually learn of Lee's farms and tenants—evidence strongly suggests Lee disclosed this information himself, sometime in mid-to-late 1937.[62] Lee remained guarded with his other colleagues, though, and most never knew of his tenants or farms.[63]

In the end, his tenancy assignment served its original purpose, to provide effective documentation and publicity for Bankhead-Jones. Three of his photographs appeared in the 108-page *Farm Tenancy: Report of the President's Committee* (1937). Through this report the Committee outlined the many problems of the tenancy system and recommended detailed and "specific measures for increasing farm security in the United States."[64]

Notably, the Committee reported, "there are many tenants whose way of life is not more precarious or economically lower than . . . the great majority of owner-farmers—some tenants indeed have an advantage over owners burdened with debt."[65] To show these "good tenure conditions" were attainable, the Committee used one of Lee's more positive photographs as evidence: an improved barn and silo on the H. H. Tripp farm, rented on a crop share lease, near Dickens, Iowa (fig. 29).

The report proved to be a successful component in the legislative campaign:

29. Barn and silo on H. H. Tripp farm near Dickens, Iowa. . . . December 1936.

Congress passed the Bankhead-Jones Farm Tenant Act in July 1937 and the RA was renamed the Farm Security Administration (FSA) in September.

Before Congress passed Bankhead-Jones, though, Stryker lost a formidable ally when Tugwell resigned in December 1936. Tugwell gave personal reasons for leaving, though rumors circulated about feuds within the Department of Agriculture, about his "seemingly indiscreet statements in the recent political campaign," and his longtime role as "whipping boy" for New Deal programs. Years later Tugwell hinted it was really Roosevelt who wanted him to step down.[66] But before he left, Tugwell safeguarded the future of his agency, in a move his biographer

called "astonishing." After announcing his resignation, without first speaking to Secretary Wallace, Tugwell told reporters that Will Alexander would replace him. Alexander's biographers remarked that "no one [but Tugwell] would have had the sheer presumption and foresight to announce, without consulting the Secretary of Agriculture the man who would be his successor."[67] Tugwell won out: the beloved "Dr. Will" became the new administrator and set an equally progressive path for the agency.

Lee wrapped up his tenancy assignment in March 1937. All told, he made an immense series of at least 850 interconnected photographs.[68] Some became the most reproduced pictures of his career.

Not interested in making singular, iconic works of art, Lee regarded these individual photographs as part of a larger whole, a visual schema discernible through the lens of his methodology. Stryker's colleague Romana Javitz, at the New York Public Library Picture Collection, expressed it best when she reflected that every Lee picture is "one word of a sentence."[69]

In harmony with Stryker's pictorial sourcebook-like vision of the File, Lee favored a comprehensive documentation and envisioned the viewer would read his images together. The multilayered methodology he developed during this first assignment charted his approach to all that followed.

1937

The Land in Ruins

Out of the long list of nature's gifts to man, none is perhaps so utterly essential to human life as soil. . . . Under many conditions, however, it is the most unstable of all major natural resources.

Hugh Hammond Bennett[1]

T HE 1930S WAS an era of tremendous soil loss, resulting from adverse climatic conditions and decades of reckless decisions, which led to improper cultivation, overgrazing, exploitative lumbering, and inadequate flood controls. By mid-decade soil erosion had destroyed more than a billion acres of agricultural land; water erosion took an additional 680 million.[2] Towns and farms washed away in record floods, forests wasted away at the hands of logging companies, and topsoil on former grasslands blew away in catastrophic dust storms.

In an attempt to thwart further catastrophe, President Roosevelt created the Soil Erosion Service (SES) in 1933 as a temporary agency within the Interior Department. On Tugwell's recommendation he selected Hugh Hammond Bennett as its first director. Colorful and outspoken, "Big Hugh" had been a true

champion of conservation since joining the Bureau of Soils in 1903. With lectures and articles, he advocated crop rotation, pasture improvement, reforestation, wildlife enhancement, and—most importantly—the use of land according to its potential.

Under Bennett's leadership, the SES utilized labor provided by federal job programs including the Civilian Conservation Corps (CCC) and the Works Progress Administration (WPA) to teach farmers how to reduce erosion by using conservation techniques such as terracing and contour plowing. In 1935, with Tugwell's facilitation, the organization was transferred to the Department of Agriculture, where it was renamed Soil Conservation Service (SCS) and continued to utilize CCC labor.[3] By the end of its first year, SCS operated 147 demonstration projects, 48 soil conservation nurseries, 23 experiment stations, and 454 CCC camps.[4]

The success of the RA—and later FSA—depended on wise soil practices. From the outset, Tugwell endorsed land-use planning, farmer resettlement, and the massive retirement of land. In 1937, his successor, Will Alexander, signed a memo of understanding with Bennett for cooperation between their two agencies.[5] Reflecting the common goal shared by both agencies of protecting the nation's soil, Lee spent most of 1937 documenting widespread land misuse. Like his other FSA assignments, this required physical endurance and a willingness to face difficult travel conditions—from going into a potential typhoid area to breathing in pulverized soil during a dust storm.

Lee began the year by documenting flood areas in southern Illinois, eastern Missouri, and western Indiana. Mid-year he documented lands stripped by exploitative lumbering practices in Michigan, Wisconsin, and Minnesota. At the end of 1937 he traveled to Montana, Wyoming, and the Dakotas where he pictured drought and wind erosion in the Northern Great Plains.

Together, his photographs form a complex narrative, showing what people did to the land and what the land did to the people.

The damage inflicted by the 1937 Ohio River flood surpassed all previously recorded floods. With heavy rains, rapid winter thaw, and lack of adequate flood controls, devastation stretched from Pittsburgh, Pennsylvania, to Cairo, Illinois.

As the water levels rose along the Ohio, Lee was working on his tenancy assignment not far away in north central Illinois. When he learned of the flood, he made a mad rush to the area, and got a series of typhoid and para-typhoid shots, which he told Stryker were "absolutely necessary . . . so that one may go [in] . . . after the flood waters subside. The authorities are very strict about this."[6]

Lee arrived in a disaster zone overflowing with equipment and emergency personnel including law enforcement, Red Cross, WPA, and CCC members. Railroad companies sent supplies, East Coast fishermen sent small boats for rescue efforts, and sympathetic citizens worldwide sent money and essentials.[7]

Also descending on the region were those, like Lee, who aimed to record the disaster. Reporters, photojournalists, wire service photographers, and filmmakers all came, including Pare Lorentz who shot footage for his documentary short *The River*, which, like his earlier work *The Plow That Broke the Plains* (1936), was commissioned by the RA.

Stryker told Lee not to attempt photographing the flood at its maximum because the "news people cover these probably much better than we would have the time." He continued, "The important thing will be the aftermath pictures. . . . You would have to show some way in your photographs that the land which was now in ruins had been . . . a prosperous farm."[8]

According to photo editor Edwin Rosskam, Stryker believed magazines and newspapers covered an event, while the Historical Section photographed a condition.[9] In the case of the Ohio River Valley, that "condition" included the devastation of 400,000 acres—more than half the region's agricultural lands—onto which was deposited 47 million tons of soil material.[10]

Lee looked for flood-damaged homesteads and what he called "remains of formerly fine buildings, fine equipment, furniture."[11] In Indiana he found an organ

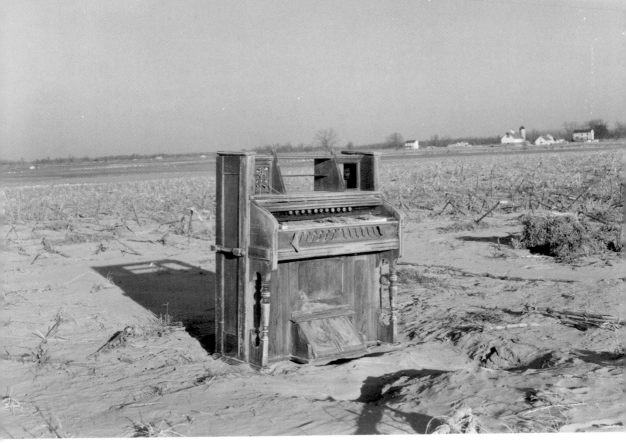

30. *An organ deposited by the flood on a farm near Mount Vernon, Indiana, February 1937.*

stranded in an open cornfield, both ruined (fig. 30). Lee's image speaks to the power of the floodwaters that transported this heavy instrument across the field, and its delicate details, bathed in bright sunshine, suggest the prosperous home where it originated. Remnants of the previous year's crop remind the viewer of the field's former productivity and the hard road of recovery ahead.

The scene is a bizarre one. Photographer and critic Edward Steichen later selected Lee's image for a special FSA spread in *U.S. Camera*, calling it "a grinning gargoyle," and proclaiming: "This photograph makes any cockeyed Dada picture seem like a blooming Christmas card in comparison."[12]

Lee photographed other catastrophic damage: washed away roads, outbuildings twisted and torn from their foundations, upside-down houses, overturned

wagons, abandoned cars up to their axles in mud, furniture sitting in inches of sediment, and people shoveling silt and debris from homes. He also pictured land-use projects for erosion prevention, including tree planting and dam and spill-way construction.

He traveled along in the flood's wake, as far west as Scott County, Missouri, where the Ohio merges with the Mississippi. There he documented displaced people, including a flood refugee in a schoolhouse at Sikeston (fig. 31). Lee's raw portrait conveys feelings of uncertainty, despondency, and fear—the human consequences of a natural disaster.

A highlight of his assignment came in March, when Doris joined him in the field for about ten days. Lee hadn't seen her in the five months since he left New York and wrote to Stryker: "It certainly is good to see her again."[13]

31. *Woman flood refugee in schoolhouse at Sikeston, Missouri, January 1937.*

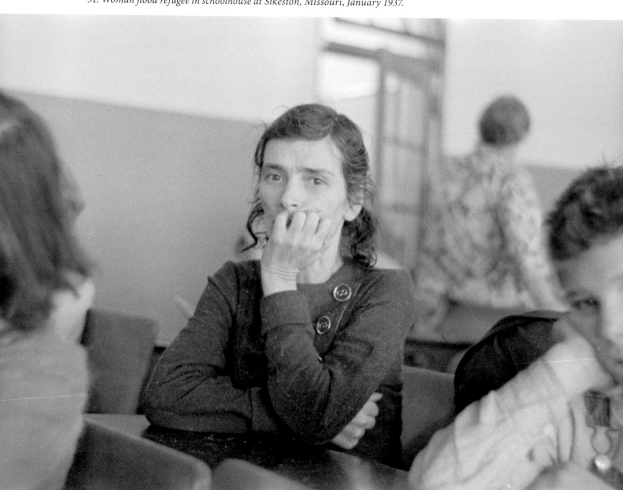

Aside from his wife's few visits, and one from Stryker, Lee traveled alone for his first two years with the FSA. Some photographers found the experience isolating and lonely,[14] but if Lee did, he never expressed it in any existing interviews or letters. Like the others, he stayed connected to Washington through a lively correspondence with Stryker. Mostly, this was through letters, though on occasion they corresponded about urgent matters through costlier telegrams and phone calls. For Stryker, the correspondence was a personal exchange: Lee (and the other photographers) wrote to him at his home so he could read the letters at night after work. Lee received his mail in the field through careful coordination: he periodically noted his travel plans—where he'd be for the next ten days or so—and Stryker would send letters (and supplies) ahead to the next town on Lee's itinerary, care of General Delivery, where Lee would call for it.

Lee later remembered these missives fondly, remarking that Stryker "always put suggestions in his letters . . . which would be ten, twelve hand-written pages, something like that." He recollected he "might get one a week, or every ten days . . . [with Stryker's] observations about the pictures that [he] had been taking" or that the other photographers had taken or commented on.[15]

Stryker also cultivated a sense of camaraderie with newsy bulletins called "Gossip Sheets" and "Weekly Letters," which he sent to everyone in the field. These breezy dispatches shared information about activities in the office and what each photographer was doing. Lee reflected, "It was very valuable to note these, and just passing all this information down. We gleaned from [Stryker's letters and bulletins] new things and felt quite a part of this whole, of the group, even though we seldom got together. This [was] a very, very good device that maintained the group feeling."[16]

Being on the road agreed with Lee. "My life really was only work," he recalled decades later. "And especially those early days because I sure wanted to prove myself and be retained on that job because it was exactly what I wanted to do."[17]

WHAT THE EMPIRE BUILDERS LEFT BEHIND:
THE GREAT LAKES REGION

By the time Lee arrived with his camera, the Great Lakes States were still reeling from the logging boom of the late nineteenth century. As lumber barons aggressively pushed into remote and untapped timberlands, they depleted the forests, leaving in their wake a wasteland of slashings and burned-over stumps known as "cutover."[18]

After stripping the land, some companies abandoned their cutover parcels, which reverted to the government for taxes; others squeezed out more profit by selling the parcels as "farmland." The soil was ill-suited to agriculture, forcing would-be yeoman farmers to augment their income with jobs in the area's mines and lumber industries. The availability of "off-farm" work vanished in the 1920s, leaving farmers without cash resources to operate. With widespread unemployment and resulting tax delinquency the region's economy plummeted. Local governments could no longer provide needed services or infrastructures such as sufficient schools and navigable roads.

By the 1930s, New Deal programs concentrated on recovery of both the land and the people. In Wisconsin, for example, the CCC and the State Conservation Commission began reforestation work and the RA resettled many of the farmers elsewhere. By early 1935, nearly 40 percent of all rural families in Michigan and Wisconsin were on relief.[19]

Stryker first mentioned the cutover to Lee in December 1936, writing that it "interests the Land Utilization people very much. The human problems up there are very much tied up with the land." He continued: "I will start work on it to see if I can arrange a photographic campaign for you up there. It will be very cold and snowy, but I believe that the winter pictures showing the problems of that group should be especially worthwhile."[20] Lee readily accepted the assignment, to which

32. *Quarters of the foreman of the logging camp. Forest County, Wisconsin, April 1937.*

Stryker responded: "I am glad that you are enthusiastic about the trip into Wisconsin and Minnesota. It takes a hardy soul to face that."[21]

Working together with the Forest Service to locate destroyed timberlands and stranded communities, the two men planned, in Stryker's words, "a series of pictures which will portray the people left behind after the empire builders have taken the forests, the ore and the topsoil . . . the remnants after [they] have finished."[22]

To that end, Lee embarked on a complete cutover documentation, from soup to nuts, focusing on what he termed the "destitution directly traceable to the land and ruthless cutting of timber."[23] He photographed desperate farm families and their last-ditch struggles to clear and cultivate forestland; Resettlement projects established to relocate them; and forest depletion and land exploitation by logging companies in the vast pineries of Michigan, Wisconsin, and Minnesota.

Lee described the ongoing cycle:

> These logging companies leave the land in horrible shape. No attempt is made to remove the slashings, peelings and dead-falls and consequently there is a constant supply of tinder to spread any fire. The logging companies usually sell the land they have cut-over to individuals who cut up what is left for firewood. After that, the land is usually offered for sale as "farm" land.[24]

He found such a sales pitch on the outskirts of Iron River, near the Michigan-Wisconsin border (fig. 33). Highlighting the disparity between promise and reality—a motif in his FSA work—Lee's image shows a "Farmland for Sale" notice staked in a marsh, stumps and other timber refuse littering the ground. The advertisement sits stranded, marooned in a swamp, like the farmers who fell prey to the cutover ruse.

Similar themes of abandonment permeate Lee's cutover series: deserted farmsteads, ditched cars, stranded baby buggies, and isolated cemeteries. Among the families who stuck it out, Lee found widespread destitution and dispiritedness. He visited some of the cutover farmers, known as "shackers," and reported most were

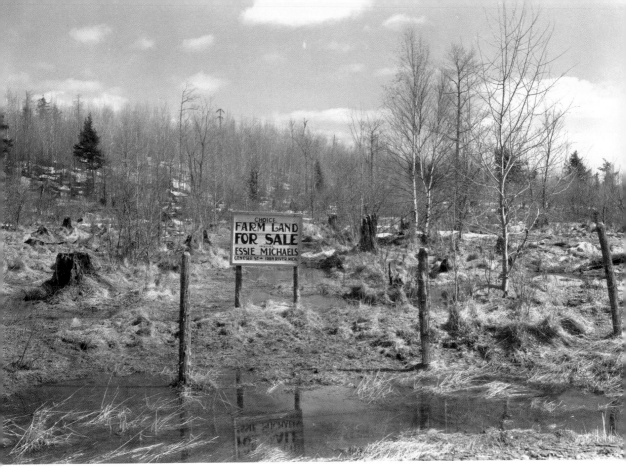

33. Signboard on land near Iron River, Michigan, April 1937.

"on WPA" (relief) suffering malnutrition and poor living conditions. He wrote Stryker that "the hardships of clearing this land of brush and stumps" were "tremendous" and resulted in "gradual demoralization."[25]

Many farmers, unable to purchase manufactured goods, repurposed what they had. Lee admired their ingenuity and pictured some of their creations—such as a kitchen cabinet fashioned from an old kerosene stove—as well as salvaged logs transformed into outhouses, water tanks, a butter churn, a swing set, and a teeter totter.

In May, Lee got another welcome field visit, this time from Stryker, who met him in Duluth; the two traveled together for about a week. Stryker chose Minne-

sota because he wanted to head up to the Little Fork River near the Canadian border and see "the last big log drive," an event harkening back to the region's lumber boom.[26] He suggested Lee's coverage of the log drive could piggyback on the anticipated success of Lorentz's upcoming film *The River*, expected to be as widely seen as *The Plow That Broke the Plains*.

Stryker's trip to the field helped Lee and his work in several significant ways. First, Stryker brought along a batch of enlargements, the first Lee had seen since starting the previous fall. Like his colleagues, Lee had been developing his negatives in the field (usually in his hotel bathroom) and mailing them to Washington. Under typical circumstances, he would have been receiving by return mail regular shipments of what were called "first prints" for his review, but the lab had been swamped that fall and winter. Therefore, the only way Lee had been able to view his work between November 1936 and the spring of 1937 was to inspect his processed film prior to shipping it off. He later recalled: "I'd look at the negatives with a magnifying glass to see that everything was sharp and then I'd try to look at the expression on the people's faces: were the eyes open? Were they closed? . . . I'd get some idea. So, I just kept working. Stryker said they were okay."[27]

Second, Stryker's field visit gave the two men a unique opportunity to discuss Lee's work in person, a boon since they usually exchanged thoughts via written correspondence. Lee's letters often detailed strengths and shortcomings of his assignments and gaps in his coverage, while Stryker dished out pictorial and technical compliments and criticisms, along with his editing decisions.[28]

In the early years, Stryker's editorial practices were draconian and destructive. He employed two different procedures for rejecting negatives. When he rejected or "killed" a 35mm negative—usually part of a five-frame strip—he punched a hole in any frame he considered unworthy of printing if the strip contained other frames he wanted to keep. Understandably, this editorial method prompted objection from photographers who saw it as defacing their work. In the decades since, these surviving hole-punched negatives have attracted significant attention in both scholarly works and popular media outlets.[29]

But sheet film was something altogether different. Since these negatives (medium- and large-format, ranging in size from 2¼ x 2¼ to 8 x 10 inches) were individual sheets, not physically connected to other frames, Stryker simply discarded much of what he rejected, a fact overshadowed by his hole-punch method for 35mm. Examination of film and caption records shows that during Lee's first six months on the job Stryker tossed out at least 21 percent of his sheet negatives.[30]

Stryker was up front about throwing away rejected negatives. One history of the FSA suggests he returned killed sheet film to the photographers, but most were frequently in the field and not in a position to keep returned film.[31] Eventually, he modified his editorial procedures and increased photographers' involvement; he stopped his hole punching, though he continued to throw out some rejected sheet film.[32]

Along with their editorial discussions, Stryker's 1937 field visit allowed him and Lee to talk about upcoming opportunities and map out future projects. As they eased their way north to the Little Fork River, they explored rural areas along the way, driving all day, taking their time, and "wandering around the countryside." Whenever they got to a small town, Stryker liked to survey it, especially at night, by walking up and down the streets and looking in store windows. Calling his boss "a marvelous observer," Lee remembered Stryker loved to "comment about what's in this window here, what does it mean about this present time."[33]

Lee, too, had an admiration for windows. A few in Iowa had caught his eye in 1936, and he documented dozens more during his FSA tenure. Many of these images evoke Atget's photographs of Parisian shop windows. But whereas Atget focused on his adopted city, Lee worked on a broader canvas, a sprawling nation. Lee valued the store window as a means for observing and studying a diversity of communities, and his serial presentations of shop displays are comparative studies of local economies across the country. For Lee, the store window "was very indicative of the way of life in [a] particular community. Actually, it was a window to the community."[34]

Like his domestic interior vignettes, Lee's store window photographs are con-

34. *Store window in farmer's marketing section of Muskogee, Oklahoma, June 1939.*

templative, multilayered compositions. For example, in the farmer's marketing section of Muskogee, Oklahoma, he found the window of a used clothing store (fig. 34). Paint peels from the wooden frame while rumpled and worn suits hang like carcasses in the display area. Lee could have minimized the reflections, but instead emphasized them, inviting the viewer to see what's forward behind the glass and what's backward behind the photographer, to another image plane where cars are parked in front of the store and across the street. A handwritten sign taped inside the glass appeals to its customers interested in acquiring life's basics at a discount: "Used Clothing, shoes for sale, why pay more." Conversely, in Washington, D.C., a few doors down from the Historical Section office, he photographed a beauty salon that suggests a more upscale clientele, able to afford a shampoo and finger wave for $1.25, or electrolysis, or Rapidol, "The Aristocrat" Hair Coloring Rinse (fig. 35).

35. Store window, Connecticut Avenue, Washington, D.C., January 1938.

Sometimes Lee included a store window's surroundings, such as in Cook, Minnesota (fig. 36). Here he found milk cans stacked below, and a wind-blown awning above, which in another view reveals its promise of "Cash for Cream."

As Stryker and Lee inched along the Minnesota countryside, they looked through countless store windows together, talking about them as reflections of the community, the region, and the times. They then made their way to the "last big log drive" on the Little Fork River.

On this excursion, Stryker witnessed Lee's intrepid nature, and the multiple field challenges he faced, both physical and interpersonal. For instance, on a remote logging access road Lee's car sank deep into the mud and he persuaded one of the lumberjacks to tow him out, a scene which Stryker caught with his Leica (fig. 37). In the image, Lee, with a chain on his front bumper and a grin on his face, steers his car while the continuous track tractor pulls him from the sludge.

36. *Milk cans and store, Cook, Minnesota, August 1937.*

37. Russell Lee being pulled out of mud by tractor, near Littlefork, Minnesota, May 1937, photograph by Roy Stryker. (Originally uncaptioned.)

At this point in his career, Lee was used to bumpy travel conditions. Most roads he took were narrow, unpaved, usually composed of dirt; at best they were covered with an aggregate such as gravel or cinder. Sometimes Lee's fieldwork was delayed because of rough terrain or bad conditions, such as the "300 miles of icy and snow packed roads" he encountered on his way to Illinois in November 1936.[35] On occasion car repairs sidelined him for as much as a week. By the end of December 1936, his car needed critical service, for damage done by dirt roads in Iowa, rendered nearly impassible from frost heaves.[36]

While most photographers encountered car trouble, not all had Lee's financial security; some were stranded in the field until they received money for repairs. For example, John Vachon wrote his wife about his difficulties paying for service as he made his way west: in Ohio, he needed a new fan belt and drive shaft repairs, and in Missouri, he had two flat tires, no heater, and a car window that wouldn't close. He described the frigid temperatures and his search for a place where he could have a heater installed using a gas card, rather than paying $16.85 cash.[37] In contrast, Lee purchased a new car nearly every year. A month after Stryker photographed him stuck in the muddy logging road, Lee traded in that car for a new one.

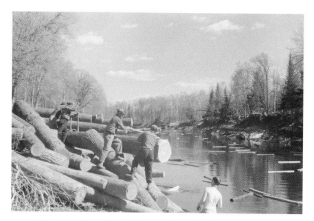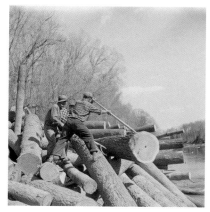

38a–b. [a] Russell Lee photographing lumberjacks using peaveys to remove logs from banks of Little Fork River, near Littlefork, Minnesota, May 1937, photograph by Roy Stryker. (Originally uncaptioned.) [b] Lee's resulting photograph.

When Lee and Stryker reached the Little Fork riverbank, they found lumberjacks using peaveys to push their logs into the water (fig. 38b). Determined to get close to the action, Lee stripped to his underwear and jumped in the water for his shot, a sight that amused Stryker, who snapped a picture (fig. 38a).[38]

Along with these kinds of physical challenges, Stryker got to see Lee's remarkable talent for developing a rapport with people, especially those reluctant to be photographed. Stryker recalled an incident near Black River Falls where he and Lee visited the homestead of destitute cutover farmers named Hale. The family's hardscrabble life was evident from their house, which they built themselves from logs, mud, scrap wood, and an outlay of $3.00. Scattered around the yard were used tires, a bed frame, upturned empty wooden crates, and old tools.

Lee approached the matriarch, whom Stryker recalled as a "very nice-looking little old lady with her hair done in a little top knot" and asked if he could take her picture. Mrs. Hale "bristled" and asked why. Lee explained he was with the government, but she refused. Lee replied, "Well, now look. There's a lot of people think that you represent a bunch of lazy good-for-nothings. We don't think so. We'd like to tell them a little bit more about who you are, what your problems are." According to Stryker, Lee "got her intrigued and she started to talk to him."[39] They

stayed the afternoon, she invited them to lunch, and wanted them to come back and meet some of her neighbors.

Lee made about a dozen pictures of the family and their home, including one of Mrs. Hale and her oldest son at the corner of their cabin (fig. 39). Stryker, who's visible on the left-hand side of the frame, later remarked, "It was one of the most

39. Mrs. Hale and her oldest son in front of their home near Black River Falls, Wisconsin. . . . May 1937.

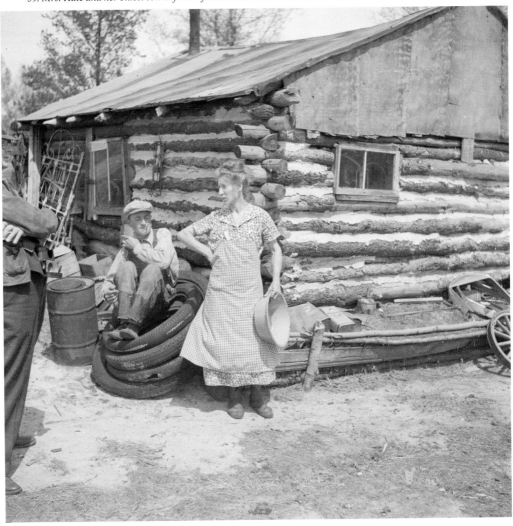

interesting experiences I had while I was in this job, one of my few experiences out in the field." Stryker termed it an "illustration of what I think was probably pretty prevalent all the way through. The photographer ran into opposition. He soon conquered it by his honesty, his forthrightness, sympathy, and a certain warmth."[40]

PAYDAY IN A LUMBER TOWN: CRAIGVILLE, MINNESOTA

Craig was known to be a hell-raising place, [and] that's where the boys went when that was what they wanted to raise.

Benhart Rajala, 1991[41]

In his coverage of the logging industry and cutover lands, Lee showed particular interest in the life of the old-time lumberjack who—like the cowboy—had become an American archetype, a symbol of an era that by 1937 had largely faded away.

Stryker pressed Lee for pictures of two notorious lumber towns: International Falls, Minnesota and Hurley, Wisconsin. Of the latter Stryker said, "If the town is as tough as is represented, you and the camera may get beaten up if you try to take pictures."[42] Lee didn't make it to either spot but found a lumber town in the Big Fork River Valley, one with an equally lurid reputation.

Known locally as Craig (named for an area logging foreman), Craigville, Minnesota, reached its heyday in the first two decades of the twentieth century. Lining the town's single street were about thirty buildings, nearly all of them saloons. There were a few general stores, a depot, Finn baths, and two hotels with "Good Eating Restaurants." During its boom, Craigville had a sawmill, lumber camp, post office, and railroad station, and hosted up to five thousand lumberjacks. Along with taverns, Craigville offered ample illegal entertainment, including houses of prostitution and gambling, and—during Prohibition—blind pigs, a low-end version of a speakeasy. Bartenders kept order with wooden clubs and black-jacks, which were always within easy reach under the bar. The town overflowed with tales of drunken lumberjacks being robbed and/or murdered (sometimes by

the bartenders); many of the victims were rolled down the hill to the frozen Big Fork River and pushed through a hole in the ice.[43]

By the time Lee visited in the fall of 1937, Craigville straddled its past as a boomtown and its future as a ghost town. The logging camp and sawmill were long gone, but the settlement maintained its rough reputation and was still in the business of supplying and entertaining lumberjacks from nearby Effie. A handful of buildings remained, most of them saloons.

To capture the rowdy behavior identified with the American lumberjack, Lee planned to photograph when he knew wallets and bars would be full, for a series he called "Payday in a Lumber Town."[44] He arrived a day early—as he typically did—to scope out the scene. By the time he pulled out his camera, locals paid him little attention. This time, though, he was nervous to be alone; he stopped in one of the bars for a few drinks, to boost his confidence and to blend in.[45]

The following day—payday—he found the spirited and lively Saturday night he'd been hoping for, and in one saloon, captured a particularly engaging tableau (fig. 40). At first glance *Saturday night in a saloon* appears to be a congenial "folksy" image and has been put to that use in the decades since its creation.

At once raucous and contemplative, Lee's photograph captures the spirit of Saturday night release. It depicts four people sitting along the establishment's well-polished wooden bar. As he did in *Christmas dinner* (fig. 23), Lee chose the vantage point of someone experiencing the event—in this case the bartender. The man on the right, by all appearances an aging lumberjack, holds a shot of whiskey to his lips. His chaser—a short beer or glass of water—stands at the ready. A rakish younger lumberjack (clad in telltale woolen plaid) and his attractive female companion watch the older man drink his shot. With a beer in his right hand, he smiles and raises his glass in a toast, suggesting his participation in Lee's image making.

Both men in the photograph embody characteristics historian Bergit Anderson attributed to the lumberjack: "Strength, endurance, valiance, skill with the axe, good humor and an unlimited capacity for consuming liquor."[46] By depicting two generations, Lee encapsulated Craigville's past as a vibrant and spirited boomtown and its imminent future as a crumbling, decaying ghost town.

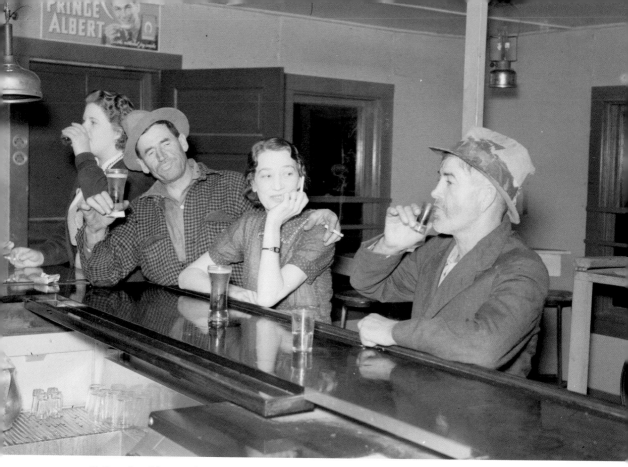

40. *Saturday night in a saloon. Craigville, Minnesota, September 1937.*

This image served dual functions for the FSA. For the Historical Section it filled the bill for Stryker's *American Background*. For the agency's design department, however, it effectively illustrated an exhibit on sexually transmitted diseases. In an alternate view, Lee identified the two women as "attendants" and the FSA used *Saturday night in a saloon* in a 1940 Public Health Service exhibit on syphilis.[47]

Thus, other Farm Security offices had no qualms about reshaping the meaning of File photographs. A May 1941 FSA exhibit utilized another of Lee's Craigville images, this one a young lumberjack with a bandaged head and right eye. Though the lumberjack had been beaten up and "rolled" in a bar, his injury served as a cautionary tale for hand tool safety, on a panel captioned: "A man is about to lose

41a–b. [a] *Lumberjack with bandaged head after being beaten up and "rolled" in a saloon on Saturday night in Craigville, Minnesota, September 1937.* [b] *Panel from safety exhibit, May 1941.*

an eye / Hand tools / a great aid when used properly can become a ruthless enemy when used carelessly" (figs. 41a–b).

DUST: THE NORTHERN GREAT PLAINS

> The rural population [of North Dakota]—and believe me it's mostly rural—may be divided into two parts: those who had a crop this year and those who had none. Those who had a crop will tell you they aren't much better off than those who had none.
>
> *Lorena Hickock to Harry L. Hopkins, November 6, 1933*[48]

On May 12, 1934, an estimated 350 million tons of the country's soil blew away, disappearing from the Midwest and reappearing along the East Coast. Chicago

received four pounds for every resident, and Washington, D.C., Boston, and New York City burned street lamps in the middle of the day because the air was gray with dust.[49] The soil continued on for hundreds of miles over the Atlantic Ocean, landing on ship decks. The worst storm occurred almost a year later, on April 14, 1935, a day known as Black Sunday. Originating in North Dakota, Black Sunday's dust storm, which stretched from the Great Plains to Texas, blew across the country and carried twice as much dirt as had been removed from the Panama Canal.[50]

Dust storms of the 1930s stemmed from climatic conditions in the Great Plains, coupled with decades of irresponsible agricultural practices. With the region's low annual precipitation, recurring drought, and high wind velocities, moisture in the soil evaporated, especially in bare fields and overgrazed areas. Homesteaders failed to adjust to these conditions when they destroyed the native sod, which held the land in place. An atypical period of heavy precipitation in the 1880s spawned the belief that cultivation actually increased rainfall; "rain follows the plow" became a popular slogan.

Within two or three years of plowing the land, negligible wind erosion occurred, causing small drifts and "dusters," which attracted attention only when the dust clouds became conspicuous. Compounding wind erosion, most of the original settlers on the Great Plains grew cash crops, further weakening the soil.

Those outside the region saw dust storms in newspapers, newsreels, and film shorts such as *The Plow That Broke the Plains* and the WPA's *Rain for the Earth*. Reporters documented the extreme toll exacted by depression, drought, and dust storms, describing scenes of misery and hopelessness. The term "dust bowl" entered America's vernacular in 1935.[51]

Stryker's photographers covered dust storms and drought-related catastrophes through 1935 and 1936. Notably these included Lange's Oklahoma and California migrant series and Rothstein's coverage in Cimarron County, Oklahoma, and the Badlands of South Dakota.

By late fall 1937, dust storms were still occurring regularly. Stryker wanted

more coverage, particularly from their origins in the Northern Great Plains. He wrote Lee: "Your work, I believe, will help us close this particular gap. Arthur's pictures of the dust and its effect on farm buildings and land are very excellent, but we do need . . . more pictures on people, their homes, and their children."[52]

Lee's work in Montana, Wyoming, and the Dakotas reveals the severe impact on farmers and their land. Long shots of barren, treeless farms emphasize the area's remoteness and desolation; bleak landscapes show fields dehydrated, stripped by wind.

Lee made imagery emblematic of the land's unproductiveness: agricultural junkyards full of discarded, idle, and broken machinery; equipment half-buried in drifting dust; threshers, binders, and plows left behind by previous owners; grain elevators sitting empty. Scores of abandoned farmhouses—given up by those who migrated to places of better opportunity—dotted the deserted tracts.

Families that stayed faced hard conditions. Farmers lived in sod houses, mud huts, and tarpaper shacks. Wells had dried up, forcing residents to haul water great distances for themselves and what little livestock they managed to keep alive. Farm animals sheltered in makeshift structures; Lee found barns made of scrap wood, dirt, and piled stones. On one homestead turkeys roosted in an old, half-buried Model T.

Dust was a relentless battle everyone fought. It blew into homes, hair, clothes, eyes, and mouths. Attempting to keep it at bay, people stuffed window and wall crevices with towels and clothing. In Williams County, North Dakota, Lee stepped out into the middle of a dust storm and photographed it overtaking a small barn and three horses (fig. 42).

This was the county where he would spend the majority of his time during the assignment and where he noted there had been no crops for eight years.[53] According-ing to a WPA study, 10 percent of the region's rural population was on relief in 1933; two years later that percentage more than tripled.[54]

To get a handle on the region's complex predicament, Lee, as he typically did, conferred with experts in the field. These included the district supervisor and

42. *Dust storm near Williston, North Dakota, October 1937.*

assistant regional director of the RA; a county nurse in Williston; director of the AAA for the Western states; and an agronomist at North Dakota Agricultural College, who Lee said "probably knows more about agriculture in this state than any other person—from a <u>human</u> as well as a soil standpoint."[55]

Lee studied the interconnected and overlapping problems of dust and drought and the effects it had on the population, particularly children. For example, schools were closing; in one nearby county there were one thousand fewer children attending than the previous year. In Williams County, rural families wanted to send their older children to high school in town but had no money for room, board, clothing, and books. Lee noted that attendance had fallen so sharply that many high schools had six—instead of eleven—players on their football team.[56]

Lee learned Williams County had the highest number of emergency grant clients accepted by the RA in the region and focused his attention on the medical problems and health concerns of residents, writing to Locke, "I'm going to give it all I've got."[57]

In his field notebook, correspondence, and captions, Lee noted the causal factors and ripple effects of some of the region's medical problems. The barren land couldn't sustain vegetable gardens and farmers couldn't keep milk cows, resulting in widespread malnutrition. He reported underweight newborns with rickets, the need for false teeth among young people, and ailments such as weeping eczema, scabies, pneumonia, and tuberculosis (exacerbated by the dust storms), noting there was no money available for medical emergencies, tonsillectomies, dental care, or eyeglasses. Confinement cases depended on the goodwill of doctors to make house calls; even in those situations, homes lacked bed sheets, let alone medical supplies.[58] He interviewed a mother with four children, all of whom she delivered herself. Their beds had no mattresses, only quilts over hard springs.[59]

In another Williams County home, Lee met a young girl with what he described as "a dwarfed arm," which he suspected was due to polio.[60] One of the most poignant photographs from his dust and drought coverage shows the girl, Florence Kramer, riding a makeshift merry-go-round with her two brothers (fig. 43).[61] All activity emanates from the image's central element, a merry-go-round fashioned

43. *Farm children playing on homemade merry-go-round. Williams County, North Dakota, November 1937.*

from a discarded piece of farm equipment: a wagon wheel, which we can now read as a powerful symbol of nineteenth-century westward expansion and traditional agrarian life, the very thing that brought settlers west and enabled them to rip up the protective prairie grass. The stark landscape on which the children play nearly envelops them; it's covered in chaff, stripped by wind and drought. A ravine on the right slowly erodes what's left. Soon the land will literally not support them.

Lee recorded the ordinary play of children with certain tenderness: an alternate view shows the boys are propelling the ride with their feet, smiling as they make the turn and treat their sister to a spin. With her afflicted left arm hanging freely at her side, Florence holds on with her right. She wears two dresses: the outer frock (probably sewn from a floral-patterned feed sack) guards her dark

dress from dirt, or her torso from the cold weather, or both. Her ankle boots, leg wraps, and cloche hat likely constitute the extent of her winter clothing.

Lee often photographed young people by themselves, apart from adults (figs. 16, 22, 23, 28, 50a–b, 65, 71, 77). Here, as in other images, they're at once fragile and resilient, managing to find pleasure even in difficult times. Lee's photograph of the Kramer children reveals his deep understanding of the interrelated problems of America's land in ruins. His yearlong documentation swung from one extreme to another—from flood to drought—emphasizing the man-made catalysts weakening the soil, what Hugh Bennett described as the most unstable but vital of all natural resources.

1938

Creative Limitations

Stryker always had budget problems. His correspondence with photographers reveals constant concerns about money, down to the smallest expense. He urged Lee to be judicious in the number of phone calls he made to the office and chided Rothstein for sending too many telegrams.[1] At one point he confided to Lee, referring to himself in the third person as he often did, "Stryker was busy this morning with the Budget Office, looking for money—that's all I seem to do—hunt money! One damn thing after another."[2]

An air of impermanence hung over the Historical Section. Even with Bankhead-Jones, the FSA faced opponents on Capitol Hill and funding was tenuous at best, fluctuating with each fiscal year. The worst came after an economic decline in late 1937—referred to as the "Roosevelt Recession" and the "depression within the depression"—which severely reduced Stryker's budget.[3] At one point, he could only afford two photographers, Rothstein and Lee.

With an eye to keeping his Section afloat, Stryker worked hard to increase its public profile, forestall future budget cuts, and find other income streams. Thus, he participated in a prominent New York City exhibit, appeased administrators by

sending his photographers on more project work, and hired his staff out to other government agencies. Lee played a critical role in all three strategies.

THE GRAND CENTRAL PALACE EXHIBITION

In December 1937, Lee took a needed five-month break from the field, the longest of his FSA tenure. He split his time between New York City and Washington, visiting Doris at their Union Square apartment and working with Stryker and Section staff in the office and lab. Stryker enjoyed their time together, writing to Locke, "It is a great pleasure to have Russell in here with me. What a grand fellow he is."[4]

During this time, Lee worked with Rothstein and Stryker to select, prepare, and install a group of FSA photographs for the First International Photographic Exposition at New York's Grand Central Palace. A combination photographic print exhibit and trade show, it featured displays by 120 manufacturers and retailers of photographic equipment. It also showcased about three thousand photographs from journalistic, pictorial, and documentary genres, and special exhibits of work by Mathew Brady and Eugène Atget. The print section was under the charge of publisher, author, and Leica promoter Willard Morgan. A champion of the Historical Section, Morgan invited Stryker to exhibit FSA photographs.

44. Roy Stryker (right) and FSA photographers John Vachon, Arthur Rothstein, and Russell Lee (left to right), likely December 1937, photograph by Beaumont Newhall.

Viewing this as an opportunity for advantageous exposure, Stryker eagerly accepted. Despite his budget limitations, he wrote to a colleague he had "rustle[d]

enough money to do a good job," and made enlargements ranging from 11 x 14 to 30 x 40 inches for an exhibit titled "How American People Live."[5] Lee and Rothstein chose about eighty photographs from the File.[6]

The show opened on April 18 and during its six-day run attracted more than 110,000 visitors, an unprecedented number for a photographic exhibition. Special trains brought enthusiasts from Buffalo, Boston, New Haven, Philadelphia, Washington, Pittsburgh, and Chicago.[7] Historical Section photographs had appeared in other art-minded exhibits over the preceding two-and-a-half years—the annual Leica and *U.S. Camera* shows, for example—but those featured only a handful of Section images and had smaller audiences.

The FSA section drew lots of attention. About five hundred visitors filled out comment cards (supplied by Rothstein) with responses that ran the gamut: some dismissed the photographs as "lousy," a "waste of taxpayer's money," and "subversive propaganda," while others found images of poverty in America eye-opening. Many expressed strong support for the exhibit and FSA programs, imploring the government to "do something."[8]

Feedback also focused on aesthetics. One visitor termed the FSA photographs "the best expression of art applied to life," and another observed, "They show that photography with a purpose may not necessarily be lacking in art or interest."[9]

Art world professionals also weighed in. Walter Abell of the Brooklyn Museum called them a "culturally integrated form of art," and Carl Mydans (by 1938 a *Life* photographer) wrote, "Farm Security Administration Exhibit is by far the winner of the show." Berenice Abbott (referring to the pictorialist Oval Table Society) wrote, "Throw out all the oval tables and have a million more photographs like these. Here photography is finding its real medium and expression. More and more power to the Farm Security Administration." Arnold Blanch called the work "The best in the show."[10] Photographer Edward Steichen and art critics Elizabeth McCausland and Rosa Reilly paid similar compliments.[11]

The exhibit did have art-minded detractors. For example, Morgan later recalled that Joseph M. Bing, a well-known pictorial photographer at the time, "threatened to pull out of the exhibition" because Morgan hung the FSA work in

a booth adjacent to his "mostly soft-focus pictures" and Bing could see one of the FSA photographs over the partition. Morgan "smoothed out his feathers" by lowering the FSA image so Bing couldn't see it from his booth, but "even then he kept grumbling about the FSA photos not being worth[y]."[12]

And Walker Evans disparaged the show in general. Just after it opened, Stryker wrote him about the special FSA section, closing his note with, "Will be interested to know what you think of it." Evans replied: "I went to the International Photo exhibit or whatever it's called, and I must say the whole thing is so commercial it made me sick. I was in not much of a mood when I came to see your show. I went to look at camera developments and wasn't prepared anyway."[13]

But Stryker's spirits weren't dampened. For him the show was an undeniable triumph and signaled a growing prestige for his documentary project. He had long sought an art world association and was tickled by endorsements from experts in the field, telling Locke the FSA photographs "went across in a big way." He continued, "Arthur and Russell did a grand job of hanging that set of pictures. It is not exaggerating a bit to [say] that we scooped the show. Even Steichen went to the show in a perfunctory manner and got a surprise when he ran into our section."[14]

To Stryker's delight, the exhibit served as an entrée to art publications and venues throughout the rest of 1938. Steichen curated a special twenty-two-page FSA section in *U.S. Camera* and journalist Rosa Reilly lauded the photographs in a *Popular Photography* article.[15] Stryker also tried for a spread in *Life*, but was unsuccessful, writing to both Rothstein and Locke with sour grapes that the magazine wouldn't publish "any pictures that have any guts to them."[16]

One of Stryker's big wins from the Grand Central Palace exhibition came when the Museum of Modern Art (MoMA) organized a traveling version (fifty photographs) of the show entitled "Documents of America," which circulated to twelve U.S. cities.[17] For Stryker, getting the photographs seen by a broad American audience—especially with the imprimatur of MoMA—was the name of the game.

The show marked a crossroads for the Historical Section and launched a lasting discourse on FSA photographs as works of art. From that point forward the images would no longer be judged on their documentary merit alone; over the

decades their place in the art world would eclipse their original role of recording the country's economic crisis.

The Grand Central Palace exhibit also became a turning point for Lee. His photographs comprised nearly a quarter of the show and highlighted his documentary achievements over the previous eighteen months: tenant farmers in Iowa, flood refugees in Missouri, cutover farm families in Wisconsin, lumberjacks in Minnesota, and drought families in North Dakota. Among his works shown were *Hands of Mrs. Ostermeyer* (fig. 17), *Christmas dinner in home of Earl Pauley* (fig. 23), *Daughters of John Scott* (fig. 28), and *Saturday night in a saloon* (fig. 40).[18]

Lee saw where his work fit in, how effective it was, and the impact its content and aesthetic had on the people who viewed it. The overwhelmingly positive comment cards, the critically favorable reviews, and the show's huge attendance had a validating effect, and visitors singled out his work, more than that of any other FSA photographer in the show.[19]

A MODEL NEW DEAL COMMUNITY:
SOUTHEAST MISSOURI FARMS

After the Grand Central Palace exhibition, Lee was anxious to get back into the field.[20] First on his itinerary was Southeast Missouri Farms, an RA/FSA project that initially drew his attention in February 1937 when he was documenting the Ohio River flood nearby. He told Stryker the project "should be decidedly interesting to cover," then mentioned it again when he came back to Washington at the end of the year.[21] However, Stryker wasn't quick to send Lee there for a few reasons.

First, he just didn't have enough photographers to cover everything. The FSA was a sprawling decentralized agency that administered its multiple programs from twelve regional offices. Smaller offices sprouted up in most states and each one oversaw its own projects. Field personnel expected Stryker's photographers to "check through" when traveling in their area. But with never more than six photographers on staff, it was impossible to cover the scores of projects across the country (fig. 45).

45. Map of FSA projects, 1937–42.

Besides the numbers problem, most regional offices wanted Stryker's team to document "progress from old home to new,"[22] and activities like home management demonstrations and field personnel glad-handing Resettlement clients. Stryker derided these requests and once told Lee a certain regional director wanted photographs of "a few rehabilitated families, some canned fruit, and some mules."[23]

Yet with such precarious funding in 1938, and seeing the need to keep higher-ups happy, he decided documenting Southeast Missouri Farms was a good idea. It had recently attracted Washington's attention, and Stryker wrote to Locke, "the administrative people are anxious for pictures, and I am certainly anxious to capitalize on their enthusiasm."[24]

For Lee, progress pictures weren't so objectionable and he didn't mind making them. Stryker admitted, "there is no one more willing to do project work than you."[25] But others disliked the conventional "before and after" format and sidestepped project assignments whenever they could. Collier remembered some photographers made a point of never going near them, considering the work "a bore."[26] Vachon described his pictures on one project as "pretty much the same old hash—women hanging clothes on the line, children sliding down slides, etc." and later recalled that if he ever did have to do project work, he photographed anything else to enhance the File, including small towns, deserted houses, and building fronts.[27]

Lee shared Vachon's approach and certainly regarded each routine assignment as a gateway to other work. But whereas colleagues covered government projects perfunctorily (or avoided them altogether), Lee embraced them, always looking for intrinsic visual appeal. Indeed, some of his better-known photographs are progress pictures (figs. 60, 62).

Over his six years with the FSA, Lee documented projects in twenty-two states, from Mississippi to Oregon and Vermont to California. Across the country he pictured Resettlement assistance recipients, from feed loan applicants in regional offices to tenant purchase clients at home. He covered water facility programs, land-use projects, and cooperative creameries, along with camps for migratory laborers, CCC crews, and defense workers.

Much of Lee's project work concerned New Deal communities. Though only a third of the agency's programs, these social experiments—like Jersey Home-steads—attracted attention because they were controversial and unpopular, associated with collectivism and socialism, and portrayed in the press as high-cost fiascos. Lee photographed a variety of New Deal communities, from cooperative industrials, garden cities, and greenbelt towns, to forest homesteads, farm communities, and cooperative plantations.

Of the seventeen planned communities he photographed, Southeast Missouri Farms was one of the most significant. In addition to being a personal favorite of Lee's, it was a milestone in construction techniques and a progressive step toward racial parity.

With the go-ahead from Stryker in early 1938, Lee finally made his way to Southeast Missouri Farms—also known as the Sikeston Project, the La Forge Project, and La Forge Farms—in New Madrid County, an area known as the Bootheel on the edge of the Mississippi Delta and Cotton Belt. Though geographically in the Midwest, economically and culturally the region belonged to the South.[28] In 1938 it was one of seven Missouri counties where sharecropping prevailed: two-thirds of the area's 25,000 rural families worked the land for half the crop (or had become day laborers, having lost their sharecropping situation). A host of factors stunted the economy: ruined land, overpopulation, under-education, the boll weevil, and the trickle-down decline in America's share of world markets.[29] Sharecroppers bore the brunt, suffering poor housing, lack of property, inadequate diet, poor health, excessive mobility, and low earnings. The county's average yearly gross income was $400 and $250 for White and Black sharecropping families respectively.[30] Often, the crop yield was not enough to pay off what the family had borrowed (usually from the landlord) over the previous year, thus leaving them in debt at the end of the season. As with tenant farmers, AAA incentives had revitalized the landowner's economic position but worsened the sharecropper's.

RA/FSA field investigators concluded that southeast Missouri sharecroppers lived and worked in a state of "poverty, deprivation, and hopelessness, with but few avenues of escape even for those who keep alive a flickering desire for some-

thing better." Houses were little better than sheds and failed "in every respect to meet the barest standards of comfort, health, and decency. It is a standard of housing so widespread and so far inferior to other parts of the State as to make extremely difficult any comparable measurement."[31]

Diseases plagued the area. Diets consisted of salt pork, corn pone, and dried beans; eggs, butter, milk, fruit, and green vegetables were rare, leading to pellagra, colitis, and malnutrition. Sanitation was primitive: most of the outdoor toilets were close to the sharecropper's water source, so dysentery, hookworm, and other intestinal diseases proliferated. Malaria was also a chronic problem as swamps and ditches offered breeding grounds for mosquitoes and most houses were poorly screened. Typhoid, tuberculosis, and pneumonia occurred at rates far above the state average. With medical care practically nonexistent, death rates (including infant mortality rates) were also greater than the state average, sometimes as much as twenty times higher.[32]

In an attempt to address these interrelated agrarian, social, and economic problems, the RA/FSA built the experimental Southeast Missouri Farms. The agency bought 6,700 acres and a cotton gin for $315,000 and allocated $345,000 more for construction and loans to qualified applicants for livestock, feed, farm machinery, and furniture.[33] The RA/FSA believed the project could serve as a model for the entire Mississippi Delta: if it succeeded, thousands of farmers might adopt the new methods, thereby healing the land and the economy.[34]

In many regards, Southeast Missouri Farms was a typical rural New Deal community: it was in the South, contained about one hundred individual farm units (of between 40 and 100 acres), and followed the agency's established sequence of land purchase and division, housing construction, land improvement, and formation of a cooperative association (which operated the cotton gin and a store).

However, it differed dramatically from other communities in its method of client selection. Normally, after purchasing project land the FSA evicted all tenants and sharecroppers, then required those interested in being a project participant to apply for a farm unit. The agency's stringent selection criteria disqualified many applicants. Families had to be low-income farm owners, tenants, laborers,

or sharecroppers. Among the varying selection criteria were age, health, economic stability, character, and number of children. Married couples with no more than five or six children were preferred. The head of the family had to be between the ages of twenty-one and fifty, free from disease and physical disabilities, and pass a medical examination before final acceptance. References were required. All candidates had to have a reputation for paying their debts, show promise of being able to repay the cost of their unit, and show evidence of initiative and ambition. In contrast, at Southeast Missouri Farms the agency resettled families who had already been working the land.

Like other projects, Southeast Missouri Farms offered educational opportunities, including courses on adult literacy, home economics, sanitation, and agricultural practices, all important elements in rehabilitation and loan repayment. A home demonstration agent taught women how to plan a household budget and use a pressure cooker to can fruits and vegetables from their gardens, thereby ensuring a balanced diet during winter months. The FSA worked with clients to create a detailed farm program: optimal crop types, acreages, and rotation schedules, plus livestock and garden plans. Of the project, one journalist wrote: "There are milk cows, hogs, chickens where two years ago cotton was planted right up to the front door. Although cotton still is, and will probably continue to be, the main cash crop, at La Forge farms it is being used to pay for the land while other products provide a living."[35]

Also, like other New Deal communities, Southeast Missouri Farms was an experiment in housing construction. Following the ballooning costs and negative publicity at projects like Jersey Homesteads, the FSA kept a tight rein on spending, capping budgets at $2,100 per house in the North and $1,200 in the South, a difference dictated by climate. The agency also eliminated bathrooms in Southern homes.

The project became a design and construction triumph when a group of architects and engineers formulated a streamlined prefabrication method to build four- and five-room houses for $930 and $1,100 respectively.[36] Constructed by mostly unskilled labor supervised by carpenters, these houses had two or three bedrooms, combination dining and living room, kitchen, and screened-in back

porch, but no plumbing. This low-cost building innovation caught the attention of Washington administrators for its potential to improve the agency's tainted public image. Stryker wrote Lee it was "getting them all excited" and asked for "a careful sequence" of a prefab home being erected, "from the bare ground until the completed house."[37]

When Lee arrived, construction was almost complete on the project's one hundred houses, each situated on about 60 acres, which also included a barn, food storage shed, and privy. It took a five-man crew about five hours to assemble one house, in a process that impressed and intrigued Lee. He wrote to Stryker: "Have been out to the project. It is a real low-cost housing job with plenty of pictorial possibilities. . . . they erect a house in a few hours down here and their work looks good."[38]

Lee trailed the crew from the shop (where they assembled the panels) to the home site (where they constructed the house) and created one of his signature linear sequences (figs. 46a–l). Aside from the concrete foundations, poured prior to his arrival, Lee documented the entire process, making about 150 images, noting that a double crew erected the house he photographed. As he did in his series at Jersey Homesteads (figs. 11a–d) he broke down a complex workflow into a series of sequential steps, creating for the viewer a cinematic experience.

Widely published, Lee's Sikeston photographs successfully boosted the image of FSA community programs. Articles applauding the agency's innovative construction techniques appeared in more than a dozen regional and national publications—newspapers, general interest magazines, and specialty periodicals—with the biggest publishing coup being the respected monthly *Architectural Forum*.[39]

Southeast Missouri Farms demonstrated the RA/FSA's remarkable strides in design and construction, especially after the Jersey Homesteads fiasco. In his classic study of New Deal communities, historian Paul Conkin remarked that the agency's sustained experimentation transformed segments of American architecture. Prior to the New Deal, rural homes, insofar as they had any design, had been modeled on urban homes or impractical designs from the past. Conkin

 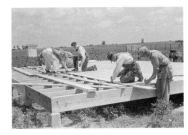 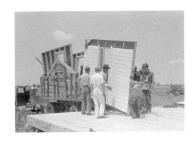

 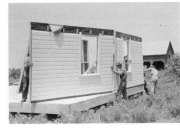

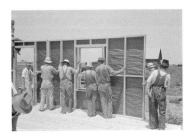

46a–l. House erection at Southeast Missouri Farms Project, New Madrid County, Missouri, May 1938.

asserted that the resettlement program marked a new beginning in functional rural architecture.[40]

The project at Sikeston also marked another bold and ambitious stride by the FSA, one toward racial integration. Of its approximately 150 rural resettlement communities, the agency partially integrated twenty-six of them, including Southeast Missouri Farms, a project of sixty White families and forty Black families.[41] Farm Security integrated the co-op store and the La Forge Cooperative Society, with each member having one vote regardless of race.[42] The agency kept the schools segregated and residents mostly remained where they had lived before, with White and Black households in separate areas. Economist and writer Stuart Chase visited the project and remarked it was "impossible to tell which area is which, equipment being identical."[43]

When Tugwell, who was White, established the RA in 1935, he made a commitment to bring poverty-stricken Black farmers into resettlement work. His choice of Will Alexander as his deputy administrator—then his successor—speaks to that commitment. Alexander, also White, was a veteran crusader for civil rights: CEO of the Commission of Interracial Cooperation from 1919 to 1930; acting president of the historically Black Dillard University from 1935 to 1936; and recipient of a Harmon Foundation award for distinguished achievement in race relations.[44] According to scholar Donald Holley, Alexander did more than any other administrator to try to get Black farmers an equal share of New Deal benefits and the FSA left one of the best records for treating African Americans equitably in the Roosevelt era.[45] Indeed, of the approximately fifty thousand rehabilitation loans the FSA made in its first four years, 12.5 percent went to Black farmers, who comprised 12.6 percent of all farm operators in America.[46]

Alexander and the FSA operated within the limitations of traditional Southern segregation and so never challenged the Jim Crow system or broke from local practices. This conservative approach reflected the Roosevelt administration's policies regarding race, which historian Doris Kearns Goodwin has described as a balancing act between what *should* be done versus what *could* be done. Roosevelt

and his administration were keenly aware of prevailing attitudes toward race and what White Americans would accept on civil rights. For instance, in 1935 Roosevelt signed an executive order barring discrimination in the administration of WPA projects, yet wouldn't support an anti-lynching campaign because he was afraid of losing his Southern Democratic base.[47]

Similarly, the FSA stayed within certain limits. When the agency did attempt racial parity, Southern organizations, politicians, and residents fought it. After a regional FSA office employed a Black staff member, the local White populace complained and enlisted their representatives in Washington to intervene and stop it.[48] The agency did succeed in creating at least ten all-Black agricultural communities, but Will Alexander and fellow administrator Beanie Baldwin couldn't persuade regional and state directors to hire African American supervisors for these projects, which was reportedly one of Alexander's greatest disappointments.[49] Baldwin later said, "Not even the FSA was foolhardy enough to try to force that down the throats of the field organization."[50]

Despite its efforts to work toward racial parity, the FSA got accused of just the opposite. For example, the Transylvania Farms project in Louisiana sparked a controversy when, after purchasing the acreage from private owners, the FSA evicted the tenants (in this case Black sharecropping families) and developed the land as an all-White project. Though the agency planned to resettle eligible displaced sharecroppers at the nearby all-Black Mounds project, advocacy groups such as the NAACP and the Associated Negro Press (ANP) made public accusations of racial prejudice in land and project allocations. (The ANP later retracted its own charges.)[51]

The FSA therefore found itself perpetually caught between two opposing forces. While civil rights organizations charged that the agency didn't do enough, critics protested it did too much. Senators, members of congress, and their White constituents, interested in preserving the racial status quo, actively blocked FSA efforts. Alexander and Baldwin understood the power of Southern Democrats on Capitol Hill and—mindful of the FSA's tenuous funding—were reluc-

tant to lead the agency in a crusade against racial disparity, choosing instead to focus on a fight they believed they could win with broad solutions to nationwide agrarian problems.

Lee, for his part, remained sensitive to African American concerns, observing and recording the country's racial divide throughout his FSA tenure. Though his—and the Historical Section's—official mandate was admittedly not race related, some of his photographs (and those of his colleagues, who, except for Gordon Parks, were White) directly address disparate treatment and discrimination, and acknowledge the separate worlds inhabited by Blacks and Whites in multiple states during the segregated 1930s.[52] Indeed, Lee later wrote that documenting the injustice of segregation was one of his many personal objectives while on Stryker's staff.[53] He spent two weeks in Illinois with Edwin Rosskam photographing a segregated Chicago for Richard Wright's book *12 Million Black Voices*. In Texas, Lee

47. *Negro drinking at "Colored" water cooler in streetcar terminal, Oklahoma City, Oklahoma, July 1939.*

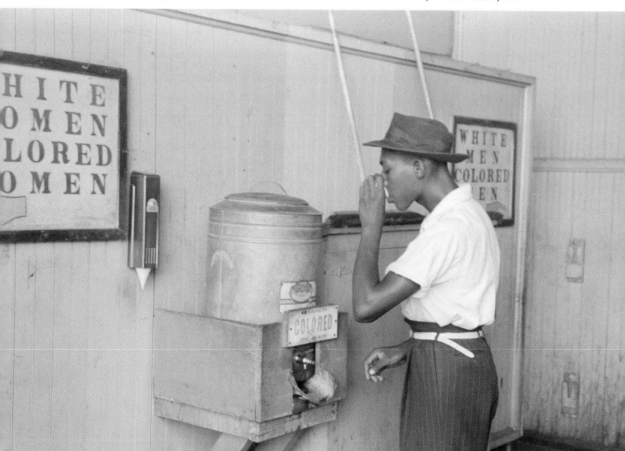

photographed a segregated county commissioner meeting in San Augustine and a segregated movie theater in Waco.[54] In Oklahoma he met a schoolteacher in Creek County who feared being fired if she asked why textbooks hadn't been sent to her rural Black school, even though the White school received theirs.[55] And while documenting passengers in an Oklahoma City streetcar terminal, Lee photographed the station's separate watercoolers (fig. 47).

Lee arrived in a Missouri in which particularly acute segregation existed. In an article for the NAACP's *Crisis* magazine, educator and FSA Division of Information staffer Constance E. H. Daniel characterized the Bootheel area as "a racial borderline" following the social patterns of the Deep South, adding that many people believed area landlords fostered racial divisiveness.[56] Another writer noted the Ku Klux Klan was "well organized in the territory and ready to deal with anyone who has the temerity to face the issue in the interests of the sharecropper."[57]

More recently, historian Colin Gordon characterized the state as a sweet spot for racial resentment, with a tradition of anti-Black racism and White supremacism typical of a former slave state.[58] Scholars and journalists have argued that Missouri's status as a border state "makes it one of the country's most fertile breeding grounds for racial strife [and that it] suffers from some of the worst racial pathologies" of both North and South.[59] Moreover, a 2017 study concluded that Missouri holds the unfortunate distinction of having the second-largest number of recorded lynchings outside the Deep South in American history.[60]

Lee encountered evidence of this violence near Southeast Missouri Farms. On an uninhabited stretch of road in the project vicinity he documented what was called the "Hanging Tree," where he noted several African Americans had been hanged (fig. 48). Literally a landscape of Black loss, Lee's photograph is a menacing reminder of the region's extralegal racial terror, of its brutal and savage past, and the ever-present prospect of future violence. His photograph also speaks to the boundaries within which the FSA was working and the agency's bold choice to forge ahead with a semi-integrated project in such a racially charged atmosphere. Even with federal oversight, the project remained vulnerable to deep-seated prejudice, a problem acknowledged in the mainstream publication *Reader's Digest*. In

48. The "Hanging Tree." Several Negroes have been hanged on this tree, New Madrid County, Missouri, May 1938.

his assessment of Southeast Missouri Farms for that magazine, economist Stuart Chase admitted the project "could be wrecked if racial antagonisms should suddenly blaze up."[61]

With equal attention to White and Black families, Lee visited more than forty households at Southeast Missouri Farms.[62] He wrote Stryker that he "shot quite a bit of film and did a lot of rushing around the project" to get the requisite "before" pictures but added he should have been there a month earlier, before the worst shacks—mainly the one-room ones—were torn down. Lee assured him he was still able to make "all sorts of pictures of living conditions that must be rectified."[63]

Echoing the findings of FSA investigators, Lee's photographs reveal dismal circumstances. With an eye to showing the worthiness of the resettlement program, he documented dozens of primitive shanties, unpainted and weatherworn, many structurally unsound with collapsing porches, leaning chimneys, or gaping holes. None had electricity, some had driven wells. Dirt yards (or cotton fields) usually surrounded the houses; gardens were scarce. Kitchens were commonly just a stove and crowded table in the corner of a room, with pots and pans and foodstuffs hanging above or sitting below. Windows were often broken and covered with cardboard or stuffed with rags. Piles of dirty bedding were strewn around rooms and draped over broken furniture. Chickens sometimes lived inside these houses.

Lee also photographed the scores of occupants—men, women, and children—during their daily activities (fig. 49). They washed laundry by hand on the front porch, prepared food in makeshift kitchens, swept the rough wood floors in a con-

49. *Mother and child, FSA clients, former sharecroppers, just before moving to Southeast Missouri Farms, New Madrid County, Missouri, May 1938.*

stant battle with dirt, pumped water in their front yard, and worked in the cotton fields.

Amid these harsh living and working conditions—foreign to most urban middle-class viewers—Lee pictured one activity most could relate to: personal grooming. He photographed a young man getting dressed in a combination bedroom-corncrib; a father shaving while sitting on an old lard can; another washing his face in a basin perched atop a ledge; a mother bathing her two daughters from a bowl on the floor; a son washing his hands at a kitchen table. And with his fondness for repeat compositions, Lee photographed a boy and a girl in separate homes, combing their hair in front of a bureau (figs. 50a–b).

Sharing many of the same details, these two images suggest comparable levels of poverty. Detritus is scattered everywhere. Newspapers—provisional insulation or makeshift wallpaper—cover the walls. Both bureaus are cluttered and, in homes without electricity, oil lamps sit near the mirrors. As they comb their hair, both children stand barefoot on dirty wooden floors.

Son of a sharecropper (fig. 50a), which depicts a young White boy, first appeared in the *Dayton Daily News* and has since become one of Lee's better-known images. On the other hand, *Sharecropper's child* (fig. 50b), which features a young Black girl, didn't see much, if any, exposure. A thorough search of Stryker's carefully compiled clippings scrapbooks reveal no evidence of *Sharecropper's child* having been published.[64] Furthermore, it also appears this photograph was not published in the years after the project ended, despite the fact it has always been together with *Son of a sharecropper* in the same section of the File.[65]

For all Lee's racial evenhandedness in his documentation, newspapers and magazines mostly featured his portraits of white project residents, despite Stryker's active promotion of Lee's African American portraits.[66] Indeed, Stryker's

50a–b. Southeast Missouri Farms, New Madrid County, Missouri, May 1938. [a] *Son of sharecropper combing hair in bedroom of shack.* [b] *Sharecropper's child combing hair in bedroom of shack home near La Forge project, Missouri.*

scrapbooks show that only five of Lee's dozens of published photographs featured Black clients. This was a hurdle Stryker recognized the previous year, in 1937, while Lange was on assignment in Mississippi. He wrote to her: "Regarding the tenancy pictures, I would suggest that you take both black and white, but place the emphasis upon the white tenants, since we know that these will receive much wider use."[67]

Reluctance to use portraits of Black farmers being helped by the FSA wasn't confined to publishers. Regional FSA personnel confronted entrenched racial prejudice in their regions, and, fearing negative response from their constituents, also resisted the inclusion of Black farmers in their public relations material. Garford Wilkinson (Amarillo office), who described himself as "sincerely sympathetic to all races, including Negroes," wrote to Fischer about an FSA exhibit prepared by Rosskam: "Why was it necessary for Mr. Rosskam to use a picture of a Negro farmer on the fourth panel? Surely he had photos of German farmers, Russian farmers, Italian farmers, Irish farmers, etc." Wilkinson described the photographs as "quite objectionable" for his audience, explaining: "I do not wish to appear as a bull in a china shop, but knowing the people in the region as I do, I doubt the wisdom of using a panel showing a Negro farmer beside a panel showing a white farm woman."[68] Arkansas official George Wolf also anticipated flak and complained to Fischer about Rosskam's image choice: "The use of a Negro farmer [on panel #4] will limit [the exhibit's] use in much of the region."[69]

Rosskam selected one of Lee's African American portraits from Southeast Missouri Farms for *12 Million Black Voices*.[70] The book drew most of its eighty-eight photographs from the File, which Stryker acknowledged to Lee would produce "some flare backs" but that it didn't worry him "in the least." Stryker continued: "We have always been interested in the negro problems, have taken pictures portraying these problems ever since we have been in existence, and will probably continue to do it as long as we are in existence."[71]

It's unclear if Lee understood the publishing landscape as Stryker did, or the resistance the FSA faced in using portraits of Black farmers in its own promotional materials, or that his substantial coverage of Black clients at Sikeston would

be largely overlooked at that time. Whether or not he had any expectations his photographs would be published, his extensive coverage shows his understanding that the economic problems of Black farmers were an integral part of the nation's rural crisis.

Lee's Sikeston documentation also demonstrates a refinement of his methodology. As he did with washstands in Iowa, he again used a serial presentation to illustrate and compare levels of household poverty. But at Southeast Missouri Farms he further humanized it by choosing children at bedroom bureaus as his visual device. Partial to this composition, he repeated it multiple times both during and after his work in Sikeston.

Son of a sharecropper and *Sharecropper's child* offer powerful, compassionate statements about the human condition. Sadly, the original negative for *Son of a sharecropper* no longer exists. Most likely it disintegrated from tainted government-issued chemicals shipped to Lee in the field.

BREAD-AND-BUTTER JOBS:
MISSISSIPPI, ARKANSAS, AND LOUISIANA

To keep his project afloat, especially during the lean times of 1938, Stryker hired out staff to other agencies. Lee later remembered, "Roy ... was fighting the battles in Washington" and he and Rothstein "practically made [their] own way" working for other bureaus: "This kept us alive. . . . [And] believe me, those were years when we sort of wondered what was going to happen there."[72]

These billable assignments—also known as reimbursable jobs—are difficult to track. Stryker's office didn't retain job records and turned over most of the negatives and prints to the commissioning agencies. But we know from his correspondence—where he referred to these assignments as "bread-and-butter-jobs"—that Lee worked for the Public Health Service, the Bureau of Chemistry and Soils, the Land Coordinating Committee, the Agricultural Adjustment Administration, and the Pennsylvania Department of Education.[73] And Stryker

often wangled it so that they paid Lee's travel expenses as he hopscotched from one assignment to another.

These agencies may have had other options, but FSA photographers had by this time built a solid reputation for aesthetic quality and intelligent documentation. The Public Health Service (PHS) administrator who regularly hired Lee and Rothstein knew they could provide pictures "accurate enough for the instruction of neophytes, yet artistic enough to use."[74]

Lee's first PHS job was at the end of August 1938 photographing skin disorders for a Dr. Norris, whom Lee described as "very much of a realist . . . not unwilling to have some real pictures of lesions, sores and all the rest of the disorders." Embracing the work with clinical detachment yet aesthetic concern, he told Stryker: "Some of the skin disorders may photograph better on orthochromatic film. . . . Am very much thrilled about this job and hope I get a good set of pictures."[75]

Lee enjoyed these assignments for Public Health, though they sometimes endangered his own: he photographed people with contagious conditions, ships quarantined for typhus, and rats that carried the disease.[76] He occasionally donned medical scrubs, but more often to protect his subjects, such as a hospital patient during an operation in Chicago (fig. 51).

For Stryker, all bread-and-butter jobs had potential benefit beyond increasing the Section's bottom line. He saw each one as an opportunity for photographers to continue picking up pictures for the FSA on another agency's dime. For example, while Lee was on a job for the Bureau of Chemistry and Soils (BCS), in Laurel, Mississippi, Stryker wrote him to use the agency's entrée to a local cotton mill to get images for the File.

Laurel, a bustling agricultural and industrial town, famous as the birthplace of Masonite,

51. Russell Lee in medical scrubs for Public Health Service job, July 1941, photograph by Edwin Rosskam.

was known for its application of chemurgy, a branch of applied chemistry using agricultural raw materials for industrial products. The BCS operated a sweet potato starch plant there and hired the Historical Section to document it. Knowing this would provide Lee access to a mill that used the starch, Stryker wrote him: "Once you get into a cotton mill, you can take a lot of pictures useful for our files. . . . [BCS] of course will pay for this. . . . Try not to use too many flash bulbs."[77]

At the cotton mill, in both long shots and close-ups, Lee documented the complex workflow of thread production: cleaning the fiber and pulling it into ropes, then feeding those into machines to make successively finer threads. His admiration for specialized knowledge and expertise shines through in his photographs of mill workers deftly operating the tools of their trade, winding thread onto spindles, spools, and warp machines.

His images also speak to his interest in human and machine interaction. In the weaving room, for example, he framed the rows and rows of looms with a sole operator moving between them. While documenting the spool winder, he pictured its operator making a knot with what he noted was "a small machine [that] costs $65 and replaces 10–15 operators."[78] At another winding machine he photographed an operator repairing a break (fig. 52). In this surrealistic image, the woman is barely visible behind the spools, diminished—almost obliterated—by the machinery.

For Lee, his coverage of the Laurel cotton mill continued a larger study he'd started earlier in the year. Though limited by official project work and bread-and-butter jobs throughout the South, he undertook a documentation of the full production cycle of cotton, the region's economic mainstay. And he used his travel itinerary (a string of official project work and jobs for other agencies) to do it.

Early in the growing season, near Southeast Missouri Farms, he pictured project residents working their way down long rows "chopping cotton" (thinning young plants and removing weeds with a hoe). Despite the invention of the inter-

nal combustion engine and the Fordson tractor—which fundamentally changed agricultural labor in the 1920s—few Cotton Belt planters mechanized because labor was cheap. In 1930 there were approximately 1,000 tractors in the South, compared with the single state of California, where 7,000 tractors operated.[79]

A few months later, Lee went into the fields of Arkansas to photograph cotton picking, another task done by hand, and his photographs highlight its physical demands. Pickers—men, women, and children outfitted with long sacks slung over their shoulders—worked their way down row after row until they filled their sack, which dragged behind them. This stoop labor strained a worker's back and the cotton burrs pricked one's fingers. Lee trailed laborers and their full sacks to the trucks and wagons where cotton was weighed and collected, and pickers waited to be paid at the end of the day.

Lee followed the trucks and wagons as they transported the loose cotton to gins, photographing two in Arkansas: one in Lehi and another at the Lake Dick project, near Altheimer. Between both facilities he captured the ginning process, as cotton progressed from loose bolls to uniformly sized bales: bolls suctioned from the wagon, fiber cleaned of seeds then compressed, wrapped in jute webbing, bound with steel straps, painted with identification marks, weighed, and loaded onto trucks. Each oblong bale weighed about 500 pounds. Regional cotton yields varied, but in Arkansas in 1938 it took about one-and-a-half acres of cotton to produce a single bale.[80]

Some of Lee's views made at the Lehi gin evoke Lewis Hine's *Men at Work* series, undertaken in the 1920s and early 1930s at industrial plants and construction sites. Hine's book, *Men at Work: Photographic Studies of Modern Men and Machines*, had been published six years earlier and his images were well-known to all the FSA photographers.[81] As Lee's friend and colleague Ben Shahn later acknowledged: "No photographer in the twentieth century cannot pay heed to Hine."[82]

At the Lehi cotton gin, Lee made a compelling worker series of a man ready-

52. *Spools of cotton thread with woman repairing break. Laurel cotton mill, Laurel, Mississippi, January 1939.*

53a–b. Lehi, Arkansas, September 1938. [a] *Putting steel straps in place to hold pressed cotton after pressure has been removed.* [b] *Negro worker at cotton gin.*

ing bales for shipment: painting the identification number on the side, weighing it, and removing it from the scale (fig. 53a). But in the most powerful view, the worker pauses and—as he sits at the loading dock, likely waiting for the next bale to come through—looks squarely at Lee's camera (fig. 53b). His lithe body and work gloves hint at the physical demands of his job, and Lee's photograph is as much a portrait of labor as it is of the laborer.

ANOTHER BILLABLE AGENCY was the WPA's Federal Writers' Project (FWP), which produced the American Guide Series: books and pamphlets on the forty-eight states and District of Columbia. Utilizing the skills of more than six thousand writers, the WPA Guide Series outlined each state's history, geography, and culture, and included maps, drawings, and photographs.

The guidebooks began appearing in 1937, and Stryker, initially enthusiastic, supplied them with hundreds of photographs. In addition to disseminating Historical Section images to a broad audience, the Guide Series shared Stryker's broader goals of a comprehensive record of America. And unlike many publications, the Series credited the agency and the photographer.

Quantitatively, the FWP turned out to be one of the Historical Section's best publishing clients: 36 guides used some 360 FSA photographs, 97 of which were by Lee.[83] The Section's work with the Guide Series was a sort of hybrid reimbursable job, as Stryker supplied photographs already in the File, but the Writers' Project also paid some costs to cover particular subjects.[84]

While in New Orleans for a Public Health job, Lee worked with writers Virgil Geddes and Lyle Saxon (the latter being supervisor of the Louisiana FWP) to photograph locales for the state guide book. Lee wrote that they were "going to make pictures of the people, the crops, industries, plantations, towns . . . [to] build up a pretty good picture." Clearly excited about the prospect, Lee said he expected that even with six weeks he'd only be able to scratch the surface, "so don't be surprised if I happen to get lost in Louisiana."[85]

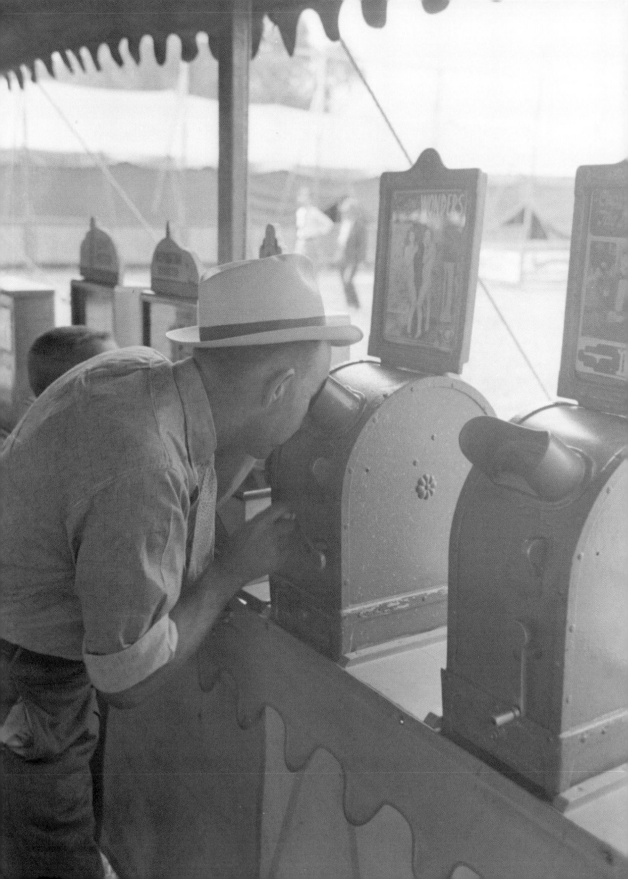

With Saxon and Geddes as his guides, Lee explored the State's industries from sugarcane in New Iberia and strawberries in Hammond, to oyster fishing in Olga and lumber in Sorrento. He trekked to the remains of plantation houses along the Mississippi River with Saxon and spent several days with Geddes aboard the packet boat *El Rito* traveling down the river to the Gulf of Mexico.[86] He attended the National Rice Festival in Crowley and visited the State Fair in Donaldsonville.

At both the festival and the fair, Lee pictured various attractions: exhibits, amusements, parade floats, display windows, and contests. But Lee also shifted his camera onto the spectators. Attracted to the act of observation, he made more than a dozen pictures of his subjects watching something else: a magic show, a street dance, a parade, a daredevil bicyclist, and a penny peep show (fig. 54).

Throughout his FSA tenure Lee continued this theme, capturing spectators across the country: at a parade in Oregon, a wrestling match in Missouri, a 4-H club fair in Kansas, a rodeo in New Mexico. He photographed children looking at movie posters outside a neighborhood theater in Steele, Missouri, and an audience watching a contortionist act in San Angelo, Texas, at the Fat Stock show (fig. 55).

With a consistently wry approach—and a penchant for signs—Lee enjoyed visual jokes involving people engaged in the act of observation. In Oregon, for example, he found a group gathered in front of an elephant (fig. 56). His deadpan image highlights the contrast between the large animal squeezed inside the small structure, consuming nearly every cubic inch. The unnecessary word "Circus" appears on the marquee.

He found another entertaining scene at a tent in Missouri (fig. 57). High-lighting colloquial language and an uncomplicated objective, Lee's image shows customers waiting around an itinerant photographer's concession, under a home-made sign guaranteeing "Photos that looks like you!" Lee shared with some of his colleagues a fascination with making photographs that commented on the

54. *Man looking through penny peep show, state fair, Donaldsonville, Louisiana, November 1938.*

medium itself, acknowledging his own role as a documentarian and noticing things photographic.

Lee's trip to Louisiana proved fruitful for the WPA Guide, which used eighteen of his photographs relating to the state's history, agriculture, and social life. However, scholar John Raeburn considers the Guide Series a generally unsuccessful venue for FSA images because of low reproduction quality and shabby image presentation, deficiencies that, according to Raeburn, eventually caused Stryker's enthusiasm to wane.[87]

Indeed, the presentation of some Lee images in the Louisiana guide is second-rate. One layout, for example, is regionally insensitive, surprising for a book billed as an authoritative regional guide. To illustrate Louisiana's cotton industry, editors drew from Lee's comprehensive survey of that crop, but used his images from Arkansas.[88]

55. *Spectators at a side show where a man unloosens himself from chains and ropes, San Angelo Fat Stock Show, Texas, March 1940.*

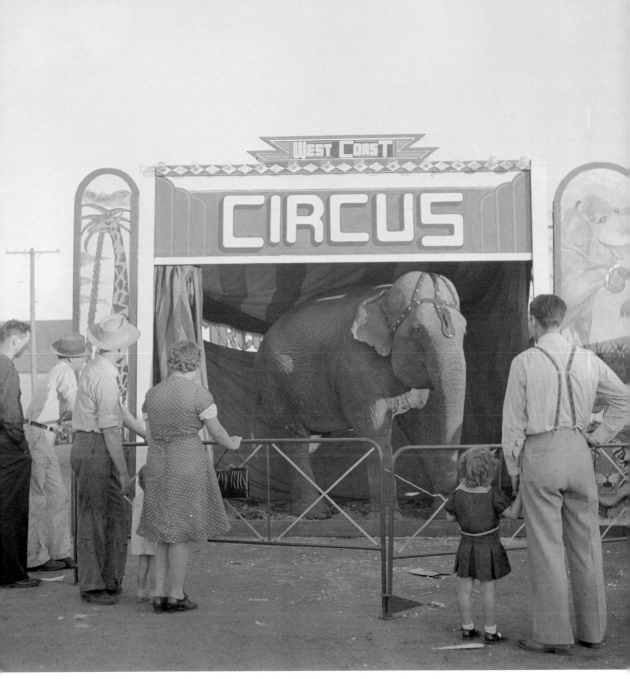

56. *Circus day, Klamath Falls, Oregon, July 1942.*

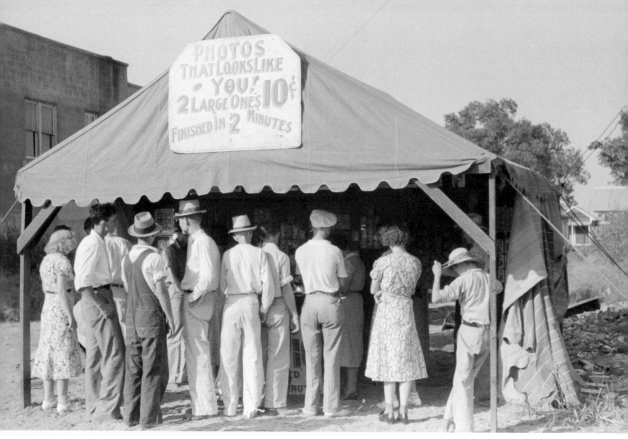

57. A crowd in front of an itinerant photographer's tent, Steele, Missouri, August 1938.

Another layout is similarly insensitive, both to Lee and his subject. Though the Guide Series did credit Section photographers, it sometimes changed captions, a common occurrence with publishers at large, and which Stryker could not stop.[89] One of Lee's images depicts a young Black girl sitting on the steps of a historically significant but abandoned plantation house. Lee wrote the original caption as: "Negro child residing in old Trepagnier house near Norco, Louisiana," and in another image from this series noted the house had been the site of a violent nineteenth-century uprising by enslaved people. Lee added: "They were held off by M. Trepagnier until the arrival of military forces which decimated the ranks and paraded the heads on poles through the streets of New Orleans."[90] Yet the Guide

Series disregarded Lee's text and the uncomfortable history he included, recaptioning the image: "Me and this old house is both plum wore out (on the steps of the ruined Trepagnier house, near Norco)."[91]

Although Lee's New Orleans job with the Writers' Project produced a mediocre publication, ultimately it changed his life. It was where he met an aspiring journalist, an impulsive, hot-tempered firebrand who eventually became his second wife.

JEAN

Dorothy Jean Smith was born in Vernon, Texas, in 1908 and grew up in a modest home in the Dallas–Fort Worth area where her father was district manager for the telephone company. As a teenager, Jean penned a weekly column of high school news for the *Dallas Times-Herald*. When the city editor offered her the chance to cover a dog show, she jumped at it, recalling: "I liked to write and I had every intention of being a writer." After seeing her byline on the front page the following Sunday, she "was hooked."[92]

Jean continued working for the *Times-Herald* and enrolled in Southern Methodist University (SMU). Her journalistic career and university education were both cut short by her romantic involvement with a reporter named George Martin, whom she married in 1928. Within a few years she left her husband and moved to New Orleans where her younger sister, Josephine, lived with her husband, Charles Cantrell, a principal owner of the famous Pat O'Brien's restaurant. Jean later recalled earning money through odd jobs, moving from one to the next.[93]

By the fall of 1938, though still married to Martin, Jean had settled into her New Orleans life. Among her circle of friends was a man working on the Writers' Project, researching courthouse records and conducting interviews with some of the area's older residents to compile histories of Louisiana parishes. In September, he planned to go around with a photographer from Washington for a few days and, as Jean recollected, she was at his home visiting him and his wife when Russell Lee

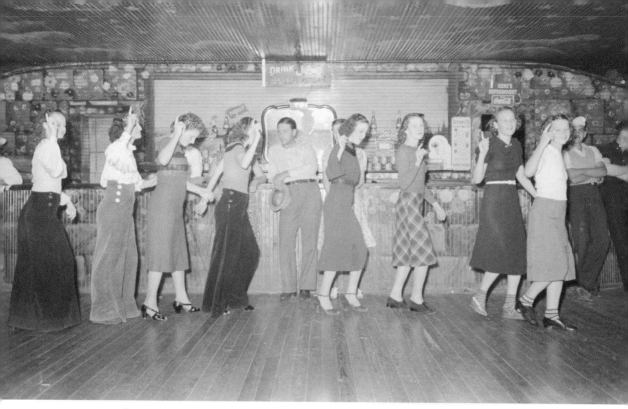

58. Roadhouse, Raceland, Louisiana, September 1938.

arrived. She recalled an immediate, mutual sexual attraction: "Russ and I took one look at each other, and it didn't take 15 seconds to know we belonged together."[94]

The writer left New Orleans with Lee but telephoned shortly after because Lee suggested Jean and the writer's wife might like to join them. They immediately accepted, and the four went off together for several days. Jean recalled: "Within 24 hours after meeting Russ, I was in bed with him, and I spent a lot of time in bed with him after that."[95]

Lee was smitten. He took Jean along on his travels throughout Louisiana, including to a roadhouse in Raceland on crab boil night. His photographs show a lively atmosphere, with patrons drinking at the bar, taking their chances at slot machines, enjoying their crab dinners, and dancing. He made a lighthearted view of eight young women in single file, right index fingers pointed to the ceiling as

59. *Girl* [Jean Smith Martin] *in back room of barroom. Raceland, Louisiana, September 1938.*

they paraded past the bar, in an introductory walk around the room, prior to a group dance (fig. 58). Lee also took a few pictures of Jean at the roadhouse, including one in front of an itinerant painter's ominous portrait of a devilish figure, framing her beneath the words "I'm Waiting for You" (fig. 59).

The following month, Doris visited Lee in the field and the couple spent a happy week together. Though he was involved with Jean, Lee was glad to see his wife, and given the open nature of their marriage, it appears that Doris accepted her husband's romance as a matter of course. They still enjoyed each other's company, and explored areas around New Orleans; Doris drove, giving Lee brief respite, and they read books aloud on their excursions.[96] During her visit, he wrote Stryker somewhat furtively:

After Doris leaves, I may take a writer, who lives down here, along with me for awhile [sic] Her name is Mrs. Martin and she is very interested in all this and I believe that it will help me and the files very much. (She has done feature work on southern newspapers.) She can help with the driving, too, Thank God.[97]

When Lee and Jean left Louisiana together in mid-November 1938, they tested the limits of propriety. His marriage to Doris was common knowledge within the FSA and though free love was acceptable in Woodstock, in mainstream thirties society it was scandalous, especially when it involved a married government photographer openly traveling with a woman married to someone else. But neither seemed to care. After knowing Lee just over a month, Jean later recalled, "I just closed up my apartment and left."[98]

The companionship Jean offered Lee differed from his marriage to Doris. A New Deal compatriot, Jean shared his social reform vision. She was a passionate Southern Democrat (and admirer of Huey Long), and devoted herself to Lee's work for the FSA, helping him in the field and providing a sense of settled domesticity while on the road.

As Lee photographed, Jean engaged people in conversation. She chatted, as she recalled, "casually, even about recipes or how they're making whatever they're cooking and things like that."[99] And she took notes for later use in Lee's captions, recording locations, dates, and names, freeing him from that task. He later characterized Jean as a "very perceptive person" who was "invaluable" to him in the field: "she'd also been a reporter and she knew just how to write and she kept great notes. She relieved me of all these responsibilities and that was simply terrific because this means that I was able to devote practically all of my time to photography."[100] Jean also helped carry Lee's bulky equipment, including his flash bulbs, later recalling with humor, "there were always at least two big cases of flash bulbs in the backseat ready to blow up."[101]

At their many hotels, motels, and tourist courts, she created a welcoming,

homelike atmosphere. Louise Rosskam recalled how Jean fashioned snug lodgings, giving their rooms a lived-in feel: "it looked as if they'd been there for a year. She would have nice decorations, and comfortable throws here and there and, I mean it was just like home. And then they'd pick up and go to the next place." Rosskam continued, "So, you can see how important she was to Russ, because I think . . . that life suited him very well . . . he had that base, to come back to Jean."[102] Jean also prepared meals whenever they could get a kitchenette, and Lee wrote Stryker of his delight with Jean's "good home cooking."[103] With the peripatetic nature of Lee's FSA work—and his unsettled youth—he appreciated her ability to establish comfortable accommodations wherever they were.

But Jean was a provocative mix of disparate characteristics. Many friends recalled her charm, graciousness, and ability to entertain with ease, and she disarmed people with her feminine beauty, sensual hooded eyes, and genteel Texan drawl. Yet in a flash she could erupt into an impetuous rage. According to fellow photographer Sol Libsohn (who later worked with Lee on the Standard Oil project), "She had a temper and the whole works, you know . . . Jean was not like Russ at all." Libsohn described Lee as a "listener" and someone who "could stand almost anything," adding that Lee never let on if something bothered him, but "you certainly would have known if Jean was unhappy."[104] Rosskam was coyer about Jean's mercurial nature: "Jean was a—it's so funny because you'd say in a way she was a lady, but she didn't act like a lady."[105]

Jean channeled that temperament to her relationship with Lee. According to Rosskam, she "really took charge of anything that Russ needed. He was number one as far as she was concerned." To illustrate, Rosskam recounted a visit with Jean during World War II, while Lee was overseas. Jean had rented an apartment in Washington and hung a wall-sized map marked with Lee's travel routes. Rosskam recalled, "she followed him day by day on that map. And we got in there one night and she was sitting there like this—with a gun [in her lap, looking at the map] and we said 'Jean, what on earth?' [Jean said] 'I can't find him . . . Anybody comes in here from that part of the world—they're gone!'"

Almost unnecessarily, Rosskam added for emphasis: "They were so close, you know."[106]

Lee valued Jean's constancy and protective nature. As someone who transitioned from a revolving door of guardians to an open marriage, he must have reveled in the prospect of having someone always by his side.

But their relationship was more complex—and compelling—than that, and Jean was more than just a supportive companion. She had her own ambitions and over time tried to revive her stalled writing career using Lee's connections and his photographs. Drawing on her field interviews and notes, she composed features for various magazines, and with unbending determination tirelessly shopped them around, aiming to publish her articles alongside Lee's photographs, an effort Lee encouraged. Unsurprisingly, this caused friction with Stryker. A conflict simmered for several years, coming to a head during their yearlong quest to publish the Pie Town story, when it became evident that her skill and talent didn't match Lee's.

Jean aspired to a career in journalism, but leaving SMU and the *Times-Herald*—and marrying George Martin—limited her options. Her circumstances and series of life choices provided fewer opportunities to learn and develop the skills she wanted, to pursue the life she imagined. Lee overlooked the inequality of their creative abilities. Mirroring Jean's devotion, from the outset he staunchly supported her writing ambitions. And when they left New Orleans together in the fall of 1938, they stuck by each other for the rest of his FSA tenure and remained together the rest of his life.

Jean made another significant contribution to Lee's life and work by introducing him to her home state. She shared her passion for Texas, and he ultimately adopted it as his own. It was a lifelong infatuation that dated to his earliest visit in 1939, when—within three months of meeting Jean—he began an in-depth study.

1939

Texas

O F THE TWENTY-NINE STATES Lee visited for the FSA, he spent the most time in Texas. From his first trip in January 1939 he was captivated, writing to Stryker: "There is going to be plenty to do in this state as it is so damned big and so diverse."[1] Some months later he enthused again, "Am anxious to take you on a trip thru Texas—it is one of the best states of all."[2]

Lee's arrival in the Lone Star State coincided with a turning point in the FSA and the File. As America recovered from the Depression, Farm Security officials aimed to leave behind the decade's ecological and financial disasters. Hoping positive publicity would appease Congress and deflect right-wing accusations that the FSA produced leftist propaganda, administrators worked to project an image of agrarian recovery and rural prosperity by promoting agency achievements and rehabilitated clients. Stryker acquiesced to pictorial demands from higher-ups. He actively sought optimistic images, a course steered largely by Edwin Rosskam, whom Stryker hired for intermittent photo-editor stints beginning in 1939.[3]

Lee photographed Texas within the context of these shifting priorities, but his coverage became a documentary tug-of-war with Stryker. While Stryker became enmeshed in a changing Washington landscape, Lee maintained his reformist

agenda and methodical strategy. To Stryker's delight, Lee found and systematically recorded a flourishing small town, satisfying Stryker's long-standing personal documentary goal. But Stryker also wanted pictures extolling FSA programs and agricultural modernization. Lee was happy to oblige Stryker on the former, but had other ideas about the latter.

THE GOOD TO MAKE THE BAD COUNT

And this was Roy's problem. . . . when I came to be editor . . . I knew that we were lopsided. We had to get a broader coverage. Now the thing that I would try to bring home . . . was to say, "Look if I am to illustrate the good and the bad, I got to have the good to make the bad count. If you don't give it to me, how am I going to get it?"

Edwin Rosskam, 1965[4]

Topping the list of FSA initiatives that administrators wanted to publicize was the cornerstone Tenant Purchase Program. Authorized by Bankhead-Jones in 1937, it was designed to help selected farm tenant families and other qualified applicants become owner-operators of family-sized farms. Combining credit (called tenant purchase loans) with technical assistance (called supervision) the Tenant Purchase Program aimed for financial and agricultural security.

Though the program aided only 2 percent of the country's tenant farmers, it became a showcase for administrators, who framed it as a magic bullet for the tenancy problem.[5] Anxious to document success stories, administrator Jack Fischer wrote directly to Lee that he was "extremely eager to build up before and after files on both tenant purchase and rehabilitation." Fischer's idea was to show "their economic condition before they are taken on our program . . . homes, working conditions, sanitary conditions, kitchens, etc." then return a year or two later for "a new set of pictures showing the degree of improvement that has been made."[6]

Lee happily complied and in January 1939 traveled to Texas, the state receiv-

ing the largest allocation of program funds.[7] And at the southern tip, in Hidalgo County, he found two domestic scenes that satisfied Fischer's request.

In the first, a smartly dressed woman stands at the kitchen counter of her new home, bought with a tenant purchase loan (fig. 60). The room's stark whiteness showcases the "sanitary conditions" Fischer asked for, and its cabinet design imparts a sense of harmony and order. With the minimalist elegance of a De Stijl painting, Lee's photograph features a series of bold geometric shapes and lines that repeat and reappear: square black hinges and latches that punctuate the cabinets echo the recessed panel doors and appear to reflect the polka-dotted wallpaper on the ceiling. The dynamic lines of the counter and cabinet apron edging complement the chevron pattern formed by the seam of the woman's skirt.

60. *Kitchen of tenant purchase client. Hidalgo County, Texas, February 1939.*

This photograph shows Lee's fondness for graphic design, evident in other images. For example, at a secondhand tire shop in San Marcos, he highlighted the geometric arrangement of black tires hung across the front of a white clapboard building (fig. 61).

Lee's kitchen tableau is another of his repeated compositions, a systematic exploration he began with washstands in Iowa, later continuing with children in front of bedroom bureaus. In his kitchen series, he photographed women in what was commonly accepted as their traditional sphere, engaged in the act of food preparation, at various economic levels and in a diversity of houses: sharecropper cabins, tenant shacks, day laborer trailers, migrant tents, and FSA-sponsored homes.

In another clean and tidy tenant purchase home, he photographed an older couple at leisure in their new living room (fig. 62). This portrait surpasses the initial concept Fischer pitched to Lee, of two sets of pictures depicting "before and after" stages of the program. As in *Organ deposited by the flood* (fig. 30) and *Saturday night in a saloon* (fig. 40), Lee captured both past and present in one image.

Tenant purchase clients at home shows a man and woman seated comfortably in coordinated armchairs; he reads a magazine while she sews. The factory-fresh Zenith console radio sitting between them indicates the couple's newfound prosperity and serves the same unifying function as a fireplace. With family photographs displayed on top—a makeshift mantel—it's become the new hearth of the home.

Lee's image reveals traces of the couple's previous financial situation in the details of their clothing: the man's shoes are worn and dirty, and a large hole in his right sock exposes more of his ankle than it covers. Similarly, the woman's shoes betray the miles behind them. Juxtaposed with their new home and furnishings, the couple appears to have been plucked from their old inferior tenant house and placed in their new and modern one without a chance to change their outfits. Conveying feelings of comfort and security, Lee's photograph symbolized an agrarian upswing and presented the FSA's centerpiece program as a panacea for the ills of tenancy.

Stryker and Rosskam wanted more like it, pictures emblematic of rural prosperity. To this end, they turned their attention to modernization of agricultural industries by machinery.

61. *Secondhand tires displayed for sale. San Marcos, Texas, March 1940.*

For the FSA, mechanization of agriculture was a complicated topic to depict. Some New Deal policies encouraged—even incentivized—it. For example, the AAA paid landowners to reduce acreage in cultivation (which displaced labor) but then landowners often used the benefit payments to purchase tractors, rendering large-scale farming more profitable. Machine-transformed farms increased efficiency, allowing farmers to cultivate more land, and with less labor per acre. In his socioeconomic study *North America*, J. Russell Smith reported that by the late 1930s family farms were becoming obsolete, concluding that mechanization had hastened their decline. A new type of tractor, which could be used for both plowing

62. *Tenant purchase clients at home. Hidalgo County, Texas, February 1939.*

and cultivating, had spread across the Corn Belt "almost like a prairie fire." Along with a corn-husker, one farmer could single-handedly produce 120 acres of corn in a season.[8] As farmers and landowners needed less help to work the soil, non-owners became "tractored-off," prompting the eviction of hired hands, tenant farmers, migrant workers, and sharecroppers, the very groups the FSA aimed to help.

Furthermore, mechanization worked at cross-purposes with the FSA because it nullified some of its own initiatives. These included the Tenant Purchase Program and planned New Deal communities, both of which advocated the family-sized

farm. In Smith's study, he concluded that 160 acres—more than twice the size of a tract at Southeast Missouri Farms—had become "an inefficient unit" because it wouldn't yield enough to offset the cost of machinery needed to work it.[9] FSA officials recognized this contradiction and though mechanization challenged the efficacy of some key agency programs, they nonetheless wanted to play it up.

Acknowledging his need to appease administrators, Stryker made machine-based imagery a photographic imperative. In a staff memo, he asked for dynamic pictures, not "too static" and "so taken that the functions of the machine are emphasized." Stressing the importance of this assignment, he added: "it behooves us to put forth more effort than we have in the past on this type of photography."[10]

From Lee, he asked for pictures of "tractors, cotton planters, 4-row cultivators, [and] potato diggers . . . machines in action, emphasizing the machinery at work." He justified the request by saying "material of this sort may be of much help when budget hearings come up. If we can play up our ability to handle this problem, then we may get more finances advanced to us."[11] He also crafted a detailed shooting script, with descriptions of what he called "come-ons," that is, images that would appeal to publishers. He specifically asked for "a few good 'angle shots' of tractors and machines."[12]

Lee cooperated . . . sort of. Machines replacing hand labor was already a theme in his work—it permeated his Laurel cotton mill series, for example. Yet Lee wasn't keen about overpraising mechanization to suit a shifting agenda.

In Texas, he made views of agricultural machinery, as well as associated images of dealers, supply shops, and signs for replacement parts. Near Santa Rosa, to illustrate widespread use, he photographed a tractor and assorted implements in a farmer's yard, which according to his upbeat caption "[show] the changes in farming methods and also [demonstrate] that even the small farmers are using the new tractors and other mechanized equipment."[13] In Ralls he visited a 4,900-acre farm worked by only nine tractors and in El Indio photographed a farmer prepping and using his tractor: priming it with gasoline, testing the clutch, starting the flywheel. And for Stryker's "come-on" angle shot, Lee photographed the farmer breaking virgin soil with a plow (fig. 63).

63. *Breaking virgin soil with tractor and plow, El Indio, Texas, March 1939.*

But Lee also drilled down beyond the glorification imagery and sought to counterbalance it by consulting labor relations experts on the regional impact of machinery. He traveled through southern Texas, spending time in Nueces County, which he called "one of the most highly mechanized counties in the country."[14] He trailed migratory laborers, who followed the state's crops from field to field and season to season, and documented harvesting, processing, and shipping of various crops.

When Lee reached Crystal City at the end of February, he witnessed the severity of the social and economic impact of mechanization, particularly on the Mexican and Mexican American community. He devoted considerable time to picturing the effects in an unvarnished way, so that what started off as an exploration of labor displacement turned into a fuller study of one of the communities most adversely affected. Twenty percent of his Texas photographs relates to this disadvantaged group—their health, living, and working conditions—for a study he pursued against Stryker's wishes.

SEQUELA:

MEXICAN COMMUNITIES IN THE RIO GRANDE VALLEY

Rembrandt's portraits . . . are all family portraits, pictures of himself.
He was finding himself. If you go deep enough into life you find yourself.

John Sloan, The Gist of Art[15]

In the nineteenth and early twentieth centuries, responding to fluctuating needs of Anglo employers, Mexican workers traveled frequently between the United States and Mexico, across a border that many perceived as arbitrary and nonexistent, because to most Mexicans, Texas was still Mexico. Depression briefly halted the movement, and in the early 1930s federal authorities deported large numbers of Mexican workers, who became scapegoats for the country's unemployment.[16]

For those who remained, mechanization weakened their economic position. Lee found that machinery had reduced the production process (and jobs) by half, yet the labor population remained the same and verged on starvation.[17] Tapping his Public Health contacts, he connected with a local doctor and PHS nurse and traveled with them through Crystal City's Mexican community.[18] Most of the dwellings they explored were nothing more than shacks of scrap wood, metal sheeting, sticks, and mud, with cardboard partitions and ceilings.

In nearly all the homes Lee visited, beds consisted of old blankets and quilts spread on the floor. Chickens roamed freely in the houses. There were inadequate bathroom facilities, which—along with a lack of running water and an overabundance of flies—gave rise to infectious diseases. He met victims of tuberculosis, syphilis, gonorrhea, arthritis, malnutrition, and impetigo. Lee was sensitive to these health problems, having had his own share of afflictions in the field. His traveling and working conditions—long days, lack of sleep, poor nutrition, inferior sanitation, and exposure to contagions—took their toll on his immune system. Periodic colds slowed him down and a few more serious ailments plagued him, including conjunctivitis, a chronic sinus infection (before the widespread availability of antibiotics), a large carbuncle on the back of his neck (likely con-

tracted while photographing skin lesions for the PHS), and a streptococcal infection in his left hand (from the same type of bacteria that causes impetigo).

Whereas Lee possessed the funds to seek medical treatment, the Mexicans he met in Crystal City did not. For example, the tubercular patients he photographed couldn't afford isolated living quarters, which would have minimized the spread of the disease. Many were in the advanced phases.

Aware of the community's high mortality rate, Lee visited a Mexican cemetery in Raymondville. There he found graves embellished with a mixture of secular and religious objects: primitive crucifixes, toys, empty food tins and bottles, shells, glassware, and paper flower wreaths. Lee made a particularly poignant image of a child's grave ornamented with a baptismal certificate, various bottles, glassware, and two small chairs (fig. 64). Chalkware figures of dogs—inexpensive prizes given away at carnivals—sit atop the chairs, facing each other as if in conversation.

64. *Mexican grave. Raymondville, Texas, February 1939.*

The burial rituals intrigued him, and he expressed his wonderment to Stryker: "that was really something with all the decorations on the graves from electric light bulbs to children's toys."[19] Lee's photographs of the Raymondville graves illustrate both the mourners' material poverty and their expressions of grief. The adornments demonstrated to him a devotion that he also encountered elsewhere in the Mexican community, in the form of domestic shrines and altars (fig. 65).

Lee found these shrines in nearly every home, and they usually consisted of a shelf in a corner, with pictures and statues of Jesus, Mary, and the saints. In writing about these home shrines, theology scholar Colleen McDannell observes that the devout without means used cheap and available religious material culture "to thicken their homes against the thinning of their lives by the material deprivation of poverty." Some items displayed included popular sacred imagery of figures such as El Niño de Atocha, San Ramón, and Nuestra Señora de Guadalupe, as well as the Sacred Heart of Jesus, the Good Shepherd, and Our Lady of Perpetual Help.[20] Objects signifying religious commitment—votive candles and rosaries— surrounded the holy images.

Lee was drawn to the shrines on several levels. Visually, he appreciated the home altars as creative expressions. He found the Catholic symbols, iconography, and rituals curious, probably because of his Protestant upbringing. And as details of interior domestic spaces, the home altars were reminiscent of one of Lee's leitmotifs: the display of family photographs.

Like religious shrines, family photographs are physical symbols of devotion—in this case, to one's personal history. To Lee, they created stories within stories, a meta-commentary of his subjects. From his first assignment in Iowa and Illinois in 1936, Lee sought family photographs displayed in homes. In each case, family pictures were not incidental details in Lee's images: he constructed compositions around them and framed their display in a shrine-like way (fig. 18). Occasionally Lee included one or more of the home's occupants with their family photographs but more often he pictured the photographs alone. The portraits hung on walls, rested on mantelpieces, decorated bureaus, and sat atop desks, sideboards, and console radios (fig. 62).

Lee documented interior spaces to inform viewers about his subjects' way of

life. Yet as John Sloan told his students, an artist's portraits also portray the artist. Lee's interest may have been driven by a curiosity with—if not an envy of—settled domesticity. Among people without material wealth, he found familial wealth and tangible connections to the past. Lee's photographs of family portraits bring to mind early daguerreotypes in which a family member holds the daguerreotype of a loved one deceased or far away.

He didn't have those connections with his own family. Although Milton Pope provided guidance and support during his short-lived guardianship, Lee's bonds to his family were largely financial. By the time he joined Stryker's staff, his only known living relatives were his father, Burt Lee, and his grandfather, Charles Werner. Lee's relationship with Charles was cordial but not close. His relationship with his father, on the other hand, remains unclear. After Adele's funeral in 1913, Burt maintained minimal contact with his son, signing off on each guardian. According to Lee, he reestablished contact with his father in the 1920s, while a university student, but gave no more detail than that.[21] Burt had remarried, drifted from job to job and apartment to apartment, and died a widower in 1950 at the age of seventy-eight, a mail clerk living in federal housing in Chicago's Logan Square neighborhood. Lee signed his father's death certificate, and his response to one of the questions suggests other family connections may have been lost to him: in the space provided for the names of Burt's parents, Lee wrote "unknown."[22]

As a cornerstone of his Mexican community series in Southern Texas, Lee surveyed the many agricultural concerns employing Mexicans: spinach in La Pryor, cabbage in Alamo, and citrus near Weslaco.

While in the region, Lee also examined pecan-shelling, an industry where he found egregious employment practices and working conditions. He focused his

65. *Children of Mexican labor contractor in their home. Robstown, Texas. Note the shrine above the children. These shrines, many quite primitive, are found in practically all Mexican homes, February 1939.*

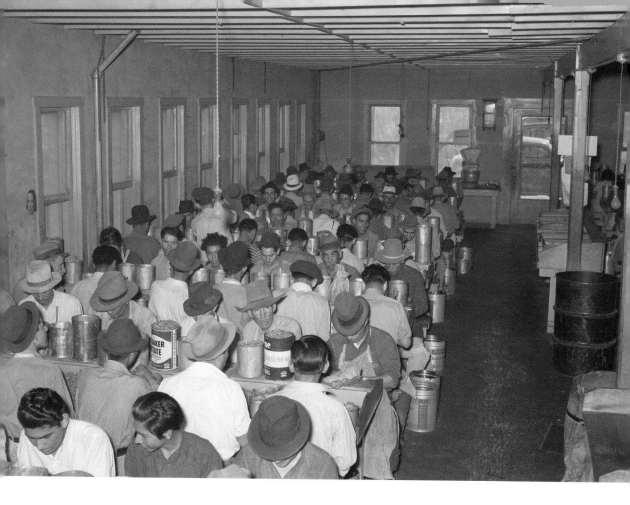

study in San Antonio, the pecan-shelling center of the country, and his series of pictures illustrates the consequences of mechanization on the livelihood of Mexican workers. Lee's 1939 visit came during a period of labor unrest resulting from the industry's rapid transition to mechanization, implemented to avoid meeting the Fair Labor Standards Act and one that put about ten thousand Mexican shellers out of work.[23]

San Antonio had four hundred shelling factories in the late 1930s and half the country's commercial pecans grew within a 250-mile radius of the city. Although mechanical cracking machines had been invented in 1889 and power-driven ones

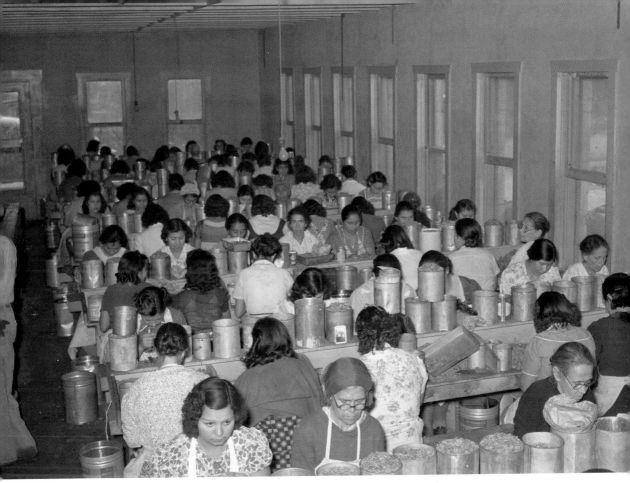

66a–b. Union plant, San Antonio, Texas, March 1939. [a] *Mexican pecan shellers.* [b] *Mexican women pecan shellers at work.*

in 1914, by the mid-1920s companies in San Antonio reversed the mechanization trend by hiring Mexicans, which was cheaper than purchasing and maintaining machines. The Depression drove wages so low that entire families pooled their income for a subsistence living. Moreover, working conditions were substandard, with poor lighting and ventilation. Air inside the factories was thick with fine brown dust from pecans and contributed to San Antonio's high tuberculosis rate, which was three times the national average.

In January 1938, one business—Southern Pecan Shelling Company—announced it would reduce wages from 6 and 7 cents per pound to 5 and 6 cents

per pound (for pieces and halves respectively) and cracker wages from 50 to 40 cents per 100 pounds. The following day twelve thousand pecan shellers walked off the job site. After attracting national attention with a strike led by activist Emma Tenayuca, and confrontations with city officials and company owners (which led to massive arrests), the workers were granted a small increase in wages and the right to unionize. They returned to work in April. By October the Fair Labor Standards Act raised their pay to the national minimum wage of 25 cents an hour, a victory that brought unintended consequences: after a failed attempt to petition for exemption from the Act, factories eventually replaced more than ten thousand shellers with cracking machines.

Lee toured the San Antonio area accompanied by Orin Cassmore of the WPA's Social Research Section. Cassmore, who wrote a landmark study on the San Antonio pecan shellers, introduced Lee to union members, who arranged a tour of the area. Lee wrote to Stryker: "The conditions are pretty bad and I am planning to devote the next two or three days to getting more pix of housing, health, etc. with emphasis on people and interiors."[24] Lee photographed unemployed workers and their families waiting in food relief lines, noting the supplies expected to feed a family of three for two weeks: a small sack of beans and a block of butter. He also visited both union and non-union factories and found miserable conditions. His captions note deficient lighting and his photographs show poorly designed workstations, as laborers sit elbow to elbow on decidedly non-ergonomic backless wooden benches (figs. 66a–b).

Lee's thorough and revealing documentation of the Mexican community irritated Stryker, who was under pressure to show agricultural prosperity. In April, shortly after Lee covered the adverse effects of mechanized pecan shelling on the Mexican workforce, Stryker wrote him that they should "start a series of pictures showing the operation and life on somewhat better farms," what he later referred to as "glorification pictures—not overdone, but still glorification."[25] He implored: "We need these very much, and they will serve a most valuable purpose, to work in with the bad conditions, which you have already covered very successfully." Trying to appeal to Lee's allegiance to the Section, Stryker told him these pictures would be

"protective coloring, you know!" and added in plainspoken language: "And on top of that, what is the use in this whole situation if there is no way out? If the State of Texas has nothing better to offer in farming, then the whole thing becomes hopeless."[26]

Despite Stryker's explicit request, Lee became intractable. As friend and colleague Louise Rosskam recollected: "you couldn't completely orchestrate Russell."[27] Insofar as Lee recognized a solely negative portrait of tenancy would have been untrue, he knew an exclusively positive portrayal of America's agricultural industries would have been equally skewed, embodying all that was negatively associated with government-sponsored propaganda, no matter liberal or conservative.

Just as problems of racial disparity were beyond the FSA's scope, Stryker knew the agency couldn't fix labor displacement in the Mexican community, particularly since federal relief was only available to those who qualified, and Mexican citizens did not. American citizens already had difficulty qualifying for relief because of residency requirements. Drought refugees who migrated to California during the 1930s, for example, only became eligible for relief after a year's residence in the state. Furthermore, the established prejudices against Mexican laborers intensified during the Depression because of job competition.

The problems of the Mexican agricultural community preoccupied Lee to the point of total disregard for any other assignments. He stopped checking in with regional directors who wanted photographs of their state. At the beginning of April, Stryker told Lee that John Caufield (Dallas information advisor) included in his official weekly bulletin a sarcastic clause titled "Port of Missing Men." Caufield wrote that if anyone knew the whereabouts "of the Washington photographer, Russell Lee, who passed through this town two months ago should report same to this office." Caufield added that "there are a lot of pictures which he took that are needed badly by this office. Also, there are supplies in San Antonio addressed to him which have not been called for."[28]

Eventually, Lee acquiesced to photographing the farms in Ralls and El Indio. But his sustained focus on the Mexican community and other problems in Texas continued to be a sore spot with Stryker. A year after Lee's first visit, he was still exploring these topics, and with irritation Stryker told him, "I must say that I can't do much

glorifying out of anything you've taken in . . . Texas . . . As I have told you before, I have come to the conclusion that it is a lousy state, judging from your pictures."[29] Stryker held on to his grievance, which surfaced more than a decade later, when he recalled telling Lee, "If Texas is no better than you make it out, I don't know why the hell you want to stay down there. Will you please get the hell into the next state."[30]

In April 1939, perhaps in an effort to distract Lee with another subject, Stryker suggested he focus on a quintessential American town. Of course, this had been one of his personal documentary goals since becoming Historical Section Chief in 1935. Stryker reminded Lee that he'd "been sending in some small town things, but they have been scattered and I believe now is the time to do an intensive job on it."[31] Four days later, passing through East Texas, Lee found San Augustine.

PORTRAIT OF A TOWN: SAN AUGUSTINE, TEXAS

Stryker's desire to thoroughly record the small town grew directly from a nostalgia-driven impulse to reconstruct the one of his youth, a place he ached to revisit as an adult. He later credited the inception of this pet project to a 1935–36 conversation with Ruth Goodhue, managing editor of *Architectural Forum*, who asked him a series of "proactive questions" about "little towns in America." Goodhue wondered, were they all "alike because they read the same boiler plate, listen[ed] to the same radios on the air, and because they [ate] the same breakfast food?" With his interest piqued, Stryker later said Goodhue's questions were just what he needed, remarking, "I have a very bad habit of writing memos to myself; I love to put things down, write . . . page after page and take it home. . . . So then there grew an outline—a perfect bombardment of 25 pages."[32]

Sparked by Goodhue's questions, Stryker crafted his formal small-town shooting script in consultation with Columbia professor Robert Lynd.[33] Lynd's book *Middletown* (cowritten with his wife, Helen, in 1929) had already become a classic study—in the tradition of the Pittsburgh Survey—of an unnamed town later revealed to be Muncie, Indiana. By adopting *Middletown*'s sociological and

anthropological approach, Stryker believed he'd avoid the romantic myth already forming around the small town, though parts of his shooting script did emphasize the idealistic simplicity of days gone by, with line items for things reminding him of Montrose, such as sidewalk displays, hitching posts, wagons and horses, and "the old swimming hole." Indeed, he readily admitted he "wanted to get back to [his] boyhood . . . to put that in the files."[34]

He continually revised this shooting script, so that by 1939 he had distilled his original twenty-five pages down to eight. "Suggestions for a Documentary Photographic Study of the Small Town in America" proposed a systematic, methodical depiction of a "series of carefully selected towns of about 5000 population." In a cover sheet, he acknowledged that "such an elaborate plan . . . is not now within our sphere of activity" but proposed looking for a set of "common denominators" shared by many small towns.[35]

67. Street scene, Spencer, Iowa, December 1936.

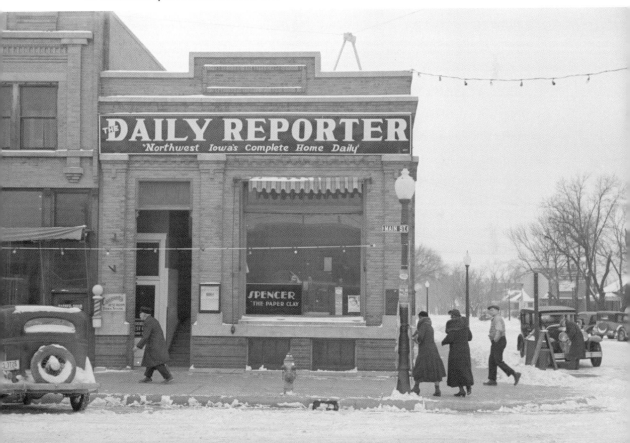

Lee was ideally suited to Stryker's objective. Besides already utilizing a common denominator approach, he understood the features of a small town and shared Stryker's enthusiasm for recording American vernacular. He had captured scenes in dozens of small towns since the winter of 1936 (fig. 67) and corresponded extensively with Stryker about his larger documentary goal. Prior to arriving in San Augustine in April 1939, Lee had already considered multiple places for a comprehensive study, including Black River Falls, Wisconsin; Laurel, Mississippi (which he referred to as a "Middletown of the South"); and his own hometown of Ottawa.[36]

Lee's initial reason for visiting San Augustine was to document the surrounding area's hookworm problem, which the FSA was trying to eradicate.[37] However, he quickly encountered resistance because of the stigma attached to the disease and noted "a great deal of prejudice in this section about the mere mention of hookworm." Lee told Stryker the county nurse almost lost her job for talking about it and "was naturally a little chary of pictures." Lee decided to scrap the assignment "for fear it might cause a little suspicion and make matters more difficult."[38] Instead of documenting hookworm, he decided to photograph San Augustine itself.

Mirroring the Lynds' investigative approach, Lee examined San Augustine via *Middletown*'s categorical framework and broke down the community into its essential elements: Working, Home and Family, Education, Leisure Time, Religious Activities, and Government and Community.

Lee's series also follows in the tradition of August Sander, the twentieth-century German photographer who created a comprehensive, cross-sectional portrait of his country's populace, categorized by social type and occupation. In similar fashion, Lee photographed San Augustine residents in their workplace and identified them by their role or job in the town, rather than picturing them in their homes and identifying them by name as he'd done on previous assignments.[39] Creating a visual schema, he photographed the sheriff, constable, tax collector, city treasurer, county clerk, county clerk stenographer, justice of the peace, fire chief, druggist, department store owner, and minister (fig. 68).

68. *Preacher reading the lesson and instructions before baptism, San Augustine, Texas, April 1939.*

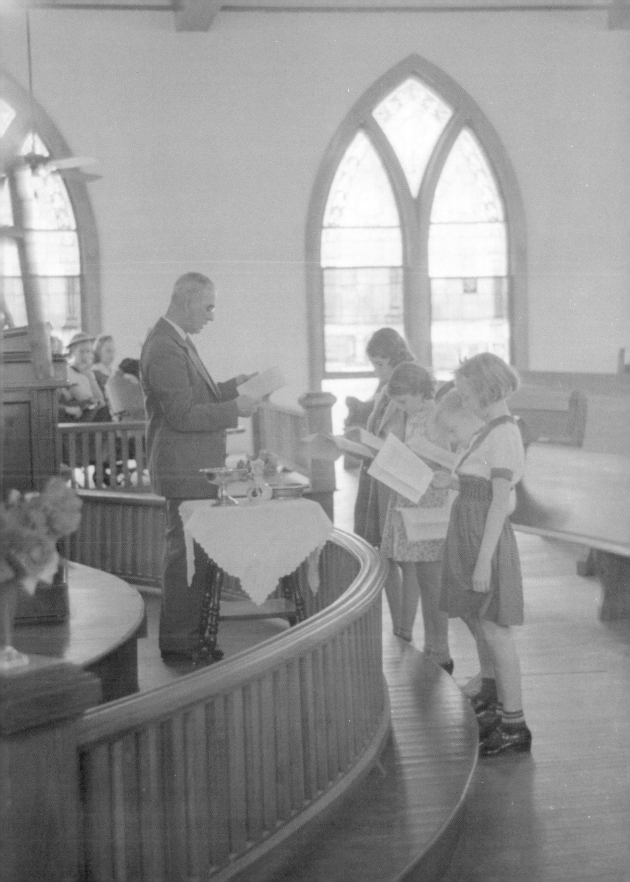

For his primary day of documenting San Augustine's commerce, Lee chose Saturday, when farmers from outlying areas traveled into town to conduct the week's business. Customers select seeds at the hardware store, get measured for trousers, and try on a pair of shoes. Merchants attend to clientele needs: a jeweler repairs a watch; a blacksmith threads a pipe; a barber applies finishing touches to a shave; an auto mechanic greases a car; a druggist mixes a prescription; a tailor presses a coat. Lee photographed the farmers before, between, and after their transactions, as they congregated and socialized at a variety of traditional meeting places and centers of activity, including the town square (fig. 69).

To depict this conventional subject Lee employed a modern perspective, one favored by Bauhaus artists. Taken from the third floor of the county courthouse, Lee's elevated view captures the town's energetic pulse as residents, resembling extras in a movie, pass through on their way to that next errand or gather in groups to socialize. On Columbia Street, cars wait for their owners to return and an itinerant preacher's panel truck warns of "The Fatal Hour." Establishments visible across Columbia include Café Texan, and a combination grocery and feed store. A conventional bronze statue of James Pinckney Henderson, the first governor of Texas, dominates the square.

Activity in front of the courthouse epitomizes the general tenor of the series. For Lee, the town represented a microcosm of rural America at a crossroads, transitioning to modernity as it straddled two centuries. To convey this in his series, Lee turned his camera toward the horse-drawn wagons, handwork, and kerosene lamps existing alongside the automobiles, machinery, and electricity. He recorded aspects of commercial, agricultural, and residential life belonging to a rapidly passing era and peppered his series with indicators of progress. A man not quite ready for the tractor poses outside a hardware store with three new pieces of horse-drawn equipment. Stores boast shelves full of patent medicines, a spike on the wall of a grocery holds bills and credit slips, and a block of ice waits to be put inside an old-fashioned icebox. Alongside these antiquated objects, Lee pictured a modern Linotype machine in the newspaper office and a sign for "Deep East Texas Electric Cooperative Inc." funded by the Rural Electrification Administra-

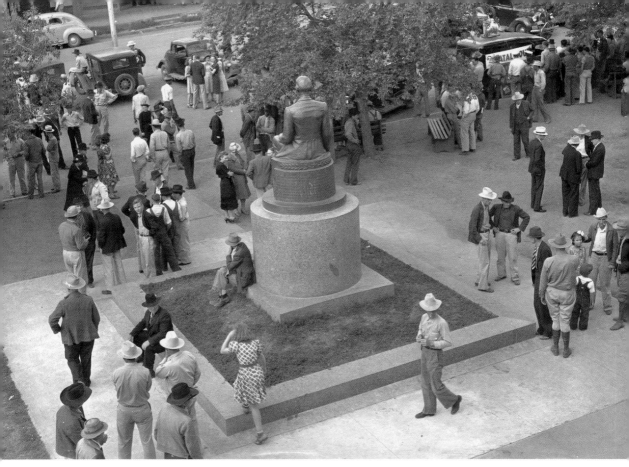

69. *Activity in front of courthouse. San Augustine, Texas, April 1939.*

tion. Near the courthouse, he found cars mingling side by side with horse-drawn buckboards and elsewhere pictured two harnessed mules standing beneath a billboard declaring "Every way I turn, it's Ford V-8."

Lee made his dichotomous portrait of San Augustine during a time when Americans were looking wistfully to an idealized past and optimistically to a modern future. In 1939 audiences flocked to performances of *Our Town* and visitors swarmed the New York World's Fair. Thornton Wilder's play, a nostalgic portrayal of a whistle-stop town at the turn of the twentieth century, resembled American Scene painting in that it appealed to the country's desire for a sentimental return to what seemed the pleasant simplicities of days gone by. In contrast, the World's Fair

was the pinnacle of modernism, with its Trylon and Perisphere, its glimpses of the urban utopia in the World of Tomorrow. Lee's portrait of San Augustine captures a snapshot of a town suspended between the past and the future, between Grover's Corners and Democracity.

Lee's series became a touchstone for the File and significantly influenced Stryker and his small-town shooting script.[40] The work was also well received outside Stryker's office. In November 1939 four photographs appeared on the cover of the *American Teacher,* and in March 1940 *Travel* magazine published seventeen in a story written by FSA associate and native San Augustinian Mark Adams.[41] In October 1940 novelist Sherwood Anderson and File editor Edwin Rosskam used eighteen images in *Home Town,* part of the New Deal photographic book movement. Although America was not yet at war, *Home Town* appeared amid nationwide discussions of decentralization of people, government, commerce, and industry because big cities were considered vulnerable to air attack. The book reinforced the notion of the small town as a nostalgic haven, the fabric of the nation, and the strength of the country.

After America entered World War II, small towns transitioned quickly from hometown to home front and San Augustine was no exception. John Vachon traveled there in April 1943 and captured a changed place, doing its part in the war effort. In Vachon's pictures, Main Street on Saturday morning is no longer filled with farmers socializing and looking over merchandise, but of troop movements passing through town. Defense posters cover the counter at the city clerk's office, a teacher rolls bandages for the Red Cross, the Texas Defense Guard conducts drills in the high school auditorium, and the editor of the newspaper copes with labor shortages.

Armed with Stryker's revised shooting script and intimate knowledge of Lee's San Augustine work, Vachon duplicated many of Lee's original scenes, including farmers looking over seed, residents at church services, buyers at the town's cattle auction, and an "old couple" posed identically to one of Lee's images. Vachon also photographed the courthouse square on Saturday afternoon, this time from the opposite side of the courthouse's third floor. However, in Vachon's 1943 view, the

square sits nearly empty with only a few residents passing through, the majority of the town's citizenry presumably occupied with war work.

AFTER LEAVING SAN AUGUSTINE, Lee continued his statewide survey, returning to Texas three more times over the course of his FSA tenure. Many of his images appeared in the *WPA State Guide to Texas.*

The FSA did improve conditions for some Mexican workers and established migrant camps in Raymondville, Robstown, and Sinton. With America's entry into World War II, opportunities for Mexican agricultural workers swelled when the U.S. government, responding to the widespread farm labor shortage, created an agreement with Mexico allowing seasonal agricultural laborers to enter the country during the war years. These critical workers, known as braceros, ensured continued production of America's food supply. During the war, the FSA recruited and transported braceros to the Arkansas Valley, Colorado, Nebraska, and Minnesota.

Lee's work in Texas affected him both personally and professionally, and for the remainder of his life he continued his advocacy efforts, undertaking many documentary projects and contributing to social causes throughout the state. His post-FSA photographic work included a study of Spanish-speaking people in conjunction with the University of Texas, a series on the State Institutions at Rusk and Terrell for the progressive journal *Texas Observer*, and a series on Austin area children with developmental and cognitive disabilities, taken to use in lobbying for local facilities.

1939–1940

Migrants

Between 1930 and 1940, approximately 4 million people—roughly 23 percent of residents—from Arkansas, Missouri, Oklahoma, and Texas migrated west. Many factors pushed people out, including the decade's lethal dust storms and drought, agricultural modernization, rural depression, and disruptive New Deal programs.[1]

California attracted the largest segment of this outflow. More than one third settled there permanently, while others relocated to Arizona, New Mexico, Oregon, and Washington. The factors pulling people to California weren't simply the leaflets, handbills, and newspaper ads for labor, but also the state's long history of promoting itself as an agricultural paradise. This population shift created labor surpluses, which drove down wages, thus many people found conditions in California worse than those they had fled.

Though they came from four different states, migrants were pejoratively nicknamed "Okies" and became impoverished social outcasts, vilified in the popular media and despised by most Californians, who considered them culturally degenerate, a burden on schools, a threat to unionized farm labor, and a strain on relief services. The state and federal government tried to address the problem with U.S.

Representative John Tolan's committee on migration, which aimed to help these destitute citizens.[2]

As the economy shifted, so too did the nature of migration. War in Europe escalated at the end of 1939 and in May 1940 Roosevelt gave his On National Defense fireside chat, urging listeners to prepare for "the approaching storm" while reassuring them of America's readiness and expanded military production.[3] As defense contracts swelled, U.S. shipyards, airplane plants, and other industries absorbed many of these agricultural workers, enabling them to escape the grinding poverty and farm worker status stigmatizing them. Some opted to continue in the fields, finding ample employment when the war boom created a labor shortage.

Between mid-1939 and the end of 1940, Lee documented both distinct phases of migration: farmers and agricultural laborers in Oklahoma searching for opportunity, and workers rushing to California for the defense industry boom. In between, he also found a group who didn't reach California, but instead stopped partway, in New Mexico, to make a go of it in an area called Pie Town. The itinerant nature of Lee's own life—though privileged in comparison—connected him in multiple ways to the migrant's unrooted existence.

THE GRAPES OF WRATH: OKLAHOMA

Along the highway the cars of the migrant people crawled out like bugs,
and the narrow concrete miles stretched ahead.

John Steinbeck, The Grapes of Wrath[4]

Documentarians began focusing on the plight of the migrant in the 1930s. Most notably, California-based Dorothea Lange recorded drought and dust bowl refugees pouring into her state. After joining Stryker's staff in 1935, she pictured migrants in Oklahoma, at camps in California, and in transit on the highway. With her husband, economist Paul Taylor, she published *An American Exodus: A Record of Human Erosion*, which traced the migrant's journey across the country.[5]

In 1936, John Steinbeck gave a literary dimension to migrant life when he wrote a series of articles for the *San Francisco News* titled "The Harvest Gypsies." In 1937, *Life* photographer Horace Bristol, inspired by Lange's work, proposed a picture story on dust bowl migrants and asked Steinbeck to collaborate with him. Working with the RA-FSA to gain access to the agency's migrant camps, the two men traveled together around California and interpreted their experiences in their respective mediums. Steinbeck's notes from this trip, along with his "Harvest Gypsies" research, formed the core of his Pulitzer Prize–winning novel.

Published in the spring of 1939, *The Grapes of Wrath* became a principal work through which America defined the Great Depression. From the outset, disputes arose attesting to—and refuting—its veracity. Libraries banned it, radio programs debated it, Californians and Oklahomans derided it, and farm associations opposed it.[6] Above all, people read it.

The day Lee left San Augustine he asked Stryker to send him a copy. Assignments in rural America kept Lee far from bookshops, so he maintained a "book fund" in Washington, which Stryker used to purchase volumes on Lee's behalf, then ship them to him in the field. Lee rated *The Grapes of Wrath* as "one of the best books" he'd ever read and proposed making a set of photographs to illustrate it. Writing Stryker that "the whole book is a shooting script," Lee resolved "to pick up as many of the shots that are so graphically told" as he could. With an eye toward the era's photographic book movement—and a desire to capitalize on it—he suggested a quasi-documentary volume: "After the set is complete, I think it might be a good idea to try to tip in . . . several 'illustrations' and see what we can make of it."[7]

Stryker agreed to Lee's plan, even though Lange had already conducted an exhaustive survey across multiple states. Twentieth Century-Fox had just purchased the movie rights and Stryker—always looking to market the File—had in mind a promotional tie-in. He wanted to sell a publisher "on the idea of a picture-book to accompany [the] novel." He told Lee, "I am just bubbling over with ideas about how we can exploit the public excitement over this whole thing . . . We should make all possible capital of it and solidify our position as far as we can."

Stryker was so keen on Lee's proposal that he told him to "drop everything and follow the ideas you have about shooting the material . . . for the next few weeks. We are going to need all the stuff we can get hold of. No shooting script will be needed since, as you say, the book could not be improved upon."[8]

However, Lee's first stab at documenting migrants in Oklahoma was a miscalculated effort before it even began. By starting with an inherently flawed methodology—visually translating a work of literary fiction—Lee disregarded the fact that Steinbeck's scenes, though based in reality, were interpretations of his own personal observations. Also, by confining himself to the book's tight storyline, Lee overlooked the complexities of the migration problem and larger movement patterns in Oklahoma. Caught up in the nationwide mania over Steinbeck's book, he failed to see that by the time it was published, migration trends had already shifted.

Lee's monthlong *Grapes of Wrath* undertaking presented one problem after another. His initial hurdle came in finding a migrant family moving to California. After conferring with University of Oklahoma sociologist Willard Z. Park, Lee narrowed his search to six potential locations, but soon discovered that by mid-1939 heavy migration had slowed. From Oklahoma City he reported, "I don't know that there is much migration at the present moment—one service station man said 10 to 20 families per day along 66—but I have been unable to find more than 1 or 2 so far and they were doubtful."[9]

Lee traveled farther east to Muskogee and made frequent trips in a 50-mile radius in search of a family ready to leave. After false starts by many who told him they were moving but eventually did not, he found the Elmer Thomas family in Webbers Falls. During the week he spent with them he was caught first in a pouring rain then a "terrific thunderstorm," got his car "thoroughly stuck" in a corn field, punctured his gas tank, and had to be "pulled out by mules after a nice walk through the downpour."[10] The resulting series (about one hundred images) is predictable and uninspired.

After his frustrating experience, Lee dropped the project. Instead, he played to his strengths and looked at the Oklahoma migrant situation from a different

perspective. Digging a little deeper, he found western migration to be only a single part of a larger movement cycle—a sinking sequence from tenant farmer to migrant worker—and decided to make that cycle his focus.[11]

Traveling through seven eastern and central counties, Lee shot about one thousand photographs, and the conditions he pictured are among the most dire in his FSA work. With underlying themes of exile, alienation, and dispossession, his images show lives defined by long hours, hard work, and stoop labor: tenant farmers toiling in fields with mules and horses, day laborers (men, women, and children) digging potatoes, picking string beans, and chopping wood.

His subjects suffered debilitating health problems. Mosquitoes and poor sanitation resulted in widespread malaria. Malnutrition and tuberculosis of the spine afflicted children, while rheumatism and tuberculosis of the lungs crippled adults. He found little evidence of medical assistance, either from local physicians or the Public Health Service. His pictures highlight the lack of community or collective spirit, except among the radical agrarian groups and labor organizations he met throughout Oklahoma, including the Southern Tenant Farmers Union, the Workers Alliance (a Popular Front group), and the United Cannery, Agricultural, Packing and Allied Workers of America.

The core of Lee's series considers housing, specifically the migrant encampments he encountered throughout the state. Many were transient, in place for a night or two, while others became semi-permanent settlements.

He discovered prejudice and a definite social order. At one site, he met a day laborer living on the banks of the Arkansas River who considered himself to be "a class above" migrants. Lee noted that this man had planted a small garden next to his tent, not for the value of the garden (since he admitted the sun would get it before the vegetables were mature), but because it would keep migrants from camping near him. He told Lee, "Those migrants don't live the way we do, course they don't have anything to live with."[12]

Other encampments sprouted up on urban outskirts. Lee found one in Oklahoma City, under the Mays Avenue overpass, inhabited by former tenant farmers who had moved closer to the city looking for work with the WPA or as agricultural

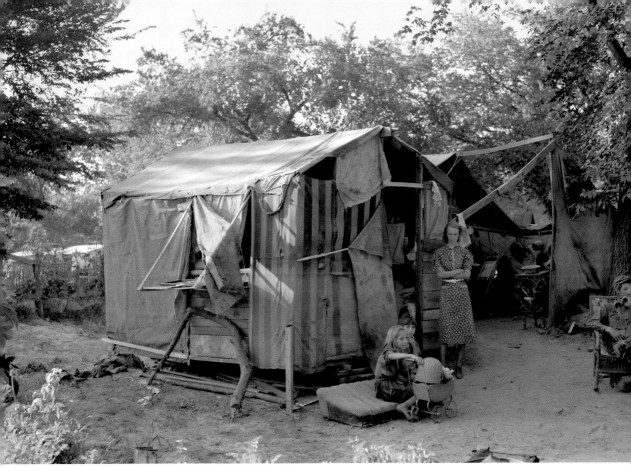

70. *Tent home of family living in community camp. Oklahoma City, Oklahoma, July 1939.*

laborers. The Mays Avenue camp was a miserable place, built on top of a former trash dump and adjacent to a hog wallow.

Lee's gritty images offer a visual equivalent of Steinbeck's descriptions in his "Harvest Gypsies" series. They show people living in make-do shelters, shacks, and tents cobbled together from scraps (fig. 70). Some camped out in the open, with their bedroll on the ground. Others slept directly on dirt. Clothing was threadbare or inadequate: children lacked shoes so that broken glass and other debris punctured the soles of their feet. Most of the food in the camp came from charity, scavenging, or theft. The local hospital donated some and migrants retrieved provisions from trash dumps or the discard pile at a vegetable packing business.

At one tent home, Lee pictured a boy eating an overripe cantaloupe; both were covered in flies. Out of desperation, camp residents stole into the stockyards in the early morning to milk the cows.

Lee found some camp residents who resorted to other means of support, outside what they could find on WPA or as day laborers. One man became a "trasher" (or garbage collector) and Lee found his children, clothed in burlap sacks, playing with the rubbish their father picked up. Others made their living by catching crawfish to sell for bait or by collecting castoff vegetable crates and selling them to their neighbors for building material.

Amid these distressing conditions, Lee found gestures of pride and marks of hope. In a tattered and trash-strewn three-sided tent, a woman pressed an article of clothing on her ironing board. Elsewhere, amid a row of shacks, children set up a "pop stand" made of wooden crates and burlap, where they sold "soda pop" for a penny a cup; both the penny and the pop were likely make-believe.

In addition to these semi-permanent encampments, Lee also visited temporary ones. Near Prague, Oklahoma, he found two migrant families stopped along the road under the shade of a tree. In contrast to Mays Avenue residents, both families were well provisioned and mobile. One prepared an evening meal of fatback and potatoes while the other worked on their automobile. Lee watched them block up the front wheel, remove the crankcase, and put bolts in the connecting rod. He noted that a member of the second family was a migrant steeplejack and "when he secures a job, the entire family, consisting of his father and mother, and wife and sister, all help with the painting."[13]

While interacting with the steeplejack's family, Lee created one of the most evocative images in his Oklahoma series: *Migrant worker looking through the back window of automobile* (fig. 71). Lee captured the steeplejack's sister as she paused in the backseat of the family car and glanced over her shoulder, through the car's rear window, beyond the picture plane. It's another of his frame-within-a-frame compositions, a visual device he favored (figs. 1, 8, 27, 34, 35, 50a–b, 76, 100).

By picturing her within the automobile, Lee created a universal migrant por-

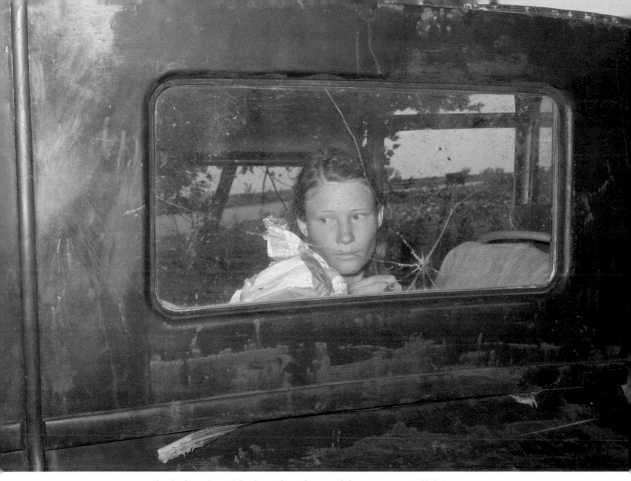

71. *Migrant worker looking through back window of automobile near Prague, Oklahoma, June 1939.*

trait. The car, a symbol of the highway, will transport this family to their next opportunity. With careful attention to detail, he used his flash to highlight the vehicle's dents, scrapes, and cracked window, and juxtapose them against the young woman's delicate features and apprehensive—yet hopeful—expression. His image calls to mind Steinbeck's narrative and some of its broader themes: work, displacement, transience, and uncertainty. The migrant experience.

BY THE FALL OF 1939, Lee's very public affair with Jean troubled FSA administrators, so much so that eventually Stryker pressured them to marry. Jean later

recalled that a man "from the state department" visited them in the field to ensure they did.[14]

In October, Lee went to New York for a legal separation from Doris, then made arrangements for a divorce in the popular and fashionable Mexico City, where the proceedings were called "migratory divorces." Meanwhile, Jean returned to Dallas and divorced George Martin. In December, soon after their divorces were settled, Russell and Jean wed in Mexico.

Lee's new marriage seemed to suit him. He wrote to Stryker, "Jean and I are getting along fine together—she's just the gal for me."[15] The marriage also pleased Stryker, who wrote to Lee, "Terribly glad, old fellow, that this is all straightened out, and that you and [Jean] are married. It is going to mean a lot to you. My sincerest good wishes go to both of you."[16]

Russell and Doris maintained an amicable relationship. Lee told Stryker: "Doris and I still correspond but it is a correspondence between friends and nothing more. My only regret is that I did not make the break with her long before I did."[17] Doris never married Arnold Blanch, though they presented themselves as husband and wife, living and working together for the next three decades. The foursome—Doris, Arnold, Russell, and Jean—socialized together over the years, and Doris and Russell remained in touch until her death in 1983.[18]

EXPRESSING THE ESSENCE: PIE TOWN, NEW MEXICO

Between April and October 1940, Lee documented a small migrant community in Pie Town, New Mexico. Over the course of three visits, he made about 730 photographs, for what has since become his best-known body of work. Yet, despite being the most frequently discussed and widely published of all his FSA photographs, Lee's Pie Town series is also his most misunderstood because critical aspects have been overlooked and outright misconceptions have been perpetuated. A closer examination of this image group sheds light on the era's accepted conventions for documentary practices and the complexities of Lee's

photographic approach, as well as his devotion to Jean and her journalistic aspirations.

Pie Town folklore begins with Lee's accidental "discovery" of the community, a myth created by Lee himself. In the 1960s, he told an interviewer that he and Jean "just happened to find it" because they were driving through and "stopped . . . at the café for a piece of pie." In the 1970s, he said the odd name on their road atlas intrigued them enough to go and find it.[19] Lee's recollections make for a good story, but his visit was more calculated.

In fact, Lee initially learned about Pie Town in August 1939, shortly after finishing his Oklahoma migrant study. An FSA field contact told Lee about a group of migrants in a remote part of his region who had left Oklahoma and Texas and established a homesteading settlement in Catron County, New Mexico.[20] Lee did some reconnaissance in April 1940, then wrote Stryker of his discovery, characterizing Pie Town as "one community we must cover," telling him a store owner he met there "called it the 'last frontier' with people on farms ranging [from] 30 to 200 acres—some living in cabins with dirt floors—others better off, but all seemingly united in an effort to make their community really function."[21]

Drawn to the American homesteading archetype and intrigued by such an experiment, Stryker gave Lee the go-ahead to cover the town, but warned him to look at it critically: "I suppose the storekeeper was right—a 'last frontier.' I suspect you had better look pretty carefully under this phrase. Sometimes we get fooled by these 'last frontiers.'"[22]

The Pie Town region was one of the final areas in America open for homesteading in the early twentieth century. With the Homestead Act of 1862, any citizen could claim 160 acres of surveyed government land. Homesteaders had five years to "prove up" their claim, which meant completing three criteria: building a house, improving the land, and growing crops or raising stock. If the original filer stayed five years, the government deeded the property free and clear. By the early 1900s, much of the country's prime alluvial land had already been claimed, so to encourage homesteading on more marginal land the Enlarged Homestead Act of 1909 increased the number of acres from 160 to 320.

Homesteaders began moving into the Pie Town area as early as 1913, with a large incursion a few years later that included many World War I veterans, and another influx in the early 1930s.[23] When the Taylor Grazing Act repealed the Homestead Act in 1934, settlers were still able to stake their claims due to a provision for some Western lands, including the rugged terrain surrounding Pie Town, considered ill-suited for grazing because of its high altitude and poor soil.

Most people streaming into Pie Town in the 1930s came from Texas, Oklahoma, and elsewhere in New Mexico on their way "west." Attracted by the reputedly simple, agrarian self-sufficiency of homesteading, many hoped to stake a claim.

When Lee arrived in 1940, about two hundred families lived there. Despite more than twenty years of settlement, the area still resembled a nineteenth-century frontier town and had no telephone, electricity, or running water. Lee checked into the Pie Town Hotel and told Stryker, "it certainly looks like the last frontier here—even the hotel rooms are furnished with only a bed, a table, a chair and a 'thundermug.' No baths are available."[24] Hotel guests used the public privy across Highway 60 during the day and a ceramic lidded chamber pot (a thundermug) in their room at night.

Lee made a photographic sweep of the community, emphasizing hard work, determination, ingenuity, and cooperation. Reminiscent of his San Augustine series, he employed the same *Middletown* categorical framework of Home and Family, Work, Education, Leisure Time, Religious Activities, and Government and Community, but told much of the story of Pie Town through a cross section of residents. He focused on four families (Whinery, Hutton, Leatherman, and Caudill) to chronicle the various steps in establishing a homestead, the challenges and hardships settlers encountered, and the solutions conceived to solve the many problems of living in such a community. These included building a house, grubbing out native rabbit brush, removing rocks, stones, and trees, and working the rough terrain for dryland farming.

With picturesque and bucolic imagery, he idealized the pioneer farmer, an archetype that New Deal historian Alfred Haworth Jones described as a representative of "American character . . . for twentieth century citizens . . . [who] cherished [the] frontier penchant for tackling problems head-on. And like him, they

believed that solutions lay close at hand." The same Americans who acknowledged the "forgotten man" of their own time also recognized their nameless ancestors who toiled in the fields and factories. [25]

Lee's word choice and tone in his captions romanticized life in Pie Town. In contrast to other self-constructed communities where Lee depicted resourcefulness and repurposing as signs of destitution—cutover farmers in Wisconsin, drought victims in North Dakota, pecan shellers in Texas, migrant workers in Oklahoma—in Pie Town he presented it as a source of pride and matter of principle. He transformed their struggles into an enchanting way of life. Noting that "these homesteaders never buy anything that they can make at home," he pictured a handmade baby crib, a tractor adapted from a truck, a quilt sewn from tobacco sacks, and a makeshift refrigeration system using rapid evaporation.

Lee's photographs also show his fascination with a community bound by fellowship. He depicted various gatherings including a square dance, an "all day Sunday visiting," a pot-luck supper, and a community sing. He made portraits of homesteaders who "always [have] time to help a neighbor build a dugout or do any other heavy work," or "[donate] . . . services as a preacher to the church." He noted a farmer, who was one of the few with a tractor, "planted his own beans at night so that he could also plant for a neighbor who was sick."[26] Just as he was drawn to family photographs as symbols of the connections people maintained with each other, he was captivated with the sense of unity he found in Pie Town.

LEE, STRYKER, AND JEAN were all enthusiastic about the Pie Town series and over the summer of 1940 each put significant time and energy toward getting it published. Stryker shopped Lee's photographs around and found significant interest; after fielding several offers, he extended first right of refusal to *Collier's*.[27] At the same time, Jean wrote a six-thousand-word, fictionalized article, which Lee wanted published alongside his photographs. With this stipulation, though, *Collier's* ultimately rejected the pairing: despite their embrace of Lee's photographs, they did not want Jean's article.

This wasn't the first time Jean crafted something to accompany Lee's photographs, nor was it the first time her writing attracted criticism. Shortly after she began traveling with Lee in the fall of 1938, she composed articles, editorials, and short stories, and though they considered the same subjects Lee photographed, they were more like magazine features.

Jean wrote in the informant narrative style popular in the 1930s. This genre (which Lee emulated in his trio of Soviet Union articles) was also called worker narrative, folk writing, vernacular literature, notes from a diary, Letter from America, or a personal experience. The "I've Seen America" type of book, a novelty in 1935, became the decade's dominant nonfiction genre; the best-selling one was Louis Adamic's *My America*.[28] It was in this style that Jean wrote of her country-wide travels with Lee, and she composed many of her articles as first-person news, like Eleanor Roosevelt's "My Day" column and Ernie Pyle's roving correspondent reports. Yet Jean's writing suffered from disorganization, distracting grammatical errors, inconsistent tenses, and forced phonetic dialect.

Jean also composed what she perceived to be socially relevant fiction, but that came off as noticeably contrived or was otherwise problematic. For example, she penned a story about intrastate migratory workers in Hammond, Louisiana, from the perspective of a White Southern woman whose Black cook deserted her to work in the strawberry fields, which one FSA scholar has since criticized as bringing "the wrong sort of racial 'interest' to [Lee's] attention."[29]

Despite repeated rejections, Lee stood behind Jean's writing and eagerly updated Stryker on her many articles, sending along copies for his review. But Stryker didn't share Lee's enthusiasm. In fact, a thorough reading of their correspondence reveals that Stryker eventually became frustrated with Jean's journalistic pursuits, which he believed competed with his quest for advantageous publication of FSA photographs. A struggle developed, one that came to a head on the Pie Town story.

In writing to Lee of *Collier's* rejection in September 1940, Stryker soft-pedaled it at first. He blamed other factors, including the country's imminent involvement in the European war. He told Lee he believed "if [*Collier's*] could have had an arti-

cle written in their style, they would have taken it without any question." Stryker continued, "National Defense is upsetting all kinds of schedules in the publishing field today—that and the European situation."[30]

After a day's reflection, though, Stryker appears to have felt a sense of urgency in getting Lee's series out before interest waned in favor of National Defense. He wrote again, "I think now is the best time to get the Pie Town stuff used. I am going to take a set up to New York, and talk to the *New York Times* about it when I go next week. The main difficulty is getting the type of article that will please these various magazines." In this letter, he spoke bluntly about *Collier's* rejection: "As I told you in my last letter, the *Collier's* people were very critical of Jean's presentation. They said they couldn't consider it without having it completely rewritten. The *New York Times* might like it, or they might decide they want it in an entirely different way." Stryker concluded, "I am more and more convinced that our job is to get the pictures, give brief stories, and let them take care of the writing. I want to talk this over with you when we get together. It is a serious problem that we have to face."[31]

Ignoring Stryker's remarks and concerns, Lee continued promoting Jean's article as a requisite part of the Pie Town story, writing Stryker that he and Jean could rework it for the *New York Times*: "It will be relatively easy for us to rewrite the article along the lines that they might indicate. If there is any particular phase that they might be interested in we feel that we have sufficient information to develop it."[32]

Lee spent nearly a year trying to publish the article with his pictures, and Jean rewrote it at least two times; three different versions are known to exist.[33] By April 1941, after having spent February and March in Washington with Stryker, Lee recognized that if he wanted his Pie Town series published at all, he'd have to let go of Jean's article.

Stryker used his connections at *U.S. Camera* to place the Pie Town photographs—with an article by Lee—in publisher Tom Maloney's new monthly magazine. Maloney had already published FSA photographs in his *U.S. Camera* annual, including the twenty-three-page section curated by Edward Steichen in 1938. As a technical publication, though, *U.S Camera* monthly had a more limited audience

than either *Collier's* or the *New York Times*. Photographers made up its primary readership and so much of Lee's text outlined the types of cameras, films, and flash equipment he used.

Lee's article and forty-five of his Pie Town photographs appeared in the October 1941 issue. By then, as Stryker feared the previous fall, publications had already shifted focus to National Defense. The cover was a patriotic red, white, and blue, and the war in Europe and impending U.S. involvement dominated the issue with prominent features such as winning entries in its "V for Victory" contest, photojournalistic coverage of the Blitz in London, and "Posters for Defense."[34] Lee's Pie Town pictures appeared quaint, irrelevant, and out of touch.

U.S. Camera is widely thought to be the first publication of Lee's Pie Town photographs, but two other periodicals had picked them up in June 1941. The *New York Times Magazine* ran a photograph of the community sing in a folksong article, though the magazine reversed the image and didn't credit Lee.[35] And four Pie Town pictures appeared in the Sunday newspaper supplement *This Week*.

After *Collier's* rejected Jean's article in the fall of 1940, Stryker turned her copy over to his friend and colleague Edward Stanley, executive news photo editor of the Associated Press, "in hopes that he [could] swing an article for *Reader's Digest*."[36] After *Reader's Digest* took a pass, Stanley continued to shop the article and photographs around, eventually finding interest from *This Week*. In what was surely a blow to Jean, Stanley completely rewrote her article and published it under his byline, though he did pay her for the story.[37]

PERHAPS THE MOST COMPELLING dimension of Lee's Pie Town series is a group of seventy-two Kodachrome photographs. These color images signify a milestone in his documentary approach, speak to a critical aspect of thirties documentary photography, and suggest the effort he expended to get the Pie Town series published.

From 1939 onward, the FSA (and later the OWI) periodically experimented with the new Kodachrome technology, and Lee was among some twenty FSA-

OWI photographers to use it. To twenty-first-century eyes, the FSA color transparencies are startling because they challenge our established knowledge and collective memory of the era, shaped largely by the File's black and white images. Early Kodachromes also convey a sense of immediacy, which photography critic A. D. Coleman has characterized as "less like reports about reality and more like actual slices of the real."[38]

Lee initially approached color as subordinate to his tried and true black and white. His earliest surviving color work dates from his Oklahoma migrant series in July 1939, when he photographed a square dance in Pittsburg County.[39] Evidence shows he first photographed scenes in black and white, then immediately re-shot them in color.

Nearly a year passed before Lee used color again, possibly because of the extra expense or Lee's dissatisfaction with his square dance pictures, which now have a pink cast, likely a result of Kodak's "controlled diffusion" film processing method, which affected the stability of the dyes. In June 1940 he shot two color photographs in Pie Town, of a storefront on Main Street and a resident posing with her red, white, and green state quilt. With these two images Lee repeated the approach he used a year earlier in Oklahoma: black and white first, then color right afterward.

Lee continued experimenting with Kodachrome in the summer after he left Pie Town. His confidence grew and in early September he photographed Colorado's Delta County Fair exclusively in color.

In contrast to most of the era's color views—slick advertising or Hollywood glamour shots—Lee refrained from making color the subject of his work. Instead, he used color to reveal more documentary detail and texture, such as a stream in Ouray County, Colorado, rendered yellow by tailings from a nearby gold mine. In this way, Lee's color work stretched contemporary boundaries of photographic expression. Photography critic Andy Grundberg has observed that the FSA photographers challenged the limited ideas about color and attempted to "create a vocabulary for the descriptive use of color [that] ran counter to—and transcended—the color conventions of the day." Grundberg notes, "The FSA transparencies are neither overly nor overtly colorful. If there is a green sign in a picture, its 'greenness'

is simply there, receiving equal weight with the words printed on it. The picture is not about greenness, nor is it organized around greenness."[40]

At the end of September 1940, Lee returned to Pie Town for the community's annual fair, which he photographed exclusively in color. The richly saturated jewel tones were the result of Kodak's innovative "selective re-exposure" method in the reversal stage of development, which resulted in a color transparency with superior long-term stability when stored under suitable conditions.

Lee's pictures of the Pie Town Fair denote the same rich sense of community that characterized his work there the previous summer. He included various components of the fair, including agricultural exhibits, souvenir vendors, food concessions, a rodeo, and a free barbecue dinner where Lee captured a meditative and thoughtful vignette, *Saying grace before the barbeque dinner* (fig. 72).

72. *Saying grace before the barbeque dinner at the Pie Town, New Mexico, Fair, October 1940.*

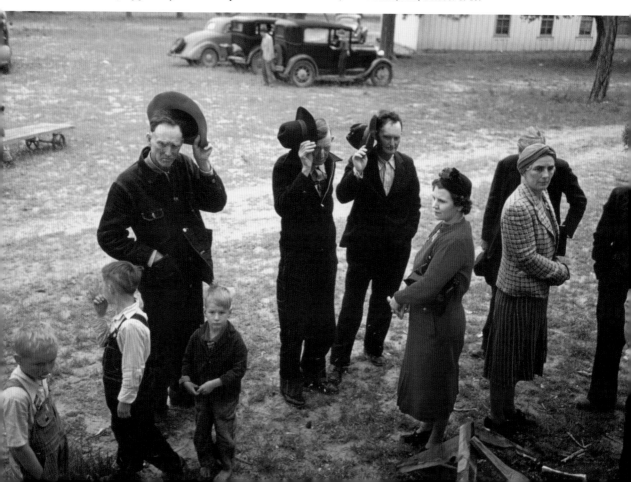

At once old-fashioned and modern, Lee's image depicts a traditional scene in a new way, with an unusually framed composition and an equally unexpected angle. Standing atop a chair or table, he captured an assemblage of residents dressed in their Sunday best, pausing to give thanks for their meal. Lee's perspective allows us to see both the crowd filling the foreground and the recently arrived visitors dotting the background. His subjects wander out of both sides of the frame, imparting a sense of movement that keeps the eye circling clockwise, from left to right and back around again. The unlit fire in the lower right corner suggests the festivities will continue into the night.

Lee captured gestures of respect and reverence: the three men have removed their hats, and the two women have clasped their hands in front of themselves. Though the group stands together, each person appears isolated: no one looks at anyone else or at the camera, save a redheaded, barefooted boy in a red shirt and brown jacket, who pauses to look up at Lee with a bit of curiosity. Lee's view of this sacred ritual bespeaks solemnity rather than religion, for though his title indicates otherwise, he eschewed showing the actual act of saying grace and instead focused on the crowd listening to it. For Lee, an astute observer of human nature, "saying grace" was a quiet moment rather than a liturgical activity.

The snapshot aesthetic and feelings of isolation in *Saying grace before the barbeque dinner* in many ways prefigures the next generation's photographic style. Indeed, journalism scholar Nicholas Lemann has observed that this image presages Robert Frank's photographic book *The Americans* (1958).[41]

Just as Lee's innovative work at the Pie Town Fair countered traditional 1930s ideas about color, another group of Kodachrome images he made that September challenges popular notions of documentary photography. These pictures duplicate his black and white work from June and are so alike in content and composition that viewers have naturally presumed Lee created them simultaneously.

In advance of Lee's September visit he coordinated with Stryker to send ahead a selection of black and white prints—what he considered his cornerstone images—to exhibit during the fair. He "tacked them on the walls [of the Farm Bureau building] for everybody to see."[42] With these as a road map, and two cameras loaded

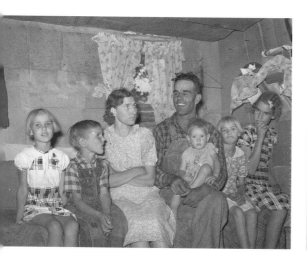

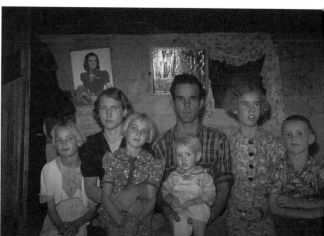

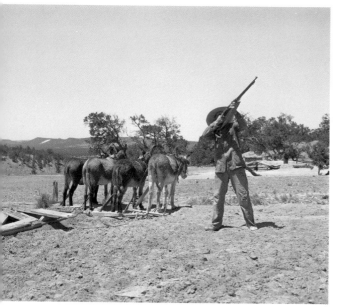

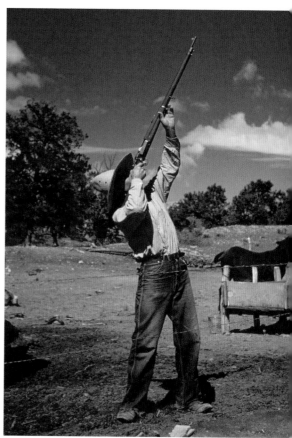

73a–d. Pie Town, New Mexico. [a] Mr. and Mrs. Jack Whinery and their five children in June 1940 and [b] October 1940. [c] Mr. Leatherman shoots a chicken hawk in June 1940 and [d] October 1940.

with Kodachrome, he re-photographed multiple black and white scenes from the previous summer. For example, in June Lee photographed Jack Whinery and his family seated in a corner of their dugout, then reshot it three months later in color (figs. 73a–b). Slight differences show the time lapse: the seating order has changed, the family wears other clothing, and the background is different.

Lee also repeated action shots. At Pete Leatherman's farm in June and September he photographed Leatherman shooting at hawks that were carrying away his chickens, his rifle aimed at the upper right corner of the image frame (figs. 73c–d). Lee conducted similar reshoots at the Whinery and Caudill homesteads.

This segment of Lee's color Pie Town work highlights a critical aspect of FSA photography: that in the 1930s posing, staging, reenacting, or otherwise manipulating a scene were accepted image-making conventions and the FSA advocated them if an effective image resulted.

Posing was common—often inescapable. For Lee, it was a way to fine-tune his composition by situating his subjects close to a focal point such as a painting or family portrait (figs. 59, 65). Posing also allowed him to accentuate a particular aspect of his subject—such as a homesteader's arthritic hands or a lumberjack's bandaged eye (figs. 17, 41a). Furthermore, it enabled him to include multiple people in a shot (figs. 15, 16, 73a–b).

FSA photographers also employed a practice they referred to as "staging." Though today the term has taken on an unfavorable meaning, at that time it was regarded as a more elaborate form of posing. In a 1943 article, "Documentary Photography," Stryker advocated staging as a viable technique. If it looked "real" or "true" it was defensible, even if the activity—such as canning—was out of season. Stryker instructed his readers: "Put a real fire in the stove and, if possible, some real fruit in the pot. Before you know it, your model will forget that she is posing or that you are in the kitchen with that terrifying instrument that has a lens in front." Stryker assured readers the model will "get interested in what she's doing rather than in the way she looks when she's doing it, and you will get a picture at least as true and lively as any candid shot. And a better composed one at that."[43]

Lee had no problem with staging. While in North Dakota, he received a shooting script for Archibald MacLeish's book *Land of the Free* and informed Stryker he would "have to stage" one of the requested images: a kitchen window stuffed with towels to block out the frequent dust storms.[44]

Yet staging had limits of acceptability, and photographers who crossed the line sparked a reprimand from Stryker and sometimes a controversy in the press. Many times, it came down to how realistic the image looked. In Stryker's mind, staging was okay as long as it wasn't, in his words, "too posed." For example, in 1936, he asked Rothstein to photograph Debt Adjustment Committee members at work "even if staged" but then criticized what Rothstein sent in: "it looks a little bit too posed . . . men [with] fountain pens in their hands poised for writing . . . would be unlikely in an actual situation."[45] On another assignment, Stryker again asked Rothstein to "do a little staging" but added that if the pictures "aren't good, you may look forward to having your ears knocked off."[46]

Some uses of flash arguably fall into this category. In an article on techniques Lee praised Rothstein's use of an extension wire and single bulb to mimic a campfire as "a clever bit of staging."[47] Yet, Lee shunned some techniques—namely multiple flash—if it made the scene look fake or resembled a "stage set."[48] Stryker believed Lee went too far in Pie Town when he used a flash to photograph a man reading by lamp light. He wrote Lee that his "flash shots gave a completely unnatural illumination" which "made the picture look a little bit ridiculous—here was a man obviously struggling to read by this poor light—and yet the room was almost as brilliant as daylight."[49] Years later Stryker recalled telling Lee, "For God's sake, I'm sick of dishonesty! If you're going to take a picture at night, take it at night, but don't take it anytime like this and then try to tell me it's night. And don't put that lamp in there like that."[50]

Reenacting or repeating a scene was also fair game, though this practice was a bit stickier, and became more so over the decades, especially for Rothstein. Besides his steer skull photographs taken in the Badlands, his famous image of a farmer and his sons walking in an Oklahoma dust storm has been marred by controversy, fueled in part by Rothstein himself. In 1943, he included this photograph in his article "Direction in a Picture Story" (published in the same volume as Stryker's

article advocating staging), and though Rothstein didn't explicitly state that he asked the group to repeat their difficult trek in front of his camera, he implied it. He used this image as the key example to illustrate the following point: "The repetition of a scene before a different background with some changes in gesture or direction of movement will sometimes result in a more effective picture." Furthermore, he detailed how he managed the action, down to asking the youngest boy to "drop back and hold his hand over his eyes" and the farmer "to lean forward as he walked." Rothstein reasoned that, "Provided the results are a faithful reproduction of what the photographer believes he sees, whatever takes place in the making of the picture is justified."[51]

The passage of time brought a sharp change in attitude—and forthrightness—about setting up or otherwise manipulating a scene.[52] This is reflected in Rothstein's amended accounts of how he made his famous dust storm photograph, for as notions about documentary truth shifted, so, too, did his story. In 1961, for an article in *Popular Photography* magazine, he made no mention of directing the scene, instead writing that he captured a spontaneous moment.[53] Fifteen years later, he decided it was "important to discuss a misunderstanding" about his conflicting accounts and explained that the confusion came from a grammar switch made by the editor of his 1943 article.[54]

Rothstein has been singled out, but many FSA photographers have acknowledged controlling, directing, or otherwise manipulating elements of their images to varying degrees. Peter Sekaer, who worked briefly for the FSA, described how he instigated a tussle among a group of boys for a better picture. Marion Post Wolcott wrote to Stryker about "staging" and "faking" things that were out of season. And Dorothea Lange moved and removed items in her Migrant Mother series, both before and after the photographs were made. She moved aside a pile of clothes and directed the children to turn their faces from the camera; once the negatives were developed, she retouched the most famous one by removing the mother's thumb from the foreground, which Lange felt was distracting. Walker Evans did not admit to manipulation, famously saying, "you don't touch a thing." Yet, scholars have since determined that Evans did tamper with some of his scenes.[55]

Like Rothstein, Stryker switched his public stance, becoming more circumspect about manipulation. Whereas in his 1943 article he applauded the benefits of staging, by the 1960s he became guarded about its use in FSA photographs. For example, in an interview with a journalist Stryker confided—off the record and in a hushed voice—that Rothstein had staged his famous photograph and asked the farmer and sons to walk in front of the cabin a second time.[56] Staging had become unmentionable. It's therefore not surprising, given the controversies dogging Rothstein, that Lee didn't discuss recreating some of his Pie Town scenes when the FSA color photographs became widely publicized in the 1970s. Since then, the subject of documentary ethics and "honesty"—particularly within the FSA work—has prompted considerable debate among scholars and journalists. Some have taken a reductive view—that any intervention is suspect—yet the concept of "authenticity" is nuanced, sometimes elusive, and the line between "truthfulness" and "fakery" can be a slippery one.[57] As Stryker expressed in his article, truth in documentary photography is "a balance of a lot of elements."[58]

That many of Lee's color Pie Town images are recreations doesn't diminish their veracity. For him, they weren't fabrications, but retellings, with photographs so uncannily similar to the black and whites most viewers have presumed them to have been taken moments apart. Although he didn't highlight the fact that he shot these color images three months later, he didn't hide it either: they're dated October 1940.[59] And all of his scenes are seasonally appropriate. In other words, he didn't try depicting spring or summer activities in the fall: his black and whites show homesteaders planting crops while his Kodachromes capture the harvest.

Jack Delano spoke for many of his FSA colleagues when he later defined his approach to manipulating a scene. With insight and eloquence, Delano said he would move his subjects to better compose the photograph but didn't believe doing so "in any way detracts from the documentary value of the photograph because that isn't what 'documentary' means to me. It isn't something you happen to see, a documentary photograph is an expression of the essence of what you are seeing."[60]

WITHIN LEE'S ENTIRE BODY of FSA work, re-photographing an assignment—let alone re-shooting it in color—is unique to Pie Town. Even when Stryker asked him to retake scenes from his Southeast Missouri Farms series after the film was ruined by improper development, Lee did not reshoot.[61] The Stryker-Lee correspondence makes no mention of Lee's decision or motivation to reshoot Pie Town, but the timing and subject matter suggest it was part of his determined effort to interest a magazine by creating a more marketable product.

Just before Lee arrived in Pie Town in September 1940, he learned *Collier's* had rejected Jean's article, yet he hadn't relinquished hope that it could be published elsewhere. Knowing some magazines were beginning to print color photographs, he may have wanted to sweeten the deal with color pictures. Lee had already done this the year before: when documenting an irrigation project "300 miles from Amarillo," he wrote Stryker, "I decided to take some [photographs] in color because there is a good chance for an article in *Collier's*."[62]

In similar fashion, over a two-day period in September 1940, he replicated in color at least sixteen of what he considered his essential black and white Pie Town scenes, and for good measure, also shot some highly stylized views—what Stryker called "front cover" or "come-on" pictures, such as his view of the red, white, and blue filling station and garage (fig. 74).

His choice to highlight the building's patriotic color scheme also suggests an effort to appeal to publishers' growing interest in National Defense.[63] In the three months since Lee's last visit, the tenor of the country had shifted and National Defense was in full swing. In May, President Roosevelt requested an enlarged army and expanded air fleet and spoke directly to America in his On National Defense fireside chat. By August, Congress appropriated $16 billion in defense spending and enacted the first peacetime draft in U.S. history. At the beginning of September, Americans listened to Edward R. Murrow's nightly broadcasts of the London Blitz. As war mobilization dominated the news, publications adjusted their whole approach.

Just before Lee's September visit—after repeated rejections from *Collier's* and

74. *Filling station and garage at Pie Town, New Mexico, October 1940.*

other publications—Stryker suggested spinning Pie Town as a National Defense story. He proposed Lee pitch a book to the New Mexico Writers' Project in Santa Fe, telling him, "I think now this is our best bet to get the Pie Town stuff used." He advised Lee to play up the patriotic angle, using "a little of the same technique" that Stryker tried "in selling the Pie Town pictures to the newspapers." He told Lee to say that here were people "who have made good when given a chance—real Americans—pioneer spirit still lives—etc., etc." Stryker added, "You'd just as well put a little National Defense angle into it, too."[64] But the Writers' Project took a pass, even with the promise of color work.

Despite their repeated efforts, Lee and Stryker never found a press outlet for

the Pie Town Kodachromes. In fact, none of Lee's color images (or those of his FSA colleagues) were published during the active years of the File. Photo historians have speculated that this was because the color work was ahead of its time and didn't conform to the era's editorial expectations for color photography—as sleek and decorative—and therefore wasn't viewed as the kind of imagery that merited the cost of color printing.[65] The FSA color photographs remained unpublished for nearly forty years. When they attracted attention in the late 1970s as so-called forgotten documents, they played a key role in the resurgence of Lee's Pie Town work.

WHEN COMPARED WITH numerous oral histories of residents, Lee's photographs of Pie Town—both black and white and color—accurately capture life in the community at that time. But Lee did exclude some less appealing details of frontier existence. For example, he omitted from his captions the chronic rat problem that plagued homesteaders living in dugouts.[66] And he didn't mention the obstacles not easily addressed by ingenuity or hard work, such as the lack of medical facilities: residents had to travel hours to see a doctor or dentist. The area also had insufficient schools, so parents transported their children miles away to the few that existed or left them with families in larger towns over the winter months.[67] Within a few years of Lee's visits, the homesteading experiment at Pie Town failed and the town largely disintegrated.

Two main factors brought about an end to the Pie Town Lee depicted. The climate of the area ultimately worked against homesteaders: in the early years of settlement, winter moisture was adequate for crops, but annual precipitation diminished, becoming too sparse to grow much of anything. By happenstance, the second catalyst of Pie Town's quick decline was also the next phase of Lee's migrant study: America's rush to defense factories and shipyards on the West Coast.

FROM DEPRESSION TO DEFENSE: SAN DIEGO, CALIFORNIA

The road of defense spending runs, loaded with more people than Joads, west to California . . . Men . . . were moving before the big defense spending began. Now money which builds planes has moved other men, too. But even where the boom in the building in airplanes has multiplied both jobs and wages, people moving to San Diego are found living in little surrounding towns. Some of them prefer tent life to paying high rents.

Jonathan Daniels
"I Watched America Awake to War," McCall's, *1941*[68]

By the fall of 1940, migration was front-page news for the second time in a decade. Whereas only a few years earlier poverty-stricken agricultural workers roamed the country in search of work, now a new wave of migration emerged, as America's National Defense program stimulated economies in small towns with army camps and industrial cities with defense factories. People flocked to jobs in ship and aircraft building, heavy goods industries, textiles, and large-scale construction projects. Factories and mills worked around the clock filling orders for military materiel, from vehicles and armaments to uniforms and blankets. After an eleven-year depression, America's economy began to recover.[69] The defense buildup also solved many of the economic problems the FSA had been trying to address when scores of unemployed agricultural workers quickly found stable employment in defense plants.

Yet the buildup created its own set of problems. Destination cities and towns experienced mushrooming growth that outpaced crucial infrastructures such as housing, water, sewage, roads, and public transportation. The resulting gridlock, frenzied conditions, and health and safety hazards attracted the attention of numerous newspapers and magazines across the country. Among them was *McCall's*, which planned a special series on National Defense.

The series was the brainchild of longtime FSA associate Pare Lorentz, who for more than a decade had been affiliated with the magazine. Prior to his government documentary film commissions, he had been a *McCall's* movie critic; after com-

pleting *The Plow That Broke the Plains* and *The River*, he returned to print media and continued his relationship with the magazine. By 1940, Lorentz had taken on an editorial role, spearheading special projects, including the defense series, which he hoped to bring about by capitalizing on his ties with Stryker and the FSA.

The collaboration Lorentz had in mind was a special section titled "Boom Town, USA," which would feature work from four of Stryker's photographers: Delano, Lee, Vachon, and Wolcott. It would be a documentary sprint covering seven boomtowns, which Lorentz would choose.

Though the Historical Section would receive no direct payment, Stryker saw Lorentz's proposal as the perfect bread-and-butter job. *McCall's* would cover all travel costs, the photographers would follow Lorentz's shooting specs, then mail the film to Washington, where Stryker's staff would print, caption, and package the prints and send them to Lorentz in New York. Stryker would keep the negatives and the photographs would appear in a national magazine.

In addition, Lorentz's project dovetailed with one of Stryker's longstanding documentary goals. Since Lee's days in the woods of Wisconsin in 1937, Stryker had been nagging him for pictures of a boomtown, though at the time Stryker anticipated a more traditional catalyst, such as the discovery of oil or gold. In September 1939, he wrote Lee that if there was a boomtown nearby, "please make a rush for it, and do a full set of pictures. The town being born—we have pictures of a town dead and dying, but . . . nothing on the boom side."[70]

Therefore, an all-expenses-paid, simultaneous documentation of seven boomtowns proved too enticing for Stryker to resist. It took a few weeks to iron out the details, but in the end, he agreed to Lorentz's proposal, which broadly reflected the public-private partnership already underway between the federal government and various defense industries producing planes, tanks, and armaments. Stryker wrote a lengthy letter to his photographers in mid-December, introducing Lorentz's project and discussing the new, defense-induced migration pattern and overcrowding of towns: "These people are having the devil of a time locating places to live. [They] are in trailers; others are in tents; Hoovervilles are springing up around the periphera [sic] of these cities. Some of our own migrants are moving into these areas."[71]

To head off possible objections about government photographers on assignment for a privately owned magazine, Stryker justified the *McCall's* project as programmatically in line with the FSA's new goals to document National Defense and highlight America's strength and virtues. Stressing that everyone was still working for the FSA, Stryker clarified, "Pictures are, after all, being taken as part of our regular assignment work on the migrant problem. Our emphasis at this particular time on industrial centers is simply in keeping with the shift which is taking place in the country." Stryker emphatically reminded his photographers, "For your own protection and information, please note carefully this statement: <u>You are, of course, still working for Farm Security Administration. We are merely cooperating with Lorentz</u>."[72]

Stryker tasked Lee with two cities. He told him to drop the job he was doing in Northern California, drive south and photograph San Diego, then fly roundtrip to Corpus Christi for a similar coverage. "This is a big order," Stryker admitted, "but I see no other way to do it."[73] He advised Lee, "Above all, <u>remember this thing is working against time</u>. You will have to cut all corners and keep away from extra things, in order to deliver these pictures as promised."[74]

San Diego's defense buildup revolved around the aircraft industry. In 1939, it employed half the city's manufacturing workforce; a year later defense personnel more than doubled when fifty thousand additional people flooded in. These workers totaled almost a third of the city's population, the highest percentage among all areas surveyed.[75] By the time Lee arrived in December, San Diego's meteoric expansion had outpaced its ability to accommodate this rapid influx, with prospective aircraft workers and their families pouring into the city at the rate of fifteen hundred per week.[76]

Working at a frantic pace, Lee focused on the critical housing shortage: those suffering from it and those capitalizing on it. He visited shack homes, trailer courts, tourist courts, FHA housing, and auto trailers donated by the FSA. He also traveled outside San Diego to Mission Valley, where he photographed a tent community of war workers and their families, including a carpenter's wife (fig. 75). According to Lee's caption, the rustic accommodations were their choice: "We're

75. *"We're living in a tent because we wouldn't pay anyone thirty or thirty-five dollars for a two-room bug trap." Mission Valley, California, which is about three miles from San Diego, December 1940.*

living in a tent because we wouldn't pay anyone thirty or thirty-five dollars for a two-room bug trap."

This image differs dramatically from the cobbled-together tent homes Lee found in Oklahoma City just eighteen months before (fig. 70). The tent appears well-made and sound, perhaps even store-bought. Whereas the matriarch in Oklahoma City is dressed in tattered clothes and the young girl sits barefoot on a discarded automobile seat, the carpenter's wife near San Diego is stylishly dressed in slacks, short-sleeved shirt, and open-toed shoes, and sits comfortably at a picnic

table while pouring herself a cup of coffee. Surrounded by supplies, she resembles a tourist on a camping trip, and will either choose to stay in her tent out of principle or find better lodgings elsewhere.

After Lee completed his San Diego assignment, he flew to Corpus Christi for a similar study, then shipped all the negatives to Washington. Stryker's staff worked through Christmas so the pictures would arrive on Lorentz's desk by *McCall's* deadline. On December 26 Stryker wrote Lee, "Anybody staying home today would have had to have two certifications from two doctors. . . . I am going into New York tonight on the last train and will take up the rest of the prints. On the whole, I think it was an excellent coverage."[77]

The first of Lorentz's defense issues appeared in February 1941. With a cover in red, white, and blue, the design reflected *McCall's* editorial changes as the country embraced more overt expressions of national pride, a shift Stryker would shortly take with the File. The second defense issue featured a double-page spread of the FSA boomtown photographs, complemented by an article entitled "I Watched America Awake to War: Boom Town, U.S.A.—First Stage," authored by Washington insider Jonathan Daniels, a staunch supporter of Stryker and the File.

In writing his essay for Lorentz's series, Daniels visited various boomtowns around the country. With rousing prose in a first-person narrative, he examined the effect defense spending had on communities and the widespread skepticism that the boom would last. So fearful were Americans that the Depression would return, Daniels wrote, "they are less afraid of war tomorrow than they are of no work tomorrow."[78]

The *McCall's* defense series signaled a turning point for the country and the File. As America shifted to National Defense, so too did Stryker, who began to fill his shooting scripts with subjects emphasizing America's strengths and virtues. Lee's work reflected that shift and reinforced the new mood of the country.

In addition to pictures of seven boomtowns—and prominent publication in a national magazine—Stryker got a little more bang out of *McCall's* buck. The Museum of Modern Art featured photographs from the series in its 1942 exhibition *War Time Housing.*[79]

1941

The Water Problem

Don't forget our old friend, the water problem. That is, after all, the main thing.

Roy Stryker to Russell Lee, 1940[1]

As nineteenth-century homesteaders pushed the frontier toward the Pacific, they found the climate too arid for growing crops, a requirement for "proving up" their claims. Settlers developed strategies to move water from the massive Western river systems in various reclamation projects, so called because they believed irrigation would "reclaim" such lands for human use.

Alongside these piecemeal efforts, the federal government developed regional water storage, delivery, and utilization projects to encourage settlement and promote growth in the Western states. Congress passed various statutes to advance irrigation projects, including "An Act Granting Right-of-way to Ditch and Canal Owners Over Public Lands, and for Other Purposes" (1866); the Desert Land Act of 1877; and the Carey Act in 1894. When Theodore Roosevelt became president in 1901 the reclamation movement gained momentum because of Roosevelt's personal experience in the West, as well as his conservation concerns, which

included sustained use of natural resources through vigilant and conscientious management. In 1902 his administration established the United States Reclamation Service (renamed the Bureau of Reclamation in 1923) to develop projects for irrigation, flood control, navigation, and recreation in seventeen Western states. Within a few decades most projects also included hydroelectric power generation as a principal benefit.

Prolonged drought in the thirties lent urgency to irrigation and water storage needs, and Congress authorized nearly forty new Reclamation projects in the Western states. Depression-era dams were doubly advantageous: besides harnessing the region's limited water resources, they produced public works jobs. The big dams of the 1930s fundamentally changed the landscape of many Western states, transforming marginal acres into productive cropland while simultaneously setting the stage for decades of environmental and political problems.

During this period, Reclamation coordinated activities with other federal agencies, including the REA, the CCC, and the FSA. Farm Security granted loans to qualified homesteaders on land within existing reclamation projects.[2]

Both Lee and Stryker considered "the story of water" a key subject for the File. Between 1940 and 1942 Lee photographed three Reclamation dams and seven Reclamation projects.[3] He crafted a "working outline for the Western States Region," which he planned would "start with the sources of water . . . in the [mountains]—melting snow springs etc. and carry it all the way thru good use and misuse of this water by man and the results."[4] He traveled throughout the West—from Texas to the Pacific Ocean—and much of his work during this period either relates to water or resulted directly from his water reportage.[5]

Concurrent with Lee's water coverage—and just after the March 1941 defense issue of *McCall's* hit newsstands with its FSA spread—Stryker more aggressively modified the File's focus to National Defense. He explained the shift in a letter to Delano: "It is very important, as I pointed out to Russell and John [Vachon] that we keep our finger in defense activities the way the whole world is moving now, and particularly the way things happen around this town, we may give much more to defense than we are now doing."[6]

Seeing the need for his office to remain relevant to changing national circumstances, Stryker asked for images highlighting patriotism, war preparedness, and the bounty of America. Instead of dust storms, droughts, and floods, he wanted photographs showing a modern nation moving forward and filled his shooting scripts with visual symbols of national pride, natural resources, and strong industry.

Lee's work from this period reflects America's shifting mindset, Stryker's new focus, and Lee's response to both. Bending his approach to meet the demands of National Defense, he created pictures showing the might of the country and the unity of its citizens: a small town in Oregon celebrating the Fourth of July; farmers harvesting wheat from bountiful, rolling fields in Washington; fishermen pulling in their catches from the Columbia River; and workers constructing Shasta Dam, an engineering tour de force in California.

Yet, while committed to National Defense, Lee remained dedicated to fully documenting his subject. And though he made patriotic images of power and progress, he also portrayed the victims—and environmental costs—of that power and progress.

UNDERCURRENTS: VALE, OREGON

In May 1941 Lee traveled to the Bureau of Reclamation's Vale and Owyhee projects, which received irrigation water from the Malheur River in east-central Oregon and the Owyhee River in southwestern Idaho and southeastern Oregon. The FSA had already resettled farmers on land from both projects and Lange had photographed them in October 1939. Lee's visit was planned as a pro forma follow-up.[7]

To cover both projects, he spent about six weeks crossing back and forth over the Oregon-Idaho border. He photographed multiple project features, including Owyhee Dam, the conduit carrying water to Dead Ox Flat, and irrigation facilities serving FSA clients. He visited several families in Nyssa Heights Lange had photographed in 1939, and pictured agricultural activities such as sheep ranching

and dairy farming, noting in his captions that dairy herd improvement had been one of Farm Security's primary interests. Lee documented the "reclaimed" water in swimming pools, water fountains, and street sprinkler wagons and highlighted power generated by Owyhee Dam—which he illustrated with an FSA client placing a roasting pan in her electric oven.

On the Fourth of July Lee visited Vale, Oregon, for that community's Independence Day celebrations, which featured a parade down Main Street in the morning and a carnival in the town park in the afternoon. The inherently patriotic parade supplied ample subject matter, including signs emblazoned with "Buy Defense Bonds," "Freedom and Protection for Our Treasures," and "We Uphold American Ideals." Lee shot close-ups of American flags billowing atop a lamppost and storefronts decorated with starred and striped bunting. Speaking to the small-town ideal and sense of community involvement, his photographs show various townspeople—including members of the American Legion and Boy Scouts—standing at attention for the national radio broadcast of the Pledge of Allegiance, which Lee noted was delivered by newly promoted Chief Justice Harlan Stone.

Lee's more potent images of the day depict personal interactions he observed among those attending the celebration. Focusing on human bonds, family affection, and groups working toward a common cause, he made photographs projecting an image of mounting national unity.

By July 1941, Europe had endured nearly two years of war and most Americans anticipated imminent U.S. involvement. Earlier in the year the Office of Civilian Defense was established, President Roosevelt signed the Lend-Lease agreement with Britain, then later declared a "state of unlimited national emergency." And three days before Lee arrived in Vale, the country initiated a second draft, requiring registration of all American men who had turned twenty-one since the first draft in October 1940.[8] Articles about the draft and National Defense appeared in magazines and newspapers across the country. Talk of war preoccupied discussions every day and everywhere.

76. Cold drinks on Fourth of July, Vale, Oregon, July 1941.

Inside a Vale coffee shop, Lee photographed five townspeople enjoying cold drinks and conversation (fig. 76). He obscured all but one diner's face, rendering the others universal symbols of small-town residents everywhere. Visible through the plate-glass window advertising "CAFE" and "Air Conditioned," two men—one the town sheriff—sit on the ledge outside and chat, while a trio clusters in conversation beside them. During a lull in the day's events, Lee pictured a moment of quiet community.

He found similar scenes elsewhere in the town, buoyant episodes of camaraderie, attachment, and cooperation. In the park, he pictured a family enjoying

a picnic, boys playfully roughhousing, couples napping on blankets in peaceful repose, and a farmer resting in the shade with his young granddaughter. Themes of fellowship and pulling together run through Lee's pictures of team-based sporting events, including a baseball game (America's pastime) and a tug-of-war contest (fig. 77).

Lee also focused on simple gestures of affection. At the carnival, he pictured people enjoying time together arm-in-arm, at games and on rides. He boarded one ride—the merry-go-round—and photographed a father standing between his two daughters on their respective carousel horses. Holding a hand in gentle support at the back of each daughter, the father is ready should one of them begin to slip.

This merry-go-round ride differs sharply from another Lee photographed, three-and-a-half years earlier in the drought-stricken northern Great Plains, where relief recipient Joe Kramer had taken a wagon wheel and built a makeshift merry-go-round for his children (fig. 43). The Kramer kids, dressed in patched

77. Boys' tug of war, Fourth of July celebration, Vale, Oregon, July 1941.

hand-me-downs, played on the family's barren land, propelling the wagon wheel with their feet.

In contrast, the family in Vale enjoying their time on the merry-go-round lived in a prosperous community, on land reshaped by a government water-use project. Celebrating a national holiday, the father accompanied his children on the mechanized ride. And unlike the Kramers, this family had disposable income to pay for their amusement: in another view, the girls (both wearing pristine white dresses) purchased tickets at a booth advertising them "ten cents [apiece], three for twenty-five" and warning riders to "get your tickets before getting on" (fig. 78). Both of Lee's picture groups portray family devotion, yet—like the Oklahoma migrant worker and California defense worker (figs. 70 and 75)—a gulf separates them. Viewed together these photographs visually encapsulate the nation's transformation, both ecologically and economically.

Lee's other photographs of carnival concessions show his awareness of simple everyday gestures and their subtle power to evoke and reinforce his underlying themes. At one attraction—a game promising "skill shooting wins"—a half dozen men lean in to watch the action; Lee stood behind them for his shot, capturing one man's arm casually draped over the shoulder of his friend. At another concession—a pony ride—a young girl sells a ticket to a boy; Lee caught the moment their hands touched to exchange ten cents for a ticket. And reminding the viewer of looming world events, he included the local newspaper sitting conspicuously in the girl's lap, facing the viewer with an ominous front-page headline, "Nazis Killed in Uncounted Thousands."

Standing beneath another ride—a swing carousel—Lee made a pair of photographs highlighting the gestures of a man and woman (figs. 79a–b). They sit in swing seats suspended from the carousel's central rotating top; as it picks up speed, centrifugal force throws them outward, away from each other, and twirls the woman around so that she travels backward. The man looks over his shoulder and, reaching toward her, extends a helping hand. Lee watched and waited for their next spin around; by the time they passed in front of him again, they had

MERRY GO ROUND
TICKETS
10¢
3 for 25
GET YOUR TICKETS
BEFORE GETTING ON

78. (opposite) *Little girls getting tickets for the merry-go-round at the carnival on the Fourth of July, Vale, Oregon, July 1941.*

79a–b. (right) *Ride at the carnival which was part of the Fourth of July celebration at Vale, Oregon, July 1941.*

connected: he photographed them smiling and holding hands, both moving forward in the same direction.

Conveying lighthearted feelings of fun and exhilaration, Lee's photographs also suggest the value of working together toward a common goal—important subtext for a country preparing to fight foreign aggression.

YIELD: WHEAT IN WASHINGTON

While Lee was documenting the Vale and Owyhee irrigation projects, Stryker issued a four-page shooting script prioritizing National Defense. He asked his photographers to look it over carefully and "begin to pick up the pictures mentioned wherever possible" which he explained "will be most useful for the preparation of exhibits, slide films and making up picture stories concerning our place in the defense program. I wish each of you would get as many of the items as possible."

Stryker's shooting script emphasized agricultural bounty—which symbolized the country's strength—and stipulated aesthetic and compositional approaches:

> Crates full of eggs—get shot looking down at angle . . . Eggs piled in baskets or dishes—close shot watch for shadows. Make this a pictorial; get one shot where size of eggs are over emphasized . . .

> Hogs . . . must have outstanding pix of fat hogs. Get pix straight down . . . Show backs only. Hogs should be packed in tightly . . .

> Shots of bull heads—make them strong after all a bull has the reputation of being mean [and] strong—ready to raise hell—so put some of it in a picture.[9]

A critical segment called for pictures of "wheat farms in Eastern Oregon and Washington," which Stryker and Rosskam wanted for a mammoth Defense Bond mural they were producing in collaboration with the Treasury Department and which would be installed in New York's Grand Central Terminal in December.

After distributing the shooting script, Stryker sent Lee a fervent reminder for splashy wheat pictures: "I guess you are not forgetting wheat harvest are you? It is very important that we get some pretty dramatic photographs." Stryker wanted shots of the fields "and the actual wheating itself" and asked that Lee go to "that rolling country up around Lewiston and over in the Palouse country." With

National Defense and the mural in mind, he added, "give it the works, plenty of clouds, lots of sky, you know, plenty of 'drama.'"[10]

For harvest images, Lee traveled to one of the highest yield areas in America, in southeastern Washington's fertile Columbia Basin, which produced more wheat per acre than any other comparable spot in the country. The region received sparse rainfall, and the hilly topography made irrigation nearly impossible, but dry land farming allowed winter wheat to grow.[11]

Besides being a high yield area, the Columbia Basin was a perfect setting for the pictures Stryker wanted. The Grand Central mural called for imagery stressing the industrial might of American agriculture, long shots of mechanized reaping across rolling fields; in the early 1940s, Columbia Basin farmers were among the first to use the combine harvester.[12] Lee therefore timed his trip for the end of July, when the wheat stood dry in the sun, ready to be cut. And he chose two counties: Walla Walla (at the confluence of the Columbia and Snake Rivers) and Whitman (in the rolling Palouse area Stryker mentioned).

Throwing himself into the middle of the action, Lee climbed aboard a combine and rode along through the fields. From this vantage point, he captured numerous views of the machine reaping, threshing, and winnowing. Wheat chaff blew all over him—and inside his camera—which he told Stryker "was really no fun." But Lee was enthusiastic about the scenery, which he described as "really terrific,"[13] and the photographs he made from the back of the combine were perfect for the mural. Rosskam chose two and collaged them together (figs. 80a–c).

As he had done with other agricultural commodities, such as cotton in 1938, Lee set out to fully document the wheat harvest process. From the wheat combine he followed the grain as field hands loaded it into sacks and onto trucks. He then tracked the sacked grain to warehouse storage in Touchet and the bulk wheat to grain elevators and rail cars in Eureka Flats and river barges in Port Kelley. He also photographed grain sampling and testing at the state inspector's office in Walla Walla.

As a part of this series, Lee included an unexpected angle of the region's large-scale grain production: animal-drawn machinery. In Walla Walla County, he made more than a dozen pictures of a twenty-mule team pulling a combine, noting it took

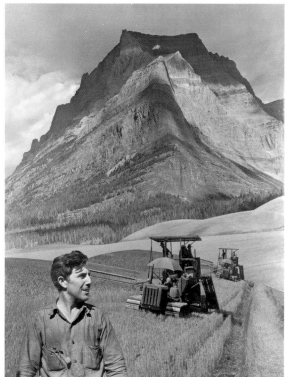

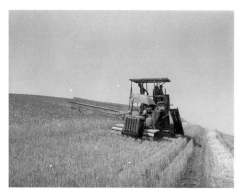

80a–c. [a–b] *Caterpillar-drawn combine working in the wheat fields of Whitman County, Washington,* July 1941. [c] Scale paste-up of the agricultural panel for the Defense Bond sales photo mural to be installed in the Grand Central Terminal in New York. In the visual unit of the Farm Security Administration, 1941, photograph by John Collier Jr.

five people, including the mule skinner, to work it. Harkening back to a pre-mechanization era, the sight no doubt appealed to Lee's interest in the country's transition to modernity. Yet, multi-animal teams weren't necessarily vanishing artifacts.

Mechanized harvester combines were more efficient, but also had more limited application on some terrain. Geographer J. Russell Smith reported that in the early 1940s, in the hilly lands of the Columbia Basin, many large production wheat farmers had reverted to animal-drawn machinery to reduce accidents.[14] Mules wouldn't do for the Grand Central mural, which needed to convey the idea of a modern, mechanized country ready for war. But Lee documented them nonetheless because they completed the story.

After a week in the wheat harvest, he dropped Stryker a note, "Have meant to write you in the last few days but I ran into a lot of swell stuff and accordingly have been very busy. . . . By the time I finish this job you should have somewhere near 400 or 500 pix on various phases of wheat in this section." He assured Stryker that in another week, "the story of wheat ought to be pretty much in the bag" and lightheartedly added: "We have had very few clouds at Walla Walla but I'm hoping that the other sections will produce some. If not, I think I'll be forced to wire Arthur for his secret formula for producing clouds or else ask you to air-mail a bale of surplus cotton."[15]

Lee's wheat series demonstrates his willingness to satisfy Stryker's changing pictorial focus and support the National Defense agenda, but also underscores his continued attention to comprehensively recording a subject. Rather than embracing a wholesale shift toward patriotic imagery, Lee stayed committed to creating a national photographic inventory. And in the end, Stryker got snappy pictures with "plenty of drama" for the mural and the full story of wheat harvesting for the File.

THE COSTS OF RECLAMATION: THE COLUMBIA RIVER

In an early memo to his photographers, Stryker drafted a list of five "well known American River Valleys" and rudimentary points that he believed might "be useful later on in developing shooting scripts for field work." Among the five rivers was the Columbia, of which Stryker wanted images depicting "scenery, forests, fishing, and power."[16] The Columbia River came up again during a field visit with Lee in 1940. According to Stryker's notes, the two men talked about covering the fishing and canning industry at Astoria, Oregon, and traveling up the river to photograph "good scenery."[17]

Lee made it to the Columbia and its tributaries in the fall of 1941. He covered all the aspects Stryker initially mentioned—scenery, forests, fishing, and power—but also a few Stryker hadn't asked for. Together Lee's photographs form an interconnected story of industrial progress, environmental devastation, and cultural loss.

The Columbia River, the largest in the Pacific Northwest and fourth largest by volume in the United States, originates in the Canadian Rockies and flows south into the state of Washington, through remote countryside hundreds of miles from main population centers. The river then turns west to form much of the border between Washington and Oregon before reaching the Pacific Ocean, which is where Lee started his coverage, at the port city of Astoria.

As planned, he documented the fishing and canning industry, a mainstay of Astoria's economy, and focused on the Columbia River Packing Association (CRPA), which processed tuna and salmon. From the docks to the warehouse he pictured the complete commodity chain, capture to can. As boats came in from the fishing grounds, he photographed crews unloading their catch, iced down in stacks of wooden crates marked "CRPA" (fig. 81). At the Packing Association he

81. Unloading boxes of salmon from fishing boat at docks of Columbia River Packing Association, Astoria, Oregon, September 1941. (Originally uncaptioned.)

pictured the detailed workflow of grading, slicing, packing, sealing, cooking, sterilizing, canning, and labeling.

In his captions, Lee noted some production statistics that pointed to the aggressive pursuit of Columbia River salmon, a significant problem acknowledged even at that time. During the salmon run's peak, the plant operated twenty-four hours a day and employed 150 butchers. In the run's first five days, the CRPA put up 125,000 cases of salmon, and in the fall of 1941 canned 2,400 tons of the fish.[18]

The Columbia River had been overfished for decades. Historian William Dietrich, in his chronicle of the river, *Northwest Passage*, postulates that salmon's grim future had been determined as early as 1807 with the invention of canning. In 1866, three entrepreneurs from Maine started a cannery and during the first season canned 288,000 pounds of Chinook. Within two decades the river had fifty-five canneries and no custom of restraint. Dietrich estimates that by the time of truly effective enforcement in the 1930s, Americans had already annihilated more than half the river's salmon.[19]

Lee also concerned himself with another threat to the salmon population: river development. Prior to the construction of its many dams, the Columbia River flowed into the Pacific Ocean, which reclamation proponents believed wasted water and energy. Federal development began in 1932 when the Army Corps of Engineers (USACE) produced its grand blueprint for a series of ten dams, each of which would back the river up to the base of the next dam upstream, beginning with the lowermost Bonneville Dam and extending upriver to its cornerstone project at Grand Coulee. Debates arose about the plan's environmental costs, especially to salmon. Dams would hinder the salmon's up- and down-river migrations and stop the unobstructed movement of water, depleting much of its oxygen and essentially smothering the fish. Despite these widespread concerns, there was no environmental review of the USACE plan.[20]

In the late 1930s, after dam construction was already underway, Congress did pass legislation to conserve fishery resources on the Columbia River and approved funds for devices (such as fish ladders) to improve spawning conditions and facilitate salmon migration over artificial barriers. In a 1938 article in the Bureau of Rec-

lamation's monthly organ, *Reclamation Era*, author Ivan Bloch assured readers that efforts were underway to ensure the survival of Pacific Northwest salmon and noted dams were only one factor among many longstanding threats to the Columbia River salmon; others included overfishing, pollution, and silting caused by soil erosion. Bloch's upbeat but somewhat dubious article lauded the USACE efforts to safeguard the salmon runs at Bonneville, the first completed of the planned ten dams.[21]

By the time Lee visited the Columbia River in 1941, "save the salmon" had become a cause célèbre. His Astoria series includes views of salmon trapped for artificial spawning, and his work at Bonneville Dam features the fish ladders mentioned by Bloch, with views that show off Lee's graphic design impulse to frame bold shapes and clean lines (fig. 82).

82. Bonneville Dam and fish ladders, Oregon, October 1941.

As Lee moved farther upriver, he encountered more costs of Columbia River development. These included the impending loss of a Native American community, the ancestral fishing rights of multiple Native American groups, and the magnificent waterscape at Celilo Falls.

The first in a series of majestic cascades and waterfalls, Celilo Falls was located 250 miles upstream from the Pacific Ocean. The falls famously represented the river's power and was ranked as the sixth largest waterfall in the world by volume—more than twice the flow rate of Niagara Falls and nearly five times that of Victoria Falls. It was also one of the greatest salmon fishing sites in North America.

Home to a Native American community dating back eleven thousand years—the oldest continuously inhabited settlement in North America—Celilo Falls served as the economic and cultural hub of multiple Native American tribes.[22] In the spring, Native Americans fished the west end of the Dalles-Celilo Canal and at Spearfish on the Washington shore, and during the fall they fished the spectacular falls at the head of nine miles of rapids. When Spanish and English explorers arrived in the late eighteenth century, they found that Native Americans possessed a sophisticated and sustainable salmon-based economy, specialized technology, a rich mythology with rules for wise consumption, and self-imposed limits on fishing.[23] To the Native Americans, the site of Celilo Falls held both spiritual and cultural significance and was as sacred as the salmon they fished from it.

In the nineteenth century two different forces began pushing Native Americans off the river: White settlers (in their aggressive pursuit of salmon) and the federal government (which forcibly moved tribes to reservations). However, the tribes reserved exclusive rights in federal treaties to fish Celilo Falls and for the next century fought conflicts and lawsuits contesting their treaty-protected fishing rights. Federal, state, and tribal governments debated access to the salmon of the Columbia River and its tributaries.

A mortal threat came with the USACE blueprint for the river, which included

a dam downriver from Celilo. Dalles Dam would permanently remove Native Americans from the river by evicting the residents of Celilo Village, destroying the falls, and endangering the salmon, thereby rescinding a key treaty component.[24] Multiple Native groups (including the Yakima nation, Warm Springs, and Umatilla confederated tribes, as well as Native Americans from Celilo Village) voiced opposition, but to no avail. In her book *Death of Celilo Falls*, historian Katrine Barber concluded that "through the authorization of dams, Congress decided Indians *did not* have a superior right to fish the Columbia when that right competed with economic progress."[25]

When Lee visited Celilo Falls in September 1941, he was aware that the fates had already been determined for the falls and adjacent village. His captions include details of the contested fishing rights and demonstrate his understanding of how the river's landscape would be irrevocably altered by the USACE master plan, which included drowning Celilo Falls and Celilo Village with Dalles Dam. While as an engineer he appreciated the reclamation strategy, as a social documentarian he recognized the havoc it would bring to the ecosystem, the human community, and the Native way of life.

To document activity at the falls, Lee trekked to various vantage points. From higher ground, he captured the Columbia River pouring over a precipice while more than thirty fishermen worked their dipnets (small nets attached to long handles) from wooden platforms extending out over the rapids. Lee also climbed down into the falls and stood at the base of a cataract, on a rocky ledge jutting into the cascading water. Here he photographed five fishermen plying their nets. For another view, he walked onto a wooden platform and captured the coordinated efforts of two fishermen working their dipnet (fig. 83). Turbulent white water surrounds them as they focus on their task. Answering Stryker's request for "plenty of drama" (though likely not in the way Stryker intended), Lee's photograph symbolizes the dramatic power of the river, celebrates the country's natural resources, and represents millennia of Native traditions.

Just as Stryker strived to document aspects of American culture before they

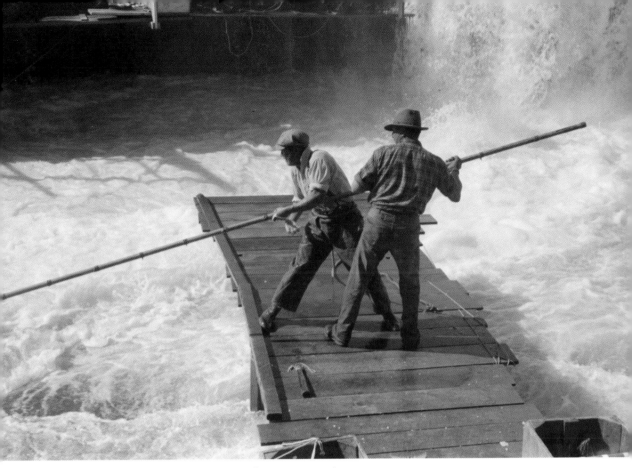

83. Indians fishing for salmon, Celilo Falls, Oregon, September 1941.

passed from sight, Lee aimed to document a waterscape and scenes of traditional fishing he knew would vanish within a generation. And they did. On Sunday, March 10, 1957—in just four-and-a-half hours—Celilo Falls and the ancestral village disappeared, flooded by the reservoir behind Dalles Dam. Like the images of Marville and Atget, who photographed areas of Paris slated for destruction in the name of economic development, Lee's views of Celilo Falls now stand as a poignant requiem, a mournful memorial to a natural wonder and a tribute to the community that lived and fished there.

FROM DEFENSE TO WAR: SHASTA DAM, CALIFORNIA

The Central Valley Project grew from a need to irrigate the region where the bulk of California's agricultural lands are located. A multipurpose plan, it was also designed to stop saltwater intrusion into rich delta soil, improve navigation, provide flood control, and produce electrical power. The project's keystone would be Shasta Dam, a curved gravity dam on the Sacramento River above Redding, California. A continuous-pour concrete project, Shasta was considered a feat of civil engineering, and like all the great 1930s dams became a symbol of strength, endurance, and prosperity. Construction began in 1938 and Lee visited the site three times over an eighteen-month period: in November 1940, December 1941, and June 1942. His photographs show his sustained fascination with the innovative building processes and technologies employed there, including the single-man concrete vibrator (which later became standard equipment on other dam projects); a nine-and-a-half-mile conveyer belt (at the time the world's longest) that delivered aggregate to the site; and an improved method for artificially cooling concrete.[26]

On Lee's first visit to Shasta Dam, in November 1940, he photographed the extensive excavation work and burgeoning foundation and the various boomtowns that sprouted up in the vicinity. Hundreds of families, lured by anticipated jobs, moved there almost overnight following announcement of the dam's construction. Property owners capitalized on their proximity to Shasta Dam by subdividing and selling their land to businesses and residents at inflated prices so that submarginal acreage increased exponentially in value.[27] Lee's extensive boomtown coverage included the communities at Buckeye, Summit City, Central City, Angelus City, Project City, and Central Valley.

By Lee's second visit, in early December 1941, Shasta Dam had become critical for National Defense since it would supply hydroelectricity to defense plants south of the site. With that designation came tightened security because of widespread fears of sabotage by domestic subversives and fifth columnists. So, six weeks before his trip, Lee requested special credentials from Stryker: "I believe that it would be advisable for you to get some clearances for me on the Shasta Dam pictures in Washing-

ton since I seriously doubt if I can get the pixs [sic] we need through field contacts." Three weeks later he wrote again, "Do you have the Shasta Dam letters? Believe you'd better have them on tap soon so they can be sent out when I'll need them."[28]

His concern stemmed from a run-in the year before when—photographing the gold mines in Mogollon, New Mexico—he was mistaken for a German spy.[29] Lee managed to produce sufficient evidence proving he worked for the government, but it took a deputy sheriff and the mine superintendent to clear up the misunderstanding. Afterward, Lee heard reports from Pie Town that the FBI had been looking for him; they later stopped and interrogated him while he was photographing a copper mine.[30]

For Shasta Dam, Lee managed to secure permission to photograph the construction, and when he arrived on December 2, he found significant progress since his last visit as abutments rose from the bottom of the Sacramento riverbed. His engineering knowledge enabled him to methodically document what may have otherwise appeared to be a chaotic scene of heavy construction and he enjoyed the assignment, later explaining he "liked to photograph industry . . . it was a part of the society. I didn't have to, I just liked to."[31]

Lee's Shasta Dam images emphasize the power and enormity of the structure and celebrate the country's strong industries and people building it. This series is full of dramatic long shots of the site and modernistic close-ups of the abundant raw materials: reinforcement steel rods, porous tiles, and pipes for cooling the concrete.

Lee traveled up, down, and around the site to photograph the construction from multiple perspectives. Among these are dizzying views from atop the 465-foot-high head tower (fig. 84).

For his shot, Lee positioned himself at the apex of the tower, which not only afforded him a dramatic vista of the Sacramento River, 700 feet below, but also a bird's-eye view of a pivotal point in construction activity: the elaborate cable way radiating from the tower that transported concrete to seven mobile towers around the dam site.[32] Always interested in human-machine interaction, Lee included two workers, their shiny hard hats catching the sunlight.

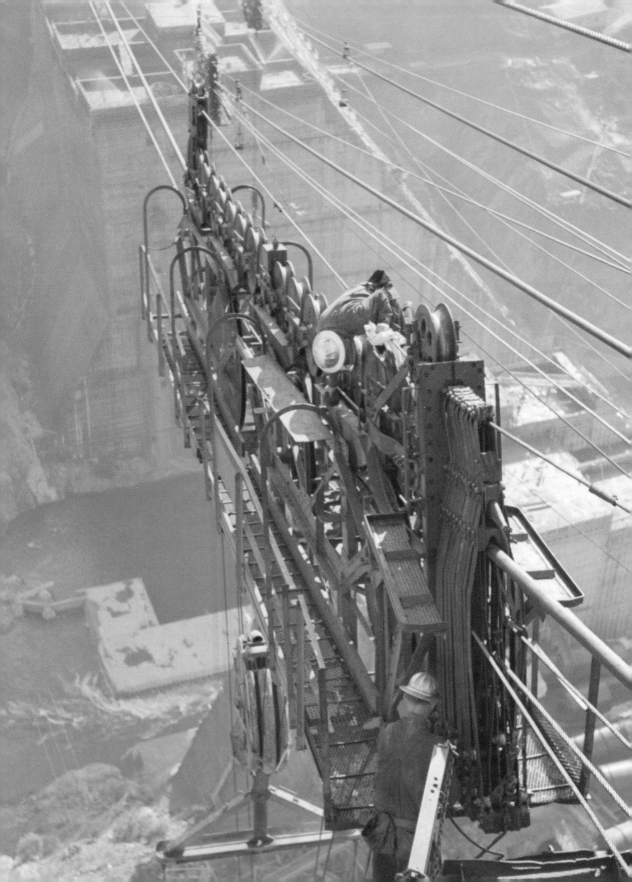

Lee detailed much of the activity at the dam through portraits of its workers. His photographs show respect for their expertise and his captions detail how each position fit into the larger operation. Around the main head tower, he met the worker who measured each component going into the concrete mixture, the "grease monkeys" in the channel irons, and the "greasers" in the wheelhouse. He photographed staff directing cable car traffic, the signal man instructing the central tower crew on handling the buckets of concrete, and the operators delivering it. On the ground, he photographed spot welders, truck drivers, bulldozer operators, and the surveying crew, including the "chain man" and "rod man."

Lee also used worker portraiture in another way, to mark the country's sudden entrance into World War II (fig. 85). In one photograph, a member of the construction crew, likely on break, sits on a bench with his lunch pail at his side as he reads the final morning extra of the *San Francisco Chronicle*, with a front-page banner headline: "US AT WAR!" Details suggest he's fresh off the job site—the bottoms of his pants are still soaked—lending a sense of urgency to his desire to get the news.

After the bombing of Pearl Harbor, officials immediately ratcheted up security around the site. Armed soldiers moved quickly to protect strategic operations, entry points, the gravel plant, and the railroad bypass tunnel. They also patrolled the 10-mile dirt road paralleling the aggregate conveyor belt.[33] Despite an increased military presence, Lee reported the general tenor around the dam site was "quite calm and thoroughly united."[34]

A week later, the Defense Bond mural opened for public view in New York (fig. 86). In addition to Lee's two images from the Whitman County wheat field, the design also included images by his colleagues.[35] Described in *U.S. Camera* as the largest photo mural in the world, it was ten stories high and 120 feet long, and was situated above the USO desk in Grand Central Terminal. It lauded the vir-

84. *Looking from main tower from which serial tram and supply buckets are operated, Shasta Dam, Shasta County, California, December 1941.*

86. *War bond mural, Grand Central Station, New York, New York*, likely December 1941, photograph by Arthur Rothstein.

tues of America: fertile land, productive industry, and, the mainstay of wartime propaganda, the promise of a youthful generation. Its primary text quoted the last line of the Gettysburg Address, reassuring Americans of democracy's survival: "That Government—By the People Shall Not Perish from The Earth." The mural received substantial press coverage and was expected to be viewed by an estimated 200 million people passing through the station.[36]

With the country at war, Stryker and Lee discussed the fragile status of the FSA, and their correspondence betrays their anxiety about the future of the photographic project.[37] Their fears weren't unfounded: detractors had become more

85. *Workman at Shasta Dam reads war extra. Shasta County, California, December 1941.*

critical, publicly declaring the agency a waste of federal funds. By December 1941 the opposition had begun mounting an attack. With the aid and influence of the American Farm Bureau Federation and Cotton Council (two organizations representing the interests of large commercial farmers), three congressional representatives began an investigation, with an aim of dismantling the agency (which since its creation in 1935 sought to strengthen the small farmer's economic position). One of the three representatives, Senator Harry F. Byrd of Virginia, formed the Joint Committee on Reduction of Nonessential Federal Expenditures and began denouncing the FSA, a contributing factor in its termination less than a year later.[38]

Administrator Beanie Baldwin fought hard to keep the agency afloat. He recalled the struggle: "By this time the heat on our projects had become so intense that we couldn't get any money to build any more, and we could hardly get money to sustain the ones we had. This was a long fight that I had, a bitter fight in Congress."[39] The Historical Section was especially vulnerable. Stryker's amorphous approach became increasingly difficult to justify and talk circulated about the File going to St. Louis and staff to other agencies.

Recognizing the Section's dubious future, Lee pledged to do whatever he could. He wrote Stryker, "In view of the war with Japan I do not know whether the direction of our work will change materially or not but at this time I wish to reaffirm my willingness to do whatever work you may consider that I can best perform."[40]

Stryker acknowledged Lee's commitment and shared his concerns, "I haven't much to tell you as to what our plans will be until after Baldwin has a staff conference which will probably be next week." Stryker told Lee he planned to associate the Section "with defense as much as possible and still retain our Farm Security status. We will probably be better off in this way." He concluded, "There is no use for me to try to give you any ideas as to where we are going. Just keep on as you have been for the next few days until I can have something more definite to write."[41]

Baldwin later remembered having frank talks with Stryker, asking him: "How long are we going to be able to continue this, get by with it? And just as important, how [are] we going to protect what we [have]?" Baldwin recalled they "had to shift [the] operation in order to save it."[42]

1942

"Defense Plants and Shipyards and God Bless America"

Ⅰ N EARLY 1942, Stryker attempted a balancing act. He wanted to maintain Farm Security status and keep his documentary project going, yet knew he had to satisfy the demands of a nation at war. Moreover, the FSA was under fire from the Byrd Committee, already waging a destructive campaign to abolish the agency, so the politically savvy Stryker sought shelter with a wartime government organization.[1] He wrote Lee, "I have been going through this every year for the last six, but this is the most serious and the worst."[2]

By mid-March, through friend and colleague Ed Stanley, Stryker formed a fortunate alliance with the Office of the Coordinator of Information (COI), an intelligence agency formed by Roosevelt in 1941. Headed by espionage specialist William J. "Wild Bill" Donovan, who would shortly lead the Office of Strategic Services (OSS), the COI conducted both overt and covert propaganda operations.[3]

The Historical Section would continue its FSA mission, but under the guardianship of this essential wartime office. Photographers would "[get] checked up by the FBI, . . . going on what is known as a 'partial security' basis," and would devote part of their time to "all kinds of stories which will be utilized by the COI in their foreign propaganda." Stryker assured Lee the COI "is not going to be very much

questioned by the brethren on the hill. In the meantime, we will be able to take on a lot of our regular Farm Security work."[4]

Mindful of the cloak-and-dagger nature of what he called "the Donovan outfit," Stryker warned his photographers not to discuss their COI assignments with anyone. He directed Lee to "tell the various and sundry information men in the Regions that we are on special assignments for defense agencies."[5] He admitted, "Lots of times, you will be wondering why you are doing the job and what it is to be used for . . . we will always try to give you an intelligent statement and adequate information depending on what secrecy is impose[d] on us. In many cases, it will be impossible for me to talk freely with you people."[6] Giving Vachon the same instructions, he added, "Our general advice . . . is that you check your curiosity in the car and wait until such time as we can give you further information."[7]

Thus, while Stryker continued sending his team on FSA-related assignments, he began fueling the COI's wartime information campaign with what he called "picture statements of our strength."[8] Besides photographs symbolizing pride and patriotism, he weighted his shooting scripts with imagery that would directly signal a capacity for victory: home front activities, including tire rationing and victory gardening, and the work of organizations such as Civilian Defense and Selective Service. For several months, Lee and his colleagues worked simultaneously for both agencies. Stryker's office staff marked and filed the negatives separately.

The death knell of the FSA photographic project sounded in June 1942, when Roosevelt established the Office of War Information (OWI). A sprawling organization, the OWI served as a government propaganda agency and coordinated war informational activities of all federal departments and agencies to disseminate war information "to the public and the world at large."[9] It absorbed multiple government information services, including the Historical Section and the work it had been doing for the COI. Stryker later recalled: "The move was in the cards. Farm Security was coming to an end. Politically, [the FSA] was, as it had been for many years, a lightning rod." He accepted the transfer, saying: "there was nothing peculiar about it. Just as we did so much work for them it was a logical thing and Farm Security was a dying thing anyway. It died shortly afterwards."[10]

When the Historical Section moved, Stryker lost the autonomy he'd enjoyed at the FSA, despite having friends and allies in top OWI positions.[11] In turn, Lee and his colleagues lost their independence in the field and had to take on OWI duty work, which largely required flag-waving imagery. Vachon later recalled this shift: "What was left of Stryker's outfit was turned into a branch of the Office of War Information to photograph defense plants and shipyards and God Bless America. Then the whole thing fell apart. That is, it stopped."[12]

Lee got in step with the new directive but didn't materially change his approach. As he'd done with his wheat series the previous summer, he wedded the needs of the home front with his drive for a national photographic inventory. For example, he suggested chronicling a draftee and his community for a "record of changing times . . . and a tremendously valuable coordinated set of pictures."[13]

Stryker, on the other hand, knew Lee's method was no longer feasible. Singular photographs that could sell ideas quickly became the new objective. Lee supplied these perfunctory images, along with his own in-depth documentation, but the days of the latter soon came to a close. By September the Historical Section was abolished altogether and Stryker's office became a photographic agency of the OWI. Lee resigned a month later.

ALL OF LEE'S 1942 WORK depicts activities in the Western states; much of it idealizes America and focuses on the country's capacity to win a war against fascism. With traces of his methodical Farm Security approach, he made photographs to foster confidence in the nation's abundant resources and to educate citizens on conserving materials crucial for the war effort. He also turned his attention to the nation's citizenry. For the COI he created a series on what it meant to be an American, to counter foreign propaganda designed to undermine the country's democratic ideals. And for the FSA he documented a group of Americans who believed in those ideals, but whose fundamental rights were summarily taken away.

SELLING AMERICA TO AMERICANS:
THE PACIFIC COAST AND ROCKY MOUNTAIN AREA

Lee's work had been slowly shifting since early 1941, when Stryker's image campaign moved from lobbying for agricultural reform to convincing Americans to fight for freedom. No more documenting the country's worn-out land and destitute farmers—by 1942 it was abundant harvests and citizens who displayed health and vitality. Both kinds of images were a call to action, a marketing tool tailored to an agenda, but rather than selling FSA programs to Congress and their constituencies, Stryker was now selling America to Americans.

Helen Wool (fig. 87), a member of the Section office staff, later summarized the content difference as "very drastic," but emphasized that Stryker "still stuck to the same basic idea" of documenting America. Enumerating end uses for the COI-OWI images, Wool explained, "We had psychological warfare films, and we had displays, and we had defense bond things, and everything else. But, underneath it

87. Helen D. Wool, Roy Stryker, and Russell Lee, ca. 1943, photographer unknown.

he was selling America as it should be sold." She reflected, "you didn't sell bonds; you sold America.... The people bought the bonds."[14]

Like Stryker's other photographers, Lee continued covering agricultural topics in 1942 but now tried to connect them with home front activities. For example, Lee envisioned a series called "Contributions FSA families can make to Civilian Defense" which would include "some shots of migrants repairing clothes, making things last just a little longer" to show how "the migrant has been conserving for years" and believed that "one of these days the migrant might well become the source of experience in how to conserve materials."[15]

Lee also developed a "Food and War" series to document Pacific Coast resources and stress the region's wartime importance. Lee wrote Stryker that he'd try to cover other operations related to the war effort but warned not to expect too much because people would wonder why an agricultural photographer was interested in non-agricultural industries.[16]

In hearty approval, Stryker underscored the need for dramatic compositions: "only pick out the things which are most dramatic and . . . offer the most important food elements. . . . watch for and photograph things which dramatize the problem of Food and War—the idea of food as a way of life—as a part of the thing for which we are fighting."[17]

Lee focused on California, where he noted more than 150 crops grew.[18] Traveling to Tulare, Imperial, Monterey, and Sonoma Counties, he photographed the olive, carrot, tomato, melon, grape, and lettuce industries, as well as a cattle operation and a chicken ranch.

With characteristic attention to process, he documented the commodity chain of growing, harvesting, processing, and marketing: from olive to oil, vineyard to winery, and hatchery to egg packing plant. At a Sonoma County plant, Lee made multiple close-ups, answering Stryker's plea, made a year earlier, for "Crates full of eggs—get shot looking down at angle . . . Make this a pictorial; get one shot where size of eggs are over emphasized" (fig. 88).[19]

Lee also turned his attention to other essential war materials, namely some of the natural resources in the Pacific Northwest and Rocky Mountain regions. These

88. *Eggs, Sonoma County, California, January 1942.*

included chromite and copper mines in Montana and timberlands in Oregon. For the latter, Lee traveled through four national forests: Deschutes, Willamette, Rogue River (now Rogue River–Siskiyou), and Malheur. There he made majestic photographs of wooded mountain vistas, with the cloud-filled skies Stryker had long been asking for (fig. 89).

In depicting logging operations in Oregon, Lee's documentary viewpoint differed in several ways from his work five years earlier in the Great Lakes region. Primarily, his 1937 images accentuated forest depletion, while his 1942 pictures emphasized the wealth of lumber yet to be harvested. His captions for these sylvan Oregon views highlight the abundant and seemingly inexhaustible—or at least

89. *Malheur National Forest, Grant County, Oregon, July 1942.*

easily replenished—supply of wood, with descriptors such as "tall timber," "stand of fir," "wooded mountainside," and "Ponderosa pine with young tree at its side."[20] Using dramatic angles he pictured colossal logs pulled by continuous-track tractors, piled on trucks, then hauled out of the forest, presumably off to the war effort. Saluting federal oversight in nurturing the timber, Lee also showed the U.S. Forest Service examining seedlings, reducing fire hazards, and selecting trees for harvest.

Another contrast between Lee's Oregon and Great Lakes pictures was his coverage of the people removing the lumber. Whereas many of his 1937 photographs depict drunken, rowdy lumberjacks, his 1942 images monumentalize a patriotic workforce doing their part for victory.

His Oregon portraits dovetail with Stryker's shooting scripts from this period. One script asked for "pictures of men, women and children who appear as if they really believed in the U.S." Stryker told his photographers to "get people with a little spirit. Too many in our file now paint the U.S. as an old persons' home and that just about everyone is too old to work and too malnourished to care much what happens."[21] Another script highlighted the importance of picturing the "huskiness of men working here and what good soldiers they will make."[22] Lee's brawny woodsmen display strength and inspire confidence, ready to supply the mammoth needs of a nation at war, in the forest or on the front lines.

Insofar as Lee's 1942 photographs extol the bounty of America's natural resources, they also underscore the shortage of raw materials needed in the war effort. With an eye to encouraging thrift and conservation of durable goods, Lee created images reflecting the wartime maxim, "Use it up, wear it out, make do or do without."[23]

To fairly distribute the existing supplies of scarce items, the Office of Price Administration implemented a rationing system, beginning with tires in January 1942. Japan's domination of Southeast Asia had cut off 90 percent of America's crude rubber supply and to conserve it, the government rationed gas and set "Victory Speed" at 35 miles an hour.[24] Lee was fortunate to have recently bought a new car; by May, Vachon was stranded in Lincoln, Nebraska, unable to replace or retread his old tires.[25]

Lee addressed the rubber shortage in some of his photographs. In California, a delivery truck raised on blocks for lack of tires caught his attention, as did a stack of four tires securely chained, of which he noted in his caption: "Tires become more precious as the days go by."[26] In Montana, he found advertisements invoking the shortage to lure customers, including one by the Forest Service: "Save your tires: Use your Nearest Forest Service Campgrounds."[27] He also visited researchers and chemists in a California laboratory working to synthesize rubber and develop a latex substitute.

In addition to searching for ersatz materials and encouraging citizens to conserve what they had, the country appealed for items such as cloth, rubber, and metal that could be recycled for military materiel. The War Production Board (WPB)

initiated salvage campaigns for rags, old tires, raincoats, garden hoses, shoes, and bathing caps, as well as anything containing steel, aluminum, tin, or copper. In October, the WPB promoted a National Scrap Metal Drive; cities and towns mobilized their residents, who scoured attics, garages, and basements. Aside from collecting scrap, the WPB aimed to build community spirit, stoke patriotism, and encourage sacrifice for the war effort.

Lee was in Butte, Montana, for their community-wide salvage drive. He photographed the frenzied activity as residents piled up tires, bedframes, buckets, piping, car parts, grates, fencing, and an enormous boiler. The slogan "Salvage for Victory!" was emblazoned everywhere, from arm bands and hats to a sign on a truck hauling in an old sedan stripped of its tires and interior (fig. 90).

Along with picturing the amassed scrap, Lee emphasized the people collect-

90. *Scrap salvage, Butte, Montana, October 1942.*

ing it. His photographs show citizens pitching in, working together, doing their part: a soldier directing activity through a walkie-talkie, downtown storekeepers bringing their scrap to the curb, truck crews driving it to the central collection site, volunteer workers unloading it. He also recorded Butte's younger residents and the WPB's "Get in the Scrap" campaign, a program launched to involve "America's Junior Army" (schoolchildren) in the war effort. A WPB brochure stressed that "special emphasis must be put on patriotism . . . that . . . each youngster is playing the part of a soldier behind the lines and is actually helping to defeat our enemies."[28]

Persuading Americans of every age that they were fundamental participants in the war effort was a critical part of the government's information strategy. Stryker asked Lee for pictures of "Mrs. America," telling him, "We have to have more pictures . . . representative of the American housewife, the good sturdy woman who can cook, who can wash clothes and dishes, who drives a car, and looks like the type we call an American." With a clear sense of urgency, Stryker told Lee, "by God I expect you . . . to know what I mean and you better get me some pictures." Tempering his anxiety with humor he added, "I am going to start having 1/8 of an inch taken off the left ear for every week that I have to wait for this material. All joking aside, we do need these pictures very badly. I can't tell you where to get them, but please get busy and help me out."[29] In Turlock, California, Lee found a woman fitting Stryker's bill and accompanied her as she tended her victory garden, sold war bonds, did Red Cross work, and shopped for groceries.

Another important component in convincing America of its capacity for victory was military preparedness. Lee visited Lake Muroc (now Edwards Air Force Base) and photographed members of the enlisted pilot training school. Traveling around the squadron headquarters and airfield, Lee photographed candidates in various work and leisure activities: eating meals in the mess hall, reading letters from home in the barracks, and listening to instructors in the classroom. To show their careful preparations, Lee pictured candidates getting dressed in high altitude cold-weather flying suits, buckling on parachutes, and donning oxygen masks. He watched their air exercises, as planes "buzzed" the field to simulate a

91a–b. Lake Muroc, California, May 1942. [a] Repairing army interceptor plane. [b] Lieutenant of interceptor squadron walking to airplane.

strafing attack and photographed other program personnel: armorers, mechanics, and a ground crew repairing a plane (fig. 91a).

Lee also made individual portraits, many of them aggrandizing, such as his view of an interceptor squadron lieutenant (fig. 91b). Ready for action in his aviator sunglasses and headset, and with his parachute slung over his shoulder, he walks confidently to his plane. From a calculated vantage point, Lee—who's reflected in the lieutenant's sunglasses—photographed him from below, isolating him against the clear sky. Answering Stryker's plea for images of "people with a little spirit," Lee created a heroic portrait of a serviceman off to do his part in the war effort.

BEING AMERICAN: TWO CALIFORNIA COMMUNITIES

In early 1942, the COI created a campaign to positively depict U.S. citizens for its Foreign Information Service (FIS). The FIS had been conceived by American playwright and screenwriter Robert Sherwood, who persuaded Roosevelt that such an

organization could play an important role in the country's information objectives by broadcasting a positive view of American ideology overseas. In his history of the OWI, Allan M. Winkler wrote that the FIS "spread the gospel of democracy throughout the world," and "based its programs on truthful news, but still managed to cast its message in favorable terms."[30]

The wars in both the Atlantic and Pacific had elements of racial conflict, and the FIS sought to counter the rise of German and Japanese nationalism with a carefully crafted overseas information campaign on American identity. Despite the country's normative systems of racial segregation, the FIS promoted an image of the United States as a country where people of all races and ethnic groups lived and worked together in peace and prosperity. In a fight against fascism, images of cultural tolerance were essential to the war effort. Therefore, Lee's COI-FIS assignments emphasized the country's social, racial, and ethnic unity.

One such assignment concerned the Pacific Parachute Company in San Diego. Founded by an African American daredevil skydiver named Howard "Skippy" Smith, the company manufactured parachutes for the U.S. military and was one of the first Black-owned and -operated war production plants. In an article on San Diego parachute manufacturers, scholar Wallace R. Peck noted "others in the minority community" urged Smith to hire only Black workers, but Smith, originally from the Deep South, refused, stating in effect that he wouldn't perpetuate prejudice and discrimination. Instead, according to Peck, Smith hired "a diverse workforce of African-Americans, Mexicans, Brazilians, Filipinos, West Indians, and Caucasians, a truly integrated group in an era when such desegregation was rare."[31] According to the Smithsonian National Museum of African American History and Culture, Pacific Parachute exemplified "democracy in action," and a "symbolic victory in the battle against racial discrimination in the national defense industry."[32]

Consistent with his other 1942 work, Lee's Pacific Parachute photographs and captions convey solidarity and also highlight the diversity of Smith's staff. In part, this FIS image campaign related to a domestic messaging strategy of "unity-in-diversity-as-strength" already in use to shape attitudes about World War II, a

strategy cultural historian William Stott later noted became central to American entertainment, propaganda, and reportage.[33]

Another group of Americans participating in the war effort played a role in FIS spin tactics: immigrants from neutral countries. Stryker directed Lee to photograph residents from Portuguese communities in California and "Swedish American actors and actresses taking part in Civilian Defense activities. Greta Garbo knitting for the Red Cross, etc."[34] With this image campaign, the FIS piggybacked on another familiar idea, that of celebrating immigrants as Americans united under democracy.[35] Yet the FIS clearly had a more complex objective, suggesting that neutral countries supported the Allies.

In April 1942 Lee photographed three Portuguese communities in the East Bay region of California. His captions affirm their sense of civic responsibility; some were leaders in their community and served on city council. He also highlighted their patriotism and contributions to the war effort: buying bonds, participating in Red Cross and USO drives, serving as block wardens in the Civilian Defense program, and creating posters for various defense groups.

A men's store owner proudly told Lee: "No Fifth Columnists here. We're 100% Americans. We are buying bonds and we want to do everything we can to keep this country, which has given us so much, free."[36] Lee's subjects also invoked the then-popular ideal of America as a melting pot, which celebrated immigrants' assimilation into American life rather than promoting the culture of their home countries. A dairy farmer near San Leandro told Lee that he and his family were "as American as fried chicken."[37]

Elsewhere in San Leandro, Lee met another Portuguese American passionate about his adoptive country, a forty-year old jeweler named Mr. H. Ormand (fig. 92). Mr. Ormand came from the Azores Islands, a strategically located autonomous region of Portugal which both Allied and Axis powers sought to control.

Lee's lengthy caption explained Mr. Ormand's path to the American Dream: immigration to the United States at seventeen, three years in San Francisco, followed by another ten in Oakland where he worked in a jewelry store. In 1932, he opened his own store in San Leandro, where he and his wife worked long hours

to build their business and establish themselves in the community. Mr. Ormand embraced the assimilation ideal, glossing over any cultural differences. He told Lee: "While I now speak a different language, all the principles of life in the United States and the Azores are the same."[38]

Illustrating this sentiment, Mr. Ormand stands before a wall of his wares, a legion of more than forty distinct timepieces, each shape, design, and face different from the next. Electric clocks—by Telechron and Westclox—mingle with one another, a Big Ben sits with five Baby Bens, and the face of a dog peers over the shoulder of Mr. Ormand, who holds out a "Tide" windup alarm clock for inspection. Just as the agency strived to represent a diverse group as alike, Mr. Ormand attempted to impose a similar sense of uniformity by lining up his heterogeneous clocks—all displaying a different time—in evenly spaced rows. Yet like the immigrants Lee photographed, they're all individual.

The same month—April 1942—that Lee embarked on his Portuguese American assignment for the FIS, he depicted another immigrant group for the FSA: Japanese Americans living on the Pacific Coast. When Japan bombed Pearl Harbor in December 1941, a tide of racial hysteria rose in the United States. Bigotry and prejudice ran deep and wartime popular culture depicted Japanese people as "yellow vermin," "mad dogs," and "monkey men." Racist caricatures featuring epicanthic eye folds, thick glasses, and prominent teeth became visual symbols of an enemy. *Life* magazine published a rule-of-thumb guide to distinguish "friendly Chinese from enemy alien Japs."[39]

Fearing saboteur collaboration with Japan, some politicians and military commanders lobbied to remove Japanese Americans from the Pacific Coast. In February 1942 Roosevelt's Executive Order 9066 authorized it. Through spring and early summer, the War Relocation Authority (WRA) forcibly evacuated about 110,000 people of Japanese descent (including nearly 70,000 American citizens)

92. Mr. H. Ormand . . . a leading jeweler in San Leandro, California . . . April 1942.

from areas designated as military zones: all of California, the western half of Washington and Oregon, and the southern part of Arizona.[40]

Authorities moved evacuees to hastily repurposed racetracks and athletic fields euphemistically named "reception centers" along the West Coast, then transported them to internment camps or "relocation centers" in desolate inland locations.[41] Internees were instructed to bring only what they could carry in each hand, leaving behind the rest of their property. While the WRA was to act as sales mediator, possessions sold for much less than actual value, resulting in tremendous financial losses. Most Americans outside the West Coast ignored the entire action.

Farm Security's connection to the evacuation was twofold. The agency's primary task was to recruit farmers to work land vacated by Japanese Americans. Lt. Gen. John L. DeWitt, commander of the Western Defense Command (and vocal supporter of the evacuation), directed the FSA to find operators for more than 6,600 farms in the middle of the growing season. Scholars have since pointed out the irony: that the same agency devoted to improving the self-sufficiency of small farmers should then be forced to participate in the eviction of such a productive group.[42] Compelled by military order, the FSA undertook the assignment with, according to historian Sidney Baldwin, "considerable reluctance." For its concern in protecting the interests of evacuees, the agency earned the label "Jap-Lover."[43] Lee documented Japanese farmers working their fields, selling their farm equipment to non-Japanese farmers, and waiting for evacuation orders in rural California. His captions hint at the dispersal of land to "white farmers."[44]

The FSA's second, more minor task involved arranging for a few hundred evacuees to help meet the labor shortage on farms in remote sections of Oregon, Washington, and Idaho. The federal government asked for volunteers at relocation centers to work for prevailing wages, then transported them for the season to former CCC and FSA migrant camps.

Over three months, Lee made a comprehensive record, expanding his coverage beyond aspects in which the FSA was directly involved. He traveled to Little Tokyo (a Japanese enclave in Los Angeles) as families prepared for evacuation:

cleaning their ancestral cemetery plots, selling their belongings, and closing their businesses. Lee pictured one store window that illustrated their tremendous financial losses: "This Entire Stock Must Be Sold at 25 cents on the Dollar."[45] He documented families arriving and registering at the Santa Anita racetrack northeast of the city, their departure by train, and finally their detention at FSA-managed camps. Lee visited three in Idaho (Twin Falls, Shelley, and Rupert) and one in Oregon (Nyssa), near the Vale-Owyhee irrigation project, which he had covered the previous summer. At the camps he photographed internees cultivating and harvesting celery, sugar beets, apricots, beans, and potatoes.

Lee rejected the one-dimensional, racist stereotypes and condescending images that persisted in popular media. Evoking his FIS assignment of Portuguese Americans, his documentation emphasizes a strong work ethic and good citizenship. He pictured Japanese Americans' beautiful homes and gardens, and photographed them saluting the flag, as well as doing typically "American" things, like reading comic books and eating hot dogs.

There's no trace of Lee's viewpoint about the evacuation and internment in the official textual records. His captions—which were edited once they arrived in the FSA office—report the evacuation and internment dispassionately. And there's no mention of the internment in the Lee-Stryker correspondence (now at the Stryker Papers at the University of Louisville). In fact, most of the 1942 correspondence between Stryker and Lee has vanished, likely due to contemporaneous administrative redaction, during a period of heightened national security and amid Stryker's fears that his office would be shut down.

However, a letter Lee wrote to Stryker describing the conditions of various camps recently surfaced after the Library of Congress acquired the Jack Delano Papers in 1996. This private, seven-page letter, dated July 28, 1942, criticizes the WRA, finds fault with camp conditions, and questions the labor arrangement. Lee informed Stryker: "There are several things you should know about [the Nyssa and Rupert] camps—things I have picked up in talking with camp managers, Japanese evacuees, and local Japanese who have been living near [here] for many years prior to evacuation."[46]

At Nyssa, he reported lack of shade, excessive dust, and low water supply, explaining, "As it gets hot as hell during the day the first two make life a little uncomfortable." Conditions at Rupert were also substandard. Though it had ample grass, water, and shade, it was a former CCC camp with barracks that had been designed to house single men, which, according to Lee, were "not so good . . . for families unless partitions were erected." Lee continued, "However, anything is an improvement over the housing in some of the centers, where . . . several families were placed in one room . . . about 15x20 feet." He added, "This lack of privacy was one of the things most resented by the Japanese and has a definite bearing on their morale." He reported that among the internees there was a "common feeling that they are forgotten" and many were losing faith in the government.

He also reported resentment toward the Japanese from migrants and local White laborers, and, acknowledging that many of the internees were American citizens, mentioned "several restrictions that FSA has had to follow that interfere with rights of citizens." These restrictions "were forced upon the FSA" by the local community, the U.S. Employment Service, and the Amalgamated Sugar Company, which paid the farm laborers' wages. Lee believed the Japanese should be allowed to work in war industries and jobs depleted by the draft, but reported a "definite antagonism toward their becoming settled in any business enterprise of their own."

Lee also relayed some of the circulating—but false—rumors, including one that Japanese Americans would be shot when they arrived at the Nyssa camp, so when they got off the train, they ran to the waiting school buses in hopes of dodging the anticipated bullets. Lee detailed another fabricated rumor, "that 17 Japanese had died of ptomaine poisoning from canned goods at the Tulelake Calif. reception center. . . . Even names of the victims were given—names of people that were known to the Japanese at the Nyssa camp."

Such a pointed critique of the internment and Lee's reports of a lack of faith in the government were politically unacceptable and potentially damaging during

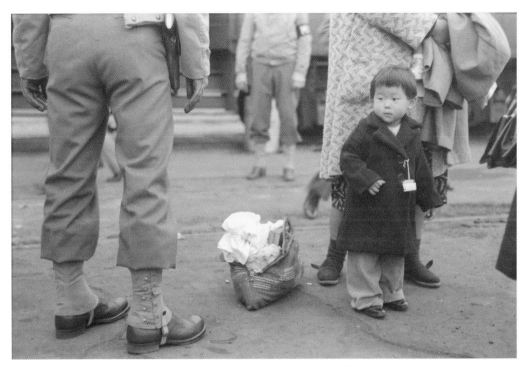

93. *The evacuation of Japanese-Americans from West Coast areas under U.S. Army war emergency order. Japanese-American family waiting for train to take them to Owens Valley, Los Angeles, California, April 1942.*

a precarious time for the FSA. Stryker removed the letter from his files and sent it to Delano, not an uncommon practice: to keep his team informed of what each member was doing, Stryker sometimes sent a letter from one photographer to another, with the request that the letter be returned. However, Delano kept it until he donated his papers to the Library of Congress.

It's hard to know if Stryker—or anyone else—also removed or destroyed any objectionable photographs Lee may have made. Most of his extant evacuation and internment photographs appear to be a neutral documentation of events transpiring before him and don't reflect the feelings he expressed in his letter. Many of his images from the Santa Anita racetrack-turned-reception center resemble pictures of pleasure travelers departing from a train station; the white

identification tags hanging from their coats are the only signs indicating otherwise. As a government photographer during wartime, Lee could not express an opinion about a government-sanctioned action, either in his photographs or via official textual records. Nor could he document certain aspects of the evacuation. For example, photographers were not permitted to photograph armed soldiers, guard towers, or barbed wire.[47] Otherwise, the work would have been censored, confiscated, or destroyed. Lange, on a WRA commission, documented the Japanese American internment; most of her photographs were suppressed for the duration of the war.

Yet Lee managed to be unmistakably critical in some of his images. As he had done throughout much of his FSA work, he photographed children as blameless victims and managed to include armed soldiers in a few of these portraits, tightly framed compositions made inconspicuously, from a crouched position. In one image, a child stands in the middle ground, while two imposing MPs stand in the foreground and background. Lee showed the guards from a child's eye-level: we see only combat boots, trousers bloused over gaiters, and leather-gloved hands hovering at their sides. The butt of a holstered pistol catches the sunlight (fig. 93).

Lee made other equally poignant views of Japanese American children. In one of the most gut-wrenching images from this series, he pictured a young girl waiting for evacuation, with two members of her family standing close by (fig. 94).

They stare stoically into Lee's lens while she grasps the antenna of her family's car, the top of which holds a fluttering American flag. A layered commentary on American democracy and identity, this mournful portrait mocks the new directive to photograph people "who appear as if they really believed in the U.S." Although such critical pictures are outnumbered by his more neu-

94. *Japanese family arriving at the center. Santa Anita reception center, Los Angeles County, California, April 1942.*

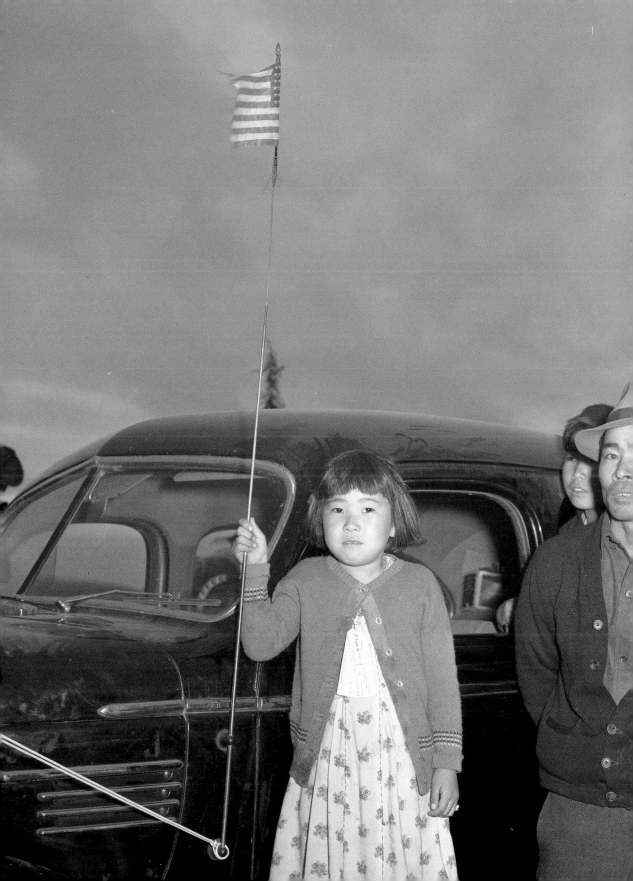

tral ones, Lee's record of the Japanese American evacuation and internment constitutes a documentation of social injustice, his last series of this type for the FSA.

These portraits—and Lee's entire Japanese American internment series—didn't fit with the carefully orchestrated narrative constructed by the COI, later carried on by the OWI. Lee grew increasingly dissatisfied with this constructed narrative, and his attitude reflected a more widespread one within the agency. According to historian Allan M. Winkler, some OWI employees became discontented with "what they regarded as a turn away from the fundamental, complex issues of the war in favor of manipulation and stylized exhortation."[48] As the official purveyor of news and information, the OWI showed the best face of the home front, an approach the Office also took in its coverage of the Atlantic and Pacific theaters. Historian Doris Kearns Goodwin noted that only a few photographs of dead American soldiers appeared in magazines and newspapers: "The bodies shown were always clothed and intact, as if they were sleeping." Goodwin wrote that the OWI "had so sanitized the war experience that few people on the home front understood what the war was really about."[49] Similarly, the OWI's controlled coverage of the domestic scene was unremittingly positive, motivational imagery stressing American virtue and a concerted national effort, a type of photography that held little appeal for Lee.

Yet it would be an oversimplification to suggest that this is why Lee left Stryker's project. He had created scores of celebratory views for Stryker's shifting information campaign. In fact, when Lee returned to Shasta Dam a final time to document the construction progress in the summer of 1942, he made a dramatic composition of three servicemen standing before the monolithic structure (fig. 95). The site's 465-foot-high head tower, which Lee had climbed the previous December (fig. 84), is visible in the background. Embodying all the OWI aimed to convey about America, Lee's photograph depicts an awe-inspiring symbol of the country's technological, economic, military, and industrial power.

Lee didn't mind making this kind of image, but only as part of a larger documentation. During his final visit to Shasta Dam he made more than 150 pho-

95. *Sailors watching construction work on the dam from Vista house, Shasta Dam, Shasta County, California, June 1942.*

tographs for the FSA (including eight Kodachromes), most chronicling the construction process. However, the opportunity for this kind of broader documentary coverage vanished when the Historical Section was abolished in September 1942.

The OWI also famously turned a blind eye to social issues, which were the core of Lee's documentary interest and what motivated him to seek out Stryker's project in the first place. Well-known problems dividing the home front included labor strikes, struggles for equal treatment in a segregated military, race riots, and the hardships caused by inadequate childcare for women working at defense plants. None of these social concerns were addressed in OWI documentation, as they would have invalidated the image of a country united in wartime.

As 1942 unfolded, Lee watched the documentary project he had helped build fall apart. When he came in from the field for a Washington visit in late October 1942, he met up with longtime FSA associate Pare Lorentz, recently commissioned an officer in the Army Air Forces. Major Lorentz was putting together a photographic team for the Air Transport Command's newly established Overseas Technical Unit and asked Lee if he would head the still picture section. Lorentz had caught him at just the right moment. Lee accepted his offer (and a captain's commission) and spent the rest of the war as an armed forces photographer. His most prolific period as an artist and documentarian had ended.

After the war, Lee went on to make many thousands of social documentary images for other organizations, yet it was his time with the FSA that became the defining period of his life. Exactly twenty years after leaving Stryker's project, Lee witnessed a massive reawakening of interest in the work he and his colleagues had created. Their photographs attracted new audiences and sparked a reexamination that continues today.

1943–1986

Reexamination

It is interesting, and understandable, that the FSA photographs are all that recall our efforts. Perhaps you and Rex understood this. I did not at the time.

<div align="right">

Beanie Baldwin to Roy Stryker, 1964[1]

</div>

FROM *THE BITTER YEARS* TO AMARILLO

When Stryker left the OWI in the fall of 1943 to start a new documentary project at Standard Oil New Jersey, he arranged for the File's transfer to the Library of Congress. Pictures made under his direction (1935–43) and those added by the OWI (1943–45) remained in use by the OWI and other organizations until the end of World War II. By March 1946, when the FSA-OWI Collection was physically moved to the Library, where it formed the core of the new Prints and Photographs Division, it was no longer an active working image file.

Though safely ensconced in the Prints and Photographs Division, the File came under attack by lawmakers in the late 1940s, the early years of the Cold War. News-

papers and magazines ran prominent stories of House and Senate members chastising the FSA documentary project, disparaging individual pictures, and questioning the "merit" of "silly" photographs "clutter[ing]" the Library of Congress.[2] Partly to limit the File's exposure to such criticism, Division Chief Paul Vanderbilt downplayed the context of its creation, instructing staff to "avoid all unnecessary reference to or mention of 'FSA' or 'OWI.' . . . Do not use these letters in correspondence, on order forms, or in conversation. . . . The sources are to be referred to on direct questions of fact. They are to be soft-pedalled in all public relations."[3]

As a result, the File largely faded from public view, though it still remained available to researchers and individual images appeared sporadically in museum exhibitions.[4] In 1955, the Brooklyn Museum organized a retrospective to mark the twentieth anniversary of the Historical Section's creation, but the exhibit, titled simply *Farm Security Administration Photography*, garnered a mediocre review.[5] A few articles appeared in special interest magazines such as *Journalism Quarterly* (1947), *Minicam Photography* (1947), *Photographic Society of America Journal* (1948), and *Harvester World* (1960). And the University of Louisville mounted a small show in early 1962.[6] All attracted limited audiences. It wasn't until the fall of 1962 that the FSA documentary project came back to the fore.

On October 18, 1962, the Museum of Modern Art (MoMA) opened the retrospective exhibition *The Bitter Years 1935–1941: Rural America as Seen by the Photographers of the Farm Security Administration*. The show was organized by famed photographer and director emeritus of MoMA's Photography Department, Edward Steichen. A spirited champion of the FSA since the Grand Central Palace exhibition in 1938, Steichen selected just over two hundred photographs, and as he had done in previous MoMA exhibits, took a sensationalist approach to image presentation, enlarging some beyond life-size.[7]

The first major spotlight on Stryker's project by a major art world personality—and a powerful art institution—*The Bitter Years* triggered a surge of renewed attention. *New York Times* art critic Jacob Deschin lauded the show, calling it Steichen's "tribute to a great contemporary and to the photographers who helped him produce one of the most impressive documentations in photographic history."[8] Those who had

lived through that time began to look back and reexamine the File, and a new generation of Americans who had grown up in a postwar boom period saw the images for the first time. The photographs had passed from current event to historical record.

Yet Steichen's show wasn't an overview of the File. It presented instead a narrow segment of the project and an unbalanced view of those who contributed to it. As the subtitle indicates, Steichen restricted his selection to the first of what could be considered four distinct phases of the File, choosing images of rural distress and excluding those of positively rehabilitated RA/FSA clients, defense mobilization, and America at war. In addition, the photographer ratio was misleading. Despite the exhibit's premise that the images were the collective work of a team, nearly half were by Lange, a fact not overlooked in Deschin's review. Lange made about 6 percent of the FSA photographs in the File; recent scholarship suggests the disproportionate number of her images in *The Bitter Years* may have been a reflection of Steichen's close friendship with her, his preference for the portrait genre, and that he "had always valued Lange's commitment to migrant communities."[9] Perhaps not coincidentally, MoMA was also planning a major retrospective of Lange's work.[10]

MoMA hosted a gala opening, which Stryker and Lee both attended, as did many of the other photographers. Lee treasured the opportunity to catch up with his colleagues and reflect on their accomplishments with the FSA. A photograph taken at the opening shows Lee and Stryker in one of the galleries, two old friends in conversation (fig. 96). Lee stands in front of a wall of photographs, including one he took in North Dakota in 1937. Over Stryker's shoulder is a large print of a sharecropper portrait Lee made at Southeast Missouri Farms.

The two men had remained close, both personally and professionally, after Lee's resignation from the OWI in late 1942. It was Stryker who suggested Lorentz ask Lee to join the ATC, knowing how dissatisfied Lee had become with the OWI. And Stryker set up a photographic lab for Lee in Washington to print his ATC work, so when Lee was stateside they saw each other frequently.[11]

After the war, Lee moved to Austin and focused on social documentary projects in the state, many for little or no compensation.[12] He continued working with Stryker, taking on jobs as they fit his schedule; he joined Stryker's Standard

96. Russell Lee and Roy Stryker at *The Bitter Years* exhibit, October 1962, photographer unknown.

Oil team as a freelancer from 1947 to 1950, along with fellow FSA-OWI photographers John Vachon, Edwin and Louise Rosskam, Esther Bubley, and Gordon Parks. When Stryker moved to the Pittsburgh Photographic Library (1950–51), then consulted for Jones and Laughlin Steel (1954–55), Lee took on those jobs when he could. The two men also collaborated in the late 1940s and into the 1950s on the Missouri Photo Workshop, where students could develop their photojournalistic skills by working with established photographers in an intensive seminar environment. A few months before *The Bitter Years* opening, Stryker had retired and moved back to Montrose, Colorado, the town of his youth. Lee remained in Texas, where he was winding down his own documentary career.

In addition to catching up with Stryker, Lee also had a chance to socialize with Rothstein, Vachon, Delano, and Bubley at the MoMA opening and at an after-party hosted by their old friend Willard Morgan. Later that night, as Delano remembered it, they "all went out to a fancy restaurant and then to Arthur's studio at *Look* magazine to have a group photograph taken" (fig. 97).[13]

In tandem with *The Bitter Years* opening, MoMA organized programmatic events. These included film screenings of Lorentz's *The River* and *The Plow That*

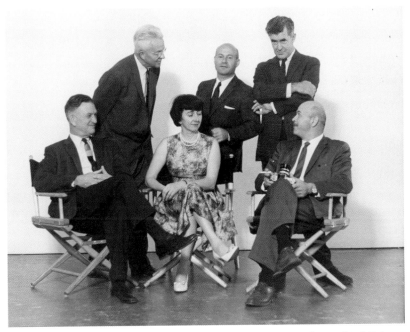

97. Russell Lee, Roy Stryker, Esther Bubley, Arthur Rothstein, John Vachon, and Jack Delano (left to right) during *The Bitter Years* event, October 1962, photographer unknown.

Broke the Plains and a symposium on the Historical Section. Lee participated, along with Delano, Lange, Rothstein, Shahn, and Stryker.[14] John Szarkowski, who succeeded Steichen at MoMA, later recalled that "over the event hung the shadow of [a] missing guest." Evans, who lived within walking distance of the museum, "had not very politely excused himself." According to Szarkowski, Evans believed the FSA had "appropriated his style without understanding its meaning" and "had no intention of lending credence to its pretensions by attending its reunions."[15] Yet, Evans's rationale—and feelings—may have been more complicated than that. He openly admitted he looked down on the documentary project and "had contempt for" his boss, Stryker (who eventually fired him in 1937).[16] Yet, during an interview a few years after *The Bitter Years*, Evans expressed embarrassment at the mention of Stryker and regret for the way he had treated him.[17]

The Bitter Years and its accompanying programs got a lot of press coverage: besides the glowing *New York Times* review, word of the show reached audiences

of local radio, regional newspapers, and national magazines. MoMA traveled the exhibition for a few years and the accompanying catalog went into three printings. *The Bitter Years* awakened a national interest in the photographic project and those who created it.

A year after the exhibit, the Smithsonian Archives of American Art included the FSA documentary project in its newly formed New Deal and the Arts program, a systematic collecting and oral history initiative. Between October 1963 and August 1965, art historian Richard Doud traveled the country interviewing every principal Historical Section photographer (except Evans), as well as administrators and members of Stryker's office staff.[18] Collectively, the interviews convey the group's shared goal to better the lives of those less fortunate. Many expressed true astonishment that they managed to pull the whole thing off. And some began considering their photographic legacy. Not surprisingly, Doud's oral history with the loquacious Stryker totaled more than seven hours and necessitated three separate meetings.

On June 2, 1964, Doud traveled to Austin to interview Lee, who insisted Jean be included; the three had a jovial, good-natured exchange.[19] Reaching back almost thirty years, Lee recollected details of joining the Historical Section staff and aspects of his assignments: long trips in the field, working conditions, technical limitations, and photographic innovations of the era.

Doud asked all the photographers probing questions. These included their viewpoint on whether or not the File had been used enough, Stryker's editorial process of "killing" negatives, and the repeated publication of a few iconic images. Whereas other photographers shared their considered opinions and assessments, Lee kept the conversation superficial and sidestepped Doud's questions. Always one to avoid the spotlight, Lee praised his colleagues, credited Stryker's direction, emphasized Jean's important contributions, and expressed gratitude for the opportunity to work for the FSA.

Even so, Doud later recalled the experience of interviewing Lee favorably, that he "meshed more smoothly" with him than with some of the other photographers. Doud remarked, "Russell Lee was one of the most comfortable individuals that I

met during my work with the RA/FSA photographic project. He was a thoughtful, intelligent man who knew what he wanted to do and how he wanted to do it."[20]

Around the time of Doud's interviews, Lee and his fellow photographers continued to witness the rediscovery of their work by a new generation of curators, academics, and critics. For example, when Doud interviewed Lange in May 1964, she recounted a conversation with a MoMA curator who had been collecting material for an upcoming show, *The Photographer's Eye,* and who expressed respect for Lee's work. Lange said the MoMA staffer told her that he "came to appreciate Russ Lee. Never really registered, seeing a little something here or a little something there, but the bulk of his work is . . . solid."[21] Lange was likely referring to Szarkowski, still a junior member of the photography world, and whom she'd just met. Szarkowski selected about a dozen FSA images—including four by Lee—for *The Photographer's Eye,* which opened a few days after Doud's interview with Lange.[22]

In 1965, art history professor Marian Davis curated a retrospective of Lee's work at the University of Texas Art Museum (now Blanton Museum of Art). Davis selected more than 250 photographs from the major periods of Lee's career and produced a slim catalog, which included tributes from contemporaries such as Pare Lorentz and photographer Barbara Morgan. Later that year the show traveled to the Smithsonian Institution in Washington, D.C.[23]

For Lee—by this time retired from active documentary work—it was a moment to look back on his accomplishments and revisit photographs he made decades earlier.[24] He crafted a one-page "Autobiography" for the catalog, a humble account of his thirty-year career, with an emphasis on the many people who helped him along the way. On the catalog's last page, he wrote a single paragraph, an epilogue expressing his heartfelt gratitude to one person:

> And at this end, I would like to say my thanks to Roy Stryker, my boss and teacher, my friend and companion on many adventures. He believes that photography is more than mere recording or reporting, more than propaganda, more than pictorial. He believes that photographs are useful tools for the historian, the economist, the sociologist, the writer or the anthro-

pologist; and that photography's only limitation as a means of communi-
cation lies within the photographers themselves. All photographers and
those who use photographs are in his debt for this concept.[25]

After the retrospective, Lee worked with the University of Texas to establish
a photography program in its art department, and in the fall of 1965 became its
first instructor. Lee influenced a new generation, both in the classroom and at his
Austin home, which became a meeting place for the local photographic commu-
nity. A regular in that circle, Roy Flukinger, remembers Lee advising students and
photographers alike to "do what really interests you, follow it through to the end,
and then you will succeed."[26]

THE LATE 1960S and early 1970s saw more FSA exhibitions and books, with
Stryker and some of the photographers actively presenting their history. In 1968,
for example, the Newport Harbor Art Museum (now the Orange County Museum
of Art) organized *Just Before the War: Urban America from 1935 to 1941 as Seen
by Photographers of the Farm Security Administration*, an exhibition of 256 prints
that traveled the country for several years. The museum printed an accompanying
catalog for which Rothstein, Vachon, and Stryker wrote prefatory notes. In 1972,
photo historian F. Jack Hurley published the landmark text *Portrait of a Decade:
Roy Stryker and the Development of Documentary Photography in the Thirties*. Put-
ting Stryker at the center of the story, Hurley traced the project from beginning to
end and interviewed Stryker, Rothstein, Mydans, Baldwin, and Lee.

Stryker had already been thinking about his legacy. He had recently placed
his papers with the University of Louisville Photographic Archives and sought
a more active role in securing his place in the File's history. Since the end of
World War II, he'd been trying to get a book project off the ground, but couldn't
interest publishers.[27]

With resurgent interest in the FSA, his moment came in 1973. At the age of
eighty, Stryker published (with writer and photographer Nancy Wood) *In this*

Proud Land: America 1935–1943 as Seen in the FSA Photographs. In an introductory essay, Stryker explained, "For thirty years I have waited to make my personal choice from the huge file that passed over my desk during those eight years." According to Wood, Stryker chose images largely to "offset the negativism of *The Bitter Years* and partly to dispel the widely held belief that the FSA pictures were *all* downbeat."[28]

Nearing the end of his life, Stryker had become nostalgic for the New Deal, which he termed "a unifying source of inspiration." He described the "exhilaration in Washington, a feeling that things were being mended, that great wrongs were being corrected, that there were no problems so big that they wouldn't yield to the application of good sense and hard work."[29]

He also looked back at his team, "gifted men and women" whose "deep respect for human beings" he admired. Stryker admitted, "I learned as much from the photographers as they did from me. I respected them and counted on them and gave them hell."[30] He enumerated each one, and their special contributions to the project, but set Lee apart:

> One photographer stood out from all the others and that was Russell. Not because he was better than the others, but because there was some quality in Russell that helped me through my problems. It was the kind of relationship between two guys that have been through the war together. When his photographs would come in, I always felt that Russell was saying, "Now here is a fellow who is having a hard time but with a little help he's going to be all right." And that's what gave me courage.[31]

Stryker also considered his own contributions, and with an eye to cementing his place in history, wrote, "I have the honesty to advance the somewhat immodest thought that it was my ideas, my biases, my passions, my convictions, my chemistry that held the team together and made . . . of their work something more than a catalogue of celluloid rectangles in a government storehouse." He reflected, "I never took a picture and yet I felt a part of every picture taken."[32]

After Stryker's book, the FSA photographs became ubiquitous. The *Washington Post* informed readers how to order prints of their favorite images from the Library of Congress.[33]

In 1976, Hank O'Neal published the outsized volume *A Vision Shared: A Classic Portrait of America and Its People*. He invited each photographer to participate by making the final image selection and approving the personal profiles he wrote. Every living photographer accepted, including Evans, to O'Neal's surprise.[34]

O'Neal's essay on Lee is thoughtful and includes a few nondescript comments from Lee—reminiscences about his time in the field—but none of Lee's insights on the work itself. Nonetheless, Lee intrigued O'Neal, who later remarked he wished he'd been able to spend more time with him because he believed there was a lot he could have learned from Lee.[35] *A Vision Shared* proved popular, and in 1976 celebrated New York art dealer Lee Witkin mounted a gallery exhibit based on the book.[36]

In 1978, Lee received individual attention with the publication of *Russell Lee: Photographer*, a monograph by F. Jack Hurley, who had written *Portrait of a Decade* six years earlier. Hurley worked with Lee on the image selection, and his essay—based on a series of interviews—reflects Lee's guarded nature. Writing that "on the surface levels of his life he is totally open," Hurley remarked that "the difficulty comes when one tries to go beneath the surface." When Hurley asked Lee about specific photographs, "the usual response . . . would be silence or a change of subject." For a long time, Hurley believed "there was something a little secretive" about Lee and speculated that the tragedies of his youth may have taken away his "ability to verbalize his deepest feelings."[37]

Hurley had met Lee in the 1960s, while working on *Portrait of a Decade*. He'd interviewed him, spent time with him, and considered him a friend. Yet Lee remained impenetrable. To emphasize this point, Hurley relayed a conversation with Jean who told him, "I don't know Russ . . . I've lived with this man for nearly 40 years and I still don't know him."[38]

In contrast to Stryker, Lee was a reluctant subject of his own book. Believing his work would speak for itself, he remained unconcerned with controlling his photographic legacy or authoring his own story in the FSA's history. That changed

the following year, in January 1979, when he attended a three-day symposium at the Amarillo Art Center (now the Amarillo Museum of Art).

Titled *FSA Photography: A Reexamination*, the symposium was organized by Art Center staff members and cultural historian Steve Plattner.[39] Lee played a central role by helping the organizers track down some of his FSA colleagues; Mydans and Edwin Rosskam weren't available, but Collier, Delano, Rothstein, and Wolcott agreed to participate along with Lee. About five hundred people came to hear the FSA veterans, while three scholars moderated: Plattner (who had recently curated a traveling FSA exhibition funded by the National Endowment for the Humanities), Hurley (fresh off the Lee book), and Werner Severin (professor of journalism at the University of Texas who had written academic papers on the FSA).[40]

Looking back on their time with Farm Security, the photographers discussed their shared commitment to New Deal reform, and described their working methods, field experiences, and individual assignments (fig. 98). Lee spoke about docu-

98. John Collier Jr., Jack Delano, Arthur Rothstein, Russell Lee, and Marion Post Wolcott (left to right) at Amarillo symposium, January 1979, photograph by Ave Bonar.

menting farm tenancy in the Midwest, migrants in Oklahoma, and small-town life in San Augustine, sprinkling his reminiscences with technical details, such as his use of flash to capture interiors.[41]

Photographers also looked ahead and considered the long-term documentary value of their work. Collier shared with the audience his view that FSA photographs were "a baseline against which you can measure a very complex pattern of change," and in some cases as "devastating evidence to measure the value of progress." Rothstein agreed, and remarked that the historical significance "will change from one period of history to another."[42]

Delano illustrated his colleagues' points with a recent encounter he'd had with an anthropologist who came across Delano's 1940 coverage of a South Carolina community about to be flooded by an Army Corps of Engineers dam. The anthropologist put together a traveling exhibition of the photographs, which, Delano told the audience, "People from everywhere came around to see. They recognized their fathers in the photographs, their grandfathers, their families. The whole history of what had happened to that area was brought back to life."[43]

When it came time for questions, the FSA photographers had difficulty connecting with the audience, whose perspectives on both government and photography contrasted sharply with their own. Many attendees had grown up in the 1950s and came of age in the 1960s, a decade of social protests, student movements, and questioning of institutions and authority. Hurley later recalled that some audience members "wanted to know how the photographers had been able to live with the fact that they were tools of something as 'unclean' as the federal government . . . [and] clearly felt that the photographers had somehow sold their artistic souls in consenting to work for Washington." Whereas the New Deal generation believed the government was supportive and humane, this younger generation associated it with the Pentagon Papers and Watergate, and believed it was a source of lies, distortions, and threats.[44]

Lee, recently retired from the University of Texas, failed to connect with the audience as he tried to provide a different view of government by contextualizing the social reform significance of the FSA project. Falling back into his professorial demeanor, he described the Depression as a "period of . . . social unrest

in the whole world," characterized America as being "in really a very sad way," and recounted the New Deal's "effort to try and get the country back." He saw his photographs as a call to action, telling the audience: "It was my job to explain—to show—these conditions so that they could be alleviated, because here were people starving, needing clothes, and so forth. You do something about this."[45]

Perspectives on documentary photography had also shifted. Some attendees came in search of critical evaluations and more theoretical discussions, which the photographers did not embrace. Nonetheless, these were understandable expectations, given the symposium's ambitious program.

Among the advertised sessions was one entitled "The Accuracy of the Documentary Photograph," bringing up topics that occasionally put the photographers and audience at odds with one another. For example, attendees asked about two conventions they found objectionable: Stryker's shooting scripts and the photographers' scene manipulations. One of the symposium organizers, curator David Turner, recalled the questions "cast a defensive attitude on the part of the photographers," but added that it seemed the FSA veterans had heard them before.[46]

Indeed, the photographers held their own. Wolcott and Lee both remarked that they looked to Stryker's scripts for ideas, but never followed them verbatim. When Rothstein's skull photographs came up, he bristled at accusations that he set up scenes, but Delano and Lee came to his defense. Delano tempered the conversation and reflected on photographic truth and the broader definition of documentary photography, telling the audience, "The photograph of the skull—what the camera saw with the skull—in one place was just as true as . . . the other place. Both photographs are true." To make his point, Delano continued, "If the five of us were sent out by Roy Stryker . . . to cover the same subject matter in the same area, the same field, we would each come back with different photographs. Which photographs are true and which are untrue is not the question. They'd all be true, but they'd all be different." Of the same mind, Lee added that they'd be "different facets." Continuing Lee's thought, Delano added, "different facets of the same basic truth. I think that's true of the whole File. . . . it tells a basic truth about what the country was like in that period."[47]

Other symposium questions were shaped by an influential but critically debated theory: Szarkowski's mirror/window analogy. A year earlier, he had curated the MoMA exhibition *Mirrors and Windows: American Photography Since 1960*, with a catalog of the same name. By that time regarded as one of photography's most authoritative voices, Szarkowski advanced the idea of a fundamental dichotomy in contemporary image-making: those who thought of the medium as a means of self-expression, a reflection of the photographer (a mirror) and those who thought of it as an unfiltered view of the world (a window).[48] He postulated that the generation of photographers who came to artistic maturity and recognition after 1960 pursued a highly personal vision geared toward creative growth, in contrast to previous generations who had consciously chosen to document the politically and socially significant issues of the day.

Szarkowkski's show had gotten prominent—but mixed—reviews in major newspapers and by the time of the Amarillo symposium it was opening at its third venue.[49] The January 1979 issue of *Modern Photography* (published just before the symposium), carried an eight-page illustrated spread about the exhibition and catalog, written by respected critic Andy Grundberg.[50]

Many audience members embraced Szarkowski's analogy, yet Collier (who a decade earlier had published a landmark book about using photographs as a means for communication and research in anthropology) dismissed it.[51] He believed a photograph was both mirror and window, and further described it as "a two-way communication . . . In other words . . . the photographic mirror has two sides to it, and at one side, you've got the communication from out there and on the other side, you've got the communication from in here. . . . And both become imbedded in the negative."[52]

Members of the audience also identified with Szarkowkski's characterization of the new generation of photographers, that they were individuals pursuing a personal artistic vision. When an attendee asked the photographers what kind of creative growth the FSA afforded them, Lee shot back, "I didn't give a damn if I was growing creatively. I was just doing my job. Let's forget this angle of art."[53]

This was an unsurprising comment from Lee, who had complicated views

about documentary photography's status as art and for decades outwardly objected to any aesthetic emphasis. For example, during his FSA tenure, in response to a letter from Stryker discussing members of the Photo League (a leftist New York documentary and artistic cooperative concerned with social causes), Lee remarked that "too many of them have the 'art' idea a little too much on their minds."[54]

Yet, from the start Lee had been disingenuous about his own artistic intentions. From the time he took up photography in 1935, he incorporated John Sloan's training to create visually compelling, socially minded photographs and embraced aesthetically based presentations of his work, both in exhibitions and print media. When Lee and Rothstein selected images for the Grand Central Palace show in April 1938, aesthetic merit factored into their choices. When Steichen devoted a section of the 1939 *U.S. Camera Annual* to the Historical Section, Lee had very clear ideas about which of his photographs he wanted to include, and in a 1941 article about flash for Willard Morgan, Lee selected images based on their formal qualities.[55]

While Lee emphasized social reform as the primary function of his FSA work, evidence suggests he didn't object to its recontextualization in the art world. By the time of the Amarillo symposium, his FSA photographs had been included in non-FSA art museum exhibitions, including *Family of Man* and *The Photographer's Eye* at MoMA as well as a 1965 exhibit at Yale University Art Gallery and another at the Whitney Museum of American Art in 1974.

Nor did Lee distance himself from the commodification of his FSA work. In fact, he wanted to maximize his income from color prints sold through a commercial New York gallery.[56] Paradoxically, Lee asserted the aesthetic and financial worth of his photographs in an art market, despite his conflicted efforts to reject the designation of artist.

Thus, it appears Lee's admonition to "forget this angle of art" had less to do with art and more to do with anxiety about how FSA photographs—and the photographers themselves—were being repositioned and viewed. In telling the audience "I didn't give a damn if I was growing creatively," Lee was rejecting the suggestion that FSA photographers exploited their position to foster their creative

growth and serve their own ends. Most of the photographers put the File and the FSA ahead of their own artistic development, which to them became a secondary, but welcome, benefit. Primarily, they wanted their work to have immediate impact on the country's rural problems and lasting value as a collective historical document. The exception, of course, was Evans. Upfront about his commitment to his own art, Evans willingly worked for the project as long as it served his personal goals. In a 1971 interview, he characterized his RA/FSA tenure as "a subsidized freedom to do my stuff! Good heavens, what more could anyone ask for!"[57] Evans's attitude prefigured the postwar movement toward individual artistic pursuits rather than group documentary projects.[58]

Lee also resisted questions about artistry because for him the subject of his photographs took precedence. He wanted the viewer to see the image, not the person who created it. *New York Times* art critic David L. Shirey recognized Lee's aim—and acknowledged his success. In a review written just a few months after the Amarillo symposium, Shirey observed that Lee "removed all barriers" in his photographs. "There seem to be no cameras between us and the people he photographs. The situation is neither contrived nor artificial. His subjects are at ease and we are at ease with them." Even though four decades had passed since Lee made the images, Shirey reflected the photographs had a "poignant immediacy and commanding urgency."[59]

The Amarillo symposium gave Lee and his colleagues the unique opportunity to witness a rebirth of their work through critical reexamination and reassessment. The discussion between attendees and FSA veterans—at times heated— exposed a sea change in evaluating documentary photography. One attendee, journalist Suzanne Winckler, observed that "Sympathy abounded on all sides, but that couldn't avert some of the inevitable conflicts that arise when practitioner meets scholar and when the wisdom of age meets inexperience in the form of youth."[60]

Among photographers and attendees alike, the Amarillo event sparked a lasting discourse. Reviews appeared almost immediately, and more critical pieces

followed. For example, points raised at the symposium reverberated with Edwin Rosskam, who was not able to attend; in direct response to the symposium he published an article in the critically minded progressive journal *Afterimage*, which had emerged in the 1970s. Entitled "Not Intended for Framing: The FSA Archive," Rosskam's essay warned against isolating the photographs from their original context: "I am not trying to diminish the importance of the excellent books on FSA photography which have recently been published. . . . [but] they approach the pictures in a way that makes me slightly uncomfortable. It seems to me that as the file ages, it is being turned from a living organism into a cult object." Rosskam continued, "What bothers me, I think, about the new emphasis on the FSA is that these pictures were all related to each other as parts of an organism are related, and were never intended for framing." Rather than singling out images, Rosskam urged readers to "immerse [themselves] in the file—take a bath, so to speak . . . [because] you have to see and feel the massive impact of the whole to know what is being stored there to be rediscovered again and again and again."[61]

A watershed event, the Amarillo symposium took place at the dawn of a new type of scholarship within the broader discipline of the history of photography. Academics and critics were beginning to impose different frameworks on their studies of the medium, in some cases borrowing from European schools of literary and cultural criticism and employing a theoretical language of comment and analysis. By the 1980s, an onslaught of revisionist discourses on Farm Security photographs appeared, many in efforts to demythologize the project and its participants. FSA scholars have since amply discussed the many shortcomings of these approaches.[62]

As uncomfortable as the reexamination was for Lee in Amarillo in January 1979, it was about to get worse. A sequence of events triggered that same month reshaped the way most people viewed his work—for the rest of his life and decades after.

In the late 1970s, the FSA Kodachromes caught the attention of photo historian Sally Stein, who was researching collections at the Library of Congress; the color work hadn't been studied since its creation decades earlier. Stein interviewed Lee, Delano, and Wolcott, but all three said they barely remembered using color.[63] She wrote an article, "FSA Color: The Forgotten Document," which appeared in the January 1979 issue of *Modern Photography*. Stein's article brought immediate attention to the Kodachromes, and especially to Lee's color Pie Town work. The magazine ran four photographs from Pie Town, including *Saying grace before the barbeque dinner* (fig. 72), and chose his portrait of Doris and Faro Caudill for a teaser on the cover.

Interest in Lee's Pie Town series surged. Both the color and the black and white images beguiled the new audience; the same notions of community, self-reliance, and pioneering spirit that captivated Lee in 1940 moved journalists, historians, filmmakers, and photographers to examine the work, visit Pie Town, and interview the subjects in Lee's photographs.

In 1980, *American Heritage Magazine* published an article about the Pie Town series and the journalist returned to experience the town as he saw it in Lee's photographs. A few months later, *Creative Camera* magazine published a similar story. In 1982, photography dealer Lee Witkin mounted a Pie Town show at his New York gallery, and in 1983, *New York Times* photography critic Andy Grundberg wrote an article on the FSA color work in *Portfolio* magazine; to represent Lee, he chose Pie Town images, which he called the "*pièce de résistance*" of the FSA color work. That same year, Hurley wrote an article about Lee's color Pie Town work in *American Photographer* magazine. In 1983, LIGHT Gallery of New York produced dye transfer prints of sixty-four color FSA transparencies and exhibited them in their midtown space; sixteen of Lee's twenty-five images were from Pie Town.[64] LIGHT Gallery then traveled the exhibit over the next several years.

Despite being less than 4 percent of Lee's total FSA-OWI photographs, the Pie Town series dominated most discussions of his work at this time. For example, in the book *Dust Bowl Descent*, author and photographer Bill Ganzel conducted a where-are-they-now type project, re-photographing people and places in FSA pictures. Of the Lee images Ganzel selected, 40 percent were from Pie Town. When Nancy Wood (Stryker's *In This Proud Land* coauthor) published *Heartland New Mexico*, she focused most of her Lee discussion on Pie Town, despite the fact that he shot more than fifteen hundred pictures in multiple New Mexico regions and communities.

Lee watched with frustration as the Pie Town series overshadowed the rest of his Farm Security career. Prior to January 1979, he'd shown little outward interest in his FSA legacy, and now became clearly distressed at his inability to control the one he saw developing. He didn't want to be remembered solely for an idealized depiction of "the simple life," but instead for a larger, multifaceted body of work and so tried in vain to contextualize the series. His annoyance at the outsized emphasis on Pie Town is palpable in film footage shot in the early 1980s by a former student, filmmaker Ann Mundy.

For her documentary film *Today, Tomorrow's History: Photographer Russell Lee* (1986), Mundy conducted extensive interviews with Lee in Texas, as well as interviews with Rothstein, Hurley, and several Library of Congress staff members. She also filmed a lecture Lee gave in 1983, titled "Photography with a Purpose," at the Society for Photographic Education in Philadelphia.[65]

Her fifty-eight-minute documentary chronicles Lee's life and career, but features the Pie Town series prominently, for Mundy also traveled there and filmed multiple people and locations Lee photographed in 1940.

All in all, her documentary is a flattering, respectful portrait of her mentor and his work. It won several awards and was broadcast on the Discovery Channel, CBS, and BBC.[66] In the finished film, Lee appears jovial, happy to talk about his FSA career: he recycled many of the same stories he told Doud, O'Neal, Hurley, and the Amarillo audience.

However, in the raw footage, not used in the film, we experience Lee's mounting displeasure about Pie Town. Amid his reminiscences about his six-year FSA career, the off-camera interviewer continued circling back to questions about Pie Town. Lee persisted in situating it as one assignment among many, and discussing his more extensive body of work.

At one point, the interviewer asked Lee to say that he saw Pie Town as a hieroglyph of the American frontier, but Lee looked squarely at the camera and remained silent. The phrase came from the 1978 monograph, a text written by Hurley and presumably approved by Lee: "The Lees saw in Pie Town a hieroglyph of the American frontier." The interviewer again asked Lee to repeat it in the first person, but Lee refused and became visibly irritated.[67] Jean later recalled hearing Lee say "I wish I'd never heard of that damn town," because, according to Jean, "it attracted too much attention, more than it deserved."[68]

Lee's exasperation is understandable. He anticipated the totality of his work would speak for itself, yet didn't recognize that its volume, breadth, and complexity could make it overwhelming or unapproachable. Pie Town, by contrast, was accessible.

Jean recognized this advantage in the 1960s and told Doud she speculated the series was well-known "because it was an isolated town, and we did a complete job and there was nothing overlapping . . . Most of [Lee's assignments] were part of something else. But this in itself was a whole, and so it's easy to point to this Pie Town project. It's easier to find . . . than say, all of the Dust Bowl photographs. . . . Pie Town's just easier to put your finger on."[69]

The recurrent attention to Lee's Pie Town series also points to a larger trend with the File, one that began during the active years of the Historical Section and frustrated Stryker and some photographers—a cycle of repetitive publication. As Collier summarized it, "The pictures they were pulling out of the files were the ones that had been used, and they got used because they were pulled out of the files by preference in the beginning . . . They represent only a microcosm of the macrocosm. And so Roy got upset about this. He saw that the same pictures were

going out . . . because if they had twenty photographs they were just pulling those over and over. Here was this huge file just sitting there."[70]

In the last several decades, Lee's Pie Town series has inspired multiple books, essays, magazine articles, photographic projects, and at least one film documentary.[71]

LEE'S LEGACY

Lee left behind a tremendous body of work depicting sweeping change in America, covering the complete range of FSA activities and tracing the arc of the country's economic recovery, beginning in one of its most desperate times and ending at the dawn of one of its most prosperous. From impoverished Midwestern farm tenants standing on the porch of their ramshackle house in 1936 (fig. 15) to robust servicemen standing before Shasta Dam's powerful edifice in 1942 (fig. 95), Lee's work commenced by calling attention to America's failures and concluded by celebrating its successes.

Though Lee went on to other photographic projects, the FSA was the apotheosis of his career. In 1964, he told Doud that his time with the FSA influenced his photography and his way of thinking, leaving "an indelible mark" on his life and work.[72]

But Lee left his own mark on the FSA, too. He mastered the new documentary mode and turned it inside out, distinguishing himself through a style, technique, and approach wholly his own. His work, and the work of his colleagues, changed the direction of American photography and became the benchmark by which documentarians still measure themselves.

Lee also affected Stryker. With contrasting but compatible temperaments, the two made an extraordinary team and enjoyed a personal friendship. By turns pragmatic and idealistic, they worked together to meet the challenges of ever-shifting political and economic circumstances. Lee was also the only photographer to work on every one of Stryker's documentary projects.

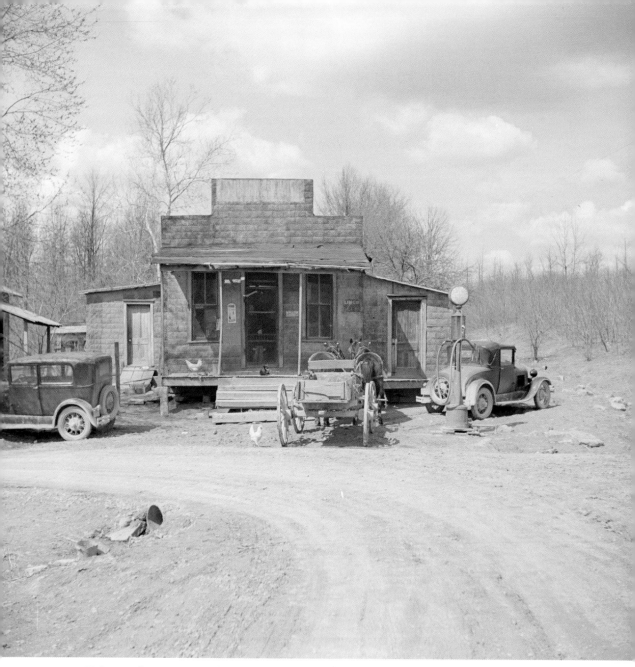

99. *Buttermilk Junction, Martin County, Indiana, April 1937.*

With an insatiable curiosity and a predilection for ordinary American things—which they believed made America extraordinary—Lee and Stryker strove for a complete visual document of their time. Stryker wrote to Lee in 1937 of their mutual goals: "I know that you and I share an urge alike, that is, a desire to photograph the whole United States at once. I have a feeling that if we don't do it this year, it may blow away by next year. I must come to the realization that we haven't the staff to keep up with my ambitions."[73]

Ostensibly fearless and undaunted by adversity, Stryker showed another side to Lee. He later reflected, "There was some quality in Russell that helped me through my problems," remarking that Lee and his photographs "gave me courage."[74] In a 1939 letter he uncharacteristically laid bare his fears and confided to Lee: "I feel today as if I were in a ferris-wheel that had broken loose from its moorings and was rolling down a steep mountain side. I just about give up—I don't see any way to keep up with things that just have to be done in this place. No matter how much you plan and how much extra time you put in, there seems to be an increasing amount each following day."[75] The two men remained close friends until Stryker's death in 1975.

Lee died eleven years later at his home in Austin at the age of eighty-three.[76] Papers throughout the country picked up the news: besides all the principal cities in his adopted state of Texas, tributes appeared in Los Angeles, Chicago, Washington, D.C., New York, and his hometown of Ottawa. His obituary in the *New York Times* acknowledged that Lee wasn't as famous as Lange and Evans, but "his work has been increasingly recognized for his penetrating eye for detail and a somewhat quieter and subtler portrayal of the human experience."[77] Indeed, Lee possessed a clear understanding of the goals and dimensions of socially conscious, reform-minded documentation, and created engaging and compassionate images that have endured.

Journalism scholar Nicholas Lemann has observed of the totality of Lee's work, "With sympathy and precision, Lee made a world from thousands of images that is distinctively his—a territory where people look and behave in a certain way and where a set of home truths about life pertains. His world has a depth and rich-

3c PRINTING CO.
OFFICE

Help!
SAVE THE
CROP

Register
104-N-2nd. ST.

BE CERTAIN

Art Metal
STEEL OFFICE EQUIPMENT

ness of human feeling that the work of many photographers who occupy higher places in the pantheon never comes close to achieving."[78]

Driven by a strong sense of social responsibility, documentary purpose, and aesthetic intention, Lee labored to create a comprehensive portrait of the Great Depression and mobilization for World War II, pivotal periods in American history. He traversed the country for six years, from a clothing factory in New Jersey to wheat fields in Washington, from payday in a Minnesota lumber camp to life in a small Texas town. Lange later remarked, "He wasn't doing this for a living . . . He was doing this because of a great . . . personal interest, and did it with gusto, and with appreciation."[79]

Lee's epic portrait of America is also the photographer's own portrait. In 1941, a shop window in Yakima, Washington, caught his eye (fig. 100). Amid an ad for an Art Metal office filing system that warns "Be Certain of What's Going on There," and a call to action to "Help Save the Crop" during a labor shortage, Lee included his own reflection, layering this image into an elaborate self-portrait—a window and a mirror. It shows a man who presented an easy public image belying a deeper complexity, a talented photographer whose keen eye, innovative approach, and spirit of adventure propelled him to record his time with great depth and breadth.

Russell Lee's FSA oeuvre is thus an extraordinary gift to us, as both a testament to his creative vision in the service of something bigger, and as a boundless and enduring visual documentation of the United States in troubled times—a documentation that has remained remarkably relevant to each new generation.

100. *Sign on store window in Yakima, Washington, the crop referred to is hops, September 1941.*

ACKNOWLEDGMENTS

This book would not have been possible without help from dozens of people over the last two decades.

For their help in my research on Lee's early life in the Ottawa area, I am exceptionally grateful to Cathi and Martin G. Myre, Jerry Danielson, Bob Nowicki; Betsy Feagans, Director of the Cora Pope Home; Paul DePaoli and Jennifer Groh of the Reddick Public Library; and the staff of the First National Bank, LaSalle County Court House, La Salle County Clerk's Office, and LaSalle County Genealogy Guild. At the University of Illinois, Peter J. Barry and Robert G. Hoeft provided guidance on farming practices in Illinois. The staff at Lee's alma maters were incredibly helpful, especially Robert B. D. Hartman at Culver Academies and Ilhan Citak, Phil Hewitt, and Brian Simboli at Lehigh University.

For their guidance in exploring Doris Lee's life and work, I'd like to thank Catherine Worsley of the Mercer Carnegie Library, Aledo, and Jo Knox of Aledo; Arthur H. Miller at Lake Forest College; Rita MacAyeal at Lake Forest Academy; Mary Pryor at Rockford College; Rose Redwood at Wheelock Clark Library, The Sage Colleges; Denzil J. Luckritz, Rector, St. John's Episcopal Church in Lock-

port; Jennifer Page, Heather Slania, Jason Steiber, and Adrienne L. Gayoso at the National Museum of Women in the Arts; and Deedee Wigmore and Emily Lenz at D. Wigmore Fine Art, Inc.

Joan Gosnell at the DeGolyer Library, Southern Methodist University, and Rachel Garrett Howell and Sammie Townsend Lee at the Texas/Dallas History and Archives Division, Dallas Public Library, supported my research on Jean Lee.

To understand the FSA documentary project and Lee's part in it, I spent hundreds of hours at the Library of Congress Prints and Photographs Division, where many staff shared their knowledge, insights, and support: Beverly W. Brannan, Donna Collins, Emily Dittman MacKinnon, DeAnna Evans, Kristi Finefield, Jan Grenci, Marilyn Ibach, Carol Johnson, Barbara Natanson, Dave Pontarelli, Lara Szypszak, and Helena Zinkham. I also extend thanks to Julie Stoner in the Library's Geography and Maps Division, where I found vintage American road maps, and the staff of the Library's Manuscript Division, where I examined the Jack Delano Papers and the John Vachon Papers.

I'm grateful to Amanda Focke, Carla Ellard, and Connie Todd at the Russell Lee Collection, Texas State University. My experiences working with that wonderful collection—as archivist and co-curator—were a milestone.

Amy Purcell at the Ekstrom Library, University of Louisville; Dorothy Causey and Sue Nichol at Fore-Kin Trails Genealogical Society in Montrose; and Sally Johnson of the Montrose County Historical Museum supported my Roy Stryker research.

So many museum, library, and gallery professionals helped me assemble puzzle pieces necessary to telling Russell Lee's story. My thanks go to Holly Reed, Joseph D. Schwarz, Gene Morris, and Nicholas Natanson at the National Archives and Records Administration; Marisa Bourgoin and Karen Weiss at the Archives of American Art; Tad Bennicoff at the Smithsonian Institution Archives; David Oresick, Linda Benedict-Jones, and Bill Wade at the Silver Eye Center for Photography in Pittsburgh; Leslie Squyres at the Center for Creative Photography, University of Arizona; the reference teams at the New York Public Library and the Franklin D. Roosevelt Presidential Library; Catherine Carson Ricciardi at

Columbia University's Rare Book and Manuscript Library; Elise K. Kenney at Yale University Art Gallery's archives; David R. Grinnell at the Pittsburgh Photographic Library, University of Pittsburgh; Molly Seegers at the Brooklyn Museum Archives; Michelle Harvey at the Museum of Modern Art; Ed Frank and Christopher Ratliff at Special Collections, University of Memphis Libraries; Sharon Chadwick and Lina Carro at Humboldt State University; Meghan Borato at the Society for Photographic Education; Christopher Flynn at the National Endowment for the Humanities; John Hallberg at North Dakota State University Archives; the staff at the Harry Ransom Center, University of Texas at Austin; Margaret Huang at the Philadelphia Museum of Art; John Hallberg, Archives Associate at North Dakota State University; and filmmaker Ann Mundy.

Bill Stoddard of Bill's Clockworks in Flora, Indiana, Paul Turney of TubeRadioLand.com, Ken and Ron Ehrenhofer of the Model A Restorers Club, and James Oakley and Craig Orr at the National Museum of American History shared their expertise to help me identify details in Lee's photographs.

Many who knew Lee or people in his orbit generously gave their time to speak with me, including Louise Rosskam, Bernarda Bryson Shahn, Sol Libsohn, Richard Doud, Governor Ann Richards, Alan Pogue, Roy Flukinger, Steve Clark, Michael A. Murphy, Rick Williams, JB Colson, Bill Wittliff, Ave Bonar, Nadine Eckhardt, Nicholas Lemann, Steve Plattner, David Turner, Tom Livesay, Nancy Sahli, Charlotte Augusta Kroll, and Joan Myers. Kathryn McKee Roberts, former Pie Town resident, shared her perspectives on that community.

Friends have been good-natured and helpful in multiple ways: I appreciate the support of Elena Baca, Raymond Boyer, David Cowey, and David Swerdloff and extend a very special thanks to Kim Venesky.

I've also enjoyed the support of Jen Concino and Steve O'Connor, who helped me navigate the legal details of seeing this book to publication.

It's been my good fortune to have had several mentors. During my internship at the National Museum of American History, curator David Haberstich sparked my initial interest in graduate school and has continued to support my work, and archivist Craig Orr trained me in archival principles, on which I continue to rely.

At the University of New Mexico, photo historian Eugenia Parry opened my eyes to different ways of looking at photographs and the people who make them.

I extend special thanks to Darcy Tell, editor of *Archives of American Art Journal*, who encouraged me to submit an article for peer review, then steered me through the editorial process, which made me a better writer and spurred me on to complete this book.

My readers—DeAnna Evans, Kristi Finefield, Jan Grenci, Laura Katzman, and Katharine Ott—gave loads of constructive criticism, which strengthened the manuscript, and words of encouragement, which helped keep me going. Additional appreciation goes to Laura Katzman for her insights and expertise during our many hours of conversation over the years, which helped me to crystallize ideas about Lee's era and the documentary context in which he worked.

Many thanks are due to the staff of the Library of Congress Publishing Office, who did excellent work in shepherding the book through all its stages. They include Managing Editor Aimee Hess and Editor Hannah Freece, retired Managing Editor Peggy Wagner, and Director Becky Brasington Clark. I feel incredibly lucky that the team at W. W. Norton/Liveright—especially Bill Rusin, Gina Iaquinta, Laura Starrett, Don Rifkin, and Ellen Cipriano—so closely shared our vision for the book and helped execute it so elegantly.

And finally, I would never have been able to write this book without my husband, Steve Hemlin, who for twenty years has been unwavering in his support of my Russell Lee work. His insights have been critical in my understanding of both Lee the man and the photographer. Together we've traveled thousands of miles—from Washington, D.C., to Woodstock, Hyde Park, Manhattan, Bethlehem, Pittsburgh, Culver, Ottawa, Louisville, Austin, San Marcos, San Antonio, Houston, Albuquerque, and beyond—on many adventures. I wouldn't trade a single one.

A NOTE ABOUT SOURCES

Image captions—Captions written by Lee (sometimes edited by the FSA) appear in italics. These captions use language about topics like race, internment, and war that were common in the FSA-OWI during this period. Captions composed or edited for clarity by the author appear in roman. The phrase "originally uncaptioned" indicates the photo did not have a title or caption—probably because it was never printed by the FSA—and is instead accompanied by a caption, in roman, derived from another photograph that appears to be from the same assignment.

Image dates—Dates of Lee's FSA photographs are the official dates assigned by the FSA office, which don't always correspond with when the images were made; there was sometimes a lag between the time a photographer shot the film and when office staff recorded it. Dates preceded by "ca." or "likely" were determined by the author, using supporting research.

Image numbers—Negative numbers in the endnotes (i.e., numbers that begin with LC-USF or LC-USW) refer to photographs in the FSA-OWI Collection at the Library of Congress. Photographs can be located by searching for these numbers in the Library's online catalog at http://www.loc.gov/pictures/collection/fsa/.

Lee archives—Russell Lee's photographic archive is spread across six institutions. His FSA-OWI work is in the Prints and Photographs Division, Library of Congress; his Air Transport Command and Coal Mines Administration photographs are in the National Archives; his Standard Oil photographs are in the Stryker Papers;

work he did for the Pittsburgh Photographic Library is in Pittsburgh's Carnegie Library; and all other work (pre-FSA photographs and postwar Texas coverage) is at the University of Texas at Austin. The Russell Lee Collection at Texas State University contains Lee's personal papers and a selection of photographs.

Lee correspondence dates—Lee often dated his letters only with the day of the week. Some of his letters in the Stryker Papers also bear estimated dates that were added later, likely by members of Stryker's office staff; these dates are not always correct, but reflect the order in which the letters are filed in the Stryker Papers. These dates are noted in parentheses. When the author was able to determine a more accurate date for a letter, that date is included in brackets.

FREQUENTLY CITED SOURCES AND ABBREVIATIONS

PRIMARY SOURCES

Cora Pope Scrapbook

Scrapbook kept by Russell Lee's great aunt, Cora Pope, 1907–42. Copy of scrapbook in author's possession, current location of original scrapbook unknown.

Delano, *Photographic Memories*

Delano, Jack. *Photographic Memories*. Washington, DC: Smithsonian Institution Press, 1997.

Delano Papers

Jack Delano Papers, Manuscript Division, Library of Congress, Washington, DC.

Doris Lee Papers

Doris Lee Papers, Betty Boyd Dettre Library and Research Center, National Museum of Women in the Arts.

Doud interviews, cited as [surname]-Doud interview

FSA participants, interviews by Richard K. Doud, 1963–65. Archives of American Art, Smithsonian Institution.

Interviews cited in this book include Charlotte Aiken and Helen Wool; C. B. (Calvin Benhan) Baldwin; John Collier Jr.; Jack and Irene Delano; Romana Javitz; Dorothea Lange; Russell and Jean Lee; Carl Mydans; Edwin and Louise Rosskam; Arthur Rothstein; Ben Shahn; Roy Emerson Stryker; Rexford Tugwell; John Vachon; and Marion Post Wolcott.

Evans-Cummings interview

Walker Evans, interview by Paul Cummings, 1971. Archives of American Art, Smithsonian Institution.

HS Textual Records
Historical Section Textual Records, Farm Security Administration–Office of War Information Photo Collection, LOT 12024, Prints and Photographs Division, Library of Congress, Washington, DC.

Just Before the War
Just Before the War: Urban America from 1935 to 1941 as Seen by the Photographers of the Farm Security Administration. Prefatory notes by Arthur Rothstein, John Vachon, and Roy Stryker. New York: October House, 1968.

Lee Autobiography
Lee, Russell. "Autobiography," *Retrospective Exhibition 1934–1964.* Austin: University Art Museum of the University of Texas, 1965. Exhibition catalog.

Lee Collection
The Russell Lee Collection, Southwestern and Mexican Photography Collection, The Wittliff Collections, Texas State University.

Lee Culver File
Russell Lee microfilm file, Culver Academy Archives.

Lee, "Flash—Elementary Technic"
Lee, Russell W. "Flash—Elementary Technic." In *The Complete Photographer: An Encyclopedia of Photography*, vol. 5, edited by Willard D. Morgan, 1,784–98. New York: National Educational Alliance, Inc., 1943.

Lee Guardian File
Guardian File of Russell Werner Lee. LaSalle County Genealogy Guild, Ottawa, Illinois.

Lee-Mundy raw footage
Lee interviews 1-2-3-4-5-6 (raw footage for *Today, Tomorrow's History: Photographer Russell Lee*) beginning December 4, 1981, Ann Mundy/Russell Lee Photography Collection, on deposit at the Harry Ransom Center, The University of Texas at Austin.

Lee, "Life on the American Frontier"
Lee, Russell. "Life on the American Frontier: Pie Town, N.M." *U.S. Camera Magazine* 4, no. 4 (October 1941): 39–50, 88–89, 107.

Lee-Plattner interview
Russell Lee, interview by Steven W. Plattner, April 11, 1979. Department of Special Collections, Ekstrom Library, University of Louisville.

Rosskam-Appel interview
Louise Rosskam, interview by Mary Jane Appel, July 1, 2000. Collection of the author.

Rosskam-Libsohn-Appel interview
Louise Rosskam and Sol Libsohn, interview by Mary Jane Appel, May 30, 1999. Collection of the author.

Rosskam, "Not Intended for Framing"
Rosskam, Edwin. "Not Intended for Framing: The FSA Archive." *Afterimage* (March 1981): 9–11.

Steichen
Steichen, Edward. "The F.S.A. Photographers." In *U.S. Camera 1939*, edited by T[om] J. Maloney, 43–66. New York: William Morrow & Company, 1938.

Stryker Autobiography
Autobiography written by Roy Emerson Stryker, January 3, 1941. Stryker Papers.

Stryker, "Documentary Photography"
Stryker, Roy. "Documentary Photography." In *The Complete Photographer: An Encyclopedia of Photography*, vol. 4, edited by Willard D. Morgan, 1,364–74. New York: National Educational Alliance, Inc., 1943.

Stryker-Doherty et al. interview
Roy Stryker, interview by Robert Doherty, Jack Hurley, Jay Kloner, and Carl Ryant, April 14, 1972. Archives and Special Collections, Ekstrom Library, University of Louisville. An edited version of this interview was published as "Roy Stryker on FSA, SONJ, J&L (1972), an Interview Conducted by Robert J. Doherty, F. Jack Hurley, Jay M. Kloner, and Carl G. Ryant." In *The Camera Viewed, Writings on Twentieth Century Photography*, vol. 1, *Photography Before World War II*, edited by Peninah R. Petruck, 133-65. New York: E.P. Dutton, 1979.

Stryker-FSA photographers conversation
Conversation with Roy Stryker, Dorothea Lange, Arthur Rothstein, John Vachon, Millicent Vachon, and Fred Ramsey, at the Vachons' New York apartment, 1952. Copies of the transcript are in the Vachon Papers and the Vanderbilt Papers.

Stryker-Hurley interview
Roy Stryker, interview by Jack Hurley, July 27, 1967. Mississippi Valley Collection Libraries, Memphis State University.

Stryker-McDougall-Hurley interview
Roy Stryker, interview by Angus McDougall and Gerald Hurley, January 1960. Archives of American Art, Smithsonian Institution.

Stryker Journal
Roy Emerson Stryker Journal, dated June 20–August 3, 1921. PR 13 CN 2008:072. Prints and Photographs Division, Library of Congress, Washington, DC.

Stryker Papers
Roy Stryker (1893–1975) Papers, Archives and Special Collections, University of Louisville.

Stryker Papers (microfilm)

Roy Emerson Stryker Papers [microfilm], 1932–64. Archives of American Art, Smithsonian Institution.

Stryker-Wood

Stryker, Roy Emerson and Nancy Wood. *In This Proud Land: America 1935–1943 as Seen in the FSA Photographs*. Boston: New York Graphic Society, 1973.

Vachon Papers

John Vachon Papers, Manuscript Division, Library of Congress, Washington, DC.

Vanderbilt Papers

Paul Vanderbilt Papers, 1854–1992, bulk 1945–1992. Archives of American Art, Smithsonian Institution.

SECONDARY SOURCES

American Images

Turner, David, dir. *American Images*. Amarillo Art Center, 1979. VHS, 60 min. This video includes excerpts from the Amarillo symposium and interviews with some of the photographers.

Appel, "Duplicate File"

Appel, Mary Jane. "The Duplicate File: New Insights into the FSA." *Archives of American Art Journal* 54, no. 1 (Spring 2015): 4–27.

Appel, "Doris and Russell Lee: A Marriage of Art"

Appel, Mary Jane. "Doris and Russell Lee: A Marriage of Art." *Journal of the Illinois State Historical Society* 111, no. 4 (Winter 2018): 82–121.

Baldwin

Baldwin, Sidney. *Poverty and Politics: The Rise and Decline of the Farm Security Administration*. Chapel Hill: University of North Carolina Press, 1968.

Conkin

Conkin, Paul. *Tomorrow a New World: The New Deal Community Program*. New York: Da Capo Press, 1976.

Finnegan

Finnegan, Cara A. *Picturing Poverty: Print Culture and FSA Photographs*. Washington, DC: Smithsonian Institution Press, 2003.

Fleischhauer and Brannan

Fleischhauer, Carl, and Beverly W. Brannan, eds. *Documenting America, 1935–1946*. Berkeley: University of California Press in association with the Library of Congress, 1988.

Ganzel

Ganzel, Bill. *Dust Bowl Descent*. Lincoln: University of Nebraska Press, 1984.

Goodwin

Goodwin, Doris Kearns. *No Ordinary Time: Franklin and Eleanor Roosevelt: The Home Front in World War II.* New York: Simon & Schuster, 1994.

Gordon

Gordon, Linda. *Dorothea Lange: A Life Beyond Limits.* New York: W. W. Norton, 2009.

Hurley, "In and Out of Focus"

Hurley, F. Jack. "The Farm Security Administration File: In and Out of Focus." *History of Photography* 17, no. 3 (Autumn 1993): 244–52.

Hurley, *Portrait of a Decade*

Hurley, F. Jack. *Portrait of a Decade: Roy Stryker and the Development of Documentary Photography in the Thirties.* Baton Rouge: Louisiana State University Press, 1972.

Hurley, *Russell Lee*

Hurley, F. Jack. *Russell Lee: Photographer.* Dobbs Ferry, NY: Morgan and Morgan, 1978.

Kao, Katzman, and Webster

Kao, Deborah Martin, Laura Katzman, and Jenna Webster, *Ben Shahn's New York: The Photography of Modern Times.* New Haven: Yale University Press, 2000.

Katzman and Brannan

Katzman, Laura, and Beverly W. Brannan. *Re-Viewing Documentary: The Photographic Life of Louise Rosskam.* 2nd ed. Washington, DC: American University Museum, distributed by Penn State University Press, 2014.

Kennedy

Kennedy, David M. *Freedom from Fear: The American People in Depression and War, 1929–1945.* New York: Oxford University Press, 1999.

Lemann

Fields of Vision: The Photographs of Russell Lee, introduction by Nicholas Lemann. Washington, DC: GILES in association with the Library of Congress, 2008.

Natanson

Natanson, Nicholas. *The Black Image in the New Deal: The Politics of FSA Photography.* Knoxville: University of Tennessee Press, 1992.

O'Neal

O'Neal, Hank. *A Vision Shared: A Classic Portrait of America and Its People 1935–1943.* New York: St. Martin's Press, 1976.

Raeburn

Raeburn, John. *A Staggering Revolution: A Cultural History of Thirties Photography.* Urbana and Chicago: University of Illinois Press, 2006.

Roll

Roll, David L. *The Hopkins Touch: Harry Hopkins and the Forging of the Alliance to Defeat Hitler*. New York: Oxford University Press, 2013.

Russell Lee Photographs

Russell Lee Photographs: Images from the Russell Lee Photograph Collection at the Center for American History. Austin: University of Texas Press, 2007.

Sloan

Sloan, John. *Gist of Art: Principles and Practise Expounded in the Classroom and Studio*. New York: Dover Publications, 1977. First published in 1939.

Smith

Smith, J. Russell, and M. Ogden Phillips. *North America: Its People and the Resources, Development, and Prospects of the Continent as the Home of Man*. New York: Harcourt, Brace, 1940. First published in 1925.

Spirn

Spirn, Anne Whiston. *Daring to Look: Dorothea Lange's Photographs and Reports from the Field*. Chicago: University of Chicago Press, 2008.

Stein

Stein, Sally. "FSA Color: The Forgotten Document." *Modern Photography* 43, no. 1 (January 1979): 90–99.

Sternsher

Sternsher, Bernard. *Rexford Tugwell and the New Deal*. New Brunswick, NJ: Rutgers University Press, 1964.

Stott

Stott, William. *Documentary Expression and Thirties America*. New York: Oxford University Press, 1973.

Susman

Susman, Warren. "The Culture of the Thirties." In *Culture as History, The Transformation of American Society in the Twentieth Century*. Washington, DC: Smithsonian Books, 2003. Reprint of the edition published by Pantheon Books in 1973.

Today, Tomorrow's History

Mundy, Ann, dir. *Today, Tomorrow's History: Photographer Russell Lee*. 1986. VHS, 58 min.

Watkins, The Great Depression

Watkins, T. H. *The Great Depression: America in the 1930s*. Boston: Little, Brown, 1993.

Watkins, The Hungry Years

Watkins, T. H. *The Hungry Years: A Narrative History of the Great Depression in America*. New York: Henry Holt, 1999.

NOTES

INTRODUCTION. OCTOBER 19, 1936

1. Stryker to Lee, December 29, 1936, Stryker Papers.
2. Lee to Stryker, January 2, 1937, Stryker Papers.
3. Lee-Doud interview.

CHAPTER 1. 1903–1926

1. Beulah Morris, Tape #1, Ann Mundy raw footage for *Today, Tomorrow's History*, Pie Town Oral History Project, University of New Mexico, Center for Southwest Research. See also George Hutton's recollections in Ganzel, 84.
2. Hurley, *Russell Lee*, 34.
3. Russell Lee, "Questionnaire for Photographers, Standard Oil New Jersey," undated [1947–48], Stryker Papers.
4. Stryker-Doud interview.
5. Betsy Feagans, letter to author, May 19, 2008.
6. For the cost of Eva Werner's house, see *Biographical and Genealogical Record of La Salle County Illinois, Illustrated* (Chicago: Lewis Publishing Company, 1900), 362. For the average value for real and personal property in Illinois, see Randy Mills and Karen Mills Hales, "'Your Loving Father, Jack': Southern Illinois Farm Life in the 1890s as Seen through the Correspondence of the Jack Pierce Family," *Journal of the Illinois State Historical Society* 106, no. 1 (Spring 2013): 51.
7. *Biographical and Genealogical Record of La Salle County Illinois, Illustrated,* 362.
8. *Ottawa in 1900* (Ottawa, IL: Ottawa Republican Times, 1900), 135.
9. See "Notes, Accounts, and Stock Considered Desperate and of No Value," October 24, 1917, Probate of the Eva Werner Estate, LaSalle County Court House, Ottawa, Illinois.
10. Jay Pridmore, *Many Hearts and Many Hands: The History of Ferry Hall and Lake Forest Academy* (Lake Forest, IL: Lake Forest Academy, 1994), 38, 43, 96.
11. *Ottawa in 1900*, 110.
12. The date of February 7, 1901, comes from Proof of Heirship documents, October 23, 1917, Probate

of Eva Werner Estate. For Eva Werner's friendship with Milligan see Paragraph One, Last Will and Testament of Eva Werner, June 11, 1914, LaSalle County Courthouse, Ottawa, Illinois (hereafter Last Will and Testament of Eva Werner). For Milligan in Italy see Richard H. Dreyfuss to William T. Surin, March 25, 1988, Lee Collection.

13. See April 11, 1901, Diary of Mrs. Burton Cook Lee, Lee Collection.

14. See April 2, 1901; April 12, 1901; and May 8, 1901, Diary of Mrs. Burton Cook Lee, Lee Collection.

15. Original birth certificate of Russell Werner Lee, La Salle County Clerk's Office, Ottawa, Illinois.

16. See Probate of Eva Werner Estate for a list of household possessions.

17. Adele Lee's obituaries only provide the surnames of her instructors, Lewis and Volcker. For mention of Ignacy Paderewski, see "Charles G. Werner Will Not Return Home This Year," undated newspaper clipping, ca. 1941–42, Cora Pope Scrapbook.

18. "Local Notes," *Ottawa Free Trader*, March 29, 1912, 1.

19. Hurley, *Russell Lee*, 10.

20. A version of this account appeared previously in Mary Jane Appel, "Russell Lee: The Man Who Made America's Portrait," *Russell Lee: A Centenary Exhibition*, exh. cat. (San Marcos: Texas State University, 2003), 4–5.

21. "Mrs. Lee's Death Follows Accident," *Ottawa (IL) Daily Republican Times*, September 19, 1913, 1. "Throng Gathers at Lee Funeral" *Ottawa (IL) Daily Republican Times*, September 22, 1913, 1.

22. Victor von Borosini, "Problem of Illegitimacy in Europe," *Journal of Criminal Law and Criminality* 4, no. 2 (1913), https://scholarlycommons.law.northwestern.edu/jclc/vol4/iss2/6/.

23. For Lee's recollection, see Hurley, *Russell Lee,* 10. For the party traveling together and sailing home, see passenger lists for S.S. *Grampian*, sailing from Liverpool, August 15, 1914.

24. See Proof of Heirship, July 1919, Probate of Eva Werner Estate; and Witness Testimony of Cora J. Pope, December 9, 1920, Probate of Milton Pope Estate. LaSalle County Courthouse, Ottawa, Illinois. See also letter from Gerald A. Danielson (longtime LaSalle County resident) to the author, July 28, 2007.

25. Mr. and Mrs. C. G. Werner to the Superintendent of Culver Military Academy, February 12, 1917, Lee Culver File.

26. Certificate of Death for Eva L. Werner, May 24, 1917, LaSalle County Clerk, Ottawa, Illinois. See "Mrs. Charles Werner, Prominent Woman, Died Last Night," *Ottawa Free Trader Journal*, May 25, 1917, and "Mrs. Werner, 59 Years Old, Is Dead," *Daily Republican Times,* May 25, 1917.

27. Diary of Mrs. Burton Cook Lee, entries dated November 18, 1900, and January 6, 1901, Lee Collection.

28. Lee Autobiography.

29. Acting Superintendent of Culver Military Academy to Charles Werner, June 19, 1918, Lee Culver File.

30. Charles Werner to C. E. Reed, March 12, 1920, Lee Culver File.

31. See page 1 of Last Will and Testament of Eva Werner; Probate of Eva Werner Estate; and Investment no. 51, Probate of Milton Pope Estate.

32. Hurley, *Russell Lee,* 10.

33. See Milton Pope to Russell W. Lee, December 20, 1918, Lee Collection. See also Milton Pope to Culver Superintendent, June 19, 1920, Lee Culver File.

34. See Reports dated November 25, 1918; October 21, 1920; November 20, 1920; December 19, 1920; and January 14, 1921, Lee Guardian File. See also Jerry Danielson, letters to the author, February 14, 2009, and April 3, 2009.

35. See Last Will and Testament of Milton Pope, May 4, 1915, clauses three, four, five, and eight. La Salle County Courthouse, Ottawa, Illinois (hereafter Last Will and Testament of Milton Pope). See also B. J. Keeney, Michelle Mitchell, Dawn Mitchell, Erin Studemann and Anne Klenck, *Fiftieth Anniversary Souvenir Book of the Milton Pope Grade School* (Ottawa: Illinois Office Supply, 2001), 27–29.

36. "Milton Pope, Financier and Large Realty Holder, Expires," *Free Trader Journal and Ottawa Fair Dealer*, September 29, 1920, 1.

37. *Culver Roll Call* (Culver, IN: Culver Military Academy, 1921), 81.

38. Major W. R. Kennedy to Horace Hull, March 1, 1921, Lee Culver File.

39. See Superintendent Order 67, January 17, 1920, Lee Culver File.

40. Horace Hull to Major W. R. Kennedy, January 5, 1921, Lee Culver File.

41. Hull to Kennedy, January 5, 1921, Lee Culver File.

42. Horace Hull to Major H. G. Glascock, April 22, 1921, Lee Culver File.

43. Hull to Glascock, April 22, 1921, Lee Culver File.

44. Information about Lehigh extrapolated from Catherine Drinker Bowen, *A History of Lehigh University* (Bethlehem, PA: Lehigh Alumni Bulletin, 1924), and W. Ross Yates, *Lehigh University: A History of Education in Engineering, Business, and the Human Condition* (Cranbury, NJ: Associated University Presses, 1992).

45. Bowen, *A History of Lehigh University*, 68.

46. Yates, *Lehigh University,* 43.

47. Bowen, *A History of Lehigh University*, 66.

48. Kenneth Whyte, *Hoover: An Extraordinary Life in Extraordinary Times* (New York: Alfred A. Knopf, 2017), 132–38; 183–84.

49. Yates, *Lehigh University,* 137.

50. Yates, *Lehigh University,* 138.

51. *The Epitome 1926* (Bethlehem, PA: Lehigh University, 1926), 127.

52. H[arry]. M[ass]. Ullmann, "The Period 1894–1938," in Robert D. Billinger, ed., *A History of the Department of Chemistry and Chemical Engineering at Lehigh University, Bethlehem, Pennsylvania, 1866–1941*, mimeo, 34. Copy in Lehigh Room, Linderman Library, Lehigh University. Quoted in Yates, *Lehigh University,* 99. See also the 1921 course catalog, which states that the Chemical Engineering course is given under the direction of the Department of Chemistry. *Register of Lehigh University 1921–1922* (Bethlehem, Pennsylvania, 1921), 65. Lehigh separated the Chemical Engineering and Chemistry Departments in 1950.

53. Lorraine Daston and Peter Galison, *Objectivity* (New York: Zone Books, 2007), 199, 236. Daston and Galison, building on the work of Michel Foucault, observe the ways in which the practice of writing focuses one's attention. See also Pam A. Mueller and Daniel M. Oppenheimer, "The Pen Is Mightier Than the Keyboard: Advantages of Longhand Over Laptop Note Taking," *Psychological Science* 25, no. 6 (June 2014): 1159–68.

54. Daston and Galison, *Objectivity,* 46.

55. Joel Snyder and Neil Walsh Allen, "Photography, Vision, and Representation," *Critical Inquiry* 2, no. 1 (Autumn 1975): 143–69; Joel Snyder, "Picturing Vision," *Critical Inquiry* 6, no. 3 (Spring 1980): 499–526; and Joel Snyder, "Visualization and Visibility," in *Picturing Science, Producing Art*, eds. Caroline A. Jones and Peter Galison (New York: Routledge, 1998), 379–97.

56. See Leonard S. Austin, *Metallurgy of the Common Metals*, 5th ed., rev. and enl. (New York: J. Wiley & Sons, 1921), 363, 364, 370.

57. Daston and Galison, *Objectivity*, 328, 48.

58. Brooke Hindle, "From Art to Technology and Science," *Proceedings of the American Antiquarian Society* 96, part 1 (April 1986): 26. See also Brooke Hindle, *Emulation and Invention* (New York: New York University Press, 1981).

59. See Stott; Finnegan; and Kate Sampsell-Willmann, *Lewis Hine as Social Critic* (Jackson: University of Mississippi Press, 2009). See also Joel Smith, "Review [of *Objectivity* by Lorraine Daston and Peter Galison]," *Art Bulletin* 92, no. 1/2 (March–June 2010): 113.

60. Hurley, *Russell Lee*, 11.

61. Letter from Gerald A. Danielson (longtime LaSalle County resident) to the author, February 13, 2009.

62. Lee's tenant on the Manlius Township farm in the 1920s was Martin Myre. I am grateful to Myre's grandson, Martin G. Myre, and his wife, Cathi S. Myre, of Seneca, Illinois, who generously opened their home and shared information about their family. Recollections about Russell Lee and Milton Pope are very positive. Martin Myre and his descendants were tenants on the farm from at least 1917 until Lee died in 1986. See *Prairie Farmer's Directory of LaSalle County, Illinois* (Prairie Farmer Publishing Company, 1917), 128, listing for "Myers, Martin."

63. Details of the Anderson foreclosure are from the Probate of Milton Pope Estate, and corresponding land records from the LaSalle County Office of Recorder of Deeds in Ottawa. For biographical information on Malina M. Anderson and George Erickson, see census records from 1870-1940, and *Prairie Farmer's Directory of LaSalle County* (1917).

64. See Lee Guardian File for inventory of the Eva Werner estate.

65. See Probate of the John Brundage Estate, LaSalle County Courthouse, Ottawa, Illinois. I met one of these descendants, at the LaSalle County Genealogy Guild in Ottawa in October 2001. She declined to give her name, but told me with some anger her family lost their farm to Mother Brundage: when John Brundage died, Mother Brundage called in the note and took the farm.

66. "Doris Lee, Former Ottawan, Is Painter with 'Humorous Sense of Violence'" undated clipping from unknown newspaper, Cora Pope Scrapbook.

CHAPTER 2. 1927–1936

1. Doris Lee, *Doris Lee*, American Artists Group Monograph Number 16 (New York: American Artists Group, Inc., 1946), [5–6]. Information on Doris and Russell Lee and their artistic development is extrapolated from Appel, "Doris and Russell Lee: A Marriage of Art." Throughout this chapter, Doris Lee is referred to as Doris rather than Lee to avoid confusion with her husband.

2. Lee, *Doris Lee,* [6].

3. Information about Americans in Paris extrapolated from Brooke L. Blower, *Becoming Americans in Paris: Transatlantic Politics and Culture Between the World Wars* (Oxford: Oxford University Press, 2011), and David McCullough, *The Greater Journey: Americans in Paris* (New York: Simon & Schuster, 2011).

4. Lee, *Doris Lee*, [8]; Hurley, *Russell Lee,* 12.

5. Louis Bromfield, "Expatriate—Vintage 1927," *Saturday Review of Literature* 3 (March 19, 1927): 657.

6. Lee, *Doris Lee,* [8].

7. See Lee-Mundy raw footage. Information about the Woodstock arts colony extrapolated from Alf Evers, *Woodstock: History of an American Town* (Woodstock, NY: Overlook Press, 1987).

8. Lee Autobiography; Doris Lee, interview by Joseph Travato, November 4, 1964, Archives of American Art, Smithsonian Institution.

9. Doris Lee, interview by Joseph Travato.

10. Gerald M. Monroe, "The Artists Union of New York," *Art Journal* 3, no. 1 (Autumn 1972): 17. The Artists Union was at 60 West Fifteenth Street.

11. Kao, Katzman, and Webster, 171 and 219.

12. Monroe, "The Artists Union of New York," 17.

13. Katzman, "Ben Shahn's New York: Scenes from the Living Theater," in Kao, Katzman, and Webster, 18.

14. See Hurley, *Russell Lee*, 13.

15. See Margaret Bourke-White, *Eyes on Russia* (New York: Simon & Schuster, 1931), and Langston Hughes, *I Wonder as I Wander: An Autobiographical Journey* (New York: Rinehart, 1956). See also

Andrew Hemingway, *Artists on the Left: American Artists and the Communist Movement, 1926–1956* (New Haven: Yale University Press, 2002).

16. Russell Lee, "System Governs Entire Lives of Russians; Few Admitted to Communist Party," likely published in the *Daily Republican Times*, Ottawa, IL, n.d., Cora Pope Scrapbook.

17. For idealization of Russian proletarian culture, see Katzman, "Ben Shahn's New York," in Kao, Katzman, and Webster, 18.

18. Russell Lee, "Recognition of Soviet Union by U.S. Should be Beneficial to Both Nations, Says Russell Lee After U.S.S.R. Tour," likely published in the *Daily Republican Times*, Ottawa, IL, n.d., Cora Pope Scrapbook.

19. Lee, "System Governs Entire Lives of Russians."

20. Lee, "Recognition of Soviet Union by U.S."

21. For informant narrative, see Stott, 190–210.

22. Van Wyck Brooks, *John Sloan: A Painter's Life* (New York: E.P. Dutton, 1955), 79.

23. Elizabeth Milroy, *Painters of a New Century: The Eight and American Art*, exh. cat. (Milwaukee: Milwaukee Art Museum, 1991), 119.

24. Sloan, 41.

25. Hurley, *Russell Lee*, 13. For 1930s attention to Daumier see Kao, "Ben Shahn and the Public Use of Art," in Kao, Katzman, and Webster, 57.

26. Walker Evans, Slide Lecture, Fogg Art Museum, November 13, 1969, quoted from Kao, Katzman, and Webster, 272.

27. See Rowland Eleza and Elizabeth Hawkes, *John Sloan: Spectator of Life*, exh. cat., Delaware Art Museum (Philadelphia: University of Pennsylvania Press, 1988).

28. Sloan, 81.

29. John Gross, "New York; John Sloan's Bygone New York Depicted in All Its Splendor and Squalor," *New York Times*, May 8, 1988. See also Sloan, 81.

30. Sloan, 70.

31. See Appel, "Doris and Russell Lee: A Marriage of Art."

32. Alfred Haworth Jones, "The Search for a Usable Past in the New Deal Era," *American Quarterly* 23, no. 5 (December 1971): 710, 715. For "usable past" see Van Wyck Brooks, *America's Coming-of-Age* (Garden City, NY: Doubleday Anchor Books, 1958), originally published under the title *Three Essays on America* (New York: E. P. Dutton, 1934). See also Jane De Hart Mathews, "Arts and the People: The New Deal Quest for a Cultural Democracy," *Journal of American History* 62, no. 2 (September 1975): 316–39.

33. "Sinking Hearts" *Time,* November 18, 1935.

34. C. J. Bulliet, "A Sullen Show," *Chicago Daily News*, October 26, 1935.

35. "Sinking Hearts."

36. Appel, "Doris and Russell Lee: A Marriage of Art," 88.

37. Lee-Doud interview.

38. Evers, *Woodstock: History of an American Town*, 442, and Konrad and Florence Ballin Cramer Papers at the Archives of American Art, Smithsonian Institution.

39. For the Circle of Confusion group, see "The Circle of Confusion: Pioneer 35mm Group Still Flourishes," *Leica Photography* 14, no. 3 (1961): 19–21. For his participation in a Leica show, see *Leica Annual 1937* (New York: Galleon Press, 1936), 68. For his articles in *Leica Photography* see Konrad Cramer, "Miniature Painting and the Miniature Camera," *Leica Photography*, June 1936, 2–3, 14; "A New World for the Photographer," *Leica Photography*, October 1936, 5, 15. For his Woodstock school, see ad in *Leica Photography*, May 1937, 21.

40. Lee-Doud interview.

41.　See Lee's pre-FSA photographs at the University of Texas.

42.　Stott, 21, 128, and 134.

43.　Susman, 159.

44.　Agnes Rogers and Frederick Lewis Allen, *Metropolis: An American City in Photographs* (New York: Harper and Brothers, 1934), plate no. 149.

45.　See John T. Flynn, "Bootleg Coal," *Collier's* 98, no. 23 (December 5, 1936): 12–13, 30, 32, 34; see also John Janney, "When Public Opinion Runs Out on the Law: The Story of Pennsylvania's $35,000,000 Robbery," *American Magazine* 123, no. 2 (February 1937): 16–17, 83–86, 89. *Collier's* ran five Lee photographs and the *American Magazine* ran six.

46.　For Lee's recollection of meeting Shahn at the AAC, see Hurley, *Russell Lee,* 14, and Lee-Mundy raw footage.

47.　Arnold Blanch, "Tendencies in American Art," in *Artists Against War and Fascism, Papers of the First American Artists' Congress,* eds. Matthew Baigell and Julia Williams (New Brunswick, NJ: Rutgers University Press, 1986), 154. First published in 1936 as *Papers of the First American Artists' Congress.*

48.　Joe Jones, "Repression of Art in America," *Artists Against War and Fascism*, 76-77.

49.　Karal Ann Marling, "Workers, Capitalists and Booze: The Story of the 905 Murals," in *Joe Jones & J. B. Turnbull: Visions of the Midwest in the 1930s* (Milwaukee: Marquette University, 1987), 14, 46n79.

50.　Lee-Doud interview. See also Lee to Stryker, January 4, 1962, Stryker Papers.

CHAPTER 3. STRYKER AND THE FILE

1.　Quoted in John Durniak, "Focus on Stryker," *Popular Photography* 51, no. 3 (September 1962): 62.

2.　Information about the Stryker family is extrapolated from my primary source research for my forthcoming book on Roy Stryker. Sources include pension records at the National Archives and Records Administration, the Stryker Papers, land records at the Montrose County Records Office, and city directories at the Fore-Kin Trails Genealogical Society in Montrose, Colorado.

3.　See *Report of the Committee on Irrigation and Reclamation of Arid Lands on the Investigation of Irrigation Projects*, March 3, 1911. Submitted by Mr. [Thomas Henry] Carter (Washington, DC: Government Printing Office, 1911), 644, 645–54.

4.　Stryker-Doud interview.

5.　Stryker-Hurley interview, reel 1, page 1. See also Stryker-Doud interview.

6.　Stryker Autobiography.

7.　Stryker-Hurley interview, reel 1 page 4.

8.　Stryker Journal.

9.　Stryker Autobiography. See also Stryker-Doud interview.

10.　Stryker-Doud interview.

11.　Stryker quoted in Stryker-Wood, 10.

12.　Sternsher, 6–7.

13.　Stryker Autobiography.

14.　Stryker-Doud interview.

15.　Stryker quoted in Stryker-Wood, 11.

16.　For "milestone," see Stryker quoted in Stryker-Wood, 11. For "hunted pictures," see Stryker-Doud interview.

17.　Kate Sampsell-Willmann, *Lewis Hine as Social Critic* (Jackson: University of Mississippi Press, 2009), 127.

18.　Rexford Guy Tugwell, Thomas Munro, and Roy E. Stryker, *American Economic Life and the Means of*

Its Improvement (New York: Harcourt, Brace and Company, 1925). This is referred to as the second edition; the first edition of *American Economic Life* was a mimeographed copy distributed to Contemporary Civilization students in the spring of 1925.

19. Stott, 212.
20. Stryker-Doud interview.
21. Stryker-Doud interview. For more of Stryker's recollections of his pictorial sourcebook, see Stryker Autobiography, McDougall-Hurley-Stryker interview, and Stryker-Hurley interview.
22. Stryker gave various figures in interviews in the 1960s. See McDougall-Hurley-Stryker interview and Stryker-Doud interview.
23. Sternsher, 265.
24. Baldwin, 56 and 95.
25. *First Annual Report: Resettlement Administration* (Washington, DC: Government Printing Office, 1936), 97–98; and Baldwin, 117. A "Division of Information" had existed prior to 1935 and administered the work Stryker did for the AAA; see for example Reuben Brigham to Stryker, December 12, 1934, Stryker Papers (microfilm). It was only after the establishment of the RA that Tugwell launched his aggressive public information campaign.
26. Shahn-Doud interview.
27. Stryker-Doud interview.
28. Stryker-Doud interview.
29. A general note about FSA captions: Captions written by Lee (sometimes edited by the FSA) appear in italics. These captions use language about topics like race, internment, and war that were common in the FSA-OWI during this period. Captions composed or edited for clarity by the author appear in roman. The phrase "originally uncaptioned" indicates the photo did not have a title or caption—probably because it was never printed by the FSA—and is instead accompanied by a caption, in roman, derived from another photograph that appears to be from the same assignment.
30. Stryker-FSA photographers conversation, 16.
31. Shahn-Doud interview.
32. For Shahn's Sacco and Vanzetti series, see Alejandro Anreus, Laura Katzman, Nunzio Pernicone, and Francis K. Pohl, *Ben Shahn and the Passion of Sacco and Vanzetti* (New Brunswick, NJ: Jersey City Museum in association with Rutgers University Press, 2001).
33. Shahn-Doud interview.
34. Stryker-Doud interview.
35. Shahn-Doud interview.
36. Mydans-Doud interview.
37. Mydans-Doud interview.
38. For "outlines of ideas" see Stryker-Doud interview. For "a way of thinking or planning . . . a device for discussion" see handwritten, undated note to Robert Doherty prefacing the shooting scripts now in the Stryker Papers. For shooting scripts as a starting point, see Stryker to Lee April 30, 1941, Stryker Papers. For photographer recollections about shooting scripts see Delano, *Photographic Memories*, 34; Rothstein and Vachon essays in *Just Before the War*.
39. In examining the online catalog for the FSA-OWI Collection at the Library of Congress (http://www.loc.gov/pictures/collection/fsa/) I have calculated that between July 1935 and September 1936 all of the photographers (Carter, Evans, Jung, Lange, Mydans, Rothstein, and Shahn, as well as darkroom chief Elmer S. Johnson and a few others identified only by their last name or not at all) shot at least 7,636 negatives. Of these, 4,708 were captioned; the other 2,928 remained untitled and were likely never printed during the active years of the project. Many of these were "killed" by Stryker with a hole-punch. Quantifying all of the images shot for the File during this time is not possible because

Stryker threw away much of the sheet film he rejected or "killed" in the early years of the project and there is little or no record of it. See a brief discussion in Chapter 5; see also Appel, "Duplicate File," 7–9.

40. The personnel records for the Historical Section are incomplete and these staff numbers are from 1941, though in 1935–36 they would have been comparable. Roy E. Stryker, "Memo Submitted to Personnel Division," 1941, Stryker Papers.

41. For Stryker's print distribution system, see Appel, "Duplicate File." For print distribution statistics, see HS Textual Records, Reel 4, Box 4, Monthly Reports. The December 1935 report does not specify the recipients as publishers, but based on examination of subsequent reports, this is implied. For Stryker quote see Stryker-Doud interview.

42. Hurley, *Portrait of a Decade,* 122-23.

43. Information about the skull incident is extrapolated from Arthur Rothstein, "The Picture that Became a Campaign Issue," *Popular Photography*, September 1961, 42–43, 79; Rothstein's comments in *American Images*; Rothstein-Doud interview; clippings in Stryker's Scrapbooks, HS Textual Records, Reels 21–23, Oversize Boxes 1–11; Hurley, *Portrait of a Decade,* 86–92; O'Neal, 21–22; and Stryker-Rothstein-Locke correspondence, Stryker Papers.

44. Locke to Rothstein, August 29, 1936, Stryker Papers.

45. Stryker, "Documentary Photography," 1,374.

46. Alfred Kazin, *On Native Grounds: An Interpretation of Modern American Prose Literature* (New York: Reynal & Hitchcock, 1942), 487.

47. For Stryker's attitude on value for future generations, see Stryker, "Documentary Photography," 1,374. For Delano's quote, see Delano-Doud interview.

48. See Anthony T. Troncale, "Worth Beyond Words: Romana Javitz and the New York Public Library's Picture Collection," *Biblion: The Bulletin of the New York Public Library* 4, no. 1 (Fall 1995): 115-38.

49. Stryker, "Documentary Photography," 1,365; Roy Stryker and Paul Johnstone, "Documentary Photographs," *The Cultural Approach to History*, ed. Caroline Ware (New York: Columbia University Press 1940), 324–25.

50. Stryker-FSA photographers conversation, 18.

51. *First Annual Report: Resettlement Administration*, 97.

52. Baldwin-Doud interview.

53. Stryker-Doherty et al. interview, 21.

54. Aiken-Wool-Doud interview.

55. Stryker-Doud interview.

56. Stryker-Doud interview.

57. See Stryker to Lee October 19, 1936, and October 23, 1936, Stryker Papers.

58. Stryker-Doherty et al. interview, 19.

59. Stryker-FSA photographers conversation, 38.

60. Conkin, 262.

61. Ralph F. Armstrong, "Four Million Dollar Village: A Belated Report to Doctor Tugwell," *Saturday Evening Post*, February 5, 1938, 34.

62. See for example, "Workers' Families Begin Rural Life," *New York Times,* July 11, 1936, L17; "New Deal Project Scored; First Voters League Calls Jersey Homesteads Wasteful," *New York Times*, September 2, 1936, L14.

63. Armstrong, "Four Million Dollar Village," 36.

64. Stryker-Doud interview.

65. Stryker's stormy relationships with Lange and Evans have been well-documented and widely discussed. For example, see Gordon, 287–300; Hurley, "In and Out of Focus," 252n2; Hurley, *Portrait of a Decade*, 142–43; Raeburn, 155-66.

66. Gordon, 292.

67. See, for example, Stryker to Lewis Hine, July 24, 1936, Stryker Papers. Scholars have criticized Stryker on his termination of Lange and Evans, and his refusal to hire Hine. See, for example, Spirn, Gordon, and Kate Sampsell-Willmann, *Lewis Hine as Social Critic*.

68. Stryker-Doherty et al. interview, 19.

69. Lee to Stryker, December 19, 1941, Stryker Papers.

70. Stryker-FSA photographers conversation, 39.

71. Edwin Rosskam and Russell Lee, "Suggestions for Points to be Embodied in a Memorandum to Civil Services," [April 1941], HS Textual Records, Reel 5, Box 5, Personnel.

72. Stryker to Lee, June 19, 1939, Stryker Papers.

73. Bernarda Bryson Shahn, "Foreword," in O'Neal, 7.

74. Hartley Howe, "You Have Seen Their Pictures," *Survey Graphic*, April 1940, 237.

75. For discussions of these and other New Deal photography projects, see Pete Daniel, Merry A. Foresta, Maren Stange, and Sally Stein, *Official Images: New Deal Photography* (Washington, DC: Smithsonian Institution Press, 1987). See also the comparative studies in Natanson.

76. For Lee's rejection of the Forest Service option, see Lee-Doud interview.

77. Raeburn, 184-85.

78. Vicki Goldberg, "Propaganda Can Also Tell the Truth," *American Photographer*, December 1978, 18.

79. Appel, "Doris and Russell Lee: A Marriage of Art," 112.

80. *Today, Tomorrow's History*.

81. Bernarda Bryson Shahn, "Foreword," in O'Neal, 7.

82. Rosskam-Libsohn-Appel 1999 interview, 3, 9.

CHAPTER 4. NOVEMBER 1936-JANUARY 1937: FARM TENANCY IN THE MIDWEST

1. See *Farm Tenancy: Report of the President's Committee* (Washington, DC: Government Printing Office, 1937): 48.

2. F. A. Buechel, "Relationships of Landlords to Farm Tenants," *Journal of Land & Public Utility Economics* 1, no. 3 (July 1925): 336. Over the last century, agricultural economists have written about tenancy as a mutually beneficial business arrangement and management system, and have proposed methods to improve it. For tenancy in the Midwest, see especially the works of Franklin J. Reiss, as well as Joseph Ackerman, C. B. Baker, Donald Baron, Peter J. Barry, Paul N. Ellinger, Cesar L. Escalante, H. W. Hannah, John A. Hopkin, Lee Ann M. Moss, and Narda L. Sotomayor.

3. See Benjamin Horace Hibbard, "Farm Tenancy in the United States," *Annals of the American Academy of Political and Social Science* 40 (March 1912): 29-39.

4. See Howard Archibald Turner, *Graphic Summary of Farm Tenure (Based Largely on the Census of 1930 and 1935)* (Washington, DC: United States Department of Agriculture, December 1936), 7, and *Farm Tenancy: Message from the President of the United States, transmitting the Report of the Special Committee on Farm Tenancy February 16, 1937* (Washington, DC: Government Printing Office 1937), iii.

5. Tenancy articles relating to Bankhead Jones (1936-early 1937) in scrapbooks kept by Stryker's office, HS Textual Records, Reel 21, Oversize Box 1.

6. *Farm Tenancy: Message from the President*, iii.

7. See President Franklin D. Roosevelt to Secretary Henry A. Wallace, "White House Statement and Letter on the Appointment of a Special Committee on Farm Tenancy, November 17, 1936," *The Public Papers and Addresses of Franklin D. Roosevelt*, vol. 5, *The People Approve, 1936* (New York: Random House, 1938), 590.

8. See James G. Maddox, "The Bankhead-Jones Farm Tenant Act," *Law and Contemporary Problems* 4, no. 4, Farm Tenancy (October 1937): 434-55; and Baldwin, 157-92.

9. R[exford]. G[uy]. Tugwell, "Behind the Farm Problem: Rural Poverty," *New York Times Magazine*, January 10, 1937, 4, 5.

10. Bernhard Ostrolenk, "Farm Tenants Make Demands," *New York Times*, August 30, 1936, F7.

11. Lee-Doud interview. See also Lee's comments in *American Images*.

12. See Lee to Stryker, n.d. (December [1 or 2,] 1936), Stryker Papers.

13. Lee-Doud interview.

14. Lee to Stryker, December 9, 1936, Stryker Papers.

15. Stryker-FSA photographers conversation, 39.

16. Lee quoted in *American Images*.

17. Stott, 134.

18. Lee-Doud interview.

19. Kennedy, 261.

20. Lee quoted in *Today, Tomorrow's History*.

21. *Sixteenth Census of the United States: 1940, Volume II (Housing, General Characteristics), Part 3 (Iowa-Montana)* (Washington, DC: Government Printing Office, 1943), 16.

22. For atlases as "systematic compilations of working objects," see Lorraine Daston and Peter Galison, *Objectivity* (New York: Zone Books, 2007), 22.

23. See *Sixteenth Census of the United States: 1940, Volume II, Part 3*, 15. Just over 20 percent of all Iowa farm homes (tenant and owner-operated) had running water.

24. Lange-Doud interview.

25. Information about flash extrapolated from Pierre Bron and Philip L. Condax, *The Photographic Flash: A Concise Illustrated History* (Allschwil, Switzerland: Bron Elektronik AG, 1998); Willard D. Morgan, *Synchroflash Photography* (New York: Morgan & Lester, 1939); and Chris Howes, *To Photograph Darkness: The History of Underground and Flash Photography* (Carbondale: Southern Illinois University Press, 1989).

26. See Lee, "Flash—Elementary Technic," 1,789, 1,795–98.

27. See Lee to Stryker, February 10, 1940, Stryker Papers.

28. Stryker to Lee, December 29, 1936; and Lee to Stryker, January 2, 1937, Stryker Papers.

29. Rosskam-Doud interview.

30. Rosskam-Doud interview.

31. Lee, "Flash—Elementary Technic," 1,784, 1,786, 1,788.

32. Susman, 159.

33. Evans, Rothstein, and Mydans used flash sparingly, but Shahn and Lange both said they didn't like using it. See Shahn-Doud interview and Lange-Doud interview.

34. Lee to Stryker April 1, 1940, Stryker Papers.

35. For filling in available light, for example, see his picture of milk bottles in the rear of a farmer's automobile in Texas (LC-USF34–035015-D). Lee wanted to use this image as an example of successful employment of flash technique for an article he wrote about flash in 1941, "Flash—Elementary Technic." See Lee to Stryker June 12, 1941, Stryker Papers.

36. See Lee, "Flash—Elementary Technic." Lee's friend and colleague, the writer, editor, and Leica promoter Willard D. Morgan, interviewed Lee about developing flash negatives for his book *Synchroflash Photography*. See Morgan, 64.

37. Lee wrote in 1941 that he used a Contax equipped with a Jacobson flashgun, a Linhof Technica with a Kalart flash unit in a specially constructed battery case, and an Anniversary Speed Graphic fitted with a Heiland Sol flash synchronizer. See Lee, "Life on the American Frontier," 46, 48. See also Lee's recollections of his equipment in Lee-Doud interview and *Today, Tomorrow's History*.

38. Cathi S. Myre, conversation with the author, April 2007. Land records at the LaSalle Recorder's Office include a 1964 photograph of the house, which has since been torn down.

39. Paul Gipe, *Wind Energy Comes of Age* (New York: John Wiley and Sons, 1995), 123–27.

40. See "The Golden Age of Agriculture" in Chapter 1 (24–27).

41. Erickson's farm was adjacent to another owned by Lee, a 240-acre farm (inherited from Milton Pope) that Lee rented to a tenant named T. W. Cooke. Lee likely visited the farm but didn't photograph it. Russell Lee, FSA Field Notebook #2, unpaginated [9], Lee Collection.

42. Russell Lee, FSA Field Notebook #2, [2], Lee Collection.

43. See Russell Lee, FSA Field Notebook #2, [1–9], Lee Collection.

44. Russell Lee, FSA Field Notebook #2, [end page], Lee Collection. Records no longer exist for either the names of individuals who received AAA benefit payments or amounts of payments made in La Salle County, Illinois, yet there is ample evidence to support my conclusions: the landlord's 50 percent share of the crops in 1936 (800 bushels corn and 200 bushels oats) indicates the total yield for the farm would have been 1,600 bushels corn and 400 bushels oats. Based on crop figures from National Agricultural Statistic Service, the average yields for LaSalle County in 1936 were 36 bushels corn per acre and 33 bushels oats per acre, suggesting that for Lee's 120-acre farm 44 acres were planted in corn and 12 acres were planted in oats for a total of 56 acres planted and 64 acres not planted; Lee and Werner received the $438 incentive check for these unplanted acres. Lee's notes show that he divided the check four ways, with half going to him and Charles Werner, and the other half to his tenants; he proposed that Charles Werner's $110 share be used to pay for the next year's seed.

45. Jerry Danielson, letter to the author, February 13, 2009.

46. For the other elevator, in Spencer, Iowa, see LC-USF33–011089-M3. For an exterior view of the Ruthven elevator, see LC-USF34–010083-D.

47. Stryker in Robert E. Girvin, "Photography as Social Documentation," *Journalism Quarterly* 24, no. 3 (September 1947): 218-19 and Stryker to Girvin, June 10, 1947, Stryker Papers.

48. Stryker to Lee, December 1, 1936, Stryker Papers.

49. Stryker to Lee, January 30, 1937, Stryker Papers.

50. Circulation figures appear at the top of the page that ran Lee's photographs: see *Des Moines Sunday Register*, May 2, 1937, 8.

51. Richard Wilson, "U.S. Studies Problems of Soil 'Slaves,'" *Des Moines Sunday Register*, May 2, 1937, 1, 9.

52. My accounting of the Tenant Madonna contretemps first appeared in Appel, "Duplicate File," 16–21.

53. George Shane, "Girl 'Mother' Photo Angers Iowa Colony," *Des Moines Register*, June 10, 1937, 1.

54. See "Iowa's Tenant Madonna Helps Out, Anyhow," *Daily Oklahoman*, June 26, 1937, 8. The paper notes the article was reprinted from the *Chicago Daily News*.

55. Arch Mercey to Lee, June 21, 1937, Stryker Papers. Mercey didn't name the caption writer, but a letter from Stryker to Locke indicates it was a member of Mercey's staff. Stryker to Locke, February 9, 1937, Stryker Papers.

56. Stryker-Doud interview.

57. See Stryker-FSA photographers conversation, 28-29; Stryker-Doud interview; Stryker to Girvin, June 10, 1947, Stryker Papers; and Stryker in Girvin, "Photography as Social Documentation," 218–19.

58. Lee to Stryker, June 25, 1937, Stryker Papers.

59. See Mercey to Lee, June 21, 1937, Stryker Papers.

60. Lee was keenly aware of the exploitation potential of documentary photography, as were some of his subjects. For example, he wrote to Locke in September of 1937 of his interactions with the leaders of a group of sugar beet workers and "assured them we were not trying to exploit them." Lee to Locke September 15, 1937. Among the scholars who have charged documentary photography with exploitation are James Curtis, Martha Rosler, Allan Sekula, Terrence Smith, Abigail Soloman-Godeau, Maren Stange, Sally Stein, and John Tagg. For a discussion of this debate, see Katzman, "Ben Shahn's New York," in Kao, Katzman, and Webster, 23–24, 123n44.

61. Gordon also makes this point; see Gordon, 232.

62. I speculate that Lee told Stryker about his farms and tenants in person during the spring-summer of 1937, either during Stryker's field visit in May or during Lee's visit to Washington in July. In March 1937 Lee wrote to Stryker he had "private business" in Ottawa and would "make up the time on the weekends." See Lee to Stryker, March 9, 1937, Stryker Papers. Lee's first written acknowledgment to Stryker of his farms was a November 1937 letter where he wrote, "After Des Moines I shall go to Aledo, Illinois . . . and then will go to Ottawa to see how the farms are getting along." Lee to Stryker, November 21, 1937, Stryker Papers. Several years later Stryker lightheartedly referred to Lee's farms in a postscript about the new retirement deduction in Lee's paycheck: "You know when you get in those declining years, you can look out over your acres in Illinois, and it will be nice to have this retirement fund for cigars and other little extras." Stryker to Lee, February 11, 1942, Stryker Papers.

63. Available records indicate Dorothea Lange was the only FSA colleague with any knowledge of Lee's farms; see Lange-Doud interview. Louise Rosskam suspected Lee had a farm somewhere, but said he never spoke about it with anyone. Sol Libsohn, who knew Lee from the Standard Oil New Jersey project, firmly believed Lee's wealth came from a cattle-feeding operation in Chicago. Rosskam-Libsohn-Appel interview.

64. *Farm Tenancy: Report of the President's Committee,* 3.

65. *Farm Tenancy: Report of the President's Committee,* 4.

66. Conkin, 181.

67. Sternsher, 303. Wilma Dykeman and James Stokely, *Seeds of Southern Change: The Life of Will Alexander* (Chicago: University of Chicago Press, 1962), 222.

68. There is evidence that Lee made more, which Stryker "killed" or edited out of the File. By my calculation Stryker destroyed approximately 20 percent of Lee's sheet film from this period. See Appel, "Duplicate File," 9.

69. Javitz-Doud interview, reproduced in Richard K. Doud, "An Interview with Romana Javitz," *Archives of American Art Journal* 41, no. 1/4 (2001): 4.

CHAPTER 5. 1937: THE LAND IN RUINS

1. Hugh Hammond Bennett, *Soil Conservation* (New York: McGraw-Hill Book Company, 1939), 5.

2. Bennett, *Soil Conservation,* 9.

3. See Sternsher, 218.

4. D. Harper Simms, *The Soil Conservation Service* (New York: Praeger Publishers, 1970), 17.

5. Baldwin, 304.

6. Lee to Stryker, January 24, 1937, Stryker Papers.

7. Information about rescue efforts extrapolated from David Welky, *The Thousand-Year Flood: The Ohio-Mississippi Disaster of 1937* (Chicago: University of Chicago Press, 2011), 72–76.

8. Stryker to Lee, January 23, 1937, Stryker Papers.

9. Rosskam, "Not Intended for Framing," 10.

10. Bennett, *Soil Conservation,* 78.

11. Lee to Stryker, January 26, 1937, Stryker Papers.

12. Steichen, 44.

13. Lee to Stryker, March 20, 1937, Stryker Papers. Doris joined Lee two other times in the field, at the end of May 1938 and then again in mid-October 1938.

14. See for example, Norman Schreiber, "Inside Photojournalism," *Camera Arts,* November 1982, 18, where Rothstein reminisced that "it was a lonely life" and described "many lonely evenings, many lonely experiences."

15. Lee-Doud interview.

16. Lee-Doud interview.

17. *Today, Tomorrow's History.*

18. Information about cutover history extrapolated from Robert Gough, *Farming the Cutover: A Social History of Northern Wisconsin 1900–1940* (Lawrence: University of Kansas, 1997). See also Loyal Durand Jr. and Kenneth Bertrand, "The Forest and Woodland Regions of Wisconsin," *Geographic Review* 25, no. 2 (April 1935): 264–71; Charles M. Davis, "The Cities and Towns of the High Plains of Michigan," *Geographic Review* 28, no. 4 (October 1938): 664–73; F. P. Struhsaker, "Land Use Problems in Michigan," *Journal of Farm Economics* 21, no. 1 (February 1939): 287–90; and Lucile Kane, "Selling Cut-Over Lands in Wisconsin," *Business History Review* 28, no. 3 (September 1954): 236–47.

19. Watkins, *The Hungry Years*, 431–32.

20. Stryker to Lee, December 9, 1936, Stryker Papers.

21. Stryker to Lee, December 17, 1936, Stryker Papers.

22. Stryker to Lee, April 16, 1937, Stryker Papers.

23. Lee to Stryker, April 21, 1937, Stryker Papers.

24. Lee to Stryker, April 15, 1937, Stryker Papers.

25. Lee to Stryker, April 15, 1937, Stryker Papers.

26. Stryker to Lee, April 21, 1937, Stryker Papers.

27. Lee quoted in *American Images.*

28. See Appel, "Duplicate File," 7.

29. See Shahn-Doud interview and Rothstein-Doud interview. For discussions of the hole-punching, see Fleischhauer and Brannan, 338–39; O'Neal, 46; Finnegan, 51; Spirn, 36; and William E. Jones, *Killed: Rejected Images of the Farm Security Administration* (New York: PPP Editions, 2010). In recent years the killed images have attracted much online attention, in various publications and forums, including *The Atlantic*, *The Guardian*, and *Atlas Obscura*. Killed images were often (though not always) duplicates, variants, mistakes, or test shots.

30. See Appel, "Duplicate File," 13.

31. Fleischhauer and Brannan, 339.

32. See, for example, Stryker to Lee, January 7, 1937, Stryker Papers. Although the hole-punching method ceased around 1938, the office still referred to rejected negatives as "killed" and "withdrew" them from the File. See "Procedure for Handling of Exposed Negatives Received from the Photographers," written by FSA staff, [ca.1938–1940], Section IX, Vanderbilt Papers. See also Lee to Clara Dean "Toots" Wakeham, March 9, 1940, Stryker Papers. For Stryker's continued practice of throwing away rejected sheet film, see Appel, "Duplicate File," 12–14.

33. Lee quoted from *American Images.*

34. Lee-Doud interview.

35. Lee to Stryker, November 28, 1936, Stryker Papers.

36. Lee to Stryker, January 2, 1937, and January 8, 1937, Stryker Papers.

37. See Vachon letters to his wife, Penny, January 7, 1942, Box 5, Folder 5; January 28, 1942, Box 6, Folder 4; February 1, 1942, Box 6, Folder 5; and February 2, 1942, Box 5, Folder 5. All Vachon Papers.

38. For other views of Lee see LC-USF33–015561-M1, M4, and M5. After Stryker returned to Washington, he wrote to Lee: "Did you develop the Leica rolls which I took? If so, how were the pictures of your BVD's." Stryker to Lee June 21, 1937, Stryker Papers.

39. Stryker-Doud interview. For a separate recounting of this incident, see Stryker-FSA photographers conversation, 43–44.

40. Stryker-Doud interview.

41. Benhart Rajala, *Tim-BERRR!! Pine Logging in the Big Fork River Country*, vol. 1 (St. Cloud, MN: North Star Press, 1991), 143.

42. Stryker to Lee, April 3, 1937, Stryker Papers.

43. See Rajala, *Tim-BERRR!!*, 136–48. See also Agnes M. Larson, *The White Pine Industry in Minnesota: A History* (Minneapolis: University of Minnesota Press, 2007).

44. Lee to Locke, September 15, 1937, Stryker Papers.

45. See Lee-Mundy raw footage.

46. Bergit I. Anderson, *The Last Frontier* (St. Paul, MN: Bruce Publishing Company, 1941), 105.

47. See LC-USF345–007473-ZB.

48. Richard Lowitt and Maurine Beasley, eds., *One Third of a Nation: Lorena Hickock Reports on the Great Depression* (Urbana: University of Illinois Press, 1981), 70.

49. Watkins, *The Great Depression*, 192.

50. Timothy Egan, *The Worst Hard Time: The Untold Story of Those Who Survived the Great American Dust Bowl* (Boston: Houghton Mifflin, 2006), 8.

51. H. L. Mencken and Raven I. McDavid Jr., eds., *The American Language* (New York: Alfred A. Knopf, 1979), 206.

52. Stryker to Lee, October 12, 1937, Stryker Papers.

53. Caption for LC-USF34–030471-D.

54. Arthur Raymond Mangus, *Changing Aspects of Rural Relief* (Washington, DC: Government Printing Office, 1938), 24–25, 198.

55. Lee to Stryker, "Tuesday" (September 1937); Clarence Lockrem (District RR Supervisor, Williston) to L. L. Scranton (Assistant Regional Director), September 4, 1937; L. L. Scranton to Clarence Lockrem, n.d.; and Lee to Locke, September 5, 1937, all Stryker Papers.

56. Lee to Locke, September 5, 2017, Stryker Papers. For reduced high school football teams, see caption for LC-USF33–011385-M1.

57. Lee to Locke, September 15, 1937, Stryker Papers.

58. Russell Lee, FSA Field Notebook #3, [72–75], Lee Collection. See also Lee to Locke, September 5, 1937, Stryker Papers.

59. Caption for LC-USF34–030812-D and LC-USF34–030826-D.

60. Caption for LC-USF34–030813-D.

61. Florence Kramer is identified in Ganzel, 76–77.

CHAPTER 6. 1938: CREATIVE LIMITATIONS

1. "Special Information for Russell Lee," page 4 of Stryker to Lee and Delano, December 13, 1940; and Stryker to Rothstein, February 9, 1937, Stryker Papers.

2. Stryker to Lee, April 21, 1939, Stryker Papers.

3. Roll, 44; Watkins, *The Great Depression*, 309–12.

4. Stryker to Locke, January 3, 1938, Stryker Papers.

5. Stryker to James McCamy, April 12, 1938, Stryker Papers. For "How American People Live," see "Modern Photography on Parade: First International Photographic Exposition" brochure and supplemental press release, Stryker Papers.

6. No definitive list of the FSA photographs in the exhibition exists, but available records show that Lee and Rothstein installed somewhere between seventy-six and eighty-four photographs. See Lee to Stryker, April 27, 1964, Stryker Papers (microfilm), NDA 8, Grand Central Palace Exhibit section ("Farm Security Exhibit Envelopes A–E"); and *The Farm Security Administration Photographs in the*

First International Photographic Exposition, April 18–29, 1938, LOT 997, Prints and Photographs Division, Library of Congress. See also Raeburn, 339n39.

7. See "Eager Crowd Opens Photo Show Early," *New York Times*, April 19, 1938, 23. See also "The First International Photographic Exposition," *Leica Photography*, April 1938, 13, 23.

8. Comments 39, 259, 265, and 9, LOT 997. The original cards (now in LOT 937, Prints and Photographs Division, Library of Congress) have been transcribed and are included in LOT 997.

9. Comments 107 and 141, LOT 997.

10. Comments 53, 272, 47, and 329, LOT 997.

11. See Steichen; Elizabeth McCausland, "First International Show of Photography," *Springfield* (MA) *Sunday Union and Republican*, April 24, 1938, 6E; Elizabeth McCausland, "Rural Life in America as the Camera Shows It," *Springfield* (MA) *Sunday Union and Republican*, September 11, 1938, 6E; and Rosa Reilly, "The Camera World on Parade," *Popular Photography* 3, no. 1 (July 1938): 24-25, 76, 78.

12. Willard Morgan to Stryker, February 26, 1964, Stryker Papers.

13. Stryker to Evans, April 20, 1938, and Evans to Stryker, April 21, 1938, Stryker Papers.

14. Stryker to Locke, April 25, 1938, Stryker Papers.

15. See Steichen; and Reilly, "The Camera World on Parade."

16. Stryker to Rothstein, April 25, 1938, and Stryker to Locke, April 25, 1938, Stryker Papers.

17. For information on the MoMA traveling show see LOT 997. Stryker had carefully cultivated this MoMA partnership: a year earlier librarian/curator Beaumont Newhall selected three FSA images for his show *Photography 1839–1937* and another six for *Three Centuries of American Art*, organized with the Jeu de Paume, Paris.

18. In Raeburn's research, twenty-four of seventy-six photographs were by Lee. Raeburn, 339n39. According to LOT 997, twenty-two were by Lee.

19. For example, see comments 45, 125, 373, and 444, LOT 997.

20. Stryker to Locke, April 25, 1938, Stryker Papers.

21. Lee to Stryker, February 4, 1937, and Stryker to Lee, May 21, 1938, Stryker Papers.

22. Stryker to Rothstein, February 5, 1937, Stryker Papers.

23. Stryker to Lee, November 23, 1938, Stryker Papers.

24. Stryker to Locke, April 25, 1938, Stryker Papers.

25. Stryker to Lee, May 3, 1938, Stryker Papers.

26. Collier-Doud interview.

27. Vachon to Stryker, Monday night (October 11, 1938), Stryker Papers. Vachon-Doud interview.

28. Constance E. H. Daniel, "The Missouri Boot-Heel," *The Crisis* 47, no. 11 (November 1940): 348; and Farm Security Administration, "Southeast Missouri: A Laboratory for the Cotton South," December 30, 1940, 1, HS Textual Records, Reel 17, Box 24, Supplementary Reference File for LOTS 1193–1197.

29. "Missouri's '100 Families' Get Houses for Shanties," *St. Louis Dispatch*, June 5, 1938, 8; Donald Holley, "The Negro in the New Deal Resettlement Program," *Agricultural History* 45, no. 3 (July 1971): 179; and Farm Security Administration, "Southeast Missouri: A Laboratory for the Cotton South."

30. "Missouri's '100 Families' Get Houses for Shanties," 8.

31. Max R. White, Douglas Ensminger, and Cecil L. Gregory, *Rich Land, Poor People* (Washington, DC: Farm Security Administration, 1938), 40. A copy of this report is in HS Textual Records, Reel 17, Box 24, Supplemental Reference File for LOTS 1193–1197.

32. See White, Ensminger, and Gregory, 43–45, 51.

33. "Missouri's '100 Families' Get Houses for Shanties," 8.

34. See Farm Security Administration, "La Forge Farms," October 5, 1940, 2. HS Textual Records, Reel 17, Box 24, Supplemental Reference File for LOTS 1193–1197.

35. "100 Families of Missouri," *Dayton Daily News*, March 31, 1940.

36. See Farm Security Administration, "La Forge Farms," 2, and "Southeast Missouri Farms," [ca. 1938-39], 1-2, HS Textual Records, Reel 17, Box 24, Supplemental Reference File for LOTS 1193–1197.

37. Stryker to Lee, May 21, 1938, and May 17, 1938, Stryker Papers.

38. Lee to Stryker, Friday Night, (June 1938), [May 27, 1938], Stryker Papers.

39. See Stryker's clippings scrapbooks in HS Textual Records, Reel 22, Oversize Box 7, for the extensive coverage for Southeast Missouri Farms. Clippings from at least fifteen publications are represented, which in addition to *Architectural Forum* include *Business Week*, *Survey Graphic*, *Collier's*, the *St. Louis Dispatch*, the *Des Moines Register*, and the *New York Times*.

40. Conkin, 172.

41. For twenty-six partially integrated projects, see Holley, "The Negro in the New Deal Resettlement Program," 184.

42. Stuart Chase, "From the Lower Depths," *Reader's Digest*, May 1941, n.p. [111]. First published in *Free America*, April 1941.

43. See Chase, "From the Lower Depths," [110].

44. Wilma Dykeman, *Seeds of Southern Change: The Life of Will Alexander* (Chicago: University of Chicago Press, 1962), 166, 173.

45. Holley, "The Negro in the New Deal Resettlement Program," 184.

46. Mary Linda Helfant, "Ten Dollars Cash Means Prosperity to Sharecroppers in the South Aided by FSA," *Springfield* (MA) *Sunday Union and Republican*, March 23, 1941, 3E.

47. Goodwin, 163–64, 331.

48. Natanson, 49–50.

49. Baldwin, 250. For the ten all-Black communities, see Holley, "The Negro in the New Deal Resettlement Program," 184. See also Conkin, 199–202.

50. Baldwin, 250. See also Natanson, 55. Baldwin also discusses de facto discrimination by the agency; see especially 196.

51. See Donald Holley, *Uncle Sam's Farmers: The New Deal Communities in the Lower Mississippi Valley* (Urbana: University of Illinois Press, 1975), 183–84. Lee photographed Transylvania Farms in 1939.

52. See "Photographs of Signs Enforcing Racial Discrimination: Documentation by Farm Security Administration–Office of War Information Photographers," Prints and Photographs Division, Library of Congress, https://www.loc.gov/rr/print/list/085_disc.html.

53. Lee to Stryker, January 4, 1962, Stryker Papers.

54. See LC-USF34–033041-D and LC-USF33–012498-M2.

55. See LC-USF34–035090-D.

56. Daniel, "The Missouri Boot-Heel," 348.

57. Mark A. Dawber, "Sharecropper Misery: Is It the Concern of the Christian Church?" *Missions (An International Baptist Magazine)*, April 1940, 201.

58. Gordon quoted in Daniel Marans and Mariah Stewart, "Why Missouri Has Become the Heart of Racial Tension in America," *Huffington Post*, November 16, 2015. See also Colin Gordon, *Mapping Decline: St. Louis and the Fate of the American City* (Philadelphia: University of Pennsylvania Press, 2008).

59. Marans and Stewart, "Why Missouri Has Become the Heart of Racial Tension in America." See also Clarence Lang, *Grassroots at the Gateway: Class Politics and Black Freedom Struggle in St. Louis, 1936 to 1975* (Ann Arbor: University of Michigan Press, 2009).

60. Chris King, "Missouri Has Second Most Racial Terror Lynchings Outside the Deep South," *St. Louis American*, June 27, 2017, http://www.stlamerican.com/news/local_news/missouri-has-second-most

-racial-terror-lynchings-outside-the-deep/article_cfd3e294-5b5a-11e7-bf19-6be74091b684.html. Scholar Dominic Capeci includes a list of the recorded lynching victims in Missouri 1889–1942 in *The Lynching of Cleo Wright* (Lexington: University Press of Kentucky, 1998), 194–96. See also Equal Justice Institute, "EJI Releases New Data on Racial Terror Lynchings Outside the South," June 26, 2017, https://eji.org/news/eji-releases-new-data-on-racial-terror-lynchings-outside-the-south.

61. Chase, "From the Lower Depths," [112].

62. Determining the precise number of families is difficult because a series of Lee's negatives from this assignment disintegrated from tainted developer. See Stryker to Lee, June 1, 1938, and June 10, 1938, Stryker Papers. From the surviving negatives, I have determined that Lee photographed twenty-two White families and twenty-four Black families.

63. Lee to Stryker, Wednesday, (May), [June 1, 1938], Stryker Papers.

64. Stryker subscribed to clipping services and also received clippings from colleagues. The clippings scrapbooks are in HS Textual Records, Reels 21–23, Oversize Boxes 1–12.

65. The File has undergone a few reorganizations; since the mid-1940s these two photographs have been filed together under "F3713 Children Washing, Dressing, Etc."

66. Recent scholarship has reasoned that the lack of FSA photographs depicting African Americans and other minorities in the popular press indicates Stryker didn't circulate or distribute them. See, for example, Sharon Ann Musher, *Democratic Art: The New Deal's Influence on American Culture* (Chicago: University of Chicago Press, 2015), 143. Stryker promoted the File through a print distribution system called the Duplicate File, sending "press prints" to magazines, newspapers, book publishers, and other outlets. Circulation records of specific images were not retained and only a fraction of these Duplicate File prints have survived, though they do surface in personal papers, the art market, auction venues, and image archives. A portion of surviving Duplicate File prints depict African American subjects, demonstrating that Stryker did, in fact, circulate them and tried to place them with publishers. For example, the New York Public Library has hundreds of Duplicate File prints portraying Black subjects; twenty-nine are from Lee's Southeast Missouri Farms work. For more on the Duplicate File, see Appel, "Duplicate File."

67. Stryker to Lange, June 18, 1937, Stryker Papers.

68. Garford Wilkinson to John Fischer, January 18, 1940. Records of the Farmers Home Administration (RFHA), RG 96, Series 2, Box 146, National Archives at College Park, MD (NACP).

69. George Wolf to John Fischer, January 17, 1940. RFHA, RG 96, Series 2, Box 146, NACP.

70. See Richard Wright, *12 Million Black Voices: A Folk History of the Negro in the United States*, photo direction by Edwin Rosskam (New York: Viking Press, 1941), 77.

71. Stryker to Lee, June 26, 1941, Stryker Papers.

72. Lee-Doud interview.

73. In addition to the Stryker-Lee correspondence, see also "Visual Work Done for Government and Non-Government Agencies," [ca. 1941], Stryker Papers.

74. Philip S. Broughton (In Charge, Office of Health Education, Public Health Service) to Lee, September 10, 1938, Stryker Papers.

75. Lee to Stryker, Tuesday, (August 1938?), (September 1938?), [August 30, 1938], Stryker Papers.

76. Broughton to Lee, September 10, 1938, Stryker Papers.

77. Stryker to Lee, November 7, 1938, Stryker Papers.

78. Caption for LC-USF34–031952-D.

79. Jack Temple Kirby, *Rural Worlds Lost: The American South, 1920–1960* (Baton Rouge: Louisiana State University Press, 1987), 77.

80. See United States Department of Agriculture, *Cotton and Cottonseed: Acreage, Yield, Production,*

Disposition, Price and Value by States, Statistical Bulletin No. 164 (Washington, DC: Government Printing Office, 1955), 30. This report specifies the yield per acre as the lint fraction of the cotton boll (typically 35 percent of the total weight) and for 1938 lists 304 pounds per acre.

81. Lewis W. Hine, *Men at Work: Photographic Studies of Modern Men and Machines* (New York: Macmillan, 1932).

82. Shahn quoted in Judith Mara Gutman, *Lewis W. Hine and the American Social Conscience* (New York: Walker and Company, 1967), 42.

83. Raeburn, 170–73, 333n5.

84. See for example, Stryker to Lyle Saxon, July 7, 1938. HS Textual Records, Reel 2, Box 2, General Correspondence.

85. Lee to Clara "Toots" Dean Wakeham, September 12, 1938, Stryker Papers.

86. See Lee to Stryker, September 13, 1938, and September 16, 1938, Stryker Papers.

87. Raeburn, 171.

88. See LC-USF33–011667-M3 and LC-USF33–011616-M4, in the folio between pages 126 and 127 of *Louisiana: A Guide to the State Compiled by the Workers of the Writers' Program of the Works Projects Administration in the State of Louisiana* (New York: Hastings House, 1941).

89. See Appel, "Duplicate File."

90. Caption for LC-USF34–031676-D.

91. See LC-USF34–031686-D. This image appears in the folio between pages 626 and 627 of *Louisiana: A Guide to the State.*

92. Jean Lee, interview by Joan Myers, Austin, Texas, May 16, 1996. Transcript in the collection of Joan Myers, Tesuque, New Mexico.

93. Jean Lee–Joan Myers interview; and Jean Lee, interview by Anne C. McAfee, August 25, 1993, 3. Summary transcript, Lee Collection.

94. Jean Lee–Joan Myers interview.

95. Jean Lee–Anne C. McAfee interview.

96. Lee to Stryker, Wednesday, (1938?), [October 12, 1938], Stryker Papers.

97. Lee to Stryker, Wednesday, (1938?), [October 12, 1938], Stryker Papers.

98. Jean Lee–Joan Myers interview.

99. Lee-Doud interview.

100. *Today, Tomorrow's History.*

101. Jean Lee–Joan Myers interview.

102. Rosskam-Libsohn-Appel interview, 4.

103. For Lee's enthusiasm about his appreciation for Jean's cooking see Lee to Stryker, January 17, 1940, March 10, 1940, and November 27, 1940, Stryker Papers.

104. Rosskam-Libsohn-Appel interview, 18–20.

105. Rosskam-Libsohn-Appel interview, 4.

106. Rosskam-Libsohn-Appel interview, 17–18.

CHAPTER 7. 1939: TEXAS

1. Lee to Stryker, "Sunday," [January 29, 1939], Stryker Papers.

2. Lee to Stryker, Thursday A.M. (1937; February 1(?), 1937; September 1939), [August 31, 1939], Stryker Papers.

3. Paul Vanderbilt characterized Rosskam's critical role on pages 11 and 12 of an undated and untitled manuscript, which begins, "Throughout the reconstruction period . . . ," Vanderbilt Papers.

4. Rosskam-Doud interview.

5. See Baldwin, 198–99.

6. John "Jack" Fischer to Lee, September 17, 1938, Stryker Papers.

7. "Grants 50 Million to Farm Tenants," *New York Times*, July 17, 1940, 37; "$9,500,000 Given for Tenant Loans," *Washington Post*, October 9, 1937, 14.

8. Smith, 373.

9. Smith, 373.

10. Memo to Photographers, January 26, 1939, Vanderbilt Papers.

11. Stryker to Lee, January 20, 1939, Stryker Papers.

12. "Suggestions for Pictures on Mechanized Agriculture, [to] All Photographers" by Roy E. Stryker, [ca. 1939], Stryker Papers. The script bears the erroneous inscription "1940–41?," likely added later.

13. Caption for LC-USF34–032302-D.

14. See Lee to Stryker, February 8, 1939, Stryker Papers.

15. Sloan, 106.

16. Information extrapolated from Matt S. Meier and Feliciano Ribera, *Mexican Americans / American Mexicans: From Conquistadors to Chicanos*, rev. ed. of *The Chicanos*, 1972 (New York: Hill and Wang, 2001).

17. Lee to Stryker, February 8, 1939, Stryker Papers.

18. Lee to Stryker, February 28, 1939, Stryker Papers.

19. Lee to Stryker, February 8, 1939, Stryker Papers.

20. Colleen McDannell, *Picturing Faith: Photography and the Great Depression* (New Haven: Yale University Press, 2004), 43.

21. Hurley, *Russell Lee,* 11.

22. I tracked Burt Lee's multiple changes in residence through Chicago city directories, census records, and his death certificate. See the *Fifteenth Census of the United States: 1930*, State of Illinois, Cook County, Precinct 54, Enumeration District No. 16-1883, Supervisor's District No. 5, Sheet 9A, lines 36 and 37; see also Burton Cook Lee's Death Certificate, State of Illinois, File No. 58274.

23. Information about San Antonio pecan shellers extrapolated from Selden C. Menefee and Orin C. Cassmore (under the supervision of John N. Webb, chief, Social Research section, Division of Research), *The Pecan Shellers of San Antonio: The Problem of Underpaid and Unemployed Mexican Labor* (Washington, DC: Government Printing Office, 1940); and Kenneth P. Walker, "The Pecan Shellers of San Antonio and Mechanization," *Southwestern Historical Quarterly* 69 (July 1965): 44–58.

24. Lee to Stryker, March 14, 1939, Stryker Papers.

25. Stryker to Lee, April 7, 1939, and March 28, 1940, Stryker Papers.

26. Stryker to Lee, April 7, 1939, Stryker Papers.

27. Louise Rosskam, interview by Nicholas Natanson, December 15, 1987. Quoted in Natanson, 144.

28. Stryker to Lee, April 1, 1939, Stryker Papers.

29. Stryker to Lee, March 28, 1940, Stryker Papers.

30. Stryker-FSA photographers conversation, 48.

31. Stryker to Lee, April 7, 1939, Stryker Papers.

32. Stryker-Doud interview.

33. "Suggestions recently made by Robert Lynd for things which should be photographed as American Background," [1936], Stryker Papers.

34. Stryker quoted in Stryker-Doud interview. For these items, see "The Small Town" revised as of May 2, 1939, with cover memos dated October 11, 1939, and October 12, 1939, HS Textual Records, Reel 20, Box 30, Supplemental Reference File for LOT 2237. For the small town myth, see Sheila Webb, "A Pictorial Myth in the Pages of 'Life': Small-Town America as the Ideal Place," *Studies in Popular Culture* 28, no. 3 (April 2006): 35–58.

35. See cover memo for "The Small Town," titled "Suggestions for a Documentary Photographic Study of

the Small Town in America," October 11, 1939, HS Textual Records, Reel 20, Box 30, Supplemental Reference File for LOT 2237.

36. Lee to Stryker, January 14, 1937; Lee to Stryker, Tuesday, (June? 1937; ca. June 30), [June 29, 1937]; Stryker Papers; and Lee to Stryker, Thursday, [November 24, 1938], HS Textual Records, Supplemental Reference File for LOT 1655, Reel 18, Box 25.

37. Lee to Stryker, April 11, 1939, Stryker Papers.

38. Lee to Stryker, April 19, 1939, Stryker Papers.

39. Lee does reveal one person's name in LC-USF34–032888-D.

40. See "The Small Town" revised as of May 2, 1939, with cover memos dated October 11, 1939, and October 12, 1939. Stryker revised his shooting script a week after receiving Lee's San Augustine images. This revised shooting script includes specific details such as "A view looking down on the square on Saturday afternoon . . ." in Section XIII. See also Section IX, 1–14, "The People of the Town and Their Work," which duplicates nearly verbatim the occupations Lee documented in San Augustine.

41. See Mark Adams, "Our Town in East Texas" *Travel* 74, no. 5 (March 1940): 5–10, 43–44.

CHAPTER 8. 1939–1940: MIGRANTS

1. Exact numbers are impossible to ascertain because people migrated multiple times from one state to another and back again. Walter J. Stein, *California and the Dust Bowl Migration* (Westport, CT: Greenwood Press, 1973); James N. Gregory, *American Exodus: The Dust Bowl Migration and Okie Culture in California* (New York: Oxford University Press, 1989); Kevin Starr, *Endangered Dreams: The Great Depression in California* (New York: Oxford University Press, 1996); and Gerald Haslam, *The Other California: The Great Central Valley in Life and Letters* (Reno: University of Nevada Press 1994).

2. Formally known as the Select Committee to Investigate the Interstate Migration of Destitute Citizens and the Select Committee Investigating National Defense Migration, the Tolan Committee's most famous hearings were in February and March 1942 concerning the removal of the Japanese from the Pacific Coast area. The Tolan Committee expressed interest in Lee's Pie Town story and wanted to interview residents Lee photographed. Stryker to Lee, September 7, 1940; Lee to Stryker, September 9, 1940; and Stryker to Lee, September 19, 1940, all Stryker Papers.

3. Franklin D. Roosevelt, "On National Defense" fireside chat #15, delivered from the White House, Sunday, May 26, 1940. Franklin D. Roosevelt Presidential Library and Museum, accessed January 18, 2019, http://docs.fdrlibrary.marist.edu/052640.html.

4. John Steinbeck, *The Grapes of Wrath* (New York: Penguin Books, 1983, first published by Viking Press, 1939), 220.

5. Dorothea Lange and Paul Schuster Taylor, *An American Exodus: A Record of Human Erosion* (New York: Reynal & Hitchcock, 1939).

6. Martin Staples Shockley, "The Reception of *The Grapes of Wrath* in Oklahoma," *American Literature* 15, no. 4 (January 1944): 351–61.

7. Lee to Stryker, April 19, 1939, and May 11, 1939, Stryker Papers.

8. Stryker to Lee, May 17, 1939, Stryker Papers.

9. Lee to Stryker, May 27, 1939, Stryker Papers.

10. Lee to Stryker, June 14, 1939, June 21, 1939, and June 22, 1939, Stryker Papers.

11. Lee to Stryker, July 7, 1939, Stryker Papers.

12. Caption for LC-USF34–033412-D.

13. Caption for LC-USF34–033377-D.

14. Jean Lee, interview by Anne C. McAfee, August 25, 1993, 3. Russell Lee Collection.

15. Lee to Stryker, April 1, 1940, Stryker Papers.

16. Stryker to Lee, January 6, 1940, Stryker Papers.

17. Lee to Stryker, April 1, 1940, Stryker Papers.

18. Appel, "Doris and Russell Lee: A Marriage of Art," 112-13.

19. Lee-Doud interview and Hurley, *Russell Lee,* 20.

20. Lee, "Life on the American Frontier," 48, and Lee to Stryker, Thursday A.M., (1937, September 1939), [August 31, 1939], Stryker Papers.

21. Lee to Stryker, April 20 1940, Stryker Papers.

22. Stryker to Lee, April 22, 1940, Stryker Papers.

23. Kathryn McKee Roberts, *From the Top of the Mountain: Pie Town, New Mexico and Neighbors!* (n.p.: Roger Coffin, 1990). The area Lee generally referred to as Pie Town encompassed multiple communities within a 20-mile radius: Tres Lagunas, Sweazaville (later Omega), Adams Diggins, Sunny Slope, Divide, Mountain View, and Pipe Springs. For most of the settlers, the community center was the village of Pie Town.

24. Lee to Stryker, May 30, 1940, Stryker Papers.

25. Alfred Haworth Jones, "The Search for a Usable Past in the New Deal Era," *American Quarterly* 23, no. 5, (December 1971): 718–19.

26. Captions for LC-USF34–036604-D, LC-USF33–012732-M3, LC-USF34–036669-D, and LC-USF34 –036715-D.

27. Other interested publishers included David Lindsay of *PM* magazine and Ed Stanley, an Associated Press editor and a friend of Stryker. See Clara Dean Wakeham to Lee, August 3, 1940, and August 10, 1940, Stryker Papers.

28. Stott, 191, 193, 251, and 252.

29. See Natanson, 65. Jean's articles are in the HS Textual Records and the Russell Lee Collection.

30. Stryker to Lee, September 19, 1940, Stryker Papers.

31. Stryker to Lee, September 20, 1940, Stryker Papers.

32. Lee to Stryker, September 22, 1940, Stryker Papers.

33. HS Textual Records, Reel 15, Box 22, Supplemental Reference File for LOT 639. This is likely the version Lee sent to Stryker in August 1940. Two other versions are in the Russell Lee Collection.

34. See *U.S. Camera* 4, no. 4 (October 1941): 27–31, 78–79, 82–83.

35. Howard Taubman, "Our Folksongs," *New York Times Magazine*, June 8, 1941.

36. Stryker to Lee, September 19, 1940, Stryker Papers.

37. Edward Stanley, "They Call It Pie Town," *This Week Magazine*, June 1, 1941, 7, 11. For payment to Jean Lee for her article, see Stryker to Jean Lee, August 4, 1941, Stryker Papers.

38. A. D. Coleman, "Mama Don't Take My Kodachrome Away," in *Kodachrome: The American Invention of Our World, 1939–1959*, ed. Els Rijper (New York: Delano Greenidge Editions, 2002), 8.

39. Lee's first known use was in Robstown, Texas, in February 1939; for mention of this image group see Lee to Stryker, March 14, 1939, Stryker Papers. These images no longer exist, probably lost in transit between the field and the File. At the time, because of Kodachrome's complex processing requirements, photographers in the field shipped their exposed color film directly to the only processing depot available, Eastman Kodak's Research Laboratory in New York. Kodak then sent the finished film to the FSA office.

40. Andy Grundberg, "FSA Color Photography: A Forgotten Experiment," *Portfolio: The Magazine of the Fine Arts* 5, no. 4 (July/August 1983): 57.

41. Lemann, xii.

42. Lee to Stryker, September 27, 1940, Stryker Papers.

43. Stryker, "Documentary Photography," 1,372.

44. Stryker to Lee, October 12, 1937, and Lee to Stryker, Tuesday, (1937), [October 19, 1937], Stryker Papers. Lee made the photographs (LC-USF34–030763-D and LC-USF34–030764-D); neither was used in MacLeish's book.

45. Stryker to Rothstein, April 29, 1936, and May 29, 1936, Stryker Papers.

46. Stryker to Rothstein, February 5, 1937, Stryker Papers.

47. Lee, "Flash—Elementary Technic," 1,789.

48. Lee to Stryker, February 10, 1940, Stryker Papers.

49. Stryker to Lee, September 19, 1940, Stryker Papers.

50. Stryker-McDougall-Hurley interview.

51. Arthur Rothstein, "Direction in the Picture Story," *The Complete Photographer: An Encyclopedia of Photography*, ed. Willard D. Morgan, vol. 4. (New York: National Educational Alliance, 1943) 1,359-60, 1,357.

52. Mia Fineman, *Faking It: Manipulated Photography Before Photoshop* (New Haven: Yale University Press and the Metropolitan Museum of Art, 2012); Lori Pauli, ed., *Acting the Part: Photography as Theater* (London: Merrell, 2006); and Michael Köhler, ed., *Constructed Realities: The Art of Stage Photography* (Zurich: Edition Stemmle, 1989/1995).

53. Arthur Rothstein, "The Picture That Became a Campaign Issue," *Popular Photography*, September 1961, 42–43, 79. See also O'Neal, 21.

54. Arthur Rothstein, "Setting the Record Straight," *Camera* 35 (April, 1978): 50–55.

55. For Sekaer's recounting, see Rothstein, "Direction in the Picture Story," 1,360. Post [Wolcott] to Stryker, September 25, 1940, Stryker Papers. For a description of Lange's Migrant Mother series, see Gordon, 237, 239. Evans quoted in Stott, 269. For discussions of Evans and manipulation of the scenes he photographed, see Stott, 267–89, 342n5, and James Curtis, *Mind's Eye, Mind's Truth: FSA Photography Reconsidered* (Philadelphia: Temple University Press, 1989), 21–44. See also William Stott, "Curtis' Aberrant Criticism," *Journal of American History* (December 1990), http://billstott.blogspot.com/2009/01/review-of-minds-eye-minds-truth-fsa.html. Errol Morris ponders manipulation and intervention in FSA photographs, notably the work of Evans and Rothstein, in *Believing is Seeing: Observations on the Mysteries of Photography* (New York: Penguin Press, 2011) and his *New York Times* blog series *The Case of the Inappropriate Alarm Clock*.

56. Stryker-McDougall-Hurley interview.

57. Curtis, *Mind's Eye, Mind's Truth*; Gordon; Hurley, "In and Out of Focus"; and Morris, *Believing Is Seeing*. Many well-known images from the FSA era have now been revealed to be staged photographs. See Ann Thomas, "Modernity and the Staged Photograph, 1900–1965," in *Acting the Part: Photography as Theater*, 126–30; Larry Rohter, "New Doubts Raised Over Famous War Photo," *New York Times*, August 18, 2009, C1; and Bill Marsh, "Faked Photographs: Look, and Then Look Again," *New York Times*, August 22, 2009, WK4.

58. Stryker, "Documentary Photography," 1,372.

59. The Kodachromes are dated October 1940 rather than September 1940 because of Historical Section office practices: Lee photographed the Pie Town Fair in color on September 27 and 28, 1940, then mailed the film to Eastman Kodak in Rochester to have it developed. By the time Eastman sent the film to Washington and the staff recorded it, it was October.

60. Delano quoted in O'Neal, 234.

61. Stryker to Lee, June 1, 1938, Stryker Papers.

62. Lee to Stryker, July 1, 1939, Stryker Papers.

63. See Lee, "Life on the American Frontier," 42. In an amusing twist, the color scheme had less to do with patriotism and more to do with corporate branding: the Standard Oil Company donated red, white,

and blue paint so Pie Town could decorate their buildings in the corporate logo color scheme. See Roberts, *From the Top of the Mountain,* 9.

64. Stryker to Lee, September 20, 1940, Stryker Papers.

65. Grundberg, "FSA Color Photography," 57; and Stein, "FSA Color: The Forgotten Document," 162.

66. Recollections of Alyne (Cox) Myers and R. Claude Holley in Roberts, *From the Top of the Mountain,* 101, 121.

67. Chapter XI, "Early Settler's Stories," in Roberts, *From the Top of the Mountain.*

68. Jonathan Daniels, "I Watched America Awake to War: Boom Town, U.S.A—First Stage," *McCall's Magazine* 68, no. 6 (March 1941): 128.

69. See Goodwin; and Maury Klein, *A Call to Arms: Mobilizing America for World War II* (New York: Bloomsbury, 2013).

70. Stryker to Lee, September 16, 1939, Stryker Papers.

71. Stryker to Delano and Lee, December 13, 1940, Stryker Papers.

72. Stryker to Delano and Lee, December 13, 1940, Stryker Papers.

73. "Special Information for Russell Lee," in Stryker to Delano and Lee, December 13, 1940, Stryker Papers.

74. Stryker to Delano and Lee, December 13, 1940, Stryker Papers.

75. Christine Killory, "Temporary Suburbs: The Lost Opportunity of San Diego's National Defense Housing Projects," and Lucinda Eddy, "War Comes to San Diego," both in the *Journal of San Diego History* 39, nos. 1–2 (Winter-Spring 1993). See also Howard B. Myers, "Defense Migration and Labor Supply," *Journal of the American Statistical Association* 37, no. 217 (March 1942): 69–76.

76. *Hearings Before the Select Committee Investigating the National Defense Migration. Part 12: San Diego Hearings, June 12th, 13th, and 14th, 1941,* 4,824. Quoted in Killory, "Temporary Suburbs."

77. Stryker to Lee, December 26, 1940, Stryker Papers.

78. Daniels, "I Watched America Awake to War," 141.

79. See *Wartime Housing, The Bulletin of the Museum of Modern Art* 4, vol. 9 (May 1942).

CHAPTER 9. 1941: THE WATER PROBLEM

1. Stryker to Lee, March 19, 1940, Stryker Papers.

2. William D. Rowley, *Reclamation: Managing Water in the West; The Bureau of Reclamation: Origins and Growth to 1945* (Denver: US Department of the Interior, Bureau of Reclamation, 2006), 316–19, 367; Eugene C. Buie, *A History of the United Sates Department of Agriculture Water Resource Activities* (Washington, DC: US Department of Agriculture, Soil Conservation Service, September 1979), 16–17.

3. Stryker to Lee, March 19, 1940; Lee to Stryker, April 10, 1940, and April 20, 1940, all Stryker Papers. Lee photographed the Salt River Project in Arizona, the nascent Middle Rio Grande Project in New Mexico, the Boise Project in Idaho, the Vale and Owyhee Projects in Oregon and Idaho, the Columbia Basin Project in Washington, and the Central Valley Project in California. Lee documented three Reclamation dams: Theodore Roosevelt Dam in Arizona, Owyhee Dam in Oregon, and Shasta Dam in California. Lee also photographed the Bonneville Dam on the Columbia River, constructed and maintained by the Army Corps of Engineers.

4. Lee to Stryker, April 10, 1940, Stryker Papers.

5. At the request of Garford Wilkinson in the Amarillo office, Lee photographed the irrigation project at Chamisal and Peñasco, New Mexico, and while there made a notable study of the area's Hispanic communities. See William Wroth, *Russell Lee's FSA Photographs of Chamisal and Penasco* (Santa Fe: Ancient City Press, 1985).

6. Stryker to Delano, April 8, 1941, Delano Papers, Box 2, Folder 5.

7. "Suggested Itinerary for Russell Lee's Pacific Northwest Trip 1941," Stryker Papers (microfilm), NDA Reel 8 in section "Outlines for Photographic Field Work," and Stryker Papers, Series II, Part C, Section 3, Subsection b.

8. See Roll, 105, Goodwin, 238, and "Roosevelt Orders New Draft July 1," *New York Times*, May 27, 1941, 1, 4.

9. Stryker, "Memorandum to All Photographers," May 14, 1941, Delano Papers, Box 2, Folder 6.

10. Stryker to Lee, June 26, 1941, Stryker Papers. See also Stryker's shooting scripts for Russell Lee: "Wheat Harvest—Idaho, Washington, Oregon," undated; "Miscellaneous Notes from Trip with Russell Lee (1940) Through Idaho, Washington, Oregon, California: Suggestions for Future Photographic Work in this Area," March 10, 1941; and "General Suggestions for Pictures in North West," 1941. All Stryker Papers.

11. Smith, 413, 624–26.

12. Smith, 626.

13. Lee to Stryker, July 24, 1941, Stryker Papers.

14. Smith, 626.

15. Lee to Stryker, July 24, 1941, Stryker Papers.

16. "Suggestions for Photographers," [before 1940], which begins with "Well Known American River Valleys," Stryker Papers.

17. "Miscellaneous Notes from Trip with Russell Lee (1940) Through Idaho, Washington, Oregon, California: Suggestions for Future Photographic Work in this Area," undated, Stryker Papers.

18. Captions for LC-USF34–070427-D, LC-USF34–070434-D, LC-USF34–070401-D, and LC-USF34–070312-D.

19. William Dietrich, *Northwest Passage: The Great Columbia River* (New York: Simon & Schuster, 1995), 333–36.

20. Katrine Barber, *Death of Celilo Falls* (Seattle: University of Washington Press, 2005), 30; and Dietrich, *Northwest Passage*, 263.

21. Ivan Bloch, "The Columbia River Salmon Industry," *Reclamation Era* 28, no. 2 (February 1938): 26–30.

22. Barber, *Death of Celilo Falls*, 20-25. It is difficult to identify all the specific tribes who lived, fished, and gathered at Celilo Falls over time and various sources provide different or indeterminate information. See Barber, 21; the Columbia River Inter-Tribal Fish Commission's website, accessed September 2, 2019, https://www.critfc.org/salmon-culture/tribal-salmon-culture/celilo-falls; and James P. Ronda, *Lewis and Clark Among the Indians* (Lincoln: University of Nebraska Press, 2008, originally published 1984), 170.

23. James A. Lichatowich, *Salmon Without Rivers* (Washington, DC: Island Press, 1999), 33–39, and Barber, 38–39, 132.

24. See Barber, *Death of Celilo Falls,* 128–29. Lange photographed Celilo Village for the FSA in October 1939. Prior to flooding the area, the USACE expelled the residents of Celilo Village and moved them to land farther from the river, providing poorly constructed housing and very little infrastructure.

25. Barber, 63.

26. Al M. Rocca, *America's Shasta Dam: A History of Construction, 1936–1945* (Redding, CA: Redding Museum of Art & History, 1994), 48, 52.

27. Rocca, *America's Shasta Dam*; Viola May, J. C. Maguire, Frank T. Crowe. David C. May, T. J. Caufield, and William A. Johnson, *Shasta Dam and Its Builders* (Pacific Contractors, April 1945); and Eric A. Stene, *Shasta Division, Central Valley Project* (Bureau of Reclamation, 1996), https://www.usbr.gov/projects/pdf.php?id=107.

28. Lee to Stryker, October 21, 1941, and November 12, 1941, Stryker Papers.

29. Lee to Stryker, June 14, 1940, and June 20, 1940, Stryker Papers. Lee's concerns about clearances were also rooted in difficulties he'd had getting permission to photograph a Weyerhaeuser sawmill in Longview, Washington, in October 1941. Lee to Stryker, October 21, 1941, Stryker Papers.

30. Lee to Stryker, June 20, 1940, and September 6, 1942, Stryker Papers.

31. Lee-Plattner interview, 16. See also Steven W. Plattner, *Roy Stryker: U.S.A., 1943–1950* (Austin: University of Texas Press, 1983), 23.

32. For schematic drawing of head tower and cable way see Johnson, *Shasta Dam and Its Builders,* 152–53. For distance of river from apex of tower, see "Seven Cableways Hang from 460-Foot Tower," *Popular Mechanics Magazine* 74, no. 3 (September 1940): 335.

33. See Rocca, *America's Shasta Dam,* 81.

34. Lee to Stryker, December 8, 1941, Stryker Papers.

35. See *The Making of a Mural*, PR 13 CN 1996:043, Prints and Photographs Division, Library of Congress.

36. Stryker's scrapbooks include clippings from the *New York Times, Philadelphia Inquirer, Time, Survey Graphic,* and *U.S. Camera*, among others. HS Textual Records, Reel 23, Oversize Box 11.

37. See Lee to Stryker, December 29, 1941, and Stryker to Lee, December 30, 1941, both Stryker Papers.

38. Senator Byrd was joined by Senator Kenneth McKellar of Tennessee and Representative Everett Dirksen of Illinois. In early 1942 the AFBF implied the FSA was attempting to create a political machine by announcing the agency paid poll taxes for many poor farmers in the South, but the poll tax was only one part of the debt the FSA's rural loan programs aimed to alleviate. Author Paul Conkin noted that the high cost of Jersey Homesteads gave Byrd grounds for attacking what he termed the FSA's extravagance, attacks that materially contributed to the abolition of the FSA. See Conkin, 275. See also Hurley, *Portrait of a Decade,* 160–62, and Baldwin, 347–56.

39. Baldwin-Doud interview, 20.

40. Lee to Stryker, December 8, 1941, Stryker Papers.

41. Stryker to Lee, December 13, 1941, Stryker Papers.

42. Baldwin-Doud interview, 20.

CHAPTER 10. 1942: "DEFENSE PLANTS AND SHIPYARDS AND GOD BLESS AMERICA"

1. For the Byrd Committee attack on the FSA and Beanie Baldwin's defense of the agency at hearings, see Baldwin, 319–21, 356-57. See also Baldwin-Doud interview, and Stryker-Doud interview. Stryker also discussed it in his correspondence with photographers. See, for example, Stryker to Rothstein, February 17, 1942, and Stryker to Lee, March 18, 1942, Stryker Papers; and Memo to Photographers, March 3, 1942, Vanderbilt Papers. Page one of this two-page memo is also in the Delano Papers, Box 2, Folder 6.

2. Stryker to Lee, March 18, 1942, Stryker Papers.

3. See Memo to Photographers, March 3, 1942, Vanderbilt Papers.

4. Stryker to Lee, March 18, 1942, Stryker Papers.

5. Stryker to Vachon, March 18, 1942, and Stryker to Lee, March 18, 1942, Stryker Papers. See also Memo to Photographers, March 3, 1942, Vanderbilt Papers.

6. Stryker to Lee, March 18, 1942, Stryker Papers.

7. Stryker to Vachon, March 18, 1942, Stryker Papers.

8. Memo to Photographers, March 3, 1942, Vanderbilt Papers.

9. Section Four of Executive Order 9182 Establishing the Office of War Information, June 13, 1942.

10. Stryker-Doud interview.

11. Gardner "Mike" Cowles Jr., of the Cowles family publishing empire, was appointed assistant director of the news bureau's Domestic Branch and coordinated information from non-military government

agencies. Ed Stanley, who Stryker considered a mentor, left his position at the Associated Press and joined the OWI as chief of the Overseas Publications Bureau. Allan M. Winkler, *The Politics of Propaganda: The Office of War Information 1942–1945* (New Haven: Yale University Press, 1978), 39; and Lester G. Hawkins Jr. and George S. Pettee, "OWI–Organization and Problems," *Public Opinion Quarterly* 7, no. 1 (Spring 1943): 29.

12. Vachon quoted in *Just Before the War*, [6].

13. Lee to Stryker, January 17, 1942, Stryker Papers.

14. Aiken-Wool-Doud interview.

15. Lee to Stryker, January 26, 1942, Stryker Papers.

16. Lee to Stryker, December 29, 1941, Stryker Papers.

17. Stryker to Lee, January 26, 1942, Stryker Papers.

18. Lee to Stryker, December 29, 1941, Stryker Papers.

19. Stryker Memorandum to All Photographers, May 14, 1941, Delano Papers, Box 2, Folder 6.

20. Captions for LC-USF34–073178-D, LC-USF34–073201-D, LC-USF34–073185-D, and LC-USF34–073172-D.

21. [Memo to Photographers] From R. E. Stryker to Russell Lee, Arthur Rothstein, in particular, February 19, 1942, Stryker Papers and the Delano Papers, Box 2, Folder 6. See also Stryker and Wood, 188.

22. Memo to Mr. Sammis, Mr. Stryker, Mr. Gorkin, From C. Hall, "'Food'—Ideas Put Forth at April 17th Conference," April 17, 1942, 3. Stryker Papers, Series II, Part C, Section 3, Subsection b. Comments refer specifically to workers at a Tennessee Valley Authority jobsite.

23. Stan Cohen, *V for Victory: America's Homefront During World War II* (Missoula, MT: Pictorial Histories Publishing Company, Inc., 1999, first published 1991), 104.

24. Office of Price Administration, *Rationing in World War II* (Washington, DC: Government Printing Office, 1946), 2, and Goodwin, 357–58.

25. Frank M. Lee to the Tire Rationing Boards of Lincoln, Nebraska, and Fairfax County, Virginia, May 19, 1942, and Frank M. Lee to James S. Heizer, May 26, 1942, Stryker Papers.

26. Captions for LC-USF34–071443-D and LC-USF34–072184-D.

27. Caption for LC-USW3–008075-E. See also LC-USF33–016222-M2.

28. "Get in the Scrap" brochure, sponsored by the Conservation Division, War Production Board, Washington, DC (1942), 4, 7.

29. Stryker to Lee, March 18, 1942, Stryker Papers.

30. Winkler, *The Politics of Propaganda*, 26, 27.

31. Wallace R. Peck, "San Diego's Parachute Manufacturers: Visionaries and Entrepreneurs," *Journal of San Diego History* 60, no. 3 (Summer 2014): 137.

32. The Pacific Parachute Company exhibit panel, Level 3 (Community Galleries), National Museum of African American History and Culture, September 2016.

33. Stott, 236.

34. Stryker to Lee, March 18, 1942, Stryker Papers. It is unclear if Lee photographed this part of the series: there are no photographs of individuals identified as Swedish or Swedish American by Lee in the File.

35. In 1938–39, the U.S. Office of Education produced a series of radio programs on CBS—*Americans All, Immigrants All*—describing the history of each immigrant group and its contributions to American society. Texts of these broadcasts are available at "Americans All, Immigrants All," accessed January 19, 2018, https://archive.org/stream/americansallimmi00unit/americansallimmi00unit_djvu.txt. In 1940, the U.S. Immigration and Naturalization Service launched a domestic radio show called *I'm an American* and interviewed distinguished naturalized citizens such as novelists, actors, musicians, scientists, and politicians. For more on this program, see "I'm an American: INS's Foray into Radio

Broadcasting," U.S. Citizenship and Immigration Services, last updated February 2, 2016, https://www.uscis.gov/history-and-genealogy/our-history/historians-mailbox/im-american.

36. Caption for LC-USW3–001845-D.
37. Caption for LC-USW3–001884-D.
38. Caption for LC-USW3–001804-D.
39. See Goodwin, 291–92.
40. Maisie and Richard Conrat, *Executive Order 9066: The Internment of 110,000 Japanese Americans* (San Francisco: California Historical Society, 1972); Carey McWilliams, *Prejudice: Japanese Americans, Symbols of Racial Intolerance* (Hamden, CT: Archon Books, 1971, first published 1944).
41. The Japanese American Citizens League has recently campaigned to change terminology related to Executive Order 9066, for example, from "relocation" to "forced removal" and "relocation center" to "American concentration camp," "incarceration camp," or "illegal detention center." See *Power of Words Handbook: A Guide to Language about Japanese Americans in World War II, Understanding Euphemisms and Preferred Terminology* (San Francisco: Japanese American Citizens League, 2013).
42. Fleischhauer and Brannan, 241.
43. Baldwin, 227–28.
44. Caption for LC-USF34–072353-D.
45. See LC-USF34–072392-D.
46. Lee to Stryker, July 28, 1942, Delano Papers, Box 2, Folder 6.
47. Linda Gordon and Gary Y. Okihiro, eds., *Impounded: Dorothea Lange and the Censored Images of the Japanese American Internment* (New York: W. W. Norton, 2006), 20.
48. Winkler, 64.
49. Goodwin, 467.

CHAPTER 11. 1943–1986: REEXAMINATION

1. Beanie Baldwin to Stryker, February 11, 1964, Stryker Papers.
2. Clippings in the Stryker Papers, Series 3, Part A, scrapbook 1938–58.
3. Memo from Paul Vanderbilt to Staff, Prints and Photos Division, July 18, 1947, Vanderbilt Papers. See also Stryker to Delano, November 7, 1947, Delano Papers, Box 3, Folder 1. Vanderbilt was an innovative archivist hired by Stryker in 1942 to reorganize the File. See Mary Jane Appel, "Paul Vanderbilt, Archivist of the File," *Archives of American Art Journal* 54, no. 1 (Spring 2015): 28–29.
4. These included *The Exact Instant* (1949) and *The Family of Man* (1955) at the Museum of Modern Art.
5. Jacob Deschin, "Social Document: F.S.A. Anniversary Show at Brooklyn Museum," *New York Times*, March 6, 1955, X16.
6. University of Louisville professor Robert J. Doherty Jr. curated *USA–FSA*, an exhibit of ninety-two photographs at the Allen R. Hite Art Institute, which ran from January 15 to February 24, 1962. Exhibit checklist is in the Stryker Papers.
7. *The Bitter Years* exhibit catalog, press release, and master checklist are available at https://www.moma.org/calendar/exhibitions/3433, accessed January 24, 2018.
8. Jacob Deschin, "Stryker Exhibit: F.S.A. Photographers' Pictures at Modern," *New York Times*, October 21, 1962, X17.
9. Jean Back, "Vantage Point: 'The Bitter Years' Reconsidered," in *The Bitter Years: Edward Steichen and the Farm Security Administration Photographs*, ed. Francoise Poos (New York: Distributed Art Publishers, 2012), 6.
10. The exhibit, curated by John Szarkowski, featured more than two hundred photographs. Lange biog-

rapher Linda Gordon notes the gossip from MoMA was that Szarkowski had not wanted to do the show but "that Steichen had insisted on it." Szarkowski began working with Lange on image selection in 1964 and the show opened in 1966, three months after Lange died. Gordon, 410 and 515n20.

11. For Lee's recollections on how he joined Lorentz's unit, see Hurley, *Russell Lee*, 21. For Lorentz's recollections, see Pare Lorentz, "Air Transport Command, 1943–1945," *Russell Lee Retrospective Exhibition 1934-1964* (Austin: University Art Museum of the University of Texas, 1965), [8].

12. Hurley, *Russell Lee*, 29.

13. Delano, *Photographic Memories*, 164.

14. The MoMA press release lists only Stryker, Rothstein, and Shahn, but Szarkowski recalls that Delano, Lange, and Lee also attended. Szarkowski, "Foreword," *Russell Lee Photographs*, viii and xiin2.

15. Szarkowski, "Foreword," *Russell Lee Photographs*, viii.

16. Evans-Cummings interview.

17. "Walker Evans, Visiting Artist: A Transcript of his Discussion with the Students of the University of Michigan, 1971," in *Photography: Essays and Images, Illustrated Readings in the History of Photography*, ed. Beaumont Newhall (New York: Museum of Modern Art, 1980), 315.

18. Doud later recalled that Evans was the only photographer who refused a taped interview. Richard Doud, letter to the author, November 3, 2015. Paul Cummings later interviewed Evans for the Archives of American Art in 1971.

19. Lee to Stryker, April 27, 1964, Stryker Papers (microfilm), NDA 8, Grand Central Palace Exhibit section ("Farm Security Exhibit Envelopes A-E").

20. Richard Doud, letter to the author, November 3, 2015.

21. Lange-Doud interview.

22. Checklist and press release of *The Photographer's Eye*, Museum of Modern Art, accessed January 25, 2018, https://www.moma.org/calendar/exhibitions/2567.

23. According to the University of Texas, the exhibit had 269 photographs. See *Russell Lee Photographs*, 24. See also Douglas Chevalier, "Russell Lee's Photo Exhibition Has Air of Honesty, No Trickery," *Washington Post*, October 30, 1965, A4.

24. Lee photographed intermittently after 1965, but those images appear to be personal travel photographs. See Boxes 3Y170-3Y172, Russell Lee Photograph Collection at the Briscoe Center for American History, University of Texas.

25. Russell Lee, "Epilogue," *Retrospective Exhibition 1934–1964*, exh. cat. (Austin: University Art Museum of the University of Texas, 1965), [16].

26. Roy Flukinger, "Russ's Children," *Journal of the Texas Photographic Society* (Summer 1987): 7–8.

27. For Stryker's book proposal and related correspondence, see Stryker Papers, Series II, Part B.

28. Stryker in Stryker-Wood, 9; Nancy Wood, in Stryker-Wood, 17.

29. Stryker in Stryker-Wood, 9.

30. Stryker in Stryker-Wood, 7, 13.

31. Stryker in Stryker-Wood, 14.

32. Stryker in Stryker-Wood, 9.

33. "Glorious Hard Times," *Washington Post*, November 18, 1973.

34. O'Neal, 12.

35. See "Question and Answer with Hank O'Neal," interview by Rachel Peart, Heritage Auctions, accessed January 23, 2018, https://www.ha.com/information/hank-o-neal.s?ic=hero-photographs -hankonealinterview-073013.

36. Gene Thornton, "Photography View: Masterpieces from the Thirties," *New York Times*, October 31, 1976, D29.

37. Hurley, *Russell Lee*, 34.

38. Hurley, *Russell Lee*, 34.

39. Information about the symposium comes from *American Images*; Suzanne Winckler, "A Shutter in Time," *Texas Monthly* 7, no. 4 (April 1979): 173–74; Dana Asbury, "Amarillo Symposium Reunites FSA Photographers," *Afterimage* 6 (March 1979): 4; Hurley, "In and Out of Focus": and my email correspondence and phone interviews with Steve Plattner, Tom Livesay, and David Tuner (the latter two were director and curator of education, respectively, at the Amarillo Art Center and key organizers of the symposium).

40. Werner J. Severin, *Photographic Documentation by the Farm Security Administration 1935–1942*, Thesis, University of Missouri, 1959, and "Cameras with a Purpose: The Photojournalists of the FSA," *Journalism Quarterly* 41, no. 2 (Spring 1964): 191–200.

41. Lee quoted in "FSA Photographers at AMoA: Lee Discusses Photographs of Interiors," accessed February 4, 2018, https://vimeo.com/50514513.

42. *American Images*.

43. *American Images*.

44. Hurley, "In and Out of Focus," 244.

45. *American Images*.

46. David Turner, email to the author, September 11, 2017.

47. Delano and Lee quoted in *American Images*.

48. John Szarkowsi, *Mirrors and Windows: American Photography Since 1960* (Boston: New York Graphic Society, 1978).

49. Hilton Kramer, "The New American Photography," *New York Times Magazine*, July 23, 1978, 8-13, 24, 26, 28; and Jo Ann Lewis, " 'Mirrors and Windows': Photography Out of Focus," *Washington Post*, July 31, 1978, B1, B7.

50. Andy Grundberg, "Currents: American Photography Today," *Modern Photography* 43, no. 1 (January 1979): 114–17, 175–76, 178, 182.

51. John Collier Jr., *Visual Anthropology: Photography as a Research Method* (New York: Holt, Rinehart and Winston, 1967).

52. *American Images*.

53. Asbury, "Amarillo Symposium Reunites FSA Photographers," 4. Lee made a similar remark in Vicki Goldberg, "Propaganda Can Also Tell the Truth," *American Photographer*, December 1978, 18.

54. Lee to Stryker, April 1, 1940, Stryker Papers.

55. Lee to Stryker, June 25, 1939, and June 12, 1941, Stryker Papers. Lee, "Flash—Elementary Technic."

56. See Lee to Delano, March 27, 1979. Delano Papers, Box 3, Folder 1.

57. Evans-Cummings interview.

58. The Photo League of New York marked this postwar shift in 1947 in one of their brochures, redefining its mission as "contributing to the growth of individual artists and to the community." Quoted in Anne Wilkes Tucker, "A Rashomon Reading," in Mason Klein and Catherine Evans, *The Radical Camera: New York's Photo League* (New Haven: Yale University Press, 2011), 77.

59. David L. Shirey, "In Touch with the Have-Nots," *New York Times*, April 8, 1979, LI21.

60. Winckler, "A Shutter in Time," 173.

61. Rosskam, "Not Intended for Framing," 11.

62. See Natanson, 9–16; Hurley, "In and Out of Focus," 245–46; and Raeburn, Chapters 9 and 10, especially 155–66.

63. Stein, 99. Louise Rosskam also shot in color and like her colleagues barely recalled it in later interviews. Katzman and Brannan, 57.

64. "Color Photographs of the Farm Security Administration Exhibition List," LIGHT Gallery Archives, Center for Creative Photography, University of Arizona.

65. For Lee's 1983 lecture, see Dinah Berland, "Russell Lee in the Service of History," *Los Angeles Times*, May 1, 1983.

66. According to the cover, the film "was judged Best Documentary in the Texas Film Festival and was awarded a CINE Golden Eagle, and the National Educational Film Festival Bronze Apple." *Today, Tomorrow's History*.

67. Lee-Mundy raw footage. For "hieroglyph of the American frontier," see Hurley, *Russell Lee*, 20.

68. Jean Lee, interview by Joan Myers, Austin, Texas, May 16, 1996, 6. Transcript in the collection of Joan Myers, Tesuque, New Mexico.

69. Lee-Doud interview.

70. Collier-Doud interview.

71. For example, see Larry Meyer, "Pie Town," in *American Heritage Magazine* 31, no. 2 (February/March 1980): 74–81; Russell Lee, "Pie Town," *Creative Camera* 193/194 (July–August 1980): 246–53; F. Jack Hurley, "Pie Town, New Mexico, 1940," *American Photographer* 10, no. 3 (March 1983): 76–85; Bill Ganzel, *Dust Bowl Descent* (Lincoln: University of Nebraska Press, 1984), 80–87; *Today, Tomorrow's History*; Nancy Wood, "Pie Town," *Heartland, New Mexico* (Albuquerque: University of New Mexico Press, 1989), 51–77; James Curtis, "The Last Frontier," *Mind's Eye, Mind's Truth* (Philadelphia: Temple University Press, 1989), 91–122; *Retracing Russell Lee's Steps: A New Documentary*, a 1991-92 documentary project of photographs, oral history interviews, and exhibit relating to Lee's Pie Town series (as well as his San Augustine series); J. B. Colson, "The Art of the Human Document: Russell Lee in New Mexico," *Far From Main Street: Three Photographers in Depression-Era New Mexico* (Santa Fe: Museum of New Mexico Press, 1994), 2–9; David Margolick, "Easy as Pie? Not in New Mexico Town," *New York Times*, February 13, 1994; Joan Myers, *Pie Town Woman: The Hard Life and Good Times of a New Mexico Homesteader* (Albuquerque: University of New Mexico Press, 2001); Paul Hendrickson, "Savoring Pie Town," *Smithsonian Magazine* 35, no. 11 (February 2005): 6, 72–82; Jerry Thompson, "Bean Farmers and Thunder Mugs: Russell Lee's 1940 Farm Security Administration Photographs and Letters of Pie Town and Catron County," *New Mexico Historical Review* 84 (Fall 2009): 463–520; Stu Cohen, "Russell Lee, Pie Town New Mexico, June 1940," *The Likes of Us: America in the Eyes of the Farm Security Administration* (Boston: David R. Godine, 2009), 124–39; and Arthur Drooker, *Pie Town Revisited* (Albuquerque: University of New Mexico Press, 2015). See also Debbie Grossman's series entitled "My Pie Town," which digitally manipulated Lee's Pie Town photographs. "My Pie Town," accessed February 6, 2018, http://www.debbiegrossman.com/index.php?/projects/my-pie -town/. The Metropolitan Museum of Art included some of Grossman's series in conjunction with the exhibition *Faking It: Manipulated Photography Before Photoshop* in 2012.

72. Lee-Doud interview.

73. Stryker to Lee, October 5, 1937, Stryker Papers.

74. Stryker, quoted in Stryker-Wood, 14.

75. Stryker to Lee, May 25, 1939, Stryker Papers.

76. Lee died of cancer on August 28, 1986.

77. Douglas C. McGill, "Russell Lee, American Photographer, Is Dead," *New York Times*, August 30, 1986, 30.

78. Lemann, xii-xiii.

79. Lange-Doud interview.

IMAGE CREDITS

All images are from the collections of the Library of Congress unless otherwise noted. Negative numbers refer to photographs in the FSA-OWI Collection in the Library's Prints and Photographs Division. Photographs can be located by searching for these numbers in the Library's online catalog at http://www.loc.gov/pictures/collection/fsa/.

1. LC-USF33–011132-M2
2. LC-USZ62–89323
3. LC-USW3–019997-C
4. From the Russell Lee Collection, Courtesy The Wittliff Collections, Alkek Library, Texas State University
5a–b. The Estate of Doris Lee, courtesy D. Wigmore Fine Art, Inc.
6. Photo © Estate of Yasuo Kuniyoshi/Licensed by VAGA, New York, NY. Yasuo Kuniyoshi papers, 1906–2013. Archives of American Art, Smithsonian Institution.
7. Russell Lee Photograph Collection [di_11035], The Dolph Briscoe Center for American History, The University of Texas at Austin
8. Russell Lee Photograph Collection [e_rl_0036], The Dolph Briscoe Center for American History, The University of Texas at Austin
9. Russell Lee Photograph Collection [di_11034], The Dolph Briscoe Center for American History, The University of Texas at Austin
10. LC-USF34–081770-C
11a. LC-USF33–011010-M3
11b. LC-USF33–011015-M3
11c. LC-USF33–011015-M5
11d. LC-USF33–011011-M3
12a. LC-USF33–011022-M3
12b. LC USF33–011022-M2
12c. LC-USF33–011012-M2
13a. LC-USF33–011373-M2

13b. LC-USF33–011372-M1
13c. LC-USF33–011310-M5
13d. LC-USF33–011366-M1
13e. LC-USF33–011623-M5
13f. LC-USF33–012332-M2
13g. LC-USF33–011366-M4
13h. LC-USF33–011372-M4
13i. LC-USF33–011370-M2
14. Roy Stryker Papers, 78.9.1908, Archives and Special Collections, University of Louisville
15. LC-USF33–011122-M1
16. LC-USF33–011129-M4
17. LC-USF33–011121-M1
18. LC-USF33–011081-M1
19. LC-USF33–011073-M4
20. LC-USF34–010063-D
21. LC-USF34–010093-D
22. LC-USF34–010091-D
23. LC-USF34–010124-D
24. LC-USF34–032264-D
25. Roy Stryker Papers, 78.9 Box 6, Series II, Archives and Special Collections, University of Louisville
26. LC-USF341–010193-B
27. LC-USF33–011104-M1
28. LC-USF34–010150-D
29. LC-USF34–010087-D
30. LC-USF341–010435-B
31. LC-USF33–011153-M4
32. LC-USF34–010777-D
33. LC-USF341–010745-B
34. LC-USF33–012569-B-M1
35. LC-USF33–011411-M5
36. LC-USF3301–011290-M2
37. LC-USF33–015559-M5
38a. LC-USF33–015561-M2
38b. LC-USF34–030036-E
39. LC-USF34–030039-E
40. LC-USF34–030584-D
41a. LC-USF33–011352-M1
41b. LC-USF345–007665-ZA
42. LC-USF34–030876-E
43. LC-USF33–011375-M5
44. LC-DIG-ds-01154

45.	Historical Section Textual Records, FSA-OWI Collection, LOT 12024, Prints and Photographs Division
46a.	LC-USF33–011472-M2
46b.	LC-USF33–011502-M2
46c.	LC-USF33–011477-M3
46d.	LC-USF33–011495-M4
46e.	LC-USF33–011477-M2
46f.	LC-USF33–011498-M1
46g.	LC-USF33–011488-M4
46h.	LC-USF33–011488-M3
46i.	LC-USF33–011492-M1
46j.	LC-USF33–011450-M1
46k.	LC-USF33–011497-M3
46l.	LC-USF34–031262-D
47.	LC-USF33–012327-M5
48.	LC-USF34–031245-D
49.	LC-USF33–011418-M2
50a.	LC-USF34–031221
50b.	LC-USF34–031151-D
51.	LC-USF33–005135-M1
52.	LC-USF34–031924-D
53a.	LC-USF33–011617-M4
53b.	LC-USF33–011624-M5
54.	LC-USF33–011752-M1
55.	LC-USF33–012606-M1
56.	LC-USF34–073319-E
57.	LC-USF33–011592-M3
58.	LC-USF33–011661-M2
59.	LC-USF34–031422-D
60.	LC-USF34–032145-D
61.	LC-USF34–035601-D
62.	LC-USF34–032010-D
63.	LC-USF33–012102-M1
64.	LC-USF34–032220-D
65.	LC-USF34–032236-D
66a.	LC-USF34–032681-D
66b.	LC-USF34–032684-D
67.	LC-USF33–011106-M2
68.	LC-USF33–012148-M1
69.	LC-USF34–033044-D
70.	LC-USF34–033992-D
71.	LC-USF34–033417-D
72.	LC-USF35–361

73a.	LC-USF34–036791-D
73b.	LC-USF35–319
73c.	LC-USF34-036826-D
73d.	LC-USF35–322
74.	LC-USF351–328
75.	LC-USF34–038162-D
76.	LC-USF33–013097-M2
77.	LC-USF33–013094-M4
78.	LC-USF34–039620-D
79a.	LC-USF34–039629-D
79b.	LC-USF34–039623-D
80a.	LC-USF34–039985-D
80b.	LC-USF34–070007-D
80c.	LC-USF342–007769-ZA
81.	LC-USF33–013153-M1
82.	LC-USF34–070651-D
83.	LC-USF33–013145-M2
84.	LC-USF33–013222-M2
85.	LC-USF34–071214-D
86.	LC-USF34–024494-D
87.	LC-DIG-ds-11127, John Vachon Papers
88.	LC-USF34–071366-D
89.	LC-USF34–073379-D
90.	LC-USW3-009595-D
91a.	LC-USW3-002938-E
91b.	LC-DIG-fsa-8d20844
92.	LC-USW3-001804-D
93.	LC-USF33–013296-M4
94.	LC-USF34–072334-D
95.	LC-USF34- 072935-E
96.	Roy Stryker Papers, 78.9.1935, Archives and Special Collections, University of Louisville
97.	Roy Stryker Papers, 78.9.1930, Archives and Special Collections, University of Louisville
98.	Photograph by Ave Bonar
99.	LC-USF34–010716-E
100.	LC-USF33–013138-M2

INDEX

Page numbers in *italics* refer to photographs.

AAA (Agricultural Adjustment Administration), 50, 51, 73, 95, 139, 175

abandonment, themes of, 112–13

Abbott, Berenice, 134; *Atget Photographe de Paris,* 58

Abell, Walter, 134

Activity in front of courthouse (Lee), 191–92, *193*

Adamic, Louis, *My America,* 208

Adams, Mark, 194

African Americans: as business owners, 264; at cotton gin, 157–59; as farmers, 144; FSA and racial integration of, 144–46; promotion and reception of portraits of, 150, 152–53; racial discrimination and, 146–47; in Southeast Missouri Farms project, 148–53; violence against, 147–48

Agee, James, *Let Us Now Praise Famous Men,* 56

Agricultural Adjustment Administration (AAA), 50, 51, 73, 95, 139, 175

agriculture: animal-drawn machinery in, 237–38; boom in, 72–73; in California, 257; in Cotton Belt, 155, 157; cotton production cycle project and, 155–59; on cutover land, 110, 112–13; Golden Age of

Agriculture, 25; homesteading and, 205–6, 221, 227; irrigation projects for, 227–28; mechanization of, 175–78, 184, 237, 239; Mexican workers in, 179; pioneer farmer archetype in, 206–7; soil loss and, 104–5; wheat harvest in Washington, 236–39; wind erosion, dust storms, and, 125–31, 196, 197–98. *See also* farm tenancy

Aiken, Charlotte, 59

Air Transport Command, Overseas Technical Unit, 6, 276

Alexander, Will W., 51, 103, 105, 144, 145

Allen, Edgar: family of, *87,* 87–88; home of, *83,* 84, 87–88

Amarillo Art Center, *FSA Photography* symposium of, 287–93

American Artists' Congress, 44

American Economic Life and the Means of Its Improvement (Tugwell), 49

American Exodus, An (Lange and Taylor), 197

American Guide Series (WPA), 159–64

American Heritage Magazine, 294

Americans, The (Frank), 213

Americans All, Immigrants All, 340n35

American Scene, 36, 65, *66*, 67

Anderson, Bergit, 123

Anderson, Malina, 25

Anderson, Sherwood, *Home Town*, 194

animals, machinery drawn by, 237–38

architecture, functional rural, 142, *143*

Army Corps of Engineers (USACE), 241–42, 244, 288, 337n3

Artists Union, 31

Art Students League, 34–35

Astoria, Oregon, 239

Atget, Eugène, 58, 115, 133

Atget Photographe de Paris (Abbott), 58

Auction, Woodstock (Lee), *42*, 42–43, 202

Baldwin, Calvin Benhan "Beanie," 51, 58, 145, 252, 277

Baldwin, Sidney, 268

Bankhead, John H., II, 73

Bankhead-Jones. *See* Farm Tenant Act of 1937

Barber, Katrine, *Death of Celilo Falls,* 244

Barber poles, 1937–39 (Lee), *66,* 67

Barn and silo on H. H. Tripp farm (Lee), 101, *102*

Baxandall, Michael, 23

Bennett, Hugh Hammond, 104–5, 131

Bing, Joseph M., 134–35

Bitter Years 1935–1941, The, exhibition (MoMA), 278–80, *280, 281*–82

Black Sunday dust storm, 125–26

Blanch, Arnold, 29–30, 36, 44–45, 68, 134, 204

Blatent Image/Silver Eye gallery, xi

Bloch, Ivan, 242

Bonar, Ave, *287*

Bonneville Dam, 241–42

Bonneville Dam and fish ladders (Lee), *242,* 242

boomtowns, 223–26, 246

bootleg mining industry, 2, 40, 59

Bowen, Catherine Drinker, 21

Boys' tug of war (Lee), 131, *232,* 232

Brady, Mathew, 133

"bread-and-butter jobs," 153–59

Breaking virgin soil with tractor and plow (Lee), 177, *178*

Bristol, Horace, 198

Bromfield, Louis, 29

Brook, Alec, 30

Brooklyn Museum, *Farm Security Administration Photography* exhibition, 278

Brooks, Van Wyck, 36

Brown, Benjamin, 61

Brundage, Louisa Reddington Pope, 26

Bubley, Esther, 280, *281*

Bulliet, C. J., 37

Bureau of Chemistry and Soils, 153, 154–55

Bureau of Reclamation: Columbia River and, 239–45; overview of projects of, 227–28; Shasta Dam and, 246–49; Vale and Owyhee projects of, 229–35

Burlin, Paul, 30, 44

Buttermilk Junction (Lee), 67, *298*

Byrd, Harry F., 252

California: agriculture in, 257; defense industry boom in, 222–26; Lake Muroc in, 262–63; migration to, 196–97; Portuguese communities in, 265–67; San Diego, 222–23, 224–26; San Francisco, 29–30; Shasta Dam in, 246–49, 274–76

cameras: flash photography with, 85–93, 216; Lee on, 324n37; Leica, 38, 52, 118, 133, 134; medium format, 38, 84, 86; Rolleiflex, 93; 35mm Contax, 38, 63, 86, 90, 93

Cantrell, Charles and Josephine, 165

captions: editing of, 98–100; publishers changing, 164; written by Lee, 321n29

Carman, Harry, 50

Carter, John Franklin, 53

Carter, Paul, 54

Cassmore, Orin, 186

Caterpillar-drawn combine working in the wheat fields (Lee), 237, *238*

Caudill, Doris and Faro, 215, 294

Caufield, John, 187

CCC (Civilian Conservation Corps), 105, 106, 110

Celilo Falls, 243–45

Chase, Stuart, 144, 147–48

chemical engineering, training in, 21–22

chemurgy, 154–55

children: effect of dust and drought on, 129; in internment camps, 271–73; photographs of, 78–79, 87–89, 90, 131

Children of Mexican labor contractor in their home (Lee), 131, 181, *182*, 215

Children's shoes and clothes (Lee), *78*, 78–79, 131, 215

Christmas dinner in home of Earl Pauley (Lee), 88–91, *89*, 97, 123, 131, 136

Circus day (Lee), 67, 161, *163*

Civilian Conservation Corps (CCC), 105, 106, 110

COI (Office of the Coordinator of Information), 253–54, 255, 263

Cold drinks on Fourth of July (Lee), 202, *231*, 231

Coleman, A. D., 211

Collier, John, Jr., *53, 238, 287*; at FSA, 2; on mirror/window analogy, 290; on project progress photographs, 138; on repetitive publication of photographs, 296–97; at symposium, 287, 288

Collins, George, 47, 48

color images: dating of, 336n59; first use of, 210–12, 335n39; lack of press outlet for, 220–21; National Defense focus and, 219–20; in Pie Town series, 212–15, 218, 294; as recreations of black and white images, 213–15, 219; "rediscovery" of, xi, 294

Columbia River, 239–45

Columbia River Packing Association, 240–41

Conkin, Paul, 142, 144, 339n38

Cooperative garment factory (Lee), *60, 63*, 142

Corn Belt, 75

Corpus Christi, Texas, 226

cotton production cycle project, 155–59

Couple on New York City sidewalk (Lee), *43*, 44

Cowles, Gardner, Jr. "Mike," 339n11

Craigville, Minnesota, 122–25

Cramer, Konrad, 38

crop speculation, 72

crowd in front of an itinerant photographer's tent, A (Lee), 67, 161–62, *164*

Crystal City, Texas, 178, 179, 180

Culver Military Academy, 15, 17–19

cutover farming, documentation of, 110, 112–13, 120–22

Dalles Dam, 244–45

dams: in California, 246–49, 274–76; on Columbia River, 241–42, 244–45; Owyhee, 229, 230; public works jobs and, 228

Daniel, Constance E. H., 147

Daniels, Jonathan, 226

darkroom equipment, 65, 87

Daston, Lorraine, 23

Daughters of John Scott (Lee), 97, *98*, 131, 136

Daumier, Honoré, 34–35

Davis, Marian, 283

Davis, Stuart, 30

Defense Bond mural, 236–37, *238*, 249, *251*, 251

defense industry boom, 197, 222–26, 246–47

Delano, Jack, *281, 287*; *The Bitter Years 1935–1941* exhibition and, 280, 281; caricature of Lee by, *92*, 93; at FSA, 2; letter from Lee to Stryker and, 269, 270–71; on manipulation of scenes, 218; on philosophy of Lee, 58; at symposium, 287, 288, 289

Deschin, Jacob, 278

Des Moines Register, photographs in, 97–101

DeWitt, John L., 268

Dietrich, William, *Northwest Passage,* 241

disciplinary eye, 23

Dixon, Royden, 65

documentary style/approach: conventions for, 204–5; as eliciting emotion, 54, 79; FSA photographers later questioned about, 289; as immersion in experience, 90–91; Lee and, 39–45, 298, 299; overview of, 5; posed, staged, reenacted, and manipulated scenes for, 213, 215–18; scientific method and, 24; truth in, 56–57; as victimizing subjects, 100

"Documents of America" exhibition (MoMA), 135

Donovan, William J. "Wild Bill," 253

Doud, Richard, 282–83, 296

Dust storm near Williston, North Dakota (Lee), 127, *128*

dust storms, 125–31, 196, 197–98

Edie, Stuart, 30, 44

Eggs, Sonoma County (Lee), 257, *258*

Eight, The, 29, 30

Enlarged Homestead Act of 1909, 205

enlargements, viewing, 114

Erickson, George, 26, 94

Europe, trips to, 14–15, 29

evacuation of Japanese-Americans from West Coast areas, The (Lee), *271,* 271–72

Evans, Walker: on *The Bitter Years* exhibit, 281; Daumier and, 35; on Grand Central Palace exhibit, 135; Hale County series, 56; *Let Us Now Praise Famous Men,* 56; manipulation of scenes by, 217; name recognition of, 3; at RA/FSA, 2, 292; Stryker and, 54, 64

Executive Order 9066, 267–68, 341n40. *See also* Japanese Americans

extension flash, 86

Fair Labor Standards Act, 184

Family of Glen Cook (Lee), *77,* 77–78, 97, 215, 298

family photographs, displays of, xii, 181, 183, 207

Farm children playing on homemade merry-go-round (Lee), 129–31, *130,* 232–33

Farm Security Administration (FSA): criticism of/opposition to, 251–52, 277–78, 339n38; funding for, 132; Japanese Americans and, 268, 270–71; mechanization of agriculture and, 175–76; optimistic images requested by, 171, 186–87; origins of, 2; projects of, *137;* racial integration by, 144–46; RA renamed as, 102; regional offices of, 136, 138, 152; reshaping of meaning of photographs by, 124–25; social reform significance of, 288–89. *See also* Historical Section; Resettlement Administration; *specific projects*

Farm Security Administration–Office of War Information (FSA-OWI): collection of, xii–xiii, 277–78; creation of, 254–55; dissatisfaction of photographers working for, 274; Kodachrome technology use in, 210–11; Lee departure from, 6–7

farm tenancy: AAA and, 73; agricultural boom and, 72–73; assignment to photograph, 74–81, 103; controversy over photographs of, in Iowa, 98–100; domestic interiors and, 80–85; exteriors and, 76–80; flash photography and documentation of, 85–93; in Illinois, 93–94; Lee's income from, 8, 24–25, 95, 100–101; media attention to, 73; in Oklahoma, 200–201; Roosevelt and, 73–74; sharecropping compared to, 71–72

Farm Tenancy: Report of the President's Committee, 101

Farm Tenant Act of 1937 (Bankhead-Jones), 70, 73-75, 97, 101, 102; Tenant Purchase Program of, 172–76

Federal Writers' Project (FWP), 159

feedback on FSA photographs, 134

Ferry Hall finishing school, 10, 28

fieldwork and car trouble, 118–19, *119,* 199, 260

File, The, 2, 5, *53,* 277–78

Filling station and garage at Pie Town (Lee), 219, *220*

First International Photographic Exposition (Grand Central Palace), 133–36

FIS (Foreign Information Service), 263–65

Fischer, Jack, 173

flash photography, 85–93, 216

Flukinger, Roy, 284

foreclosures, 26–27

Foreign Information Service (FIS), 263–65

Frank, Robert, *The Americans,* 213

FSA. *See* Farm Security Administration

FSA-OWI. *See* Farm Security Administration–Office of War Information

FWP (Federal Writers' Project), 159

Galison, Peter, 23

Ganso, Emil, 30, 38

Ganzel, Bill, *Dust Bowl Descent,* 295

Garments hanging near telephone (Lee), *81,* 81

Geddes, Virgil, 159, 161

Girl [Jean Smith Martin] *in back room of barroom* (Lee), *167,* 167, 215

Golden Age of Agriculture, 25

Goldstein, Philip, *60*

Goodhue, Ruth, 188

Goodwin, Doris Kearns, 144, 274

Gordon, Colin, 147

Gordon, Linda, 64

Gorky, Arshile, 30

Grace, Eugene G., 21

grain elevators, 25, 95–97, *96*

Grand Central Palace, First International Photographic Exposition at, 133–36

Grand Central Terminal, Defense Bond mural for, 236–37, *238, 249, 251,* 251

Grapes of Wrath, The (Steinbeck), 198–99

Great Depression: back-to-the-land movement of, 61; documentation of, 40–45, *41, 42, 43;* Steinbeck and, 198; Tugwell on, 50. *See also* New Deal; Roosevelt, Franklin Delano

Great Lakes States, cutover documentation in, 110, 112

Greenwich Village, studio with Doris Lee in, 30–32

Grundberg, Andy, 211–12, 290, 294

Gushen, Louis, *60*

Hair tonic salesman advertising his wares (Lee), *62,* 63–64

Hale, Mrs., Lee visit with, 120–22

hands of Mrs. Andrew Ostermeyer, The (Lee), *79,* 79, 97, 136, 215

"Hanging Tree," The (Lee), 147, *148*

health issues. *See* medical issues

Henri, Robert, 30

Herbrandson, J. E., 81

Hindle, Brooke, 23–24

Hine, Lewis, 48–49, 64, 85–86; *Men at Work,* 157

Historical Section: abolishment of, 255, 276; "American Background" photographs of, 58; budget problems of, 132, 177; concerns about future of, 252; controversy over, 56–57; creation of, 52–53; exhibitions of photographs of, xi, 45, 133–36, 278–82; hiring of Lee for, 59, 64–65; locations of, 45, 52, 59; mission of, 52–53; photographers of, 54–56, 64–65, 136, 153–54; posed, staged, reenacted, and manipulated scenes for, 213, 215–18; print distribution of, 56–57, 67, 97–98, 150, 152, 194, 207, 296–97; support staff of, 56. *See also* File, The; Stryker, Roy Emerson; *specific photographers*

Hofmann, Hans, 30

Holley, Donald, 144

home front: documentation of activities on, 256–63; problems dividing, 276

Homestead Act of 1862, 205

homesteading, 205–6, 221, 227

Home Town (Anderson and E. Rosskam), 194

Hoover, Herbert, 21, 50

House erection at Southeast Missouri Farms
 Project (Lee), 67, 142, *143*

housing construction at Southeast Missouri
 Farms, 141–42, *143, 144*

Hull, Horace, 19–20

Hurley, F. Jack: on images in nongovernment
 publication, 56; on Pie Town, 294, 296;
 Portrait of a Decade, 284; *Russell Lee:
 Photographer,* 286; at symposium, 287, 288

Hurley, Wisconsin, 122

Illinois: farm tenancy in, 93–94; Ferry Hall, 10;
 LaSalle County, 24, 26; Ottawa, 9–10

Imber, Sam, *60*

immigrants from neutral countries, 265–67

Independence Day in Vale, Oregon, 230,
 231–35

Indians fishing for salmon (Lee), 244, *245*

informant narrative style, 34, 208

internment camps for Japanese Americans,
 267–68, 269–72, 274

Iowa, farm tenancy in: controversy over
 photographs of, 98–100; exteriors, 76–80;
 flash photography and, 85–93; interiors,
 80–85

Japanese Americans, 267–72, 274

Japanese family arriving at the center (Lee),
 271–72, *273*

Javitz, Romana, 58, 103

Jersey Homesteads project, 59, *60,* 61, 63, 65,
 139, 141, 339n38

Johnson, Carol, xiii

Jones, Alfred Haworth, 206–7

Jones, Joe, 30, 44–45

Jones, Marvin, 73

Jordan, Burton, 24

Jung, Theodore, 54

Katzman, Laura, 32

Kazin, Alfred, 57

Kellogg, Paul, 48, 49

Kitchen of tenant purchase client (Lee), 138, *173,*
 173–74

kitchen series, 173–74

Kodachrome, 210–11, 212. *See also* color images

Kramer, Florence, 129–30, *130*

Kramer, Joe, 232

Kuniyoshi, Yasuo, 30, 38–39, *39,* 44

labor, photographs related to, 40–41, 155–59, 249

labor organizations, 200

La Forge Project. *See* Southeast Missouri Farms
 project

Lake Muroc (Edwards Air Force Base), 262–63

land misuse: documentation of, 105; dust storms
 and, 104, 125–31, 196; logging and cutover
 farming, 104, 110, 112–13, 120–22; Ohio
 River Flood and, 106–9

Land of the Free (MacLeish), 216

Lange, Dorothea: *The Bitter Years 1935–1941*
 exhibition and, 279, 281; in California, 197;
 Celilo Village and, 338n24; on flash gun of
 Lee, 85; at FSA, 2; internment camps and,
 272; on Lee, 283, 301; *Migrant Mother,* 56,
 99; migrant series of, 126, 217; MoMA
 retrospective exhibition of, 341n10; name
 recognition of, 3; in Oregon, 229–30;
 Stryker and, 54, 64, 65

LaSalle County, Illinois, 24, 26

Laurel, Mississippi, 154–55

Lawson, Ernest, 29

Leatherman, Pete, *214,* 215

Lee, Adele Werner, 10–14

Lee, Burton Cook, 10–12, 14, 17, 183

Lee, Doris Emrick: at American Artists' Congress,
 44; education of, 28–29; experimental portrait
 of, *31;* marriage of, 68, 204; as painter, 29,
 36–37; papers of, xiv; *Thanksgiving,* 36–37,
 44; visits to field by, 108–9, 167–68

Lee, Jean: Pie Town and, 207, 210, 296; as writer, 208–9. *See also* Martin, Dorothy Jean Smith

Lee, Russell Werner, *3, 69, 119, 120, 133, 256, 280, 281, 287*; after WWII, 280; as artist, 3–4, 5–6, 67–68, 291; birth and early life of, 9, 12; characteristics of, 8, 19, 65, 75, 120–22, 286; on creative growth of photography, 290–92; death of, 299; Delano caricature of, *92,* 93; education of, 15, 17–19, 20–23; experimental portrait of, *31*; farewell card for, 6–7, *7*; farms owned by and tenants of, 16, 18, 24–27, 29, 74, 93–95, 101; hiring out of, 153, *154,* 154; introduction to photography of, 38–39; Kuniyoshi portrait of, *39*; legacy of, 297, 299, 301; life on road of, 109, 118–19, *119*; marriages of, 29, 68, 167–68, 170, 203–4; methods of observation of, 23–24; military service of, 6, 276; mistaken for spy, 247; Mundy interview of, 295–96; O'Neal and, 286; as painter, 29, 37–38; photographic approach of, 9; resignation from OWI of, 255; Stryker and, 2–3, 68–69, 75, 109, 280, 283–84, 297, 299; Stryker on, xiv, 120–22, 285; on working method and flash technique, 90

Lee, Russell Werner, works of: *Activity in front of courthouse,* 191–92, *193*; American Scene iconography, 65, *66,* 67; in art museum exhibitions, 291; *Auction, Woodstock, 42,* 42–43, 202; Barber poles, 1937–39, *66,* 67; *Barn and silo on H. H. Tripp farm,* 101, *102*; *Bonneville Dam and fish ladders, 242,* 242; *Boys' tug of war,* 131, *232,* 232; *Breaking virgin soil with tractor and plow,* 177, *178*; *Buttermilk Junction,* 67, *298*; captions written by, 321n29; *Caterpillar-drawn combine working in the wheat fields,* 237, *238*; *Children of Mexican labor contractor in their home,* 131, 181, *182,* 215; *Children's shoes and clothes, 78,* 78–79, 131, 215; *Christmas dinner in home of Earl Pauley,*

88–91, *89,* 97, 123, 131, 136; *Circus day,* 67, 161, *163*; *Cold drinks on Fourth of July,* 202, 231; Cooperative garment factory, *60,* 63, 142; *Couple on New York City sidewalk, 43,* 44; *A crowd in front of an itinerant photographer's tent,* 67, 161–62, *164*; *Daughters of John Scott,* 97, *98,* 131, 136; *Dust storm near Williston, North Dakota,* 127, *128*; *Eggs, Sonoma County, 257, 258*; *The evacuation of Japanese-Americans from West Coast areas, 271,* 271–72; *Family of Glen Cook, 77,* 77–78, 97, 215, 298; *Farm children playing on homemade merry-go-round,* 129–31, *130,* 232–33; *Filling station and garage at Pie Town,* 219, *220*; Garments hanging near telephone, *81,* 81; *Girl* [Jean Smith Martin] *in back room of barroom, 167,* 167, 215; *Hair tonic salesman advertising his wares, 62,* 63–64; *The hands of Mrs. Andrew Ostermeyer, 79, 79,* 97, 136, 215; *The "Hanging Tree", 147, 148*; House erection at Southeast Missouri Farms Project, 67, 142, *143*; *Indians fishing for salmon, 244, 245*; *Japanese family arriving at the center,* 271–72, *273*; *Kitchen of tenant purchase client,* 138, *173,* 173–74; Lieutenant of interceptor squadron, *263,* 263; *Little girls getting tickets for the merry-go-round, 233, 234; Looking from main tower . . . Shasta Dam,* 247, *248,* 249, 274; lumberjacks using peaveys, *120,* 120; *Lumberjack with bandaged head,* 124–25, *125,* 215; *Malheur National Forest,* 257–58, *259*; *Man looking through penny peep show, 160,* 161; *Mexican grave, 180,* 180–81; *Mexican pecan shellers, 184,* 185; *Migrant worker looking through the back window of automobile,* 131, 202–3, *203*; *Milk cans and store,* 65, *118,* 118; *Mother and child, FSA clients, 149,* 149; Mr. and Mrs. Jack Whinery and their five children, *214,* 215;

Lee, Russell Werner, works of (*continued*): *Mr. H. Ormand . . . a leading jeweler,* 265, *266,* 267; *Mr. Leatherman shoots a chickenhawk,* *214,* 215; *Mrs. Hale and her oldest son,* 120–22, *121; Negro drinking at "Colored" water cooler,* 146, *147; Negro worker at cotton gin,* 157, *158,* 159; *Old-style wooden windmill in farmyard,* 93–94, *94; One of Edgar Allen's children sitting on the bed, 87,* 87–88, 131; *An organ deposited by the flood,* 106–7, *107,* 174; "Payday in a Lumber Town" series, 123; *Piano with photograph and mementos, 80,* 81, 181; Pie Town, New Mexico, series of, xiii, xiv–xv; *Preacher reading the lesson,* 190, *191; Putting steel straps in place to hold pressed cotton,* 157, *158; Quarters of the foreman of the logging camp, 111;* Repairing army interceptor plane, 262–63, *263; Ride at the carnival,* 233, *235,* 235; *Roadhouse, 166,* 166–67; *Sailors watching construction work,* 274, *275,* 298; *Saturday night in a saloon,* xiii, 123–24, *124,* 136, 174; *Saying grace before the barbecue dinner,* xi, *212,* 212–13, 294; *Scrap salvage, 261,* 261; *Secondhand tires displayed for sale,* 67, 174, *175;* series of photographs, 67; *Sharecropper's child combing hair,* 131, 150, *151,* 152, 153, 202; *Signboard on land near Iron River,* 112, *113; Sign on store window in Yakima,* 202, *300,* 301; *Sign painter, viii,* 65, 202; *Signs in cooperative elevator, 96,* 96–97, 202; *Soda jerker flipping ice cream, 91,* 92; *Son of sharecropper combing hair,* 131, 150, *151,* 152, 153, 202; at Southwest Texas University, xiii; *Spectators at a side show,* 161, *162; Spools of cotton thread,* 155, *156; Store window, Connecticut Avenue, Washington, D.C., 117,* 117; *Store window in farmer's marketing section of Muskogee, 116,* 117; *Street scene, Spencer, Iowa, 189,* 190; *Tenant purchase clients at home,* xiii, 138, 174, *176; Tent home of family living in community camp,* 201, 225, 233; *Unemployed, New York City,* 40–41, *41;* Unloading boxes of salmon from fishing boat, *240,* 240; *Washstand in corner of kitchen, 83,* 84; *Washstand in house, 82,* 84; "*We're living in a tent,*" 224–25, *225,* 233; *Woman flood refugee in schoolhouse, 108,* 108; *Workman at Shasta Dam reads war extra,* 249, *250*

Lehigh University, 20–23

Lemann, Nicholas, 213, 299, 301

Let Us Now Praise Famous Men (Agee and Evans), 56

Library of Congress, transfer of photographs to, 277

Libsohn, Sol, 169

Lieutenant of interceptor squadron (Lee), *263,* 263

LIGHT Gallery of New York exhibit, 294

Little girls getting tickets for the merry-go-round (Lee), 233, *234*

Locke, Ed, 57, 59

Logan, Mrs. Frank G., 37, 44

logging industry, 110–14, 118, 120, 122–25, 258–59

Looking from main tower . . . Shasta Dam (Lee), 247, *248,* 249, 274

Lorentz, Pare: Lee and, 283; *McCall's* and, 222–23, 226; military service of, 276; *The Plow That Broke the Plains,* 106, 114, 126, 280–81; *The River,* 106, 114, 280–81; Stryker and, 270

Louisiana: *American Guide Series* photographs in, 159–62; Transylvania Farms project in, 145

lumberjacks and lumber towns, 122–25

lumberjacks using peaveys (Lee), *120,* 120

Lumberjack with bandaged head (Lee), 124–25, *125,* 215

Lundquist, Lucille, 30, 44

Lynd, Helen, 49

Lynd, Helen, *Middletown,* 188

Lynd, Robert, *Middletown,* 49, 188

machine-human interaction, interest in, 155

MacLeish, Archibald, *Land of the Free,* 216

Madsen, Harry, home of, *82, 84*

Malheur National Forest (Lee), 257–58, *259*

Maloney, Tom, 209

Man looking through penny peep show (Lee), *160,* 161

Martin, Dorothy Jean Smith, 165–70, 203–4. *See also* Lee, Jean

Martin, George, 165

Marville, Charles, 58

McCall's boomtown project, 222–26

McCausland, Elizabeth, 134

McDannell, Colleen, 181

mechanization of agriculture, 175–78, 179, 184-85, 237-38

medical issues: from dust and drought, 129; of farm tenants in Oklahoma, 200; hookworm, 190; of Lee, 179–80; of Mexican migrants, 179, 180; of Missouri sharecroppers, 140; from shelling pecans, 185

Men at Work (Hine), 157

Mercey, Arch, 99–100

Metropolitan Museum of Art, 4

Mexican and Mexican American communities in Rio Grande Valley, 179–88

Mexican grave (Lee), *180,* 180–81

Mexican pecan shellers (Lee), *184*

Mexican women pecan shellers at work (Lee), *185*

Middletown (R. Lynd and H. Lynd), 49, 188

Migrant Mother (Lange), 56, 99

migrants: defense industry jobs and, 222; farm tenants as, 72; as heading west, 196, 199, 206; in Oklahoma, documentation of, 197–203. *See also* Pie Town, New Mexico

Migrant worker looking through the back window of automobile (Lee), 131, 202–3, *203*

military preparedness, 262–63

Milk cans and store (Lee), 65, *118,* 118

Miller, Kenneth Hayes, 30

Milligan, Ella Fitch, 11, 12, 13, 14–15

Mirrors and Windows exhibition (MoMA), 290

mirror/window analogy, 290, 301

Missouri: Scott County, 108; segregation and lynching in, 147–48; sharecropping in, 139–40. *See also* Southeast Missouri Farms project

Missouri Photo Workshop, 280

Modern Photography, xi, 290, 294

Monroe, Gerald M., 31, 32

Morgan, Barbara, 283

Morgan, Willard, 133, 134–35, 280

Mother and child, FSA clients (Lee), *149,* 149

Mr. and Mrs. Jack Whinery and their five children (Lee), *214, 215*

Mr. H. Ormand . . . a leading jeweler (Lee), 265, *266, 267*

Mr. Leatherman shoots a chickenhawk (Lee), *214,* 215

Mrs. Hale and her oldest son (Lee), 120–22, *121*

Mundy, Ann, *Today, Tomorrow's History: Photographer Russell Lee,* 295

Murrow, Edward R., 219

Museum of Modern Art (MoMA): *The Bitter Years 1935–1941* exhibition of, 278–80, *280,* 281–82; as collector of Lee photographs, 4; "Documents of America" exhibition of, 135; FSA images in exhibits of, 329n17; *Mirrors and Windows* exhibition of, 290; *The Photographer's Eye* exhibition of, 283, 291; *Photography 1839–1937* exhibition of, 329n17; *Three Centuries of American Art* exhibition of, 329n17; *War Time Housing* exhibition of, 226

Mydans, Carl, 2, 55, 59, 134

Myre, Martin, 93, 317n62

Myre, Sina, 93

National Defense: boom in industry related to, 197, 222–26, 246–47; Defense Bond mural, 236–37, *238,* 249, *251,* 251; FSA and, 223–26, 228–29, 236–37, 254, 260; publishers' interest in, 209, 210, 219; Roosevelt fireside chat on, 197, 219; Shasta Dam and, 246–47; status of, in July 1941, 230

Native Americans and Celilo Falls, 243–45, 338n22

negatives: inspection of, 114; "killed," 114–15, 321n39, 327n32

Negro drinking at "Colored" water cooler (Lee), *146,* 147

Negro worker at cotton gin (Lee), 157, *158,* 159

New Deal: communities of, 139; faith in, 68; implementation of, 50; Jersey Homesteads project, 59, *60,* 61, 63, 65, 139, 141; photographers on work during, 288–89; Stryker on, 285. *See also specific agencies*

Newhall, Beaumont, *133,* 329n17

Newport Harbor Art Museum, *Just Before the War* exhibition of, 284

New York Public Library Picture Collection, 58

New York Times Magazine, 210

New York World's Fair of 1939, 193

North America (J. R. Smith), 49, 75, 175

Northern Great Plains, as origin of dust storms, 127

notebooks, keeping of, 23, 94–95

objects in homes, documentation of, 80–85

observation, methods of, 22

Office of the Coordinator of Information (COI), 253–54, 255, 263

Office of War Information (OWI), 276; creation of, 254–55; dissatisfaction of photographers working for, 274; Lee departure from, 6–7, *7*

Ohio River Flood, 106–9

Oklahoma, documentation of migrants in, 197–203

Old-style wooden windmill in farmyard (Lee), 93–94, *94*

O'Neal, Hank, *A Vision Shared,* 286

One of Edgar Allen's children sitting on the bed (Lee), *87,* 87–88, 131

Oregon: logging operations in, 258–59; portraits taken in, 259–60; Vale, 229–35

organ deposited by the flood, An (Lee), 106–7, *107,* 174

Ormand, H., 265, *266,* 267

Ostermeyer, Andrew, 79

Ottawa, Illinois, 9–10, 16

OWI. *See* Office of War Information

Owyhee Dam, 229–30

Pacific Parachute Company, 264

Paderewski, Ignacy, 12

Park, Willard Z., 199

Parks, Gordon, 2, 280

participant-observation method, 47

Pauley, Earl, home of, 88–89

pecan-shelling industry, 183–87

Peck, Wallace R., 264

period eye, 23

Photographer's Eye, The, exhibition (MoMA), 283, 291

Photography 1839–1937 exhibition (MoMA), 329n17

"Photography with a Purpose" lecture (Lee), 295

Photo League of New York, 291

PHS (Public Health Service), 153, 154, 179–80

Piano with photograph and mementos (Lee), *80,* 81, 181

Pictorial Sourcebook of American Agricultural History (R. Stryker), 50–51

Pie Town, New Mexico: color images of, 212–15, 218, 294; discovery of, 205; documentation of, xiii, xiv–xv, 207–8; focus on images from, 294–97, 298; homesteading in, 205–6; Hurley on, 294, 296; images displayed at

Fair in, 213, 215; images of, 204–5; J. Lee's article on, 207–10; R. Lee's photographic legacy and, 294–97; obstacles faced by residents of, 221; patriotic color scheme of, 336n63; publication of images of, 209–10; recreated images of, 213–15, 218, 219; Stryker and, 208–9

pioneer farmer archetype, 206–7

Plattner, Steve, 287

Plow That Broke the Plains, The (Lorentz), 106, 114, 126, 280–81

political perspective, influences on, 31–35. *See also* reformist agenda

Pope, Milton, 16–18, 25, 26, 183

Portuguese Americans, 265–67

Preacher reading the lesson (Lee), 190, *191*

prefabricated homes, construction of, 141–44

Progressive Era, 16, 48

Public Health Service (PHS), 153, 154, 179–80

Putting steel straps in place to hold pressed cotton (Lee), 157, *158*

Pyle, Ernie, 208

Quarters of the foreman of the logging camp (Lee), *111*

RA. *See* Resettlement Administration

racial conflict and FIS, 264

racial integration, 144–46

racial prejudice, 150, 152, 187, 267

racial segregation, 146–47

racial violence, 147–48

Raeburn, John, 67–68, 162

rationing system, 260

Reclamation Service. *See* Bureau of Reclamation

reformist agenda: of Hine, 49; of J. Lee, 168; of R. Lee, 171–72, 186–87, 195, 291; of New Deal, 91–92; of Stryker, 48–49, 64, 74–75

Regionalist style, 36

Reilly, Rosa, 134, 135

Repairing army interceptor plane (Lee), 262–63, *263*

repeat compositions/serial presentations, 82–85, 150, 153, 174

repeating or reenacting scenes, 56–57, 216–17, 289

repetitive publication of photographs, 296–97

Resettlement Administration (RA): AAA and, 73; creation of, 51; J. Jones and, 45; Lorentz and, 106; photography operations of, 52–54, *53*; Subsistence Homesteads program of, 61, 63. *See also* Farm Security Administration; Historical Section

Richards, Charles Russ, 21–22

Ride at the carnival (Lee), 233, *235,* 235

Riis, Jacob, 10, 48–49, 85–86

River, The (Lorentz), 106, 114, 280–81

Rivera, Diego, 30, 32

Roadhouse (Lee), *16,* 166–67

Roosevelt, Eleanor, 208

Roosevelt, Franklin Delano: farm tenancy and, 73–74; Japanese Americans and, 267–68; Lend-Lease agreement and, 230; On National Defense fireside chat of, 197, 219; policies regarding race of, 144–45; Tugwell and, 50. *See also* New Deal

Roosevelt, Theodore, 227–28

Roosevelt Recession, 132

Rosskam, Edwin, *53, 154*; Defense Bond mural and, 236, 237, *238*; as freelancer, 280; at FSA, 2; FSA exhibit prepared by, 152; *Home Town,* 194; on Lee's flash technique, 89; "Not Intended for Framing," 293; as photo-editor, 171, 172; on role of Historical Section, 106; *12 Million Black Voices* and, 146

Rosskam, Louise: color images of, 343n63; on flash photography of Lee, 89; as freelancer, 280; at FSA, 2; on J. Lee, 169–70; on R. Lee, 187; on R. Lee and Stryker, 69

Rothstein, Arthur, *133, 281, 287*; *The Bitter Years 1935–1941* exhibition and, 280, 281; "Direction in a Picture Story," 216–17; dust storm and drought-related coverage by, 126–27; *Farmer and sons walking in the face of a dust storm, Cimarron County, Oklahoma,* 56; First International Photographic Exposition and, 133, 134; at FSA, 2; as hired out to other agencies, 153, 154; staged photo controversies and, 56–57, 216–17, 289; Stryker and, 54, 58; at symposium, 287, 288, 289; *War bond mural, Grand Central Station, New York, New York, 251*

Rural Electrification Administration, 85, 192–93

Sailors watching construction work (Lee), 274, *275,* 298

salmon population, threats to, 241–42

San Antonio, Texas, pecan-shelling industry in, 183–86

San Augustine, Texas, 188–94

Sander, August, 190

San Diego, California, 222–23, 224–26

San Francisco, California, move to, 29–30

Saturday night in a saloon (Lee), xiii, 123–24, *124,* 136, 174

Saxon, Lyle, 159, 161

Saying grace before the barbecue dinner (Lee), xi, *212,* 212–13, 294

Schickele, Rainer, 75, 76

Scott, Marie, *98,* 99, 100

Scott County, Missouri, 108

Scrap salvage (Lee), *261,* 261

Secondhand tires displayed for sale (Lee), 67, 174, *175*

segregation, documentation of injustice of, 146–47

Sekaer, Peter, 217

senior citizens, 79–80

serial presentations/repeat compositions, 82–85, 150, 153, 174

Severin, Werner, 287

Shahn, Ben: at American Artists' Congress, 44; *The Bitter Years 1935–1941* exhibition and, 281; Daumier and, 35; on Hine, 157; as painter, 36; at RA/FSA, 2, 45, 52, 54

Shahn, Bernarda Bryson, 65, 68

Sharecropper's child combing hair (Lee), 131, 150, *151,* 152, 153

sharecropping, 71–72, 139–40

Shasta Dam, 246–49, 274–76

sheet film, 115

Sherwood, Robert, 263–64

Shirey, David L., 292

shooting scripts: evolution of, 57–58; mechanization of agriculture in, 177; National Defense focus of, 229, 236, 254, 260; purpose of, 55; for small-town project, 188–89, 194; for wheat, 236, 338n10

shrines and altars, domestic, 181

Signboard on land near Iron River (Lee), 112, *113*

Sign on store window in Yakima (Lee), *300,* 301

Sign painter (Lee), *viii,* 65

Signs in cooperative elevator (Lee), *96,* 96–97

Sikeston Project. *See* Southeast Missouri Farms project

Sloan, John, 30, 34–35, 38, 183, 291; *The Gist of Art,* 179

small-town project, 188–94

Smith, Dorothy Jean. *See* Lee, Jean; Martin, Dorothy Jean Smith

Smith, Howard "Skippy," 264

Smith, J. Russell: on animal-drawn machinery, 238; *North America,* 49, 75, 175

Smithsonian Archives of American Art, New Deal and the Arts program of, 282

Snyder, Isadore, *60*

social documentary movement, 3–5, 24, 49. *See also* documentary style/approach

social issues and OWI, 276

Social Security, 79–80

Soda jerker flipping ice cream (Lee), *91,* 92

Soil Conservation Service (SCS), 105

Soil Erosion Service (SES), 104–5

Son of sharecropper combing hair (Lee), 131, 150, *151,* 152, 153

Southeast Missouri Farms project: description of, 140–41; documentation of, 148–53; economy and, 139–40; as experiment in housing construction, 141–44; housing construction at, 141–44; Lee and, 136, 148; mechanization and, 177; racial issues and, 147–48, 150, 152; Stryker on, 138

Southern Democrats, power of, 145–46

Southern Pecan Shelling Company, 185–86

Southwest Texas University, xiii

Soviet Union, trip to and reports on, 32–34

Special Skills Division, 45, 65

Spectators at a side show (Lee), 161, *162*

Spools of cotton thread (Lee), 155, *156*

staging photographs, 56–57, 215–17, 289

Stanley, Edward, 210, 253

State Conservation Commission (Wisconsin), 110

Steichen, Edward, 107, 134, 135, 209, 278

Stein, Sally, "FSA Color," 294

Steinbeck, John, *The Grapes of Wrath,* 198–99

Store window, Connecticut Avenue, Washington, D.C. (Lee), *117,* 117, 202

Store window in farmer's marketing section of Muskogee (Lee), *116,* 117, 202

store windows, photographs of, 115–18, 202

Stott, William, 39–40, 49, 265

Street scene, Spencer, Iowa (Lee), *189,* 190

Stryker, Alice Frasier, 48

Stryker, Ellen, 46–47

Stryker, George, 46

Stryker, Roy Emerson, *1, 69, 133, 256, 280, 281;* *American Economic Life and the Means*

of Its Improvement, 49; birth and early life of, 46–47; *The Bitter Years 1935–1941* exhibition and, 281; Black subjects of photographs and, 150, 152; career of, 49, 50–51, 52–53, 277, 280; characteristics of, 1–2, 65; communication with Lee, 109, 110, 112; departure from OWI of, 277; Duplicate File prints of, 331n66; editorial practices of, 114–15; education of, 47–49; on effectiveness of photographs, 97; farm tenancy bill and, 74–75; FSA and, xiv; on glorification pictures, 186–87; "Gossip Sheets" and "Weekly Letters" of, 109; on Hine, 49, 323n67; on hiring photographers, 64; *In this Proud Land,* 284–85; as leader, 54–55; on Lee, xiv, 120–22, 285; Lee and, 2–3, 68–69, 75, 109, 280, 283–84, 297, 299; legacy of, 284; on Mercey, 99–100; on National Defense focus, 228–29, 236–37; philosophy of, 106; photographs of Lee by, *119, 120;* *Pictorial Sourcebook of American Agricultural History,* 50–51; Pie Town series and, 208–9; on racial prejudice, 152; repetitive publication of photographs and, 296–97; small-town project of, 188–89, 194; visits to field by, 113–14, 115, 118, 120, 121–22, 239. *See also* Historical Section; shooting scripts

Survey, The, 48

Survey Graphic, 48, 56, 67

Susman, Warren, 40

Szarkowski, John, 281, 283, 290

Taylor, Paul, 54, 197

Taylor Grazing Act of 1934, 206

Tenant purchase clients at home (Lee), xiii, 138, 174, *176*

Tenant Purchase Program, 172–76

Tenayuca, Emma, 186

Tent home of family living in community camp (Lee), *201*, 225, 233

Texas: agricultural machinery in, 177–78; Corpus Christi, 226; Crystal City, 178; Lee on, 171; Mexican and Mexican American communities in Rio Grande Valley of, 179–88; pecan-shelling industry in, 183–86; San Augustine, 188–94

This Week (Sunday newspaper supplement), 210

Three Centuries of American Art exhibition (MoMA), 329n17

Tolan, John, 196–97

Tomlin, Bradley, 30

Transylvania Farms project, Louisiana, 145

Tripp, H. H., farm of, 101, *102*

Tugwell, Rexford Guy: AAA and, 73; *American Economic Life and the Means of Its Improvement,* 49; Bennett and, 104; Black farmers and, 144; on documentary art, 68; as economist and professor, 48; on farm tenancy, 74; FDR and, 50; Historical Section and, 53; Jersey Homesteads program and, 61; RA and, 51–52; resignation of, 102–3; Soil Conservation Service and, 105

Turner, David, 289

12 Million Black Voices (Wright and E. Rosskam), 146, 152

Unemployed, New York City (Lee), 40–41, *41*

Union Settlement House, 48

Union Square, New York City, 31–32

University of Texas, 283–84

Unloading boxes of salmon from fishing boat (Lee), *240,* 240

USACE (Army Corps of Engineers), 241, 288, 337n3

U.S. Camera: annual publication of, 67, 107, 135, 209, 291; annual show of, 134; monthly publication of, 209–10, 249

Vachon, John, *133, 281*; at *The Bitter Years* opening, 280; on fieldwork and car trouble, 119; as freelancer, 280; at FSA, 2; on OWI work, 255; on project progress photographs, 138; San Augustine work of, 194–95

Vale, Oregon, 229–35

Vanderbilt, Paul, 278

visualization, methods of, 23–24

Wade, Bill, xi

Wallace, Henry, 50, 51, 74, 103

War Production Board, 260–61, 262

War Time Housing exhibition (MoMA), 226

Washington, D. C., 45, 50–51, 59, *117,* 117, 133, 169, 209

Washington, wheat harvest series in, 236–39

Washstand in corner of kitchen (Lee), *83,* 84

Washstand in house (Lee), *82,* 84

washstands, 82–85

water, documentation of story of, 126–27, 228, 337n3. *See also* Bureau of Reclamation; dams

Webb, Herbert V., *7*

"We're living in a tent" (Lee), 224–25, *225,* 233

Werner, Charles, 10, 11, 17, 18, 95, 183

Werner, Eva Pope, 9–11, 12, 14–16

wheat harvest series in Washington, 236–39

Whinery, Jack, family of, *214,* 215

Wilder, Thornton, *Our Town,* 193

Wilkinson, Garford, 152, 337n5

Williams County, North Dakota, 129–30

Wilson, Richard, 98

Winckler, Suzanne, 292

wind erosion, 125–31

windmills, 93–94, *94*

windows, photographs of, 115–18, 202

Winkler, Allan M., 264, 274

Witkin, Lee, 286, 294

Wolcott, Marion Post, 2, 217, *287,* 287, 289

Wolf, George, 152

Woman flood refugee in schoolhouse (Lee), *108,* 108

Wood, Nancy, 284, 295

Woodstock, New York, arts colony of, 30, 68

Wool, Helen, *256,* 256

Workman at Shasta Dam reads war extra (Lee), 249, *250*

Works Progress Administration (WPA): *American Guide Series* of, 159–64, 195; discrimination barred in project of, 145; Ohio River Flood and, 106; *Rain for the Earth,* 126; Social Research Section of, 186; soil erosion and, 105; *State Guide to Texas,* 195; workers at Jersey Homesteads and, 61

World War II: Lee's service in, 6, 276; salvage campaigns during, 260–62; US entrance into, 249; US military preparedness in, 262–63. *See also* home front; National Defense

WPA. *See* Works Progress Administration

Wright, Richard, *12 Million Black Voices,* 146, 152

Zorach, Marguerite and William, 30, 44